THE CONSUMMATE CANADIAN

A Biography of Samuel Edward Weir Q.C.

Mary Willan Mason

Natural Heritage / Natural History Inc.

THE CONSUMMATE CANADIAN

The Consummate Canadian
A Biography of Samuel Edward Weir Q.C.
Mary Willan Mason

Natural Heritage Books

The Consummate Canadian
Mary Willan Mason

Published by Natural Heritage / Natural History Inc.
P.O. Box 95, Station O,
Toronto, Ontario M4A 2M8

Design by Derek Chung Tiam Fook
Colour Separations by Colour Innovations, Toronto, Ontario
Printed and bound in Canada by Hignell Printing Limited,
Winnipeg, Manitoba.

Canadian Cataloguing in Publication Data
Mason, Mary Willan,
 The consummate Canadian : a biography of Samuel Edward Weir Q.C.

Includes index.
ISBN 1-896219-40-3 (bound) ISBN 1-896219-38-1 (pbk.)

1. Weir, Samuel E. (Samuel Edward), 1898-1981. 2. Weir, Samuel E. (Samuel
Edward), 1898-1981 — Art collections. 3. Art, Canadian. 4. Art, Modern —
19th century — Canada. 5. Art — Collectors and collecting — Ontario —
Niagara-on-the-Lake — Biography. 6. Lawyers — Ontario — Niagara-on-
the-Lake — Biography. I. Title.

N5230.C22W45 1998 709'.2 C98-931048-5

Le Conseil des Arts | The Canada Council
DU CANADA | FOR THE ARTS
DEPUIS 1957 | SINCE 1957

Natural Heritage / Natural History Inc. acknowledges the support received
for its publishing program from the Canada Council Block Grant Program.
We also acknowledge with gratitude the assistance of the Association for the
Export of Canadian Books, Ottawa.

TABLE OF CONTENTS

ACKNOWLEDGMENTS

FIRST AND MOST OF ALL MY THANKS FOR UNREMITTING HELP, SUP-PORT and kindnesses must be proffered to the members of the Board of The Weir Foundation, to Eugene LaBrie, past president of the Weir Foundation, to Margaret Ferguson, president of The Weir Foundation, to Joyce De Vecchi, honourary secretary of the Weir Foundation and to the late John Robert Weir, past secretary of the Weir Foundation. My thanks and deep appreciation go to James Campbell, Curator of the Samuel E. Weir Collection and Library of Art, for sharing so generously his profound knowledge of the Collection as well as so many hours of his time; to Judy Mahoney, Mr. Weir's faithful housekeeper, who became a dear friend; to E.C.H. Phelps whose archival interests and never failing fund of information were invaluable and to Margaret Markert, so generous with help and hospitality.

My thanks go also to William P.C. Baldwin, Paula Elliott Bawtenheimer, Hugh Blair, Margaret Blair, John Brook, Charles Brunner, John Burtniak, Jack Choles, Moira and William Cooper, Jeanette Earp, Isobelle Erskine, Barry Fair, Dorothy Fiedelleck, Charles B. Kirk, Alexander Kiss, Penny Krull, Eva Lynn, Nancy Poole, Hugh MacMillan, Margaret May, J.H. Moore, Hon. J. Douglas McCullough, Gretchen McCulloch, Dr. J.P. McMillan, George Neely, Paddy O'Brien, Rory O'Donal, Anne Kolisnyk, Dr. Joseph Solevich, Richard

and Muriel Pendergast, Sandra Guillaume, Leon Warmsky, Karen Bergsteinsson, Wayne Crockett, Paul McIlroy, Raymond Peringer, Dennis Reid, Philip Schiavo, Gerry Sherlock, Tony and Kathy Szabo, Fred and Fran Thompson, Susan Binnie, Agnes Van der Meulen, Betty Webster, Marie Smibert, David Silcox, Albert Soren, Tom Smart, Lorne Stewart, Nathan Strauss, Richard and Yvonne Pagani, Mary Di Matteo, and to others who wished to remain anonymous.

INTRODUCTION

SAMUEL EDWARD WEIR, BARRISTER-AT-LAW AND ONE OF HER MAJESTY's Counsel, Learned-in-the-Law, distinguished internationally and the third lawyer from Ontario to be called to the Bar in the Province of Quebec, was born on August 12, 1898 in London, Ontario, and died in his home, River Brink, at Queenston, Ontario on January 18, 1981.

It has been my privilege to meet, through his friends and an immense body of correspondence and notes, Samuel Weir, a man both deeply loved and reviled with scorn. It is axiomatic that such a human being must have led an interesting, controversial and unusual life. He was a man of many parts, of incisive wit and great intelligence as well as having a breath-taking talent for pursuing the least and most illusive crumb of learning about any subject that caught his interest with single-minded passion. At the same time, oblivious to the interpretation by the world at large, he could put himself into a position that would automatically subject him to a misunderstanding of his motives.

Beautiful objects whether they be flowers, sculptures, art works or art in general, entranced Samuel Weir even as a small child and all became his passion throughout his maturity. A true connoisseur, his strong curiousity led him to enquire, to investigate, to know and to understand his collections of art, of antiquarian books, of antique clocks and of coins

and finally to share his pleasure in his acquisitions with all who come to his home, River Brink, the house he designed to be a library and museum for all time.

How did all these characteristics, together with brilliance of mind and stern self discipline, come to rest in one complex person? To begin to understand, we must go back to eighteenth century Germany and early nineteenth century Ireland. On both sides of his family he was descended from pioneer stock, each family coming across the Atlantic with the intention of becoming established in what is now south of the Canada - United States border. Each family eventually settled in what was Canada West in British North America, due in one case to vagaries of wind currents and to unforeseeable political developments in the case of the other.

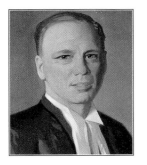

1 THE WEIR FAMILY

ARCHIBALD AND MARY CURRIE WEIR, M. 1817

SAMUEL EDWARD'S GREAT GRANDPARENTS, ARCHIBALD AND MARY Currie Weir, both of Highland Scottish stock, emigrated unexpectedly to Upper Canada from Straid Mills, near Ballymena in County Ulster of what is now Northern Ireland, where their families had been living for some generations. Archibald and Mary Currie were married in Ballymena in 1817. The groom was twenty seven years of age and his bride, twenty five. Archibald, as the eldest son, was expected to carry on the family business in the linen trade. His father, also Archibald, had built up a prospering export business with its chief outlet in the New World at Philadelphia. On a more or less regular basis for the times, Archibald senior had crossed the Atlantic to further his business and to visit an uncle who had fought in the Revolutionary War and who had received a land grant in Pennsylvania for his participation.

The year of Archibald's and Mary's wedding turned into a year of tragedy. The sailing ship upon which Archibald senior was returning to Ulster encountered heavy seas and an Atlantic gale which sent it to the bottom with all hands on board, leaving his widow with four sons and a daughter. In the same year, 1817, the first of a series of catastrophic famines plagued all of Ireland. So it was decided that Archibald and

Mary would set sail the following year to re-establish business connections with linen merchants and drapers in Philadelphia, leaving the younger sons to manage the mill and business in Ballymena.

On the voyage over to Philadelphia, Atlantic gale force winds again beset the Weir family and their undertakings. Their ship was blown off course to such an extent that it was forced to tack on a northerly heading. Eventually, after a harrowing encounter with rolling seas and bitterly cold winds, the ship made port at Halifax. With such an experience, and doubtless with the death of Archibald senior much in their minds, the two young people were very uneasy at the prospect of the dangers of regular sailings back and forth on the treacherous Atlantic. With their feet on firm ground, it did not take much convincing for them to end their trans-Atlantic crossings then and there, especially when they learned that free land was available for the asking in Upper Canada. It is not recorded whether they asked themselves where Upper Canada was. Archibald abruptly abandoned the linen exporting business and applied for a land grant. The couple made arrangements to sail once again, this time on inland waters, and to proceed as far west as possible by whatever means they could find to the promised land. They disposed of their stock of linens and anything else they felt they believed non-essential and set off.

Mary, however, did hang on to her pewter teapot. Wherever they were headed, Indian country or whatever, Mary's prized possession was coming too.

Two storms at sea, one after the other, altered their plans and Archibald and Mary Weir became the founders of one of Canada's most distinguished pioneer families, leaders in every calling and profession they chose, from one end of the country to the other, from sea even unto sea.

Their destination ultimately became Five Stations, a village now known as Talbotville Royal, in Elgin County where the Weir land grant was parcelled out to the pair. After spending two years there, where their daughter, Margaret, the first child, was born in 1820, the Weir family took up their 100 acre grant in London Township, County of Middlesex, the North Half of lot 12, 15th Concession, fronting on the 16th Concession.

It was in the summer of 1822 when Archibald and Mary had settled in and built themselves a shelter that Archibald went off the property on an errand to the nearest village. Mary, left alone with little Margaret, a toddler, and James on the way, was hoeing in her garden and keeping an eye on the child. Straightening up for a moment to relieve her back, she looked around and noticed a couple of Indian men approaching the cabin, in what seemed to Mary, a rather furtive way. She was

used to neighbours dropping in without a knock or a by-your-leave as was their custom, but this seemed a little different somehow. Scooping up Margaret, Mary ran for the cabin. At once it was obvious to her what had attracted the pair. It was her teapot, her shiny teapot, which they had observed from time to time and coveted.

With Archibald out of the way, the men no doubt thought it a good opportunity to make off with the teapot and melt it down for bullets. Mary entered the cabin, Margaret on one hip and her good garden hoe in the other hand. One of the Indians made as if to attack her. Mary straight armed him with her hoe. The other would-be thief dropped the teapot in fright and the pair made off as fast as they could, leaving a trail of blood from Mary's clout with her weapon. The pewter teapot is still given a place of honour in the home of one of her descendants, the little dent where it was dropped in such a hurry still in place.

Archibald lived as a farmer all the rest of his life and died in 1869 at the age of 79. Mary died in 1888, aged 96, still the feisty pioneer's wife. It was said that she suffered a fatal heart attack while pumping water in the town well at Granton where she had gone to live in order to be close to her daughter, Sarah Weir Grant. Mary's last home where she lived independently until the end of her days was in an apartment

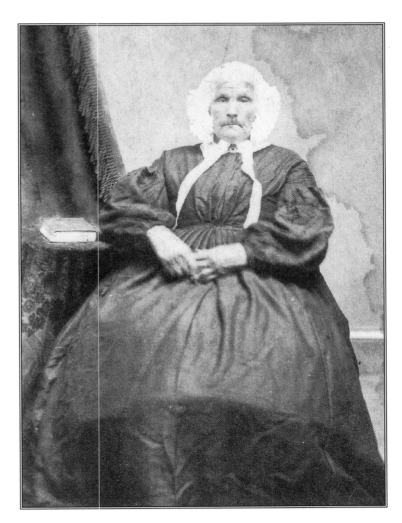

Mary Currie Weir, born 1792; married 1817; died 1888.

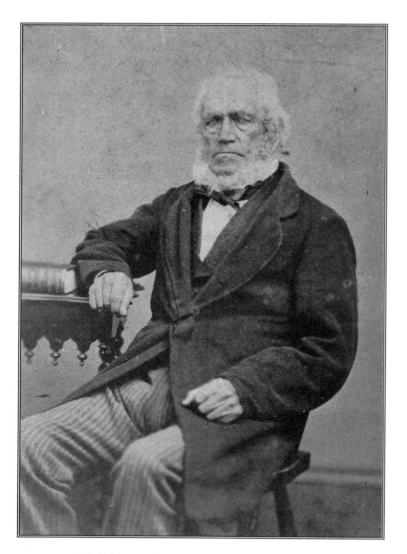

Archibald Weir, born 1790; married 1817; died 1869.

over a store. In the way of general stores of the era, it is to be hoped that it carried a good line of fine Irish linens.

In his will, Archibald left the farm to Mary, an unusual tribute and an indication of his confidence in her ability to take care of herself and the farm. She had demonstrated her control of many a situation involving wolves, Indians, bears and assorted other hazards of pioneer life. Upon her death the farm was to be divided equally between Margaret, the first born and James, the eldest son. Margaret had married Frederick Fitzgerald and produced eleven children. Her grandson, Fred Fitzgerald, became a well known and respected ear, nose and throat specialist in New York City, whom Samuel Edward Weir frequently consulted and with whom he had a close friendship.

Perhaps because she had married well and lived in a splendid stone house in Granton, Sarah, the fifth child, received only five shillings from the will. It was to Sarah that Mary turned when the farm was no longer her home, and she settled in the village near her daughter. Archibald's and Mary's other sons, Robert, John, and their eighth child, Samuel, our Samuel Edward's great uncle, also were left 5 shillings apiece. The other daughters, Mary Ann, Jane, Martha and Elizabeth were left one hundred or two hundred dollars apiece, a not inconsiderable sum in those days.

JAMES AND SUSANNAH SUTTON WEIR, M. 1851

James married Susannah Sutton, also of pioneering stock. He later left his father's land grant for land acquired through his marriage and took up farming near Hensall, Ontario, south of Clinton on the former Highway 4. Ultimately they would have nine children.

The Sutton family, originally from Yorkshire, had moved to County Wexford, Ireland, as tenant farmers of a Lord Morris who had assigned them to his Irish grant of land. It is of interest to note that a Sutton, remaining in England, founded Charles House School where the Wesleys were educated. Archibald and Mary's third child, Robert, married Martha, the younger sister of Susannah. Consequently, James' and Robert's children were double cousins, not an uncommon occurrence among pioneering families. No doubt all were proud of their Wesley connection.

James and Susannah Sutton Weir had nine children. The eldest, Richard, about whom we hear more, began his career as a teacher in Petrolia. Their second child, Mary, died of typhoid in 1874 at the age of twenty one. Another Archibald, the third child, born in 1855, married Agnes Cruickshank and practised law in Sarnia. The couple had two children, Charles, born in 1896 and Agnes, born in 1907, who both practised law in

their father's firm. Agnes, after her marriage to Archibald Randolph, continued her practice and collaborated in legal matters with her cousin's son, Samuel Edward. Agnes Randolph's two daughters, Penny and Libbie, were taken to London on many an occasion as small children. While Agnes and Samuel Edward consulted together in his chambers, the two little girls entertained themselves on the escalators in a nearby London department store. This commodity, unknown in Sarnia at the time, was a source of great fun for the youngsters.

Of the six remaining children of James Weir and Susannah Sutton Weir, all girls, the eldest, Susan, died in infancy; while three married and left the area. The two youngest, Anna, born in 1866, and Jane, known in the family as Jennie, born in 1868, had teaching careers, the former in Port Hope and the latter in London. It is possible that Jennie Weir had known Samuel Edward as a little boy in the London public school system from 1903 onward when he started school and Jennie was a school marm, aged 35. Jennie must have known Samuel Edward's father, her cousin George Sutton Weir, in his role as Medical Officer of Health for the London school system. Both Anna and Jennie died as spinsters, not uncommon in those days.

Richard married Margaret Moir and ultimately

became a Presbyterian minister, his last charge in Ontario being at Petrolia. Richard's sister, Jennie, remarked somewhat uncharitably that he had "preached every Presbyterian church in Ontario empty." Richard and Margaret decided to take advantage of the land grants being offered to those who were willing and able to homestead on the western prairies, then known as the North West Territories. They set out for Kenaston in 1878. Margaret Moir Weir remembered her experiences as a young pioneering wife in a story she wrote in 1923. She disguised herself and Richard as Peggie and Pat, chronicling the vicissitudes and adventures of the hardy folk who established themselves in what is now the Province of Saskatchewan. Her account "Years Ago," providing us with a vivid picture of the earliest pioneer life in western Canada, is part of the Weir Collection at River Brink.

Although he had gone west to farm, the Reverend Richard received a call to take a charge in Prince Albert. During the course of his ministry, he had several charges in Saskatchewan and neighbouring states to the south. Emulating his father, Richard and his wife also had nine children, born between 1878 and the 1890s. They were true pioneers of the west and their seven living children distinguished themselves in various professions and occupations throughout Canada.

Their eldest child, Elizabeth, became the tax collector of Saskatoon, an unusual career for a woman at the turn of the century. The second , Susan, married Hugh MacLean M.D. of Regina and subsequently of Los Angeles. Susan was a gifted watercolourist and her daughters feel that she could have had a distinguished career as an artist had she been able to have had formal training, but in that society it was the sons who were given special education leading to careers. Susan Weir MacLean told her daughters that at one time her father, the Reverend Richard, preached in what was a log cabin outside the fort at Winnipeg. When her father went into Winnipeg, the children asked for candies for a special treat, but she always asked for crayons. She also told them that she and her sisters slept on a tick mattress filled with wheat stalks in the cabin. Seeds of wheat had a habit of falling in little pieces on the floor and the three little girls nibbled them with glee. Margaret, Marion and Isobel, Susan's daughters remember their grandfather, the Reverend Richard, as being a devout and strict minister of the cloth but with a sense of humour.

On her honeymoon, Marion and her husband, Harold McKim Graham, an ophthalmologist practising in Vancouver, came east to Hensall and arranged for her great grandfather, James Weir, then in his eighties, to be admitted to a hospital where he died. Margaret, on her honeymoon, with her bridegroom, Kenneth Blair, a wing commander in the RCAF

later awarded the MBE, visited her grandfather, Reverend Richard, who upbraided her for wearing "silly high heels." Marion and Margaret both remember staying at grandfather's house over Christmas, where the Reverend Richard had erected a Santa Claus on the roof. The three young girls were bedded down in "Grandpa's" study, which they loved. The walls were lined with books and the girls knew where to locate "Grandpa's law books" and where to find accounts of "juicy law cases," as they put it.

Mary, the third child of Reverend Richard married Lucien Phillips, the City Clerk of Saskatchewan, so perhaps it was through her husband's connection that her sister, Elizabeth, became Saskatoon's tax collector. Mary and Lucien Phillips had two sons, Roy and Nathan.

Reverend Richard and Margaret Moir Weir's fourth child and eldest son, James, married Isobel Cross and had a distinguished career as a professor of engineering at McGill University. He died in 1941, leaving one son, James Craig Weir, who practised law in the west. At one time, Samuel Edward wanted him to join his London firm, but James declined.

The fifth child, George Moir Weir, became Minister of Education and Health in the government of British Columbia. Born between 1883 and 1888, he died in December of 1949. George is remembered as having a wonderful sense of humour.

His daughters, Margaret and Moira and his nieces, Margaret, Marion and Isobel found even his asking of the blessing at mealtimes so hilarious that they were all reduced to helpless giggling. His wife, Marie, is remembered as being a "beautiful cook, but not an entertaining person." It was George who kept the little girls in constant laughter, meanwhile maintaining a perfectly straight face.

Richard and Margaret Moir Weir's sixth child, Archibald Richard, married Muriel May Taylor of Prince Edward Island in 1912. Ultimately, Archibald became the Registrar of the University of Saskatchewan. This couple had three children. James Donald of Calgary, a Rhodes scholar, was the winner of a further scholarship which took him to South America where he became Chief Geologist of Standard Oil of California. The other son, John Arnold, born in 1916, became Professor of Genetics at the University of Kansas at Lawrence, Kansas. Margaret Phyllis, the third child, born in 1919, married Reginald McNally and went to live in Charlottetown, PEI.

The youngest child of Reverend Richard and Margaret Moir Weir to survive (the two last born died as infants) was John Alexander, born in 1890, while the Reverend Richard held a charge in a bordering state of the United States. Also a Rhodes Scholar, the first in the Weir family to gain this prestigious award, John Alexander, became the first Dean of the Law

School at the University of Alberta in Edmonton. He married Elizabeth Teviotdale, born in England. There were three children of this marriage. Elizabeth, born in 1927, who, after gaining her Ph.D in Chemistry, taught at Carnegie Technological Institute in Pittsburgh. Her married name was Toor. Ramsay, born in 1929, graduated in medicine and went on to practise as an internist in Camrose, Alberta. The youngest child, also John Alexander, born in 1933, graduated in law and became a lawyer in Edmonton. As a student of law in London, England, John Alexander junior met Samuel Edward while he was attending the Commonwealth Law Conference in 1955. Together they travelled for a few days to Ballymena in Ireland as Samuel Edward was interested in tracing his ancestry there. John Alexander remembers seeing the old family linen weaving mill and also remembers seeing a family connection on a tombstone depicting a skull and crossbones, the grave of a privateer from Hanover, whose money apparently started the mill.

ROBERT AND MARTHA SUTTON WEIR, M. 1854

The third child and second son of Archibald and Mary Currie Weir, Robert, Samuel Edward Weir's grandfather, was born in 1824. He became a Presbyterian minister or so it was said by the family, although there is no appropriate listing in the Presbyterian Church records. Later he joined the Methodist Church, in which he was ordained. In 1854, he married Martha Sutton, as already mentioned, the younger sister of Susannah, James' wife. She had taught school and also worked as a tailor. In her forty five years of life and twenty years of marriage, Martha bore ten children, all of whom lived with the exception of her firstborn son, Richard, who died in infancy. Because James, Robert's elder brother, had relinquished his inheritance of the original Weir land holding, Robert and Martha took over the farm. Robert and Martha's second and first living child, John died in 1890 at thirty four years of age and seems to have disappeared without a trace in all family documentation. There is no recording of his activities and no mention of a marriage nor of descendants.

Robert and Martha's third child, George Sutton Weir, ordained as a minister, was a preacher of the Evangelical Methodist Church. He also graduated from the University of Western Ontario with a degree in medicine, gaining his M.D. in one of the first classes of the faculty in 1907. George Sutton married Sarah Bawtenheimer and of their five children, the fourth was Samuel Edward, the distinguished lawyer and collector of art who established River Brink and is the subject of this book.

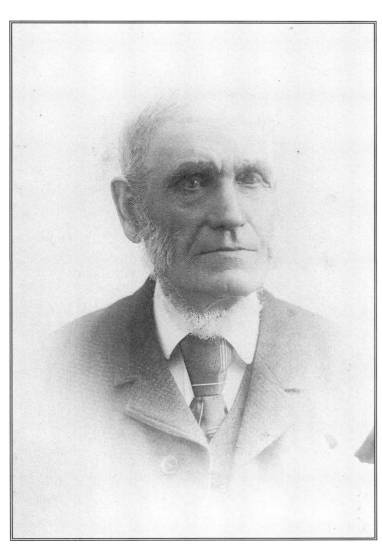

Robert Weir, Samuel Edward Weir's grandfather, born 1824; died 1907.

The fourth child of Robert Weir and Martha Sutton Weir, Samuel, born in 1860, had a distinguished career in the newly designated academic discipline of education. He received an A.B. from Northwestern in Chicago in 1889. In 1891, he graduated A.M. from Illinois Wesleyan and was ordained as a Methodist Episcopal minister, serving in Wichita, Kansas and Cheyenne, Wyoming. In 1889 he married Caroline Voss and a daughter, Helen Irene, was born to the couple in 1891. Upon Caroline becoming ill, Samuel brought his family back to Chicago and became an instructor in mathematics at Northwestern in 1892. After Caroline's death in 1894, Samuel left the child with her maternal grandparents and enrolled in the University of Jena, Germany, to study philosophy, graduating with a Ph.D and the highest marks ever bestowed on a foreign student. In 1898 Samuel returned to the United States, married Sarah Richards, and was engaged as Professor of Ethics and History of Education at New York University. He established the first School of Education in the United States in 1897 with a faculty of three and himself as Dean. In 1901, he moved on to several colleges and eventually went to the College of Puget Sound in Tacoma, Washington. There he taught until 1938, leaving a legacy of students across the United States acknowledging with gratitude his great influence on them. Although appearing to some as rigid and remote, his

granddaughter, Margaret Markert, the daughter of Helen Irene, attests to a real warmth and concern not apparent on the surface. "I always felt he might be rather lacking in a sense of humour and prone to take himself very seriously," she adds. This characteristic he seems to have shared with his brother, George Sutton Weir, the father of Samuel Edward.

Robert and Martha's fifth child, Susannah, the first daughter, born in 1862, married Robert Burnett on January 2, 1889. Prior to her marriage she had taught school. They farmed in Hensall, Ontario and in 1899 took up a land grant in the Boscurvis Scout Mill district of the North West Territories, which became the Oxbow district of the newly constituted province of Saskatchewan in 1905. They had six children, the first, Martha, born in 1892 died at the age of fourteen. The second, Alexander, 1894-1982, also known as 'Uncle Sandy,' is well remembered.

During his bachelor days Alexander was a great favourite of his nieces and nephews. His niece, Agnes Eva Lynn, Edward Francis Burnett's daughter, recalls his generosity with great fondness, giving presents to his nieces and nephews in the depressed thirties. In 1911, Alexander built himself a house in Oxbow, a very large house with a tower. Unfortunately raccoons climbed up to the roof and found it to their taste. The raccoon damage was responsible for the roof falling in and the house was demolished. During World War II, he collected a sizable amount of rubber for the war effort and his nieces remember being taken to the movies on some of the proceeds on December 24, 1944, a very great treat. Finally, in 1946, at the age of 52, he married. His bride was May Moore of London, Ontario, who for some years prior to her marriage, had been secretary to our subject, Samuel Edward in London. Samuel Edward, the eastern cousin, was considered a great matchmaker in finally persuading Sandy to marry and in providing a much admired bride, whose city clothes were the sensation of Oxbow. The couple had no children and retired to White Rock, British Columbia where they are buried.

George, 1895-1975, Susannah and Robert's third child, married Lily Craft and the couple had two sons, James and William. Their next child, Edward Francis, 1897-1985, married and had seven children. He was more interested in horticulture than in farming and was instrumental in the development of rust resistant wheat.

Susannah and Robert's fifth child, Mary Jean, 1899-1978, married G.B. Street in 1931. She was a registered nurse and it was said she had delivered all the babies and had looked after almost everyone in southern Saskatchewan throughout her career. In 1955 when the couple moved to Shaunavon following Street's retirement, Mary Jean became matron of the nursing home until she herself retired.

The youngest child of Susannah and Robert Burnett, Agnes Kirkman Burnett, was born in 1901, the only one of their children born in the West. She taught school until her marriage to Jack VanderMeulen in 1925. The couple farmed near Yorkton, where Agnes now lives, the only known first cousin of Samuel Edward still alive. Agnes and Jack had two children, a boy and a girl, both with descendants still in Saskatchewan.

The sixth child of Robert Weir and Martha Sutton Weir was James, born in 1863. James also went west to seek his fortune and became a well known journalist in British Columbia. According to Samuel Edward, he was a friend and crony of western leaders and politicians.

Two more children of Robert and Martha Sutton Weir, Mary, born in 1865 and Margaret, born in 1867, died in infancy. Edward Francis, the last son, born probably in 1869, became a doctor, practising in Meadville, Missouri. A daughter, Huldah, born in 1874, was Martha Sutton Weir's last baby. Martha died of typhoid and complications shortly afterwards. Huldah, raised by an uncle on her mother's side, Edward Sutton, married Walter McBain and had seven children, twenty two grandchildren and thirteen great grandchildren, all of whom seemed to have farmed in Saskatchewan and Alberta.

George Sutton was fifteen and Samuel, George's

George Sutton Weir, Samuel Edward's father, born 1859; married 1884; died 1944.

brother, after whom Samuel Edward was named, was fourteen when their mother died. The two boys remained close all their lives. Before his fifteenth birthday, George Sutton suffered some sort of injury while working on the farm and for the rest of his life had a hole right through his leg. His grandniece, Margaret Markert, the granddaughter of Samuel and Caroline Voss Weir, and the daughter of Helen Irene, remembers seeing it when she was a small child.

Robert Weir remarried shortly after Martha's death, but it was not a happy choice for him nor for his children. The second wife, recorded only by her surname Neilson, deserted the household and it can be imagined that, in the years when George Sutton and Samuel were adolescents, the home was anything but a joyous, happy place. George's brothers, as far as is known, all did well in the world, especially Samuel, and despite their Aunt Jane's mistake, the surviving sisters married well. It is interesting to note that all the children left home as soon as it was practical.

JANE WEIR AND DAVID CHAMBERS, M. –

Robert Weir lent a considerable sum of money to David Chambers, his sister Jane's husband, mortgaging the Weir farm to do so. Chambers was not particularly well liked in the community. An Englishman, he was known as an accountant and had worked in San Salvador, sometimes as a teacher. It was rumoured by some that he was a remittance man. Whatever his scheme was for making himself and others rich, his latest venture came to nothing and he was sued for embezzlement. Unable to repay Robert the money he had borrowed, his default led to the foreclosure of the original Weir land grant. Fortunately, Robert was able to set himself up on another property where he specialized in dairy farming. Thus Samuel Edward's grandfather, a Methodist minister and a dairy farmer, became a milkman, delivering milk to homes in what had grown to be the town of London.

As would be expected, family relationships were strained by Chambers' actions. Numerous letters written between the brothers and sisters and their children reveal that Aunt Jane Chambers was thought of as a rather embittered, elderly, childless widow after Chambers' death. Her nieces and nephews found her trying, but if she had thought that Chambers had married her solely in order to gain control of money from Robert's generosity as well as her own legacy of two hundred dollars from the will of her father, her bitterness is understandable.

OTHER DAUGHTERS OF ARCHIBALD AND MARY CURRIE WEIR

Other children included Mary Ann (1825) who married John Stacey and lived in London Township. Jane, of the unfortunate marriage, born in 1827, was followed by two more daughters. Sarah (1830) married James Grant, the founder of the town of Granton, Ontario. Martha (1832) married twice, first to Squire Corless and subsequently to Bernard Stanley, seems to have lived her entire life in London Township. The last child of Archibald and Mary Currie Weir, a daughter, Elizabeth (1837) married a school teacher, James Harrison. She had been willed one hundred dollars by her father. The couple lived in St. Mary's, had several children and were known far and wide for their hospitality. In their parlour, an organ held pride of place and frequently relatives and friends were drawn to the evenings of music and singing.

THE YOUNGER SONS OF ARCHIBALD AND MARY CURRIE WEIR

Then there was Samuel Weir, the eighth child of Archibald and Mary, who married Hannah O'Brien. The couple had four children, two girls and two boys both of whom seem to have died without issue. Samuel was left five shillings in his father's will.

John, the last son, born in 1835, married Anne Jane McSully of Strathroy. The couple had three daughters, then a son, about whom nothing is known other than their names: Mary Jane, Martha Ann, Margaret Elizabeth and George. Their fifth child, Robert Currie, was born in 1877 and married Josephine Pearl Johnstone on June 12, 1912. Known as Bert, he and Josephine Pearl had two children: Mary Josephine (1914) who married Duncan Alexander Mackay and John Robert, who married Vera Eugenie Eustace. Two children were born to John and Vera: Barbara Joan who married William George Stiles and Robert Stuart, who married Karen Clothilde Sass.

Robert Currie Weir became a well known physician, practising in Auburn, Ontario. On the fiftieth anniversary of his practice, he was given a celebration by the entire community and a great many of the children he had brought into the world over the course of half a century came to wish him well. John Robert, Samuel Edward's second cousin, served in the Royal Canadian Air Force in World War II. Despite the disparity in age, the two became close friends and remained so. John's wife, Vera, acted as an 'honorary' secretary to Samuel Edward after his retirement. When this work became an almost full time occupation for her, the situation was brought to his

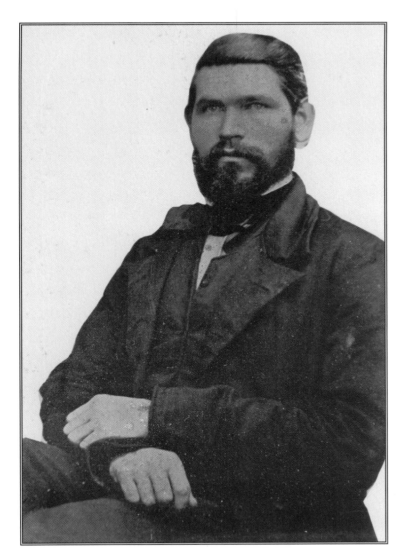

Samuel Weir, Samuel Edward's namesake, born 1860.

attention, and Samuel Edward attended to his oversight in her favour.

So it is that Archibald and Mary Currie Weir, blown off course on their voyage to the New World, inadvertently laid the foundations of a pioneering dynasty from Upper Canada, ultimately to the entire country as well as in the United States, a thoroughly impressive legacy of leaders, founders and pioneering farmers from coast to coast in North America.

24

2 THE BAWTENHEIMER FAMILY

THE MATERNAL SIDE OF SAMUEL EDWARD'S FAMILY WERE THE Badenheimers. It was from a small village in Baden in the German Palatinate that four young men, probably brothers, left their home to try their luck in the New World at regular two year intervals. Of one brother, there is no trace of his having landed. He may have been under the age of sixteen and hence too young to take the oath of allegiance to the King of England upon arrival, or his ship may have been lost at sea. The two elder brothers, Johann Christian and Johann Wilhem Badenheimer, arrived in September of 1749 and September of 1751 respectively, aboard the brig, *Two Brothers*, in two separate crossings out of Rotterdam bound for Philadelphia. Two years later, the third brother, Johann Peter Badenheimer, arrived in Philadelphia in September of 1753 aboard the snow *Rowand*. A snow is defined as a sailing vessel rigged in manner similar to a brig but with a trysail mast just abaft the mainmast and considerably smaller than a brig, more manoeuvreable and sometimes used in warfare. Each of the brothers, upon arrival, disembarked in Philadelphia and had to take an oath of allegiance to the British Crown as well as an oath of abjuration and fidelity to William Penn and the proprietors of Pennsylvania. The two elder brothers appear to have left Pennsylvania subsequently and to have settled in North Carolina. Johann Peter travelled north to New Jersey.

That each son left the Palatinate as soon as he approached sixteen years of age would indicate that the land around Baden, known for the quality of its vineyards and its wine, where the family had farmed for generations, was now of insufficient harvest potential to support five sons for division among them. The first born, as was the custom, remained at home.

Political unrest in Europe also may have contributed to the departure of the younger four. The War of the Austrian Succession broke out in 1740 when Johann Peter was three years of age. Charles VI, the last Holy Roman Emperor died in 1740 and left no male heirs. He had exacted promises of fealty to his daughter and heiress, Maria Theresa, from his various vassals, kings and electors. The emperor was no sooner entombed than Maria Theresa, who had succeeded to the thrones of Austria, Bohemia and Hungary, was faced with Frederick II, the Great, King of Prussia, marching into Austria. Charles Albert, Elector of Bavaria, Philip V of Spain and August III, King of Poland and Elector of Saxony, also made their claims to the Palatinate and the war was on. Maria Theresa was supported by Hungary, Britain and the Netherlands. Bavaria, France, Poland, Sardinia, Saxony and Spain supported Frederick and the other insurgents. For five years battles and skirmishes made the farmers' lives difficult and precarious, although the Badenheimers' produce no doubt was in high demand. At last the Treaty-of-Aix-la-Chapelle was signed in 1748, but it was an uneasy peace. In 1756 the war known as The Seven Years War broke out, three years after Johann Peter had left his home. He was nineteen years of age and must have been relieved to have left the constant uncertainty that frequently led to open warfare. Emigration may well have been an attractive alternative to providing cannon fodder for the Electors of Saxony and Bavaria.

After he made his way north, young Johann Peter was registered as a member of the German Reformed Church in Mount Pleasant, New Jersey. He eventually married and his wife bore him three children, one of whom a boy, born in 1773, was named Peter after his father. By this time the original spelling of Badenheimer had become more phonetically pronounced as Bawtenheimer, and so it was spelled.

Young Peter Bawtenheimer married a woman identifiable only as Grace and the first two of their ten children were born in New Jersey. In 1800 Peter and Grace Bawtenheimer made their way to Upper Canada along with Peter's brother, John. Although nothing is known of their activities, if any, in the Revolutionary War, many families who had not actively supported the revolution, finding themselves socially and commercially ostracized over a period of time, came north to what remained of British North America. They were not given

land grants as United Empire Loyalists had been, but were able to bring whatever fortune they possessed and to buy land. A descendant recorded the brothers' account of the journey, in part, "coming with horses and on foot, there being no vehicles, by way of Niagara crossing the river on a ferry boat following Indian trails and deer tracks westward till they arrived in what is now the city of Hamilton which was only a few huts at the time. Peter took 200 acres at the Cold Springs, lot 36, 1st Concession, township of Ancaster. John settled on a bush lot of 200 acres south of what is now Copetown."

Those who had supported the British in the War of Independence which ended in 1776, or who had remained obviously neutral, were made to feel less and less welcome in the new United States and were still arriving as loyalists. Peter and Grace settled down on their lot and their third child, Daniel, Samuel Edward's great grandfather, was born in 1803, to be followed by seven more children. In time the Ancaster and Blenheim townships of Wentworth and Oxford counties respectively were well populated by Bawtenheimers. So much was this the case and so popular was the name of Peter, that one Peter Bawtenheimer changed his name to Beheimer so that his mail and his real estate dealings should not be confused with those of a same named cousin and their transactions end up in considerable confusion.

Good farmers all, the Bawtenheimers prospered and in the early years of the 1800's Peter went back to New Jersey to buy a wagon and horses. When war broke out between British North America and the United States in 1812, Peter put his Yankee bought wagon and his teams of horses to work hauling supplies for the British troops. It was known that his wartime activities had brought him "a good deal of wealth."

In time young Daniel married (Catherine) Katy Chrysler, whose father, Henry, had died in the war of 1812. The couple settled on a farm given to Daniel by his father Peter, on lot 4, Concession 6 in Blenheim Township. Daniel, William, Peter, John, James and David, all sons of Peter, farmed near to one another. On Sundays the brothers took turns visiting one another back and forth making their roundabout way by boat on the Nith River. Daniel's younger brother, Peter, married Rachel Chrysler, Katy's sister. As in the Weir family, there were double cousins aplenty.

Daniel's second son, Henry, the grandfather of Samuel Edward, apparently felt the call to preach from his childhood. Born in 1826, he studied for the Wesleyan Methodist Ministry, became an itinerant preacher in his early twenties and was given his first charge at the age of thirty. He began his career in Wellesley, a village west of Kitchener in 1856. The following year he was based in Kincardine. In 1858 he began the year at

Bayfield and later was moved to Stratford. After his ordination in 1859, while he held the charge of Morris Township in Huron County, Henry established himself in Blyth. In the year of his ordination, he married Martha Amanda Barber, whose parents had come to settle in Upper Canada from the United States. A petite and high spirited young beauty of sixteen, Martha Amanda was born in 1842. Henry, who was thirty-seven at the time, is reported to have remarked that he deliberately chose a young wife that he might mold her into the proper attitude and behaviour of a minister's wife. Henry, it would appear, took his responsibilities and himself with great seriousness as a god fearing minister of the gospel.

According to family lore, while still in Blyth in 1860 the Bawtenheimers' first child, Sarah, Samuel Edward's mother, was born over the blacksmith's shop. Then, in 1861, it was on to Teeswater where in the following year the Reverend Henry was declared supervisory minister. From 1863 until the year of Confederation in 1867 the family was quartered in Clinton where Charles was born in 1864, followed two years later by another daughter, Frances, known as Frankie. By 1868 the family was on the move again, this time to Oil Springs and Petrolia, about twelve kilometres apart, where Henry's health "failed." The poor roads, mud and winter weather which made travel between the two charges daunting undoubtedly contributed to symptoms brought on by exhaustion. In 1869, another daughter, Mary, was born in the new charge at Paris where the family remained until 1873. Eva Jane, who later married Alexander Thompson, a lawyer, was born in Paris in 1872.

In 1874 the family was sent to Toronto for one year and, in 1875, the Reverend Henry received a call to take charge of the Cape Croker Indian Reserve near Wiarton. There to "convert the heathen" he took great pride in being the first Methodist minister to be so appointed. After two years of preaching and ministering to the Ojibway on the Reserve and establishing a thriving religious community, the Reverend Henry and his family were moved again. This time it was to Kilsyth, not far from the Reserve and close to Owen Sound, a charge that would last for three years until 1879. In 1881 the Reverend Henry was moved back again to minister to Cape Croker, where he preached to his growing flock until his death in 1882. The last child, Laura Alberta, known as Bertie, was born in 1881, the year before Henry's death.

Upon their arrival at Cape Croker, the Bawtenheimers found their home, the manse, [which,] according to one account written for the Methodist Conference of 1875, was, "...an old Indian house, damaged furniture, loss of garden, an old dirty Indian house which was being repaired...Mrs. Bawtenheimer's health was so very poor. Rev. Henry built a

Henry Bawtenheimer born 1822; married 1859; died 1882,
Samuel Edward's maternal grandfather.

small barn and kitchen, put up out-houses and fenced fifteen acres, planted trees, levelled and cleared the yard. He built a church with contractors from Owen Sound with a spire." A dismaying experience it must have been for Martha Amanda and the children.

Nevertheless it was all part of the custom of the Methodist Church of the time that each minister must present himself, his wife, his family and all their belongings to the Methodist Conference in Toronto, held each year in June at which time assignments were decided and announced for the following year. Thus a preacher, his wife, pregnant or not, did not know from year to year where they would be located for the following twelve months. Sarah was fourteen when the Reverend Henry arrived at the newly created charge of Cape Croker. Even before they could clear out the debris and filth from the 'manse,' a highly inappropriate word for their shelter, the garden had to be dug and prepared for the seeds to be planted to ensure that the family would, hopefully, have sufficient food to keep them alive over the winter.

To profess the word of God under such circumstances demanded strong commitment from both minister and wife. Henry, a strict taskmaster with himself as well as with his family, was described as being very pious and very narrow in his views. Descendants of Henry and Amanda tell family tales of

29

the children having to stand behind their chairs at mealtimes while the Reverend Henry ate his meal first. Then the children would be allowed to seat themselves after their father had finished his meal. Martha Amanda waited on Henry and ate with the children. The Reverend Henry took himself and his position with great seriousness. In 1881, he ended a letter to his daughter, "Yours very truly, Father," hardly the outpouring of a loving parent.

Sarah is reported to have told her children that as a young girl, she played with the Indian children of the Reserve, but she was at least fourteen when she arrived and as the eldest would have had a great deal of responsibility for her brother and sisters. Frances was about nine, Mary was six and Eva Jane three, so it may well have been that it was the three little girls who had Indian playmates and their brother Charles, a ten year old, would have had Indian friends as well. Since Martha Amanda's health was not robust, especially with another baby on the way, Sarah would have had a great many tasks thrust upon her. A big girl, she grew to be very tall and square jawed like her father. The other girls were petite like their mother.

Henry's poor and 'failed' health finally gave way on April 15, 1882.

In the Minutes of the Toronto Methodist Conference of 1882, it was noted that:

Martha Amanda (Barber) Bawtenheimer born 1842; married 1859; died 1930, Samuel Edward's maternal grandmother.

"Bro. Bawtenheimer was born in the Township of Blenheim in the year 1828 (sic). God blessed him with pious parents, they being among the pioneer Methodists of that part of Canada. He seems, like Samuel, to have loved the Lord from his early childhood, for his sorrowing wife now says, "I cannot tell the exact date of his conversion, but I have often heard him say he could not remember the time when he did not pray and earnestly wish to be good." He, having become convinced of his call to preach, entered the Ministry of the Primitive Methodist Church in 1855, and after one year of acceptable service in that connection, offered himself to the Wesley Methodist Church by whom the offer was accepted."

The obituary then lists his various callings, noting that he preached with great acceptance to the Indians. An assessment of his character follows, which gives an insight into the home life of the Bawtenheimers and Sarah's early experiences.

"Bro. Bawtenheimer possessed great intellectual ability — was of a generous, sympathetic, sensitive nature, and had a warm loving heart. He was a devoted Christian, a faithful pastor and loved to preach Christ. In forming an estimate of his character, however, we should, in loving sympathy, remember his long years of sickness — the last twenty years of his life having been, with a few intervals of rest, one long agony of excruciating pain, which shattered his constitution, blighted his prospects, and what, to a highly nervous and sensitive nature like his, was exquisite torture, involved those whom he loved with him in a common misfortune; this threw a sombre shade of gloom over his whole nature, and would, had it not been for the sustaining grace of God, have overwhelmed him in an awful despair. But God did sustain him, for even when his lips were quivering with anguish, he recognized the source of this agony and knew it came with a divine purpose...

During his last illness he was singularly patient and submissive and constantly raised his heart to God in prayer for his blessing to rest upon himself and his family. His undying devotion to his work was strikingly manifested

a few Sabbaths previous to his death, for when the hour of divine service had come, he requested his attendants to carry him to the 'house of god,' that he might once more proclaim to his flock the story of redeeming love, and point them to that home whose delights he was so soon to experience."

Reverend Henry Bawtenheimer died, "in sure and certain hope of the resurrection to eternal life," and was buried on the Cape Croker Reserve. Shortly afterward the house burned to the ground and all Rev. Henry's books, furniture and other possessions were lost. Martha Amanda took her family back to the site of her husband's last charge in Owen Sound.

When the Bawtenheimers had been moved to Toronto in 1874, Sarah was fourteen and so was given a slight taste of life in a city. She must have found the Reserve a distinct culture shock. Earlier, in 1856, her father had met Timothy Eaton of the department store at Stratford and the two staunch Methodists had struck up a close friendship that was to endure until Reverend Henry's death. At age sixteen, Sarah left the manse and family life for the city, applying to her father's friend for employment in his store, now located on Queen Street in Toronto. Timothy Eaton, who made it his policy to employ

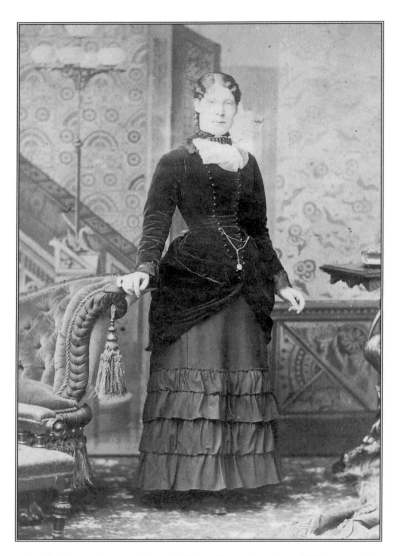

Sarah Bawtenheimer, Samuel Edward's mother born 1860; married 1884; died 1935. Photograph taken while she worked at Eaton's, c. 1880.

'daughters of the manse' in his store had housing arranged for Sarah in a boarding house on Adelaide Street, just west of York Street. This establishment, suitable for young ladies, was run by a Mrs. Lee who had come to Toronto from Kirkton, Perth County, where Timothy Eaton had started his merchandising. Another of Mrs. Lee's boarders was a young art student, Homer Watson from Doon near Kitchener, who later was to have so great an influence on Samuel Edward's early art collection.

Sarah started off in the ribbons department. Her hours were from 8 am until 6 pm, five days a week, and 8 am until noon on Saturdays. Her wages were $2.50 per week. Church attendance on Sundays was not only expected of all Eaton employees, but was insisted upon. Timothy frequently took Sarah to church himself, along with his family, and kept an eye on her for the sake of his old friend. By the time Sarah was eighteen she was permitted to attend a few parties, most decorous affairs they would have been, always escorted by a suitable relative. In Sarah's case, this was Sam Bitts, a second cousin and a young law student. In those days heavy curtains were drawn across the Eaton store windows on Saturday closing time, so that there could be no desecration of the Sabbath by possibly enticing passersby to covet merchandise on display and thus centre their thoughts on worldly matters.

When Sarah was twenty one, she left Eaton's with a flattering letter of recommendation signed by Timothy Eaton himself, pointing out that she had risen to be second in charge of the millinery department for the past year. She took a position in Armstrong's General Store, a dry goods emporium in Brigden, a small village on what is now Highway 80 in Lambton County.

It is more than likely that Sarah had a secret reason to want to give up a promising career in the city. Perhaps she had attended a summer Methodist Meeting Ground which gave young people of that faith an excellent opportunity to hear a variety of preachers and also to meet one another. These summer meetings were very popular and, it must be added, well chaperoned. Perhaps Sarah met up with her family at the June Conference of 1881 and was introduced by her father to a young student, George Sutton Weir by name. Perhaps she had met him previously when the family was stationed in Owen Sound and he was teaching school in Georgina Township in Bruce County. At any rate when George Sutton Weir went to Plympton in Lambton County as a teacher and student minister, Sarah found employment nearby. As the saying of those days went, 'she had set her cap for him.'

Attracted by more than his preaching, Sarah decided to cultivate their friendship and mutual admiration. She no doubt had been given a copy of her father's tract, published in

1877, *Lectures on the Bible and Other Subjects*, printed by an unidentified 'book and job printer' in Owen Sound and perhaps enjoyed sharing this work with George Sutton. It was while Sarah was living in Brigden that she received the telegram informing her of her father's death.

After the fire Martha Amanda moved immediately from the Reserve to Owen Sound with what little goods she had saved after the house had burned to the ground. Charles, Sarah's brother, who is reported as having said that he would like to be a preacher like his father, seems to have left home. Martha Amanda, now on her own, was having great difficulties trying to make ends meet. It was Sarah who wrote to the Conference of Methodist Bishops requesting some sort of pension for her mother and four younger sisters. The reply was to the effect that there would be no pension as the Reverend Brother Henry had failed to remit one year's payment on his pension. The Bishops' advice to Sarah was to get a job and support her mother and sisters, a rather tall order for a girl of twenty two who had been helping already and whose family was in exceptional need. Frances was sixteen, Mary was thirteen, Eva Jane was twelve and Laura Alberta an infant. Timothy Eaton wrote to Martha Amanda offering to take the infant and raise her, but the widow refused.

Martha Amanda, now a vivacious and dainty young widow of thirty-nine, once her husband was gone, set about her new responsibilities. It is not recorded exactly how she managed, but in all probability Sarah helped as much as she could. Young Frances was the beauty of the family and one way out of her money troubles would be for Martha Amanda to arrange marriages for her girls. Accordingly, Frances, being 'polished up' so as to attain the best possible marriage, was subjected to lessons in painting, singing and horseback riding. It may have been that Martha Amanda was a good hand at needlework and repaid her daughter's teachers in kind. Timothy Eaton also may have contributed to the family's needs from time to time.

An opportunity came for a marriage with young Will Marshall, twenty three, and the son of a great lakes shipping owner in Owen Sound. Later in 1882, he and Frances, known in the family as Frankie, were married. From all accounts Will Marshall, who was put in charge of the family interests in Duluth, Minnesota, was a young man of considerable spirit and an overbearing husband. Being employed on a laker in the family company meant he was away from home a great deal and lived what was described as a rough life. Frankie lost a baby in 1883 and died shortly afterward.

Martha Amanda's eldest daughter, Sarah, twenty-four years of age in 1884 and described by her exceptionally beautiful

sisters as being "strikingly beautiful with lovely creamy skin, blue eyes and shining auburn hair," was next to marry. Undoubtedly she was a lovely bride, but perhaps more simply dressed than Frankie was at her wedding. Sarah would have been an elegant figure nonetheless, probably in a gown of brown silk more than likely with a bustle in the very latest fashion. However, the wedding party must have been an unusual sight, the bride, a statuesque and commanding presence at just under six feet in height, and the groom, a slight man of 136 pounds and five and a half feet tall. As was customary, the bride was described on her marriage certificate as "spinster, resident of Owen Sound," while George was described as a student, resident of Plympton. The couple was married by the Reverend George Clarke in the Wesley Methodist Church in Welland, Niagara County, with Mary Burgas and John Foss as witnesses. Although Sarah and her siblings wrote to one another with frequency in later life, there is no surviving communication, no card, telegram or greeting of any kind from Martha Amanda to her daughter, nor from the sisters on her marriage. Until the wedding day, the couple was each employed in Lambton County, but it was not an uncommon occurence for a couple to travel together to another settlement for the ceremony.

As a student for the ministry in Canada, George was prohibited from marrying prior to ordination, however, in the United States, he could become a circuit rider before ordination and marriage was permitted. Since Welland borders New York State, the newly wedded pair proceeded directly to George's first posting at Grayling, in the Alpena District of the Detroit Conference of the Methodist Episcopal Church where he was admitted on trial. It would seem that two very lonely young people, each from a home devoid of displays of affection and each raised in a hair shirt philosophy of service before self, as well as in poverty, had found each other. Leaving their country and their relatives was worth the risk. To be with one another was apparently their decision.

By 1885 Martha Amanda now had three unmarried daughters. However, her son-in-law, Will, was a widower and her eldest remaining daughter, Mary, was sixteen. She arranged for a photographer in Owen Sound to take their pictures in the elaborate and detailed high fashion of the 1880's. The two older girls were great beauties and Laura Alberta was a very pretty child. Soon it was arranged that Mary would marry Will Marshall and take the youngest, a five year old, with her to Duluth. Laura Alberta, known as Bertie in the family, was to become a sort of skivvy for Mary, a pious young woman who took after her father in her ideas of rectitude. In the family it was said that Mary would rather walk through a muddy

puddle than step over a playing card lying on the street. The religiously upright Mrs. Will and her rough living husband must have been quite a pair. Mary did produce two daughters over a period of time. In 1903 Sarah would travel to Duluth to be with her and assist with her first childbirth and again for the second child. In 1906 Mary was considered to be in fragile health and the second baby was brought back east by Sarah to be raised for a few months in her home. In the meantime Eva Jane married the lawyer Alexander Thompson of Paris and seems to have had a happy marriage. Later, her son Arthur Thompson would article with his cousin Samuel Edward.

On July 1, 1893, Martha Amanda was married for the second time to a farmer from the Owen Sound area, William Morrison Wilson. He was said by her descendants to have been mean and unkind to her. Martha Amanda did not reclaim her youngest, Bertie, now a child of twelve, once she remarried. Perhaps she felt that Bertie was better off in Duluth. This, however, was not quite the case. Bertie existed in a state of virtual slavery. She was responsible for scrubbing, cleaning and wringing out Will's work clothing at midnight when he arrived home and had to be up at 3.30 a.m. to prepare his breakfast. Will apparently harassed her. When she was still a schoolgirl he made a serious attempt to assault her sexually, an act which was witnessed by two little friends who had come to call for her

on their way to school. The mother of one told Bertie to tell the police, but she was afraid to do so. Later in a long letter to Eva she expressed regret at not having reported him. "I hated, hated, hated Will Marshall," she wrote. Bertie did try to tell Mary of Will's behaviour, but Mary lost her temper saying, "Don't talk to me like that of my man."

A picture taken of Bertie when she was about sixteen shows a very beautiful girl dressed in the height of fashion, a photograph taken after she had run away from an impossible situation. She went west to Idaho and then to Panama City where she speculated in a gold mine which failed, worked as a journalist, ran a picture show and a rooming house. She took the name of Mrs. Jesse Saunders, although there is no account of a marriage to a Saunders, thought to be a travelling salesman. Rumour had it that she ran a bordello. Eventually she turned up in Tampico, Mexico, where she died in poverty in 1925. Her sister, Eva Jane, visited her in 1917 and members of the family mailed money to her from time to time. Unfortunately, it seems she never received any of it as the envelopes had been slit open and the cash removed.

Near the turn of the century, Martha Amanda's second husband died and she was once again a widow without an income. She wrote to a man she had met on the train during her honeymoon trip with Wilson, a G.A. Bayne from Victoria,

British Columbia. They married in Calgary on May 12, 1909, when the bride was sixty-seven. Martha Amanda went west with him, but would soon return to Ontario. Later Bayne came east, but Martha Amanda declined to follow him out west again. After he died in 1921, Martha Amanda travelled from one daughter's establishment to another until her death in 1930. The frail Martha Amanda, thrice widowed, lived to be 87 years of age.

The year following his marriage, George Sutton Weir, still on trial by the church fathers, was assigned to Alcona and Black River in the Alpena District. In 1884 he had been classed as a travelling second class deacon and assigned to Tawas City in the Alpena District. Two years later, he became the Reverend George Sutton Weir, admitted to full connection, elected and ordained deacon, and remained in the same charge. Sarah and George's first child, Ethel Ruth, was born in their home in Black River that same year.

A riding circuit was an exhausting business as Sarah well knew from her father's experiences. The average extent of a circuit had a preacher travelling for two weeks at a time, home on Saturday to prepare for the Sabbath and then out on his circuit again, relying on the faithful to feed and house him overnight. This was a lonely time for Sarah, far from her relatives and home, and with a little baby to care for as well.

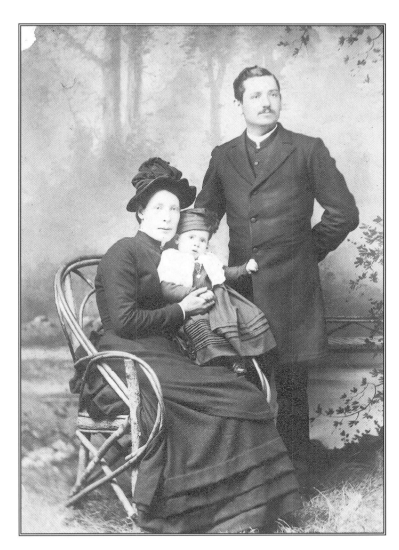

Sarah and George Sutton Weir with Ethel Ruth, born 1886.
The photograph taken in Tawas City in 1888.

In 1888 George was elected and ordained elder at the Conference held in Detroit from September 12 to 18. His Tawas City appointment was renewed, which must have come as a happy relief to Sarah, for her son, George Harrison, was born there that same year. The following year the little family was uprooted and sent to Laingsburg in the Saginaw District.

It was while he was stationed in Tawas City, now a resort area on Lake Huron, and ministering to the communities on his circuit situated on water courses emptying into the lake, that George contracted malaria and became very ill. Many struggling hamlets were subjected to epidemics of malaria from the mosquitoes in the swampy surroundings and some were completely depopulated. While Sarah and her babies seem to have escaped, George's health was seriously impaired. Desperate to try anything to restore his well being, he took courses in popular new alternatives to traditional medicine, appealing, if not widely understood or researched. He obtained an M.E. Diploma as Master of Electro Therapeutics from the National College of Electro Therapeutics in Lima, Ohio, and a Ph.G degree from the Ohio Institute of Pharmacy in Columbus, Ohio, the latter institution being on the Homeopathic Register. There is no record of George travelling to Ohio, so it must be assumed that these were mail order degrees. Apparently these studies did not help to improve his health.

One of George's last duties in Tawas City was on June 20, 1889, when he gave the Benediction at the First Annual Commencement Exercise of the Tawas City Public Schools, in the Opera House at 7:30 pm, a source of pride and gratification to the young minister. After having served the Alpena District of the Detroit Conference of the Methodist Episcopal Church, George, still suffering from his malaria bout, was sent south to Laingsburg in the Saginaw District in the fall of 1889. The little family was no doubt thankful to be uprooted this time and to leave the mosquito infested shores of Lake Huron. On Christmas Day 1889, George was the officiating clergyman at the wedding of his brother, Samuel Weir, to Caroline Voss in Oswego, Illinois. The following year, George was assigned on a supernumerary preacher status, which means temporarily without employment, usually due to illness or family problems.

Later George would write of his early experiences as a minister:

The Presiding Elder did not think they paid me properly. He refused to return me for another year and sent me to Alcona and Black River. I had no conveyance and had to do my work on foot. I walked eight miles to preach and had to walk the eight miles back to preach and look after the Sunday School. I

finally moved to Black River, where my daughter was born. I was moved to Tawas City because the preacher, W.J. Balmer, claimed he had been unfairly dealt with and the church was torn to pieces. The members were divided and unfriendly to each other. Mr. Balmer did not try to bring about peace and helped the trouble to become worse. Another trouble arose. The town was supported by a saw-mill which depended on Canadian logs. When the supply of logs was cut off there was no work for the mill to do and the people had no means of support except a little work they picked up on the shore loading and unloading boats on shore. My family had but little to support them. Here I was taken sick with a most malignant type of malaria. I never recovered entirely from the malaria and still feel bad effects from it at times. I still trust and love my dear Saviour and my prayer is,

'More love to thee, oh Christ, more love to thee,
E'en tho it be a cross that raises me.'

George and Sarah took stock and decided to pack up and come back home to London. Their hopes for George's career as a rising young minister were dashed. "He never fully recovered," according to Sarah many years later. As he had not been an outstanding success at teaching before he entered the ministry, he did not resume that choice of career. George had a low level of tolerance when it came to high spirited young people and had left London early in his teaching career, probably while he was still in his teens. Insistent on obedience, he set strict rules of behaviour. A story was told of him that when a young lad behaved in a manner that George considered to be obstreporous, he punished the boy and the parents considered the punishment too severe. In the nineteenth century this would have been the strap or caning. The parents complained to the principal. George Sutton's reply to the parents was a couplet:

"You are all ass but ears,
So don't you meddle with the Weirs."

His country school teaching first in Bruce, and later Lambton counties, began shortly after the undiplomatic rebuke.

The little family arrived back home in London in 1890, but George Sutton's careers in education and the ministry were both in tatters and the family breadwinner's health was permanently undermined by malaria. The future looked uncertain.

3 AN IMPOVERISHED BEGINNING

ONCE BACK IN LONDON, GEORGE SUTTON WEIR TOOK WHAT employment he could find, some odd jobs and sometimes as a conductor on London's street railways. The family moved into a small house at 795 York Street in London's east end, a working man's district. It was a modest dwelling similar to a number of others on the street, with no means of heating other than a fireplace. All their lives the Weir children suffered from colds, bronchitis and pneumonia and it may well be that constantly being cold as small children contributed to the weakness in their lungs. Indeed the next few years were very difficult ones for the little family. There is no record of George ever attempting to preach on a regular basis again, although the family attended church with great regularity. George probably felt that his health was not up to the rigorous demands made on a preacher or a circuit rider and, as well, he was not connected with The Toronto Conference.

In 1895 another daughter, Martha Frances Irene, was born on July 12. As Sarah's struggles to keep the little family clothed and fed increased, she did dressmaking. One of her customers, Mrs. Robarts, was the mother of John Robarts, later to become Premier of Ontario. At times she took in washing, an exhausting enough task for her own family's needs, let alone others. It was a trying comedown for her, living in a small town intent on making its mark financially. Its citizens did not

extend much sympathy to the impoverished. Sarah kept her head up as best she could and dwelt on the achievements of George's brothers, notably Samuel who was doing brilliantly in Germany, to uphold family pride.

A letter from Samuel was always eagerly received by George. On April 3, 1895, he sent a postcard to George from Schenkendorf Strasse, 27, Etage III, Leipsic, Germany:

My dear brother: —

It is so long since I heard from you. I shall only risk a postal this time. I made the examination March 6th with highest honor summa cum laude. This honor is seldom given to anybody and was never before given by the University of Jena to a foreigner. I am now settled at the above address. It took some time to find a comfortable room at a reasonable price but I have it very pleasant at last. Leipsic is a big city and things are not so simple as at Jena. I will study here till Aug. 1, partly in Philosophy and partly in Theology. There are lots of Americans here. I am located pretty well out of their way. Met the preacher however and am probably booked to preach on Easter Sunday in the American church. But for the language and the flags and the official forms one could hardly notice the

difference between Leipsic and an American city of similar size. I will find a carry for Harry and send it as soon as you have written. Your address is about as uncertain as mine — Aff. Sam Weir.

George and Sarah had been living at 795 York Street for five years when Samuel's post card arrived. There may well have been misgivings about the suitability of the neighbourhood on George's part which gave Samuel the impression that they had moved. For the next few years however, the house on York Street was all the family could possibly afford. On August 12, 1898, Sarah gave birth to her second son, our Samuel Edward, called Samuel after his distinguished uncle.

Whether George was unable to find the cash to pay the realty taxes on the York Street property or whether he was forgetful or even resented paying taxes at all, the tax bill was overdue by the end of the year and was in arrears. Two years later, Samuel Edward's brother, Charles Wilfred Paul, Sarah's last child was born. Samuel Edward was known in the family as Ted and sometimes Teddie while Charles Wilfred Paul was called Paul. Later Ted chose to be known to friends and clients as Sam and Paul changed his name to Carl. However, within the household the boys were always Ted and Paul.

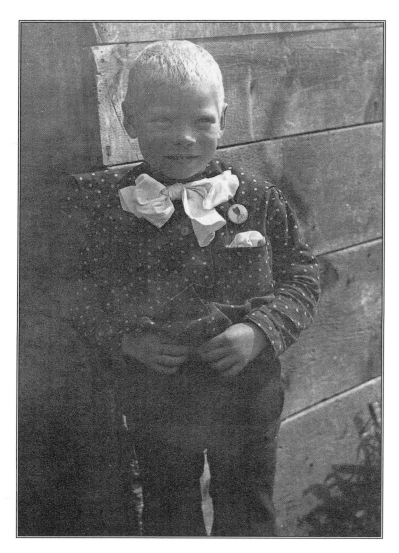

Samuel Edward, born 1898, photograph taken circa 1901.

42

When Paul was a year old, George was superannuated by the Detroit Conference and thus was entitled to a pension which he refused to accept, saying that "others need it more than I." The talk in London was that the Weirs were "poor and proud." His self denying piety was hard on Sarah and the children.

In 1902 a warrant was issued by the City of London for unpaid taxes on the York Street property and it was sold to A.E. Danks in two parcels, for $3.37 and $3.38 plus $1.80 each for costs of sale. This was a severe blow to Sarah's pride. Friends of Samuel Edward's remember their mothers saying that Sarah Weir seemed to be "always in tears." With so much stress and worry it was not surprising that George's health, never robust after the bout of malaria, gave him further trouble. After developing a severe pain in his abdomen and being unsatisfied with the doctors' inabilities to relieve him, George decided to study medicine himself, with a doctor in London as was the custom. He persevered with his studies even though he had taken on work as a truant officer during the school year and as tram conductor when time permitted.

The following year, 1903, in a letter to his brother Samuel, he mentions "trying to hustle the boys off to school." By then Samuel Edward was five, Carl three and George Harrison, or Harry, was fifteen. Sarah had travelled to Duluth

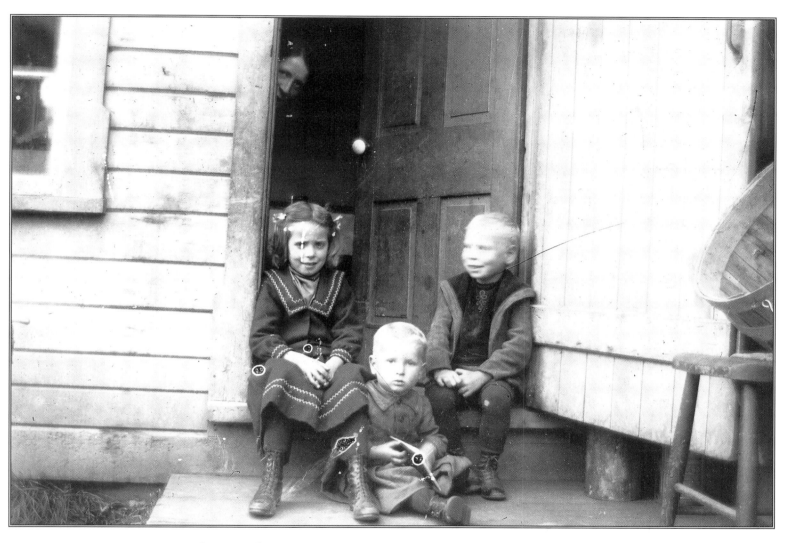

Martha Frances born 1886; Charles Paul born 1900; and Samuel Edward born in 1898.
Photo taken on York Street in 1903. Sarah peeks around the door.

to help Mary, her sister, in her first childbirth and had brought the baby back with her to London as Mary was considered too frail to care for the baby herself. In the meantime George's father, Robert, now blind and unable to continue with his dairy farm and milk delivery, came to live with the Weirs and also was cared for by Sarah in the cramped quarters of York Street. Certainly Samuel Edward was given an example of service to others from his early childhood.

By December of 1903 the sale of York Street for unpaid taxes was completed. Early in 1904 George bought a larger house for $150.00 down at 197 Sherwood Avenue. Set on ten acres, the storey and a half dwelling with four bedrooms, a parlour, a kitchen and study, also had a long verandah with a rod for hanging fowl. The heat for this house was supplied by a fireplace. By August George had assumed a first mortgage of $900.00 and a second of $500.00. Odd jobs helped the family's meagre income. Now that the Weirs lived on ten acres of land they acquired a cow, Stella's Cream Cup. She is alleged to have produced milk with a butterfat content of 7.5%. It seems that everybody in London knew about the Weirs' remarkable Stella.

Samuel Edward was sent off to school in Grade 1 with holes in his stockings and his clothing much the worse for wear. He was teased, laughed at and picked on by the other children and frequently had to defend himself physically. The area in the east end of London has been described as brutal, where fists and hard fighting determined the social pecking order. Fortunately, six year old Samuel was big for his age and strong, but the bitterness of those early years of extreme poverty, the hazing and having to look out for Paul left its mark on a proud and sensitive child. Paul became very ill in the same year with encephalitis, now known to be a viral infection, but at that time it was thought that encephalitis could be caused by a blow to the head. Samuel Edward, our young Teddie, now had even more responsibility for Paul, especially after his brother developed a permanent limp.

By 1905 the family finances showed a slight improvement, but the reason for the lessening of money troubles increased the tension in Teddie's and Paul's social lives. With both in the public school system where George, their father, was the truant officer, student life held other difficulties for the two boys. 'Monkey Weir' was the name given to George by a student faction more noted for its high spirited flouting of authority than for obedience and scholarship. Teddie's soubriquet was, naturally, 'Little Monkey,' a name he detested. It was bad enough for a very intelligent high-minded proud child to turn up at school in torn and shabby clothes, but the taunt of 'Little Monkey,' attacking both the child and the father, laid the foundation for a certain resentment of the well to do and accepted children of his age.

Just as in his earlier days as a teacher, George Sutton Weir was a strict disciplinarian and an upholder of respect for the law as well as for himself as an embodiment of law. At this time Dr. John Dearness was a school inspector, well known and feared. With his approval, persistent cases of truancy and general mischief were put in detention rooms in the Children's Shelter at George Sutton's direction. Upon one occasion three unusually troublesome lads were placed in solitary detention overnight on George's suggestion and under his control, but it was noted that in this instance he obtained the consent of the parents first. This sort of action may have given George and perhaps the parents some satisfaction, but it did nothing for the acceptance of Teddie and Paul into the society of their peers. Fisticuffs and torn clothing continued, much to the despair of Sarah.

It is interesting to note that in 1905 and the early years of the century no one thought to question children on their reason for fighting, or if they were questioned, some sort of personal pride forbade them telling their mothers of the situation. Telling their fathers would, of course, have made the whole situation even worse. There is no evidence that Ted's Aunt Jennie, a teacher in London, ever interested herself in her cousin George's fortunes or the predicaments of his children.

In 1955, the *London Free Press* ran a fiftieth anniversary issue, and harking back to school matters in 1905, reprinted an excerpt:

"A new venture in public relations was undertaken in 1905 by Inspector Edwards and the public school staff. This was an elaborate exhibit of work done by the pupils. It was held in the City Hall and was open to the public for a week. At the invitation of the trustees, the Minister of Education was invited as their guest. On Friday, the concluding day, the teachers from Chatham attended in a body. The undertaking proved to be an unqualified success and netted a profit of $235, which was divided among the schools for library books.

The trustees at this time had a very resourceful truant officer in the person of George Weir. His monthly reports to the board indicate that truancy was probably a more serious problem than it is now. Mr. Weir, however, had no intention of being thwarted in the successful performance of his duty by any mere boys. In handling persistent cases he made use of detention rooms in the Children's Shelter. On one occasion, with the consent of the parents, three unusually troublesome lads got a taste of solitary confinement. Whether Mr. Weir ever

taught school is not known. He appears, however, to have been a man who would try anything once, for in one of his reports he tells of Substituting for two weeks for one of the teachers in the school on Colborne Street south, a two room building that for many years had a heavy enrolment of primary children. Undoubtedly Mr. Weir had a busy, if not pleasant, two weeks."

Ted's sister, Ruth had left school with a leaving certificate and had gone to work in the classified advertisement section of the *Farmers' Advocate*. Harry soon followed and found work as a monotype operator with The *London Free Press*. He seems to have had considerable skill in draughtsmanship and in composing a picture with a camera. Ruth took every opportunity to see something more of the world than London offered. With her friends from the office she went on overnight trips, sending postcards to her mother from Toronto and Buffalo. She sailed on the *Turbinia* from Hamilton, round trip $2.39. "This boat belongs to Eaton's," she wrote. Paul's postcard from Buffalo came with the message, "Yesterday we went through coontown and you never saw so many blackberries in your life," a statement reflecting the racism of the time.

George Harrison born 1885. The photo was taken 1905 when he was 19 years old, the year prior to his death of typhoid fever in Winnipeg.

In the summer Harry was transferred to the Winnipeg office as a monotype operator. He took delight in photographing the city and made up some of his best views as postcards, probably with the idea of making a sideline business for himself. The examples show a keen eye for 'taking a good shot.' By wintertime his mother was concerned lest he not have enough warm clothing. Early in 1906, she hastened out to Winnipeg with an overcoat for him. He had contracted typhus and, by the time she arrived, he was hospitalized with typhoid fever and died shortly afterward. Sarah was heartbroken. It was said of her that "she never got over her son's death at the age of eighteen." Sarah kept the cards and letters she received from church members. One sad note starts, "We hope Mr. Weir is better," and goes on to discuss church meetings with a strong note of complacent piety, but by the time the letter was delivered Sarah was on her way back to London and Harry was dead.

Ruth was doing very well and had risen to be head stenographer at *Canadian Woman*, a subsidiary of *Farmers' Advocate* and, in her summer vacation of 1906, went west to Oxbow to visit her Aunt Susannah Weir Burnett. In the same summer in the continuing saga of misfortune that seemed to shadow the Weirs, Ted was involved as a catcher in a baseball game and, having discarded his mask, caught a hardball on his forehead. He was knocked unconscious for a short period, probably about

half an hour. Later in life he would blame his eye troubles on that game of baseball. The pitcher was a student minister and somehow that seemed to make everything all right in his parents' eyes.

Sarah's health deteriorated slowly but steadily. There is a continuing sense of hopelessness in her letters, a few that have survived, a bending to what God has ordained for her with yet an attempt to keep her pride intact. The following year, in 1907, George was ready to take the Council examinations. He had been at a medical school which belonged to a company, Eckels and Moorhouse, with Dr. Hugh McCollum as his mentor. Having studied on a part-time basis and obtained his medical degree at the University of Western Ontario in the first medical convocation, class of 1907, George was then named Medical Officer of Health for the Middlesex Board of Education, London School District. Again their father's new position did not help the boys get along with their peers. Part of Dr. George Weir's responsibilities was to vaccinate each student. It is entirely possible that the new M.O.H. was not particularly gentle with the obstreperous.

Ted was now nine years of age, and while life was a little easier financially, George Sutton was still a stern and strict Father in the God fearing manner of the times. Ted joined the work force as a carrier boy delivering the *Farmers' Advocate*.

47

Hating the circumstances of the impoverished family, he was determined to work his way out of the situation, a determination that never left him.

George's brother, James Weir, the newspaper columnist from British Columbia, came through town in the summer of 1907 and, seeing how very keen Ted was to play baseball, took the boy downtown and outfitted him with a mitt, grander than anything Ted had dreamed of possessing, along with a good bat. Ted was ecstatic. However, after James left town, the shop sent George the bill. Perhaps it was James' way of letting George know he had been hard on his children. "You can imagine what effect this had on my father's temper," Ted wrote to a relative years later.

Ruth was learning to get along in the business world. She was twenty-one, popular with a group of friends and, sensing the repressed atmosphere in the family, tried to ameliorate it in various small ways. She mailed cards to Ted and Paul for Easter, knowing how pleased they would be to receive their own mail, even though posted locally from London. By Christmas, the cards were posted from New York City, the message to Paul, a typical older sister admonition, "Don't eat too much candy." To Teddie she asked, "What will Santa bring you?" Ted's answer, written the day after Christmas was that he and Paul "…got rubber boots from Santa and that there had

been a Christmas tea party with a great many cousins."

In early springtime of 1907 Paul had come down with mumps, but Martha and Ted apparently escaped. About the same time of the year, Ruth had noticed an advertisement in the *Farmers' Advocate* offering positions to train young ladies as nurses in the Roosevelt Hospital in New York. Ruth left home on September 12, 1907 and, although she faithfully wrote letters to her mother at least once a week, Sarah felt her absence keenly. George's father, Robert Weir, died the same year. Sarah had cared for him faithfully in his blindness for all the years he had made his home with them.

That Ruth found the regimen at Roosevelt Hospital arduous goes without saying. Sarah kept her many letters and they tell of long hours, the many cases of typhoid fever and her excitement at witnessing a transfusion, "a very rare operation," she writes. When bats got into her ward, she told her women patients that they were sparrows. The incident apparently went off without panic. From her inquiries about the health of her family, it seems that George's face had been a concern for some months, apparently a rash. As well, Ruth was disturbed about Sarah's pain in her head and ears. "If your ears bother you, you should have them looked after. I lost a patient last week from septic meningitis induced by ear trouble."

Sarah kept the invitation addressed to Dr. and Mrs.

G.S. Weir to be present at Ruth's graduation on Friday May 7, 1908, but either they could not afford the trip or George was reluctant to spend the money. Ruth continued to nurse at Roosevelt Hospital and on December 23, she sent a card to Martha, "How does the medal look?" Martha, now fourteen, had graduated with distinction from public school.

On September 12, 1908 Ruth wrote, "A year ago tonight, I was in Buffalo at this time." Once when she had been on vacation, "Returned safely. I have to put in another year. I dislike it." Nursing seemed to be Ruth's avenue of escape from Sherwood Avenue. The next day she wrote, "I have a patient who weighs 400 lbs – hemiplegia and aphasia. A Catholic priest came to see her, a very handsome young priest. Another patient, typhoid, is going home. She is an actress and a widow by courtesy. She is a lady friend of the night city editor of The Sun and we are going to have dinner together." Sarah's reply to this has not been preserved so we can only conjecture what the reaction of Sarah might be and particularly of George, to their daughter's hobnobbing with handsome young Catholic priests and her friendship with an actress of questionable reputation indeed. From both their backgrounds, there must have been misgivings about her exposure to sinful temptations.

With a growing worldliness, Ruth refers to her patients as "old frauds," but she writes that she is pleased that the family

is having gas illumination installed. "I suppose you will be turning night into day when the gas is installed – hope you don't get in too deep. We have just been entertaining Father Walsh, the finest looking young priest." Did she mean to provoke them, or was she letting them know in subtle ways that she was her own person now? Ruth continued to send postcards and short notes to Martha and the boys, always keeping in touch with their progress in school and their interests...to Martha, "How's the French coming along?"... to Paul, "I will look after the watch and the gun and the shot. But you know I will not be home for a long time. Maybe not till a year from Christmas." – to Ted, "Thanks for the Easter card." Sometimes there was no message, just "Dear Ted" on a postcard.

By now the family's finances had improved to the extent that the Sherwood Avenue home contained a piano. Both Ted and Paul were given lessons by a Miss Northcott who came to the house. Ted continued to love playing baseball although at various times there was concern that he had some sort of heart trouble. When he was almost twelve, Sarah went to Duluth to be with her sister Mary in her second childbirth. She stayed with Mary until she felt her sister could cope and sent a postcard of a laker to Paul with the message, 'How would you like to see a sight like this, Paul?' The boat was laden with

150,000 tons of coal. To "Teddie dear," she wrote, "We will soon be home so keep your courage up. Uncle (Will) says he will send something beside the ball for the 'little boys.' " Sarah brought the baby, Shirley, back to London in June of 1910. In October, Ruth took Shirley back to her mother in Duluth, writing to Sarah that, "Baby was fine all the way. Mary is pretty tired and so am I. Uncle Will is as fresh as a daisy." Ruth remained in Duluth to do private nursing for a period of time.

Sarah's remark to Teddie on courage may well have been occasioned by the effects of an attack of George's ulcer in her absence. More than likely it was a recurrent ulcer disease caused by an infection which resulted in a chronic and painful inflammation for which there was no real help or cure until antibiotics. George suffered periodically and his family suffered along with him.

Ted worked hard at his studies, but it was Martha who stood first in her class year after year and it was Martha whom the family considered the 'real student.' Paul was not inclined to excel at school work, his injuries and illness from earliest childhood no doubt contributed to his difficulties. As well as delivering papers, Ted began to work in the Post Office as soon as he was fourteen. During rush seasons, he brought a little money from the sorting departments in to the household. "Letters," he later wrote to an art dealer in England who had

sent him an etching which had arrived rather bent, "are handled rather respectfully but packages are thrown all over the offices, sometimes as far as fifty or seventy five feet. The mail sorters get a good skill at throwing things into bags a long distance away and they won't bother to walk with them." This first hand information doubtless accounted for the detailed instructions Sam gave to various art dealers later on and his fury when his instructions were not carried out.

It was while Ted, or Sam as he now wanted to be known to the world at large, was working in the Post Office that he noticed a lithograph in a shop window. He passed it by many times and finally decided to part with fifty cents, a not inconsiderable sum of money in 1912, and take it home. It was the first acquisition, a lithograph of *Sir Wilfred Laurier* from the J.W.L. Forster portrait, in what was to become the consuming passion of his life, amassing a remarkable and significant collection of Canadian art and artifacts, along with an extensive library.

During this period George Sutton was able to acquire a ten acre property on Oxford Street West. The Sherwood Avenue property was sold and the family moved in to 139 Oxford Street. This would be home to Sam until his retirement from his law practice and the move to River Brink at Queenston. There were fruit trees on the property and room

for the children to indulge their separate loves. Paul was the young farmer on a modest scale. Sam was the horticulturist. A love of beautiful, unusual and exotic plants and flowers remained an absorbing interest to Sam all his life. Although there had been difficulties with the tax department as George Sutton either had a bad memory or intentionally ignored the notices, but here at last the family could settle down. However, the house was anything but luxurious, without a furnace and dependent on coal oil lamps for light.

When World War I was declared in August of 1914, Sam was still at Central Collegiate High School with one more year to go, a teenager with a passion for baseball and a growing interest in the garden and the flowers it produced. Paul was still a problem, given to attacks of irritability, a legacy in all probability of the encephalitis as well as pain from an arthritic condition of the spine. He seems to have been very much the baby of the family, being given extra consideration by all, but was more interested in taking care of the livestock than in doing well at school. In such a situation, it can be understood that serious minded Ted was taken for granted and sometimes his achievements were passed over lightly in the family.

Paul received a Christmas letter from Ruth on Roosevelt Hospital stationery, dated January 3 on the envelope. Ruth never dated her correspondence, but fortunately her letters to her family were preserved in their envelopes, the cancellation marks revealing when they were written.

"How was the New Year's goose? I suppose the Weir family did not get much of the Christmas one. How are Pat and Buster and the cows? Is Buttercup giving good milk? It was too bad about the poor chickens. Did you save any of them? (I think you are a regular Shylock.)"

Perhaps a cold snap was too much for the hen house. It would seem that Paul had a little business venture going in the back yard.

At some period before Sam graduated from the collegiate, possibly in the Easter holidays or on weekends in early 1915, he found work in a wartime factory producing explosives. Sam was fascinated by the processes and told his father he wanted to study chemistry and work in that field. George was opposed and persuaded Sam to stay in school, graduate and get himself articled in a law firm. A career in chemistry for Sam would mean that two of his children would be living at home and pursuing degrees. At this time Martha was working part time in Dr. Hadley Williams' office while studying at the University of Western Ontario for a degree in English and History. Sam reluctantly

51

agreed to abandon his hopes for a degree in chemistry or chemical engineering and, immediately after his graduation with honours from the collegiate in June of 1915, started working as an articled clerk at Meredith and Meredith, a very highly respected law firm, for the sum of $2.00 a week.

Early in 1915, Ruth apparently left the staff of Roosevelt Hospital and went into private nursing. She sent postcards home to the boys with views of her whereabouts: Larchmont, New York; Allenhurst, New Jersey. Sam received a postcard in June, "How are the exams?" By August the adventurous Ruth Weir R.N. had volunteered to go overseas with the American Red Cross and on October 27 she wrote to her mother, "Just sailing, La Touraine." For the remainder of the year Ruth sent cards to everyone in the family at the rate of two or three times a week. No doubt her tidbits of news were received with rapt attention: to Martha from Bordeaux, "very beautiful;" to Sarah, "a view of the cathedral;" to Ted, "How goeth the law? Do you know what this statue commemorates? I don't." It was a view of the Girondins. Just the sort of communication that would have Sam going to an encyclopaedia, Ruth knew, to discover details of the political party, named Girondins for the members of the French Legislative Assembly and National Convention from the Gironde region between 1791 and 1793. Their views were

Samuel Edward, after high school, while he articled with Meredith and Meredith.

verging more on republicanism than the Parisian deputies, but ultimately they were defeated by the Montagnards. Ruth was well aware of Ted's compulsion to learn and to investigate every field that came to his attention. In November, Ruth visited Paris and wrote, "Paris is lovely. We drove through the Arc de Triomphe along the Champs Elysee, saw the Eiffel Tower. Love to all."

Ted had been working long hours every day, six days a week after his graduation. On Friday August 15, Sarah made him a little presentation. "My dear Ted. Birthday greetings. Here is Harry's tie pin. I know you will take care of it and perhaps value it as highly as he did." But Ted's birthday was August 12. She missed it by three days and Harry had been dead for nine years. One wonders how strong a memory Ted retained of the brother who had died nine years ago. In the hundreds of Ted's letters to his relations later in life that have survived, never once was mention made of Harry.

The family's interest was centred on the faraway doings of Ruth. How the family must have marvelled at their Ruth seeing the wonders of the world! Postmarked again from Bordeaux, she wrote to Paul, "You should see the big carts drawn by little donkeys about the size of Buster."

By December Ruth was one of the hard working nurses caring for the French wounded in the disastrous offensives of late 1915. On December 26, Ruth wrote to Martha, "We are having a party — plum pudding — and I may be incapacitated. I got a real American fruit cake for the blessés and champagne and we had a grand treat this afternoon. Last night at midnight mass in the chapel — the patients went on stretchers, chairs and crutches. It was a sight never to be forgotten. Our Abbé is a dear old soul." Sarah kept this letter so presumably Martha shared its contents. Ruth drinking something alcoholic, going to mass in a Catholic chapel and speaking so warmly of a Catholic priest — George and Sarah must have had grave misgivings about temptation assailing Ruth and that more than the war was contributing to the world's downfall.

For Ted, the combination of his new world of learning at Meredith and Meredith, together with Ruth's accounts of a sophisticated existence, made for a broadening insight on the world which contrasted strongly with the blinkered attitude of his religious upbringing.

Ruth encouraged Martha, Ted and Paul to learn French and, early in 1916, sent Martha a ring made by a wounded French soldier, out of a piece of German shrapnel. As the war drew on, Ruth wrote more and more frequently of food shortages, sugar every other day and lack of heating for the patients. She frequently reminisced about the food in her

family home, Paul's maple syrup, the hens laying fresh eggs and about an animal, Sherry, who "is most disappointing in the matter of progeny." She did manage to get a Swiss cowbell for Buttercup, and from a letter of Ruth's, we learn that Sarah's mother, Martha Amanda, was making one of her prolonged and tiresome visits. George and his mother-in-law did not find each other companionable, a family situation bound to be upsetting to the sensitive Ted. By August Ruth had been promoted to Major and had started her long search for a suitable present for Ted. It was to be a chess set worthy of an up and coming young lawyer and Ruth kept on searching until she found what she wanted.

Sarah kept many letters from Martha Amanda. In one short note her mother details her travels from one relative to another, discusses her health and ends with a post script, "You forgot to send the money." This last is possibly a contribution to Martha Amanda's welfare or an agreed upon sum to be sent by all the sisters to Bertie, but it must have been a drain on the Weir finances. Martha Amanda Bayne's letter to Sarah in July of 1916 asks rather anxiously about Paul, "How is Paul standing the work?" Allowances were made for the baby of the family by everyone.

Ted continued to work hard at Meredith and Meredith and to save every penny he could. For the next three years he would have to live in Toronto when attending Osgoode Hall, the only way to qualify for the bar in Ontario. He seems at this juncture to have had no social life at all outside church attendance. Martha, at twenty-two, obtained her B.A. with honours in her English and History course and won the Governor General's gold medal for obtaining the highest marks of all arts graduates. Ruth wrote to her in August upbraiding her for not learning to swim. "So what if you swallow some water?" but ending with "Hope you get a nice school. How does Ted like the law?" By the last year of the war, Ruth was worried about Sarah's health and urged her not to work so hard — "Let things slide a bit." While Paul's health was a concern to Ruth, she asked her mother about Ted. Martha apparently had written to say that Ted was not well. Ruth was continually concerned about Ted's heart troubles. She speaks of being very cold, that they cannot keep the hospital warm with its hard stone floors and the lack of coal for the fires. Sarah had obviously found the cows a chore, and Ruth's advice was "to do what you please with the cows."

In 1917 after two years of successful articling, Ted went off to Toronto for his studies at Osgoode Hall. Shortly before his lectures were to begin in September of that year, he left home and made his way by train to the big city. His feelings can be imagined on the ride from London into Union Station, a

mixture of the excitement and anticipation any young person must feel at the start of a major adventure, coupled with concerns and worries about the state of his finances. Had he saved enough? Would there be expenses he had not counted on in his budget? Apparently he went directly to a boarding house run by a Mrs. Susan O'Shea, listed as a designer who let rooms at 74 Baldwin Street. It was Martha who travelled to Toronto to see how he was making out. She spent Labour Day weekend with him, leaving very early on the Monday morning in order to get to Sarnia for commencement of her teaching duties on Tuesday morning.

Ted wrote home: –

"Labour Day 1917
Dear dad and all: –
Martha got here safely and Mrs. O'Shea let her have a room. The train was an hour late caused, I suppose, by Exhibition and Labour Day traffic. We went to the Exhibition Saturday afternoon. There was a crowd and that made it difficult to see the exhibits. I expected, at least, to see something extra-ordinary but was disappointed and although there was a huge conglomeration of things I found nothing of interest but some rattlesnakes, deep-sea fish, a West Indies

Exhibit, and some cottage cheese mixed with a little peanut butter and moulded in various shapes.

I got up early this morning and went down with Martha to the Union Station, breakfasted at the Walker House Cafeteria, spent the morning reading at the office and wandered around town this afternoon. I will read some more tonight but I find it tedious and hard to keep my interest up. I haven't touched law.

A week ago Sunday I sat out on the Island and finished Salton on "Hereditary Genius." I now have on hand Hamertori's "Intellectual Life," "Essays in the Art of Writing" by R.L. Stevenson, "The Ocean," by Sir John Murray and a book on authors called "18th Century Sketches." Quite a collection as you see.

I'm a bit worried about my Law School work. In the first place, I don't know how to study. I thought of taking a heavy meal in the morning and quitting supper but it wouldn't be feasible when boarding. I have decided to try getting up at 5.30 and have some toast and cocoa and study until breakfast. I will try walking or exercising an hour after supper to overcome its effect of drowsiness and reading say from 7.30 to

9.30. I have some doubt whether I can stand that much work but it will probably be necessary.

The enclosed circulars were got at the Exhibition. I wish you could send me some magazines for light reading — some Literary Digest if you have any. Martha found her pin — Ted."

Both loneliness and anxiety were Sam's lot as he began the formal part of his legal training, and his reading material as he outlined to his father was hardly likely to afford him light hearted amusement.

Five days later on September 6 he wrote again to the family.

"Saturday

Dear People: —

I have moved and am writing this in my new room. The address is

 S.E. Weir

 Knox College Residence

 Toronto,

but as the parcel will come by express possibly you had better send it to the office (120 Bay). It is unlikely

the delivery man could find anybody to sign his book. It is chilly down here and I caught a cold last night or this morning. I think I had better have my overcoat. I don't know whether to go up thanksgiving or not. I could go up Saturday noon & return Tuesday morning. I could bring the overcoat back with me then. I don't like to spend the money (something like $5.00) as I have so little left and must buy some text books. I lost $2 out of my pocket Friday. I will have to have the coat pressed anyway and am not particularly anxious to go up. What do you think about it? For myself I think I had better have the coat sent down with the bathrobe. I suppose they could both go in a suit box. ..."

Sam went on to describe his room, its position facing east onto the quadrangle and its bay window.

Although it was not encouraged, but it may have been condoned, Osgoode students were not expected to work in a law firm. For many a student however, it was a necessary adjunct to a livelihood. Sam seems to have been taken on by G. Wilkie of Corley, Wilkie, Duff and Hamilton whose address was listed at 120 Bay Street.

An October 1917 letter had Ruth musing that "Ted

seems to have a near thing of it making ends meet." For his second and third years he found a cheaper lodging on Washington Avenue nearby. Later he claimed he had been at Osgoode on scholarships. All his professional life Ted, or Sam, longed for an undergraduate degree in law, a LL.B.

In writing to Ruth in 1917, Martha may have sounded gloomy and depressed in her letter as her friends, including a special one, went off to war. She apparently indicated to Ruth that she did not enjoy teaching particularly. After the war her special friend returned from overseas, shell shocked and with amnesia. Remaining unmarried, Martha stuck it out teaching English and History at a high school in Sarnia, until her retirement in 1959.

The year after the war ended the family was eagerly waiting to hear that Ruth would be coming home. Ruth wrote on January 22, 1919, "I am on my way to Rumania. The Red Cross gently but firmly suggested that I go. It's only until July. There will be 60 of us in the party – six nurses. I will keep a little diary. I will be giving out aid and food. No nursing." Unfortunately, although Ruth's letters number in the hundreds, the 'little diary' has not survived.

Ruth's career in Romania centred around parcelling out food in remote mountainous areas and ensuring that peasants planted the seeds rather than eating them at once. In this she was so successful that her activities came to the notice of Queen Marie of Romania. Ruth was invited to stay in the palace upon more than one occasion and the Queen accompanied her on several of her missions. Ruth was decorated with the Regina Maria medal, the highest honour that could be bestowed on a foreigner by the Romanian government. Altogether she had provided 700,000 meals in one year. In June of 1920, Ruth contracted malaria and was invalided to Paris. Part of her prescribed treatment was taking pills laden with arsenic. By October, Ruth was invalided back to New York City and although still ill, she returned to London, celebrated as a war heroine.

When Ruth first arrived in Romania, she was headquartered in Bucharest, but when visiting Constanta on the sea coast, she celebrated her thirty-third birthday with a party. Her presents were jokes from her friends, except, "but I did get a beautiful Turkish rug from my buddy." This was more than likely a reference to Wilbur Howell of New York, also serving in the American Red Cross and whom she later married. In Constanta also Ruth found what she had been searching for, a chess set for Ted. The one she found was of amber, intricately and delicately carved, and made in Moscow. Wilbur approved saying, "it was very fine."

Ruth and Wilbur Howell announced their marriage in the City of New York as having taken place on January 22, 1921.

57

No mention was made of a specific location, neither a church nor a city hall civil ceremony. Apparently there were no Weirs present, with the exception, of course, of the bride. Wilbur was to become a great influence on Sam in his growing interest in and appreciation of art. The two men became devoted friends and Wilbur's acceptance of and hospitality to his wife's family made him a quite exemplary son-in-law.

At some time between 1915 and 1920, Sarah underwent an operation for exophthalmic goitre. Dr. Hadley Williams, Martha's former employer, performed the operation. Sarah must have been feeling tired and irritable, usual symptoms of the condition quite often brought on by strain and worry. Although letters written to those serving overseas were not to be retained, a letter from Sarah to Ruth from 1919 has survived, telling that, "Paul has sprayed the fruit trees. Ted is a very important person in some ways, in others the veriest infant, but he will improve with age in both directions, I hope."

There was more encouragement for Ted from Ruth than from Sarah. She wrote to Ted, "Don't worry about your shingle. There is always room for a good lawyer." To Sarah she wrote that she was happy that Martha now had a good school. "We have all got that wretched lack of self confidence "and with Martha in Sarnia and Ted in Toronto, "you must be very quiet with only Paul at home."

Ted was still a most impecunious student, studying and working with great earnestness and with no social life, no money to spend on dating girls or any sort of student high jinks and frivolity. In his final year in the spring of 1920 it was Ted's turn to succumb to the influenza epidemic that took more lives than the hostilities then known as The Great War. He was at home for three weeks, cared for by his mother, and was allowed to write his final examinations late.

On October 1, 1920, Ted was called to the bar. Although he had graduated from Osgoode Hall earlier in the year despite the influenza, he had to wait for the first graduation ceremonies succeeding his twenty first birthday. His were the highest marks, one of four out of a class of 244 who graduated with honours, a most distinguished record but at a cost of loneliness and with none of the light-hearted camaraderie typical of an undergraduate.

4 HIS EARLY YEARS OF PRACTICE

EVEN BEFORE HE WAS CALLED TO THE BAR, SAM HAD BEEN EMPLOYED in the firm of Ivey and Ivey in London. One of the first cases he worked on, an appeal case concerning H.J. Garson and Co., the plaintiff, versus Empire Manufacturing Co. Ltd., defendant, involved alleged short weights and dirty metals. In the Supreme Court of Ontario Ivey and Ivey acted for the defendant. The appeal was dismissed with costs by the plaintiff to the defendant. The case was heard before the Chief Justice of the Exchequer, Sir William Mulock, and Messrs. Justice Riddell, Sutherland, and Masten. Sam was well pleased to have helped with the presentation of the case and kept everything related to it in a special file.

In 1921, he wrote to the External Registrar, University of London, South Kensington:

> *"Dear Sir: I am in receipt of the pamphlet containing the Regulations relating to degrees in Laws for external students and after reading the notes upon State 116, I am in doubt about my manner of admission.*
>
> *I am not a graduate in arts of any university, but I am a graduate of Osgoode Hall (Ontario Law School Toronto) where I received the degree of Barrister-at-Law before being called to the Bar. Does this entitle*

me to admission of your law examinations? I am exceedingly anxious to write for the LL B (honours) but cannot go to London for your matriculation examinations. I, of course, have an honour certificate of matriculation into the Ontario universities and have standing in several subjects equivalent to the first year of our universities (Toronto and McGill). I can give references as to my fitness and would point out that I have received scholarships at Osgoode Hall."

There is no record of a reply. For many years an LL.B. to put after his name was to become a consuming passion. Later Sam would pull many strings in his quest to be awarded an LL.D., but to no avail.

In August of 1922, Sam registered with the University of Chicago for eight departmental examinations, all approved for those whose practice would be in Ontario. However he never enrolled. More than likely he found the load he was bearing at Ivey and Ivey too time and energy consuming to do justice to eight subjects of study. His object was to enrol in Law School in Chicago or to acquire an A.B. He would have been given one year of credit for "Home Study," but the remaining three years would have had to be spent on campus in Chicago,

a dream that had to be put on hold for lack of money and which was never fulfilled. He had hoped to be given all four years in "Home Study," but that was impossible.

In the early twenties the firm became known as Ivey, Elliott and Ivey and later Ivey, Elliott, Weir & Gillanders. By 1923, the firm name was listed as Ivey & Co., in 1924 as Jeffery & Co. By 1925 it had reverted to Ivey & Co, in 1926 Jeffery & Co once more. In 1927, the practice was listed as Jeffery, Gelber, A.O. McElheran & E.G. Moorhouse. Ten years later in 1937, Sam was in business for himself.

In the early years of his practice, Sam would be involved in a bankruptcy suit brought by London Life Insurance Co. against Lang Shirt of London. A complicated series of actions began after the president of the company was found to have borrowed on his own life insurance policies from Aetna Life Insurance Co. in order to benefit Lang Shirt. When the bankruptcy of the shirt manufacturer loomed, the president took his own life. Sam helped to prepare briefs on the case which lasted over a period of years.

As soon as Sam started out as a young lawyer with Ivey and Ivey, he began to buy bonds and stocks with whatever bits of money he could spare. With memories of his father's ineptitude in the management of money, taxes in arrears, the sale of property for realty taxes and bought back later with a

penalty, in arrears again, then having to move, Sam was determined that his goal was to be solvent and debt free.

At some time in 1920 or possibly 1921, an entirely unplanned encounter did a great deal to change Sam's life. An itinerant picture salesman called on him at his office, showed him Dame Laura Knight's watercolour *Ballet Girls* and Sam fell under its spell. Forty five years later in a letter to L.A. Dowsett of Leger Galleries in Bond Street, Sam wrote:

> *"I was got into the art collecting by Laura Knight. A man named Carroll who used to travel pictures through Canada and the United States landed a watercolour on me which had been done by Laura Knight for reproduction in a magazine. It was of ballet girls."*

This uncharacteristic purchase marked a real change for him from the usual stocks and bonds. Acquiring something which appealed to him aesthetically and which was just to be hung on a wall to be admired gave him enormous pleasure. He was fascinated and, as time went on, collecting paintings and objects of distinction and beauty which caught his fancy and gave him delight competed with his compulsion to amass a fortune through an investment portfolio.

An early client, E.V. Harmon, who lived in the East

Samuel Edward Weir of London, Ontario, at the outset of his career in the early 1920s.

61

Twenties, the Gramercy Park area of New York City, was landlord to over thirty properties in London. Sam looked after Harmon's holdings, an example to him early in his career of the advantage in handling other's finances as well as the advantages of being a landlord himself. On behalf of another client, Ben Baldwin, the young Sam travelled to Holyoke, Massachusetts more than once in order to effect the sale of a service station. A business and personal friendship began with Baldwin senior and his two sons, Bill and Bentley, that lasted for many years. Sam also acted for the W.R. Kent estate which was comprised of an impressive number of real estate properties stretching from Montreal to Manitoba and which was not wound up finally until 1937. Payments to Sam for handling these properties seemed rather sporadic, but eventually he was paid handsomely for his ministrations and he began to appreciate the possibilities of an international practice. Such early experiences whetted his appetite and expanded his horizons far beyond London, Ontario.

Ruth, now retired from the American Red Cross, and Wilbur Howell lived in Lower Manhattan on Washington Square with a kitten, Nicu, an offspring of Sarah's cat. In one of the many letters to Sarah, Ruth recommends romaine and Simpson lettuces as well as asparagus, common enough perhaps in New York shops of the time but rare and pricey for the Weirs. Martha Amanda, now widowed for the third time, divided her days between her two daughters, Sarah and Eva, both living in Ontario. Her visits to Sarah's household were rather dreaded if inevitable events.

In the summer of 1921, Sarah wrote to Ruth that a cow has freshened and that she is so very weary. "Why house clean?" asked Ruth in reply, "Let it go," — not advice to be followed easily by a woman of Sarah's pride. Sarah apparently had complained of eczema and Ruth commented that she doubted that diet had much to do with it. Sarah wrote that Martha's hand pained so she bound live fish worms around it. The source of this bit of medical advice is not divulged and neither is the opinion of George M.D. nor of Ruth R.N.

About this time Paul was packed off to visit his sister briefly and Ruth accompanied him back to London. In the early years of her marriage Ruth spent a part of the summers in her old London home. A little weakness from her bout of malaria in Rumania still remained and, now having been diagnosed as having high blood pressure, London was a welcome respite from the heat of New York City. Ruth's letters to Wilbur give a picture of Sam busily tending to his delphiniums and watering the lawn, Paul doing odd jobs for the neighbours, and Ruth and Paul incessantly playing 'the banana song.' *Yes, We Have No Bananas* was a popular foxtrot of

62

the early twenties, a song which Sam and Martha apparently considered beneath contempt. Eventually it was played only in their absence. Ruth was an avid antiquer and wrote to Wilbur of her finds in anticipation of his coming to join her in London and their doing some antique hunting together.

The following year Sam was still working in the office of Ivey, Elliott and Ivey and took on his first big case, acting for Mr. Tomer, plaintiff, in a case of wrongful dismissal, against Crowle, defendant. Although the suit dragged on for several years through appeals, the plaintiff was finally awarded in excess of $5,000.00 dollars, a very large settlement for 1929.

Sam's credibility as a lawyer specializing in insurance received recognition in Toronto, when in 1922, he acted as solicitor for the Paramount Insurance Co. Founded some twenty years prior with a head office in Toronto, the company was now in the process of obtaining letters of patent. Sam's application was successful under the provisions of the Ontario Insurance Act. He was not listed as one of the five directors, but he was considered to be a brilliant and promising young man at twenty-four years of age. Sam turned his expertise in real estate to mortgage his father's property, taking out two mortgages in his own name for $2500.00 and $600.00. At that time, a large furnace, 'Good Cheer,' was installed at 139 Oxford Street West to the comfort and peace of mind of the entire family. No more

constantly piling wood onto fireplaces to keep some warmth in their bones, nor waking up in a freezing cold house. The furnace was well named.

Perhaps it was Ben Baldwin's business concerning the service station that brought Sam to Boston in 1923, ostensibly as a tourist, but also with an introduction to Horace Morison, counsel-at-law at 92 State Street. Morison took Sam and a 'distinguished surgeon' to dinner at the Harvard Club. Sam wrote to Morison some thirty years later, recalling that he had been very impressed and remembered the occasion with great pleasure. It would seem that Sam still had his eye on an international practice.

In 1923, he left Ivey, Elliott and Ivey, now Ivey, Elliott, Weir and Gillanders, and returned briefly to Meredith and Meredith, the largest litigation firm in Western Ontario. But it was a shortlived association, for in 1924, Meredith and Meredith dissolved their practice and Jeffery, Weir, McElheran and Moorhouse was established.

It was probably in the same year that, while on a business trip to Toronto, Sam saw *Lothian Hills* by Homer Watson (1855-1936) and fell headlong in love with it. Painted in 1892, prior to Watson's excursion into an Impressionist style, the painting remains an example of Watson's best period and was quite probably the single work of art which consistently over

63

the rest of his life gave Sam the greatest pleasure and satisfaction. "It was," he wrote to a friend, "my first purchase other than the wash drawing of Laura Knight's." He bought it on the instalment plan for fifty dollars a month directly from the artist. *Lothian Hills* was sold to Sam for $1000.00 less the commission of 33 1/3%. It was his in 14 months. Sam, Homer Watson and the artist's sister, Phoebe, remained friends till the end of the lives of both Watsons. The painting continues to hold the place of honour over the fireplace in the main gallery of River Brink. Sam did not count the J.W.L. Forster portrait of *Sir Wilfred Laurier*, the oilette on canvas, "acquired for 50¢ in my student days" probably in 1913 or 1914 as a serious part of his art collection or perhaps he had forgotten all about it.

In 1924 Sam and Martha were guests of a friend at Yale. Martha caught sight of a stone angel on the campus and never forgot her. A casting of the angel eventually found its way to the Frick Museum. Sam, Ruth and Martha each paid homage to it, Ruth in her capacity of her interest in an art gallery on Fifth Avenue and Sam on his frequent visits to New York. After Martha's death in 1959 Sam started long and involved negotiations to bring a casting of the *Ange de Lude* to River Brink to overlook his home and garden in Queenston, Ontario. He wanted the statue as a memorial to Martha for whom he had planned an apartment for her use in his dream home.

"Yesterday was Ted's birthday, but we all forgot it," Ruth wrote to Wilbur in August of 1924, a sad commentary on her family's attitude. That summer Sam was an acting prosecuting attorney and according to Ruth, "spends his days running around to small towns, doing his office work at night." The chief bread winner of the family worked long hours and seems to have been taken for granted by the family. Ruth wrote to Wilbur of Sam's knowledge of an expired chattel mortgage, listing some interesting things supposedly from the estate of Governor Higgins of New York State, and other items she thought would entice Wilbur to come up to London. Wilbur's knowledge of antique furniture and of art objects in general, as well as of paintings, was a source of inspiration to both Sam and Ruth.

According to Ruth, one of the first if not the first, of Sam's many vacations from his law office was to have taken place in the fall of 1924. Sam and Arthur Nutter, the architect and a frequent guest in the Weir home, perhaps a paying boarder, planned to drive to the West Coast, an adventure indeed in the automobiles of the time. However Arthur Nutter lost a considerable sum of money in a Florida bank crash at West Palm Beach and the trip was off. This was the first intimation of a restlessness in Sam that would show itself in frequent trips and excursions. Despite the material rewards of

Four generations, in 1929, the year prior to Martha Amanda's death.
Martha Amanda seated, careworn Sarah standing, and Ruth with her daughter, Sarah Howell.

his law practice and the dividends from his growing portfolio, Sam was always ready to get out of the office and see the world.

Religious differences seemed to haunt Sam in his choice of young ladies. One such was a French Canadian, a staunch Catholic and a designer and creator of women's fashionable wear. Possibly Sarah's dressmaking activities were the means of acquainting them. However, an alliance with a Catholic was not to be thought of in George's opinion and the young *canadienne* was not about to renounce her faith. Sam also had a dear friend whose parents were Presbyterians. Feelings over church union were still raw in the twenties and her parents forbade the development of a serious attachment with a Methodist. They remained friends throughout their lives and she never married. She felt that Sam's home life was such that the taking of any prospective bride to meet the parents would be an impossibility.

In 1920 or thereabouts, Sam had met a young lady from Guelph, Mary MacDonald, known to her friends as Topsy. They corresponded incessantly by letter and apparently chatted on long distance telephone at great length like a pair of teenagers. Topsy was a keen horsewoman, so Sam took riding lessons in London, rode every morning before going to the office and joined the London Hunt Club. He does not seem to have made any other use of his membership. After the

romantic attachment cooled down, he and Topsy remained friends and his enthusiasm for horseback riding waned. The social life of the London Hunt Club could be most exclusive especially to a member who was not considered part of the inner social circle of the city.

Sarah was surprised at his keenness for riding, but pleased that he was enjoying the morning exercise, albeit tempered with a certain reserve according to her letters to Ruth. She had come to depend very heavily on Sam as the man of the house and the prospect of his leaving Oxford Street and establishing his own home was not one she could look upon with enthusiasm. Sam realized the responsibility of his position as the only child left, not only at home, but in the vicinity. It was a weight on Sam's shoulders and a strong factor inhibiting him in his social life and his seeking a wife.

The situation was relieved somewhat in 1925 when Martha Amanda, Sarah's mother died at the age of 87. George Sutton and his mother-in-law had never been compatible. The high spirited Martha Amanda and the tyrannical George Sutton were at odds with one another, so much so in fact, that George was vehemently opposed to her being buried in a Bawtenheimer plot, particularly the one at Cape Croker. The clergyman's widow who had subsequently remarried not once, but twice, was not fit to be buried beside the Reverend Henry in

his opinion. Mrs. G.A. Bayne was buried elsewhere. Apparently Sarah's mother had lent Sarah some money. In a letter shortly before her death she advised her daughter that she would "take interest at 5 1/2% for the present. Don't worry about the principal." Earlier in the year Sarah had received a short note from her mother in which she discussed the weather and the state of her health. A post script was curt and to the point, "You forgot to send the cheque."

Sarah's health continued to deteriorate. Despite being overworked, overtired and generally run down with anxiety, she seems always to have mustered strength enough to extend hospitality to Ruth with her little family in the summertime, occasionally to Wilbur and frequently to Arthur Nutter. Sam later angrily upbraided the architect for availing himself so frequently of the Weir hospitality, but it may well have been that Nutter was a paying guest and therefore a small help to Sarah in her constant battles with balancing her budget.

That same summer Ruth was anxious for her mother to come and visit her in her new home in Sunnyside, Queen's County. Ruth wrote to Sam urging him to encourage not only Sarah to come but Paul also. Their fares were paid for by Ruth. This turned out to be Paul's opportunity to leave home for good. He became a merchant seaman, sailing out of New York. By October of 1925, Paul had sailed through the Panama Canal,

sent a postcard to George Sutton from Los Angeles and sailed up the western seaboard to Seattle, where he looked up his Uncle Samuel, Sam's namesake. Paul's comments on a postcard to Sam reveal much about Paul. He and the distinguished educator did not find much to say to one another. "Saw Uncle Sam," he wrote, "too prosy and long winded to suit me, but he's distinguished looking and students like him." Samuel's opinion of Paul is not recorded.

The summer following Paul's becoming a sailor, Martha, he and Ruth took a motoring holiday in Quebec. Paul, who now wanted to be called Carl, managed to get into an automobile accident near Three Rivers. Ruth was unhurt, but Carl was shaken and Sam was called upon to help his brother. Later Ruth would write to Sam that their brother had been drinking again as though it were not an unusual occurrence. Carl's frequent headaches and pains had made him extremely irritable and hard to bear, but the family made allowances constantly and forgave him again and again. Apparently Carl got off lightly with only a fine. In a letter to Wilbur, Ruth had made mention that she missed her nightly cocktail while in London in the Weir's teetotal regimen. However, by this time, Martha could be enticed to take a little alcoholic refreshment. Times were indeed changing with the young Weirs at least.

At Ruth's suggestion, Sam wrote to the Romanian

Charles Wilfred Paul, born 1900,
pictured circa 1925 in New York City.

ambassador in Washington offering his services as honorary consul for Ontario, together with letters of recommendation from Ruth and from an influential friend of Ruth's, a Madame Sihleanui. Although it was arranged that Sam should meet the ambassador in Detroit, nothing came of it. Sam was ever on the alert to enrich his spheres of influence. It would appear that the handling of relatively minor legal matters was becoming increasingly boring and restricting to a brilliant and restless mind filled with curiosity, eager to know and understand in depth whatever was encountered.

In June of 1926, a damaging story concerning Sam made the front page of the *London Free Press*. "HOLD-UP IS CHARGED IN HOTEL SITE" trumpeted the paper. Sam had acted as Trustee in an Indenture of Mortgage dated October 1920 and duly registered in London, made to him by the Benson Hines Company Limited securing the sum of $50,000 with interest, trustee's compensation and costs against the lands. The committee for the Lloyd George Hotel Site on Richmond Street refused to pay what in Sam's opinion and what in fact was the cost of administration of the mortgage over six years. The *Free Press* thundered in bold face type, "Demand for what is alleged 'handout' bar to million dollar proposition...Hotel committee refuses to make 'donation' on grounds of moral right."

Sam sued the *London Free Press* for $10,000 libel claiming damages and costs. By September of 1927, the case was settled with an apology to Sam in the *Free Press* and $50.00 for Sam's costs. Sam claimed that the story libelled him and damaged his reputation. He had retained John McEvoy of Toronto to represent him, showing his distrust of the legal fraternity in London. Sam was sure that somehow there had been a misrepresentation tipoff by person or persons unknown. He wrote to the editor demanding to know the source of the story, but was unsuccessful. His notation at the bottom of the docket with its angry initials, so angry that the pen almost sliced through the paper, gives evidence that Sam felt there had been backbiting envy and a vicious attempt to discredit him. That there was some justification for Sam's thinking can be appreciated when it is remembered that to many of his contemporaries he was still 'Little Monkey,' the boy who had come to school in tattered clothing, the upstart young lawyer without a bachelor's degree who was making a habit of winning his cases. It had been someone's delight to spread the rumours that Sam's father had been the town dog catcher and that his mother was half red Indian, both of course untrue and viciously meant to discredit him in the environment of a small Ontario town's attitude in the twenties and thirties.

Sam and John McEvoy, later the distinguished judge,

had come to know each other the year before when they both acted for a Mr. Brownlee, plaintiff, in a suit brought against a Mr. Zinn. Zinn's automobile had collided with Brownlee's horse drawn waggon and Brownlee subsequently died of his injuries. The fate of the horse is not recorded.

While on one of his many business travels, *Son of the Pioneers*, a painting by Marc Aurele de Foy Suzor-Coté (1869-1937) caught Sam's eye and he bought it forthwith. He immediately wrote to Suzor-Coté and the letter was answered by Suzor-Coté's brother who handled his brother's affairs while the artist was living in France. A close relationship developed over the years, first with the brother, then with Suzor-Coté's widow. Sam, by now a collector in the truest sense of the word, conceived the idea of acquiring an example of each one of Suzor-Coté's bronzes, a project in which he almost succeeded. Naturally a relationship with Roman Bronze Casting of New York developed on very cordial terms. Roman Bronze had a contract with the Suzor-Coté family to make all of the artist's castings.

Sam's clients often complained of overly lengthy waits to get their work done. His somewhat jaunty replies were usually to the effect that he had been or was about to go on holiday. Sometimes he blamed illnesses and chest problems, and it is true that pneumonia and flu attacks did bother him

69

frequently. However, procrastination was a habit which would aggravate clients and sully his reputation as a brilliant advocate, although his meticulous thoroughness in preparation and attention to detail would win the day in the end. As well as making himself an expert of outstanding ability in the legal side of obtaining mortgages, Sam's natural bent for doing everything with the uttermost thoroughness led him into the adjacent field of the legal aspects of home building. By 1927, he had built the last house on the property acquired from his father, at profit to himself. London had grown and there were no more cows in the back garden.

Sam was also instrumental in forming Canadian Mortgage Investment Trust with Wilbur F. Howell as President, three other directors and himself as Secretary-Treasurer. Even though his reputation as an able counsel in mortgage and insurance matters and as a winner in various court cases was growing, there was no acceptance of him in London society. Because of insensitive treatment he had received earlier, social acceptance assumed an importance for him that was to become an obsession and a source of great bitterness. He had bested some of London's legal scions in court and that would never do. Becoming wealthy and thumbing his nose at the town's social set was his answer to the snubs.

Always with a keen sense of where to invest, Sam formed London Home Builders, the first housing development in the city and became its secretary in the boom days of early 1929. Wilbur was also on the board and the head office was located in New York City, presumably with the intention of attracting American capital. From 1929 until 1940, Sam caused his name to be put on every law list he thought germane to his area of expertise, British, Irish and American.

Early in his career he had been invited to join a law firm in Baltimore as a partner, but declined with regret. He could not take his parents along and he felt he could not leave them alone. His practice was going well in 1930, even with the onslaught of the Depression and he very prudently invested whatever he could spare in United States securities, although there was always something left over for his growing art collection. Many of his mortgages were foreclosed in the dark days of early 1930, but nevertheless Sam always seemed to come out on top.

As has been noted, even from childhood Sam had a deep love for beautiful flowers and shrubbery. Characteristically he read widely and informed himself in the study of horticulture and botany. It was to be typical of Sam's way of getting exactly what he wanted that, when he decided to have a showy bed of iris in the garden, he contacted the two best known firms in Paris, France, the world leaders of the iris

trade, and ordered a total of seventy five rhizomes, specifying in great detail the specimens that he wished. It was in the last year of prosperity, 1928, prior to the stock market crash, that Sam began to order flower stocks in profusion.

Two significant works of art were added to the collection in 1930. *Laurentian Landscape* by Franz Johnston was bought by Sam at an auction at Waddington's in Toronto for $21.00 and *Canada West* was acquired from a London dealer, who subsequently was asked to look out for legal portraits, an embellishment Sam probably had in mind for his office.

5 THE YOUNG POLITICIAN AND THE EMERGING ART COLLECTOR

WHEN SAM ENTERED LONDON POLITICS, THE PLATFORM THAT brought him success as an alderman in Ward 2 had an all too familiar ring: "I was brought into the field by the thought that the citizens of London are unduly burdened by mounting taxation. Just what can be done about it is a matter for study." Characteristically Sam did point out areas of waste and laxity in management. The Depression years had had a devastating effect on property owners whose investments had crumpled and whose realty taxes were all the more burdensome.

When, later in 1933, Sam was elected by acclamation to the Hospital Board, he presented a budget, not only reduced in size but balanced, to the city council. Taking away the unsanctioned custom the kitchen staff had of relieving the premises of sufficient food to keep their families fed was one of his adjustments, albeit not one calculated to increase his popularity with the kitchen personnel. After an efficiency expert, brought in at Sam's suggestion, found that 13,000 more meals were eaten in one month than the hospital had patients, Sam's comment was, "With fewer than 400 employees eating three meals a day, that still leaves 5000 meals to account for. That seems remarkable." The hospital under his guidance decreased its expenditure by $25,000.00, an immense sum in 1934.

Sam's singlemindedness in his distaste for the paying of any kind of tax would be made evident in all his years as a

Samuel Edward Weir, Chairman of the Hospital Board, 1934.

politician as was his ability to make suggestions. Planting a hedge and trees around the hospital to stop street noises disturbing the patients was one of Sam's proposals, especially as the trees could be obtained free of charge and the planting done as a work relief measure. The painting of the hospital was done also as a relief measure and Sam suggested to the Council that

lower paid employees should have their wages increased rather than those on salary. He also suggested an 'open door' policy to enable all doctors to be entitled to attend and care for their patients in public wards, "since it is paid for by all the taxpayers." The superintendent opposed the motion, but it carried. Having been subjected to discrimination himself, Sam was particularly sensitive to how others were affected in somewhat parallel situations.

Sam's practice took him with increasing frequency to Toronto. In 1931, proposed by C.M. Garvey, seconded by F.M. Baker, he joined the Albany Club, in order to have a convenient and comfortable overnight base in the city. At that time, a Homer Watson hung over the fireplace in the club. Sam took delight both in getting to know the painting and in having his taste confirmed in such surroundings. He wrote to Homer Watson on May 9, 1932:

"I wrote to you in January to say I was coming in March or April, but I will be in Kitchener, Friday, next week. My mother says you got your meals in the same house on Richmond Street, Toronto. [Mrs. Lee's boarding house where Sarah stayed while working in Eaton's.] *She had an album in which you had some sketches but when she was married the*

family moved about a good deal and it seems to have been lost — which is a calamity. I belong to the Albany Club and have been hoping to see you there but have not had that luck, so I have taken consolation from the picture over the fireplace. I love it. Sincerely…"

Sam's letters to his sisters Ruth and Martha were always signed, 'Yours faithfully,' and even to various young women with whom he contemplated matrimony through the years, endings were never so heartfelt and the word 'love' was not used. Increasingly Sam's accumulation of art treasures was to become his deepest love. Various relationships with human beings ended in disappointment or acrimony, but apart from selling the odd painting, usually to trade up to something better, Sam's collection was the part of his life that was closest to his heart. His admiration and indeed affection for the creators is evident from his letters. Always on the lookout for the best deal, Sam was happy to circumvent dealers and negotiate a sale directly with those with whom he had become friends, and his relationships with the artists he admired and their survivors went far beyond even friendly business deals. Many a portrait commission for Kenneth Forbes, a popular and fashionable painter, came from Sam's suggestions to friends, particularly those in New York.

Homer Watson wrote to Sam from Doon in 1935 to tell him that he had painted Sam's favourite painting in the Albany Club in 1891 or 92, that it had been shown in the Spring Exhibit of the Montreal Art Association, received a prize and was returned. He had kept it until 1930 when the Toronto Art Gallery had a show of his works after which it went to the Malloney Gallery and thence on loan to the club where Sam saw it and "loved it."

In his growing practice Sam was handling various mundane cases, one of which was for a lady who was suing the London Street Railway. She claimed that she was shaken up on a bus and that her old tuberculosis flared up as a result. The case was dismissed with costs. In another, Sam billed a client in Florida for some work done to collect rentals for $10.00. The client wrote back that his bill was too low and sent $30.00. Sam's billing practices seemed to vary considerably. He billed high when the work was tedious and bored him, low when it brought prestige or he took satisfaction in it.

Another of Sam's clients, now resident in the United States, for whom he acted in a case regarding funds from a securities firm, sent him letters repeatedly requesting his fee. It took Sam ten years to get around to the billing. In another case ten years prior Sam had taken part in the Murrell and Williams murder trial acting for the accused. He liked to say years later

74

that they had got the accused off although he was fairly sure that the client was guilty.

Paul, in the meantime, had taken out citizenship in the United States and had received a certificate of graduation from Sperry Gyroscope Co. Inc. to operate gyroscope equipment in 1930. At odd intervals he would show up unannounced at Ruth's over the rest of the year. In 1931 Ruth and Paul parted company. Paul had spent some shore leave in her home while she was visiting London. He overfed the dog, turned up his nose at meals prepared for him, fried food at midnight and hammered something down in the basement, generally infuriating Wilbur who had been left at home to cope in New York's summertime heat. More than probably it was the first time in his life that Paul had been told that he was a spoiled brat, selfish and inconsiderate and Paul could not face it. He stomped out of the house leaving his clothes behind. Many years later Ruth gave them to a charity.

The following year, in 1932, Sam visited the Canadian National Exhibition at Toronto and went to see the paintings, exhibited in the old picture gallery, an annual feature of the fair. A landscape by Frank Panabaker caught his eye. He wanted it and wrote to Panabaker, as was his custom, offering half the price quoted in the catalogue. Panabaker wrote back, "The price on it is, I think, a moderate one but I would be willing to let you have it for $100 less, that is $400.00. I am glad you are interested in the picture." Sam would not meet the offer and Panabaker was adamant.

As much as Sam took great satisfaction in beautiful paintings on his walls, he also wanted to beautify the Weir home and garden. He made a number of purchases from Thornton Smith in Toronto, which initiated a long series of telephone calls and letters concerning wrong deliveries, damages to items in shipping and so on. Sam demanded perfection and when this was not the case his letters to tradesmen on many an occasion became acerbic. A table was sent back to the prestigious Rawlinson and Co. on Yonge Street with a detailed list of its shortcomings.

For six years beginning in 1928 and lasting until 1934, Sam, the brash thirty year old, attempting to refurbish his family home, had dealings with Maurice Adams Modern Furniture, Portman Square, London, England. There is a massive file on Sam's receiving the catalogue, ordering chairs, one at a time, detailed discussions of the colour of Spanish leather for the seats, and on Sam ordering straight not cabriole legs as were shown in the catalogue. Adams eventually became fed up with Sam's constant haranguing and long enquiries without the actual placing of an order. By June of 1932, there was a balance of 3 pounds long overdue. Sam eventually

ordered six chairs over a period of several years. Adams wrote more than once that it was impossible to match the colour of the leather seats unless they were ordered as a set at one time. Adams wrote that the firm was fed up and wished they had never had anything to do with him. Finally, on May 25, 1934, he wrote to Sam that he was instituting proceedings for the recovery of £3.0.0 outstanding since Sept 30, 1932. The chairs, some of them, may be seen nowadays in the main gallery of River Brink, the Spanish leather seats now aged and indistinguishable from one another in colour.

Sam was determined to make the house on Oxford Street into a gentleman's town house. An antique table at an auction was knocked down to him for $12.00. He also picked up a coal bucket and fireplace implements listed by the auctioneer as being circa 1800 for $12.00. In July of 1935, he ordered a pewter cigarette box, ash trays and other items from a West End of London dealer and thanked him for sending his catalogue of sterling flatware.

Besides his art and his books another passion of Sam's was developing, this time for antique clocks. On December 28, 1932 he purchased a grandfather clock from Donald MacCallum who claimed it came from Fern Tower Mansion House, Scotland and at one time belonged to the Duchess of Abercrombie. With what pride must Sam have introduced the clock with its history of noble ownership to Oxford Street, hoping for the approbation and admiration of his parents.

Even in 1933 Sam had ideas about buying a dairy farm. Typically he began by subscribing to the *Island Cow*, St. Helier, Jersey and wrote to breeders in the United Kingdom concerning Jerseys and Guernseys, "about 7 years up in years in calf to good sires." With his law practice demanding much time, along with frequent holidays in New York and southern parts to escape cold weather, plus his civic commitments, it is difficult to see him in charge of a farm as well.

Books were another passion. When Louis Carrier, a book dealer in Montreal, offered him remainders on sale, Sam snapped up a copy of *Maria Chapdelaine*, illustrated by Clarence Gagnon, and many other volumes. Friends tell of being invited to dinner and stepping in a sort of slalom course of unopened boxes of books down the hall, with more stacked everywhere around his library. He knew what was in each box, he claimed, but had not had the time to unpack them. Auction houses and book dealers from the United Kingdom, the United States and across Canada were eager to apprise him of special sales and items they knew would be of interest to him and the growing collection. He corresponded at length with all who offered anything that caught his eye. In a letter dated February 27, 1933, to Dr. Georges Bouchard M.P. Sam writes of his pleasure of

reading *Other Days, Other Ways* and of his having the French version as well. He asked to have both copies autographed, as "…it would certainly add to the 'keeping qualities' of the book and I would appreciate it very much."

Ruth wrote to Sam on June 20, 1933, in some excitement. "Your new picture — what is it?" Presumably an enthusiastic note had reached her earlier. Alas, no acquisition of a painting is recorded for that year. Either it is among the works with no acquisition date or was subsequently sold or traded.

With an eye on his art collection and tending to focus more and more on Canadian artists and subject matter, Sam wrote early in July 1933 to Wilfred Gagnon, brother of the artist Clarence, in Quebec about purchasing an etching. Wilfred Gagnon replied that he had no etchings of Canadian subjects. "His Canadian subjects are oil sketches and paintings which he has sold or has with him in Paris."

July 14, 1933 is the date on a letter when Sam wrote once again to Wilfred Gagnon, the brother of Clarence, still hoping to acquire etchings of Canadian subjects. Wilfred wrote back that all Canadian prints were disposed of except the *Sulpician Gardens in Montreal*. Canadian subjects, oil sketches and paintings, were either sold or with Clarence in Paris, he repeated. However prior to these exchanges, Wilfred had sent Sam eight etchings, all of subjects in France, for him to make a choice. Sam bought three.

Curiously enough, Sam was deadset against the pasteurization of milk. There were high feelings pro and con on the subject and E.E. Reid, managing director of London Life Insurance Co., sent Sam a copy of the *Public Health Journal* with the notation "I cannot believe that you would persistently oppose a by-law that is absolutely in the interests of the health of this community if you could be convinced of the facts…" Fortunately Sam's stand on the issue was defeated.

For the next three or four years Sam journeyed frequently to New York on behalf of a client, a rug dealer from Armenia who had disagreements with customs officers, deliveries, payments and with another Armenian, apparently the supplier. The two dealers had difficulty agreeing about anything, one in London and one in New York. Sam made good use of his time in New York to explore the antiquarian book dealers and to examine prints and etchings.

Extensive files concerning London Home Builders are discoloured, dirty and dusty, indicating that they sat out on a floor for many months, perhaps years, without benefit of a duster, nor would it seem that they were disturbed by any interest being taken in them after the company ceased to operate. As well as life insurance company shares and other investments, Sam was evidently becoming a landlord. A bill

from the Public Utilities Commission indicates that Sam was the owner of a number of rental properties.

A story in the *Border Cities Star* of March 22, 1935, bylined by Merrill Denison, so interested Sam that he cut it out and saved it. Being interviewed about *The Pioneer Mill*, which was purchased by Princess Louise, Marchioness of Lorne and wife of the Governor General, the Marquis of Lorne, and presented to her mother, Queen Victoria, for Windsor Castle, Homer Watson told Denison, "So home I went and commenced to paint with faith, ignorance and delight."

Ruth, by the mid 1920's, had become a partner in an art and antique firm, D. Caz-Delbo Art Galleries, *Maison Française*, Rockefeller Center. She kept Sam up to date on whatever she thought would entice him to add to his collection and, in one letter, mentions "a Titian, Reni and some other old ones." From time to time Sam did make a purchase from *Maison Française*, one of the first being a Guillaumin, a relatively minor Impressionist, unknown to most art lovers in the thirties. Wilbur was already a very knowledgeable guide for both Sam and Ruth and they learned a great deal from him. In 1934, for $110.00 US, Sam purchased *Lake Edward* 1866, by Otto Jacobi, the German painter who settled in Montreal in 1860.

Sam's reputation as one knowledgeable in artistic areas was growing. In February of 1935 he was invited to give a talk on Homer Watson to the Baconian Club of London. He declined, writing, "I am taking time for City affairs which should be devoted to my business. City business has grown in bad times. Later, when I am lucky enough to be off Council, I will be glad to do my part."

An unsigned letter addressed to Irene (Irene Rempfer) the daughter of Sam's Uncle Samuel, and therefore a first cousin of both Sam and Ruth, gives an insight into the life of the Wilbur Howells. Prohibition was in force in 1935, but Ruth's father, George Sutton Weir, M.D., regularly prescribed alcohol for her as treatment for her high blood pressure. The letter to Irene gives the impression that the old family horror of the demon drink had abated in the American West as well.

On Hotel Times Square letterhead and dated July 25 (1935):

"Dear Irene

Yesterday was a busy day for me. I went to the office of the steamship company as well as to those of Interest which has charge of this trip in Russia. I got out about 1.30 p,.

Then I went to Howell's office on E. 18th St. He is one of the senior officers in Robert Gair Co. The company manufactures boxes, cartons, containers etc

in large quantities for the package trade chiefly for the nationally advertised brands such as Lux Post Toasties etc. Wilbur is a nice, conservative middle aged businessman. The afternoon tea and evening bridge type. Believes the British parliamentary system of government is the ideal type.

He took me to dinner. Ruth is a Weir — calm efficient, a good cook. Said her "slave" was on her vacation, did her own work. We had a broiled steak for supper — a combination salad served on wooden bowls, raw Italian onions, two vegetables, besides corn on cob. Blueberry pie a la mode. Iced tea when I got there. Iced tea while I was there and iced tea when I left.

Sarah, the 10 1/2 year old daughter was at home. Billy the 6 1/2 year old boy was in camp and I did not see him. Sarah is a homely — red headed chubby youngster — but a very bright child. Efficient — knows how to meet people on her behaviour when company is present. She was born in Romania Ruth and Wilbur met in that country and gave me plenty of pointers covering my conduct.

It might interest Mary [Irene Rempfer's grand

daughter, born in 1923, so 12 years of age] to know that Sarah has a collection of over 70 dolls sent her and given her from all over the world. She has them nicely put away in a book case. She is a methodical child, helped her mother serve without fuss or feathers and went ahead nicely. She loves to eat and eats quantities of food. She just started wearing glasses. Slight case of near sightedness.

I stayed at Howells until midnight. They live about 10 minutes from the heart of the city in a development with artists, musicians, actors, business people, teachers, professors. It's a very nice location and they have a nice home. They have all kinds of antiques. Told me lots about the Toronto Weirs. Ruth's mother died within the year and her father at 77 or 78 is still mentally alert, but intensely religious.

The Howells wanted me to stay or come out again before I left and I may. They want me to go to Bucharest where they have friends and where Sarah's and Billy's godmothers live. They were both born in Romania and it seems you have to have godmothers there.

It is terrifically hot in New York. Sultry and

oppressive until I think I might get asthma or hay fever or 'sumpin.' I do not think I would like to live here. The continuous noise gets me.

While Wilbur has a good salary, a responsible job, etc. he has nothing ahead much. Their public schools are terribly overcrowded, 70 pupils per teacher, classes in shifts, night schools etc. Result - Sarah goes to a private school 2 miles away, very expensive, likes French and music, and Billy mechanically inclined. But all of their salary goes to education, living taxes and a little entertainment.

I invited Wilbur to go along with me to Rumania and the family to come to S. Dak. and visit us sometime.

I wish I had my Oliver with me. I could then write as fast as my rambling thoughts flow along. Goodbye until tomorrow."

Ruth had inherited her mother's intense pride and determination to put a good face on her situation.

Sarah died on April 15, 1935. The cause of death was listed as myocardial inefficiency. She had suffered a cerebral thrombosis about two years prior. So far had the family abandoned their strict abhorrence of alcohol that Sarah had been enjoying a nightly comforting brandy at bedtime. Sam

preserved the half empty bottle that was left at her bedside for many years as a sort of relic of the mother he loved deeply and tried to please although he knew her greatest love was for Harry, her firstborn and Paul the baby, the indulged 'invalid.' Paul let it be known after his mother's death in no uncertain terms that he wished to have nothing whatever to do with his family. The long suffering Sarah had regarded Paul's treatment of her and of his family as a cross to be borne, but it saddened her last years.

Shortly after his mother's death, Sam got in touch with Kenneth Forbes in Toronto and commissioned him to paint Sarah's portrait from a photograph and snapshots. He also sent samples of her hair. Sam's first letters to Forbes began "Dear Mr. Forbes," but as was Sam's custom, they were soon on Ken and Sam terms and continued on a close friendly basis for many years. Sam bought the somewhat idealized portrait on time.

At some point in 1936 Ruth met Richmond Barthé, a sculptor who was making a name for himself in New York City art circles. Together Ruth and Sam plotted to have Barthé make a bust of George Sutton from his earlier pencil drawing. Eventually busts were cast and a copy presented to the Medical Faculty of the University of Western Ontario, because George Sutton had been a graduate in the first medical convocation. Sam and Ruth each had busts made for their homes.

As well as art, Sam was busily picking up the odd shares, as he could not yet afford board lots, in ones, twos and fives of various life insurance companies. They were to become the underpinnings of his extensive investment portfolio and his fortune. In these Depression years, his contemporaries were probably in difficulties as young married men, financing mortgages and struggling to make ends come even close, let alone meet, but Sam lived at home and salted away his earnings in shares, stocks, art and books as well as enormous improvements to the family home. There were bound to be some envious young lawyers around London.

In November of 1935, Sam visited Homer Watson in hospital. Almost destitute and out of public favour, Watson tried to paint in a less detailed, more impressionistic manner, yet he could not desert his real *metier* which, sadly, seemed out of date and old hat to a younger public. Homer and his sister had lived with utmost frugality since the death of his wife in the old home at Doon. Sam organized a private form of financial help for the pair. It was much needed. When Watson died on May 30, 1936 of the following year Sam was not only at his bedside, but he had gone to stay with the Watsons to help out when he realized how ill the artist was. He continued to stay on for a short time after the death to help Phoebe sort things out.

From Phoebe he purchased *The Fog Cloud (Old Smoky from the Sea, off Sir James Ross' yacht)* painted in 1909. Although he was a staunch friend and a supporter of Phoebe, yet Sam, along with others, sought to obtain pictures from her at the lowest possible price. Sam made a number of efforts to place Watsons with various dealers without much success. In Phoebe's letters to Sam she sounded desperate and rather bitter at the lack of interest in her brother's works. Still an ardent admirer during the last days of poverty and rejection, Sam was interested in acquiring the Homer Watson *Waning Winter* which he had seen at the Western Fair in London. However Fred Lawson of the National Gallery wrote to Sam that it was not for sale, that it was owned by the National Gallery.

At this time Sam was in the midst of controversy at the Hospital Board and he and Jeffery, his law partner, were not getting along amicably. It all came when Sam could not well have afforded the time spent in Doon. His actions on behalf of the Watsons give an indication of how greatly he revered Homer Watson as an artist, "The Canadian Constable," and with what compassion Sam could respond to another's needs.

By the end of 1935, on December 28, the *London Free Press* announced that Samuel E. Weir had retired from the Hospital Trust. No doubt anticipating the dissolution of Jeffery, Weir and Moorhouse, Sam was determined to run his own show. It was

also the conclusion of his civic political career in London for some time. He was approached to run for mayor but declined. Two years of bickering on the Hospital Trust had wearied him of public office.

As usual, when Sam was in charge of anything, there had been controversies at the Hospital Trust. Sam proposed that, since only juniors on the medical staff treated patients in the public wards, that those patients who wished could pay $1.00 a day and be put into private or semi-private rooms, in order that they could be seen by their own doctors and not treated as indigents. "I do not believe in discrimination in any form," he announced. Unfortunately the $1.00 a day scheme did not fly. 'Closed wards' won. The nurses on staff agitated for an eight hour day. A Dr. Meek had bequeathed money for a Meek Memorial Laboratory to be run as a cancer clinic. There was some thought that the new Meek wing should be added to Victoria Hospital. "Powerful voices," according to the *Windsor Daily Star*, "University of Western Ontario had so far prevented the hospital from establishing the clinic." Sam advised the hospital board to take legal action if Dr. Meek's wishes were not carried out. "A small faction at the University of Western Ontario wanted a new hospital, but a determined attempt would be made to establish an unpopular million dollar hospital." Sam was opposed, "Too much of a good thing and

paid for by the taxpayers of London," was his comment. The Victoria Hospital ended 1935 with a surplus of $10,000 and Sam's picture appeared in connection with this feat in the *Windsor Daily Star* of December 28.

Late in 1935, Sam, with his characteristic compassion for the needs of others and addressing what he thought was a shocking oversight, wrote to F.S. White M.P., seeking a pension for Judge McEvoy's widow, pointing out that she had been given two years salary and nothing else. Mr. White was not sympathetic to bringing the matter up in the House. "Judges are paid too much," was the sitting member's opinion. Sam persisted and some time later, a more generous consideration was provided for the widows of judges.

While attending a Canadian Club luncheon in Toronto, Sam was seated next to a young man who said he wanted to write a history of the Canadian Pacific Railway. Sam told him it had already been done. Later he sent the young man three books of reference. Assiduous in his search for knowledge and information, Sam was equally keen to share the results of his research with others.

All his life Sam wanted to get to the source, not only of information, but also of suppliers, purveyors and manufacturers. It was more than an innate desire to cut out the middleman. Sam wanted to be able to discuss his wants

with a responsible member of whatever firm with which he was in contact. He ordered Harris tweeds and other woollens directly from the weavers in Scotland, then took the fabrics to Lombardo, the tailor in London, Ontario and, incidentally, the father of Guy, the band leader. Sam ordered glassware and crystal from the United Kingdom and a liqueur cabinet at the same time. Even though George Sutton had his tyrannical ways, Sam was in control of his own wants in the alcohol department. Dominion Shirting of Kitchener custom made his shirts and there is a welter of communications as to exactly how they are to be made and from which materials. The samples of fabrics were saved. Sam wrote a cheesemaker, one Schenk, in Wellesley, ordering 100 pounds in 5 pound sizes with the notation, "…would certainly be glad to have June cheese if you can accommodate me." Probably he was thinking of gifts to his sisters and clients. He wrote S.J. Wolf, the *New York Times* sketch artist, enquiring about having his portrait done, but nothing came of it.

Back in February, George Sutton had been responsible for the purchase of a new furnace to replace 'Good Cheer' acquired in the twenties, but according to Sam, writing about it to Ruth, "Made a mess of the deal." It needed a number of repairs, so more than likely George had tried to economize by buying a second hand number. In great annoyance Sam rode to the rescue, getting it all put right.

On May 15th, in a postscript of a letter to Sam, Ruth wrote, "There was a package of unopened letters here returned by Paul with a note enclosed saying he wished to be able to forget his past life entirely and did not wish any further communication from his family because they stirred up memories which distressed him. So I suppose we may as well respect his feelings to that extent." Ruth's letter was written just thirty days after their mother's death.

In June of 1935, Sam wrote to the firm of Herbert S. Weggs of 68 Temperance Street, Toronto, who also had an office in St. Thomas, to investigate the possibility of a relationship or even buying out the St. Thomas practice. The answer came, "Mr. Rowland says he has no practice he could dispose of." Sam was seriously searching for a close relationship with a Toronto firm. After his mother's death, he may not have felt quite so tied to Oxford Street.

At the end of the year the Senate of the University of Western Ontario received Sam as a member of that body, ratified and passed by Sam's friend, T.F. Kingsmill, Mayor of London and Grant Crawford, City Clerk, on December 16, 1935. He served for two years, a tribute to his years of contribution and dedication to the London City Council and the Hospital Board.

84

6 SAM THE MASTER IN HIS OWN FIRM

EARLY THE FOLLOWING YEAR, 1936, THE PARTNERSHIP OF JEFFERY WEIR and Moorhouse was dissolved, but not without some acrimony. A rather peremptory letter from Jeffery senior had given Sam three months salary and the information that his room was needed at once. Jeffery's son had just joined his father's firm. Sam's new firm, Weir and Associates, formed with Sam in charge and in control, was to be known as specializing in insurance law. While Sam made several other tentative attempts to buy into Toronto practices, nothing materialized. He set up his office at 110 Dundas Street and shortly thereafter acted for a William Shea of London in a case which brought a certain amount of publicity, that of "The Chicken in a Bottle." Shea, an employee of a firm producing chicks as pets for the Easter market, slipped a white Leghorn pullet into a five gallon jar. Against the anguished cries of animal lovers, Sam was quoted in the *London Free Press* as saying, "It looks quite happy to me." W.B. Henderson, counsel for the Humane Society, laid charges. Sam's files on the case disappear at this point. The fate of the chicken is not known.

For the next ten years, Sam's files seem to be in a disordered state. One wonders how he ever found anything. He liked to spell the word file with a 'y', a practice suggested by neither the *Oxford English Dictionary* nor Webster's, nor by Funk and Wagnell nor Random House. It would seem his own

spelling appealed to him. During this time he worked closely with his second cousins, Charles Weir and Agnes Weir Randolph of Sarnia. Agnes frequently came to London to Sam's office, bringing her small daughters, Penny and Libby with her. Penny remembers happy days while her mother worked with Sam, riding up and down in the department store escalators across the street, a great convenience for Agnes in keeping the children happy and occupied.

Sam's reputation as a head office lawyer for London Life Insurance Co. was well established. He was insistent on doing all their mortgage work in London, an indication of his basic insecurity and inability to share the work load. Inevitably some rancor developed. Sam stormed out and immediately acted for many of the other Canadian insurance companies.

The friendship with Topsy MacDonald continued to flourish. Throughout the twenties Topsy had encouraged Sam to write stories for a hobby. After all, he was so good at regaling her with various anecdotes and tales about his practice. He indicated that he would like to try and perhaps would write his autobiography. Sam's many letters to Topsy sought advice on personal matters and Topsy always came up with wise comments. Topsy and Martha had hit it off from their first meetings and while they became friends, Ruth was the stumbling block. Sam was giving serious thought to marrying

Topsy back in 1924, but Ruth advised against it strongly. Whether she felt that Topsy, or anybody else, was not good enough for her brother, or whether she simply disliked Topsy, or perhaps wanted to continue to exert the greatest amount of influence and power over both Sam and Martha is impossible to say. Perhaps it was a combination of various emotions, mixed with concern for Sarah and George being on their own.

Eventually Topsy left Guelph and went to work in Toronto where she and Sam saw one another frequently. They shared an absorbing passion for their gardens and horticulture generally. Their many letters and notes to each other were ones of friendship and understanding. Topsy's were frequently light hearted and playful, addressing him as Sir Edward or dear Mr. Weir. No one else, it seems, had ever treated Sam with such spontaneous and lighthearted gaiety and he often seemed a little nonplussed.

By March of 1936, Sam again turned to Ruth on the question of marriage to Topsy. This time Ruth brought up the question of her age, probably now in the late thirties. She suggested that a consultation with a gynecologist would be in order if Topsy would consent to be evaluated. Even when Topsy seemed keen to undergo such an examination, Ruth still was not enthusiastic about their marriage. Martha was supportive, but did not want to rile Ruth. Following their mother's death,

Ruth assumed more and more the role of the family matriarch. She certainly ruled her roost and Wilbur almost never complained about the Weir invasions in their small house for long periods of time.

In the preceding month of that year, Sam had been appointed to the disciplinary committee of the Middlesex Law Association, a position for which he was well suited. He also approached Robert Gray of Gracechurch Street, London, England, to interest him in acting for lenders to mortgagors on Canadian properties. He also made inquiries to various law firms in Toronto, Montreal and Detroit for possible co-operation. Always on the lookout for the possibility of a dearly desired LL.B., Sam also wrote for the calendar of the law school at Columbia University.

That spring it came to Sam's attention that a Morrice was for sale in Paris. On May 21, 1936, Sam wrote to M. Alfred Poyet, of 53 rue la Boetie, Paris, "I have heard...that you have on hand for sale *La Communiante*, the largest canvas of which is in La Musée de Québec and painted about 1898." Sam drove a hard bargain with the Parisian dealer. M. Poyet was left in the position of trying to find other paintings so he could make good on what he claimed was a loss for the sale. The following year, 1937, Sam did get another from Poyet, *Le Porche de l'église de San Marco, Venise*. Later in the thirties, Sam would meet Frank

Worrall, an art restorer lately arrived from England, who would exert a great influence on Sam's choice of acquisitions. Sam grew to trust him implicitly and in later years referred to him frequently in letters to various galleries a "my art restorer" and "the famous art restorer."

By June of 1936, Sam was in communication with Galerie J. Allard, 20 rue des Capucins, again on a tip from Ruth about a Morrice. The price was 1500 francs. Sam offered 1000. Allard agreed but without the frame. Sam then offered 875 francs for another. Allard refused. "These paintings brighten when cleaned, so 1000 francs it is," Sam wrote. With Ruth engaged in the Fifth Avenue art gallery, Sam had an insider's track on the going prices of the works in which he was interested. The Morrice arrived in November, 1937, but with a problem. The francing stamp of a post office, presumably Parisian, had made an impression on the face of the painting which Sam claimed was not possible to remove. Sam wrote that he was anxious to obtain more of these little Morrice paintings but to pack them, please, with more care. After a series of letters to Galerie Allard regarding this purchase, the gallery agreed to send 500 francs to Sam as compensation for poor packing. It was the first of many clashes Sam had with galleries in France and England over packing inadequacies.

On October 17, 1936, Sam wrote to Ross Hamilton, at

the Waterloo Trust and Savings Co., Waterloo, to thank him for the repayment of a small loan. Sam went on "Mr. Lewis, his assistant telephoned me this morning to say that they have a bid of $225.00 on the Colling painting which you were looking at and they say that if you wish to do anything better on this you can have the picture. There has, of course, been no evidence submitted to me, that they did get this bid. Yours very truly." The Mr. Lewis referred to was none other than the Leslie Lewis later accused and convicted of art forgery in the State of New York and with whom Frank Worrall was associated. Worrall collaborated with Lewis in many restoration projects, but Sam would defend Worrall's claim of innocence of forgery at the later trial.

Two days later Sam wrote to Hamilton. "...Because Homer Watson is now dead the show should be put on but the meeting decided against it. [The Annual Meeting of the Art League, the precursor of the interested persons who founded what later became the London and Region Art Gallery]. He [Mr. Bassett] thinks you should try the Canadian Club. Then you can address the luncheon meeting."

Ross Hamilton later became curator of the Homer Watson Gallery in Doon. At this point Sam seems to have been more interested in wheeling and dealing in art related matters than the day to day operation of his law practice. He wanted to

help dispose of his late friend's paintings, all those that he could not afford to buy himself. As it turned out Waterloo Trust with E. Putnam, chairman of the board, acquired all available Homer Watsons and engaged Frank Worrall to refinish and restore them.

Later in the year on December 23, the *London Free Press* announced that the Attorney General, Arthur S. Roebuck, had made Samuel E. Weir and A.M. Lebel of London, King's Counsels, among the seventy-three named throughout the province. Many cards and letters arrived for him, and, obviously pleased by the province-wide interest, Sam filed the congratulatory mail together with care.

A case at this time, requiring a little detective work, intrigued Sam. Miss Amorita Heath of Brantford sought help from him in solving the sort of mystery that would be sure to engage his curiosity and his interest. Miss Heath had come into possession of a copy of Bunyan's *Pilgrim's Progress* inside which was a letter written by Admiral Nelson in 1797 after he had lost his arm. Somehow the letter and some furniture from a ship of Nelson's had come to rest in Mount Pleasant, Ontario. Unfortunately everything had disappeared and try as they would, Sam and Miss Heath were unable to track the letter or the pieces of furniture. Sam dearly would have loved to have acquired the two chairs and two engravings. Alas, they seemed

to have walked away of their own accord.

In mid September, Sam wrote to Ruth that George Sutton had suffered another attack of his ulcer condition. He had had an operation prior, but now was more ill than ever. Sam packed him off to the hospital without giving his father a chance to argue about it. The previous day when Sam had stayed home to watch him, the doctor had been summoned and stayed with him for over an hour. George Sutton, although very much weakened by the attack, did recover.

In late November of 1937, Sam took Topsy to stay with Ruth for a few days. Most certainly marriage still was being contemplated, but Ruth's approval was critically important to Sam. After the couple had left for home, "It is very hard to advise you regarding matrimony. You will have to weigh the pros and cons and make up your own mind," Ruth wrote to Sam and without her blessing, apparently, the wedding was off. In later years when Sam spoke of the broken alliance, he was in tears. He did write to Topsy a few months later, wanting to see her again. Topsy's reply, if there was one, is lost. She had waited seventeen years for a formal proposal and it was now over as far as she was concerned.

That same fall Sam had more trouble with Galerie Allard's casual attitude to ensuring that their wares were properly packaged for a Morrice, *Palais des Doges*. Some sealing wax overheated and the picture was damaged. Worrall claimed that some of the damage was permanent and the value, therefore, was depreciated and that he would contact Lloyd's of London for insurance payment. Worrall informed Sam that the canvas was broken in two places and that he would make a wooden backing as a repair. He also noted that a Paul Peel required re-stretching, cleaning and varnishing. Furthermore a Jacobi needed re-lining because of a hole in the sky area, "the size of a quarter." Sam's reply was that ... "My own idea is that it is better not to touch up a painting unless it is absolutely necessary," a view which more closely corresponds with current thinking than the often overdone restorations of Worrall's early twentieth century training.

For the next three years, Sam advertised his legal cards in the newspapers surrounding London: St. Marys, Strathroy, St. Thomas and others. He also acted as Trustee for the Middlesex Bar Association and continued in that capacity for at least thirteen years, accumulating information he would later use in his publicity for election as a Bencher in the Law Society of Upper Canada. All his files on real estate sales and mortgages were carefully arranged and detailed. But along with this orderly attention to detail, Sam continued to support his friends, such as the agreement he drew up for his old friend Bentley Baldwin who sold a horse, one *Ne'erdowell*, for $500.00,

along with natural love and affection to his brother Billie. For the next two years Sam was actively involved in pressing for a benevolent association of the Bar.

With Weir and Associates firmly in place and Sam in control, the future looked promising.

7 AN INTEREST IN ART BROADENS

IN THE SUMMER OF 1938, SAM AND MELVIN BASSETT OF THE University of Western Ontario Department of Romance Languages were in correspondence regarding the formation of a library and art gallery to be in London. A special committee of the Library Board was struck, which ultimately became the London and Region Art Gallery. "I can get the various factions involved to do something progressive and worthwhile rather than springing at each other's throats or grabbing everything for themselves," Sam wrote. He served well and truly in his efforts to establish an art gallery for the city and can be regarded as a founding father of the gallery. At the same time he sought advice from Bassett on acquiring property in Quebec for a summer retreat, "a chance of picking up some good French," and also he wanted, "contact with some of the good people, as well as those close to the soil." Bassett's letter revealed that "... but it is plainly indicated in my own mind that you are the one to set things in motion with Mayor Kingsmill..."

George Sutton recovered from his bouts of illness of the previous year and went to New York to stay with Ruth in the spring. He wrote to Sam that Ruth needed more closet space, so Paul's clothes and effects were disposed of for good. It was arranged that 'Father,' (never the more familiar Dad) would return to London over the summer to escape from New York's heat. However, on June 1 Sam wrote to Ruth, "Father is digging an enormous hole in the garden and ordering employees about.

He has to be bossing somebody. Get him back out of here right away." Sam was frantic, desperate and furious. His carefully, lovingly and expensively planned gardens were at serious risk. A letter to his father while he was still in New York was signed, 'Yours truly,' hardly the ending from a loving son. But this latest petty tyranny and despotism were too much to be borne.

That Sam was finding his father's actions vexatious was borne out by his letting off steam, as it were, in telephone calls to his old friend Homer Neely. For the past ten years or so Sam and his father had quarrelled frequently and severely. Homer Neely dreaded the phone calls that were difficult and frequently very lengthy in recapitulating a particular disagreement step by step. Would Homer come over and settle the argument was the usual request. They had met sometime around 1935 at a wedding anniversary party at Homer's residence when Sam had arrived a day early. He stayed for two or three hours, tiring Homer, as both men remained standing and apparently Sam did most of the talking. Sam showed up again the next night alone, although the other men brought their wives or a partner, and a friendship emerged.

In 1938, records noted that George Sutton was in arrears again on his part of the Oxford Street property. Two vacant lots were sold for $254.68 and $161.75 back taxes. Sam had arranged for the taxes to be reduced in the same year for the 1939 taxes. For the future for taxation purposes, the property held by George Sutton on Oxford Street was now listed as being owned by Charles Weir, W.F. Howell, Martha Frances Weir, George Sutton and Sam. Presumably, Charles, also known as Paul and Carl, was unaware of his inclusion.

When the Western Art League mounted an exhibition of fine etchings and engravings, on loan from the National Gallery, upstairs on Dundas Street next to the Esquire Grill, Sam wrote a congratulatory article which was printed with a by-line in the *London Free Press*. After commenting on the wood cuts and etchings, Sam ended with:

> "The lesson for all of us is that it is much better to acquire inexpensive prints of undoubted excellence, such as prints now on exhibition, than to purchase paintings and more ambitious things which are artistically poor and more costly. For those who cannot afford good individual things at the large prices which they deservedly bring — and we are practically all in this category — it is preferable to patronize the print makers who are able to meet our pocket books by a production of 25, 50 or 100 copies of an original work of art. And remember that the catalogue of print makers

includes most of the great artists."

Sam practised what he preached and his interest in prints and etchings of early Upper Canada has produced the splendid and incomparable collection that is presently in the Weir Library and Collection of Art. The year before he had added two Watsons, purchased for $40.00 apiece from Phoebe; had decided to acquire the Suzor-Coté bronze *Femmes de Caughnawaga*; and, at some time prior to 1937, had obtained the Laura Knight drawing *Two Female Ballet Dancers Seated*. In the following year, 1939, only one art acquisition is known, *The Little Model* of Suzor-Coté. During this period, however, boxes of books from auctions and from dealers in England and New York were arriving with frequency. Friends continued to speak of unopened boxes everywhere in the house and having to undergo a circuitous course in the hall to avoid them.

Sam was a vital source of information for Muriel Miller when she was writing her biography, *The Life of Homer Watson*. Frequently she would be in touch with Sam who gave her all the help she sought. At the same time, Sam and Ross Hamilton were establishing a close friendship which would last for many years. Their mutual interest in both Watson and Canadian paintings in general and historic art works in particular led to various purchases and exchanges of works of art between them.

The bronze, *Femmes de Caughnawaga*, by the renowned French-Canadian sculptor, Marc-Aurèle de Foy Suzor Coté.

Hamilton urged Sam as a governor of the University of Western Ontario to lobby for the establishment of a chair of Fine Arts at Western as Toronto, Queen's, McGill, Acadian and the University of British Columbia and others had already done. Incidentally Hamilton told Sam that he knew of a first rate candidate. Sam thanked Hamilton for the suggestion, but was too busy with his law practice, his father's health and his growing correspondence with book dealers throughout the eastern United States and Great Britain to promote the idea with much vigour.

During this period, Sam had several cases going that brought him attention in the local papers, keeping him in the public eye. When he and thirteen other prominent Londoners went to Toronto to attend a farewell banquet in the Royal York Hotel for the Right Hon. R.B. Bennett, the *London Free Press* made note of it with a front page story and pictures. Sam kept a few copies of the page. It must have been a balm to his sensitivities to be included in the distinguished group.

In 1939 Sam took his cousin Arthur, the son of his mother's sister, Eva and her husband Alexander Thompson, as a student articling with him. By now relations between Sam and Ruth had cooled somewhat. The question of who would take care of George Sutton was a sore point between them. Ruth's children were growing and the house in Queens was not large. George Sutton liked to keep himself busy and his

carpentering activities, sometimes at night when others in the family preferred sleeping, upset the family's nerves. Sam refused to have him around in the summertime messing up the garden when Sam was in his office. He dreaded coming home to discover what the active George Sutton had taken it into his head to do. It was preferable to have 'Father' in New York. Finally, on May 4, Ruth wrote to Sam, "I am ignorant of any reasons why you should not feel free to visit me. I hope it is not serious...It is always a pleasure to have you. I was hoping that you might bring Mary over to the fair." Everyone else called Sam's friend Topsy and the closeness of their friendship had been a thing of the past for over a year, largely due to Ruth's lack of support for their marriage.

In June of 1939 Sam wrote to his father in New York to comment on Martha's visit home to London to see the King and Queen and Martha's observation that she knew her father was anxious to come home. In the letter Sam wrote, "There is no way of looking after you at ALL and the house is so upset so I am afraid you will have to defer it for awhile." Sam gathered up his father's medical instruments and equipment and put them down in the basement where George Sutton could go over everything and keep what he "absolutely needs" and dispose of the rest. Also Sam indicated that he wanted some things needed for the house which George Sutton could bring

with him over the border. Sam wanted Oxford Street to himself in the planting season without George Sutton's interference, but the request to bring some household materials was his way of indicating that George Sutton would be coming back, later.

An annoying situation concerning a drainage problem on the Oxford Street property was finally resolved in court. George S. and Samuel E. Weir were given 30 days to resolve the problem of water draining into the neighbour's property. The issue had arisen when the neighbour built on the property and the city installed a new road. Sam claimed the new water course was not his fault, but he had it attended to after the court order. No doubt it seemed all the more vital to keep George Sutton away from digging large holes in the garden.

With the bequest from the estate of John Wycliffe Lowes Forster in hand, The National Portrait Gallery was founded on April 22, 1939. Listed as founders of the Gallery were Dr. H.J. Cody, President of the University of Toronto, Dr. Duncan McArthur, Dr. C.T. Currelly, Mr. B.N. Davis and Mrs. Emma Frances Forster. The eminent Canadian portraitist, J.W.L. Forester, who had been commissioned to portray the Emperor and Empress of Japan amongst other notables, died in 1938 and left fifteen portraits of well known Canadians of the day to be the nucleus of the National Portrait Gallery. Sam was

greatly interested in the concept and served with twelve others as Members of the Corporation. The National Portrait Gallery limped along for a few years throughout the war but gradually fell into abeyance. Sam resigned in disgust after repeated attempts to invigorate the officers into holding annual general meetings, declaring the assets and so on did not succeed. At the time of dissolution there was a sum of approximately fifteen thousand dollars in funds, the fifteen Forster paintings and twelve pen and ink drawings of eminent Canadians by C.W. Jefferys. The paintings eventually landed in the storage facilities of the Royal Ontario Museum. The concept of a National Portrait gallery was moribund.

Sam was asked by an employee of one of the insurance companies with whom he did a considerable amount of business to place a value on one of his paintings. Sam declined, suggesting that the man consult an expert who would charge him but that his advice would be more suited to his best interests. While he was becoming an acknowledged expert in the fields in which he had particular interests, he had no ambitions in becoming a professional at the beck and call of any of his business associates who were curious about the dollar value of their possessions. He had other more pressing goals. Earlier in the year Sam had filled out an application form to join the New York Bar Association. He had written to a number

of lawyers specializing in real estate to investigate the possibility of establishing a practice in New York, acting for Canadians or for Americans with Canadian interests. In the meantime there was work at home. Later in 1939, Sam drew up a mortgage with Confederation Life for the Salvation Army in London. He billed the mortagor only for his out of pocket expenses.

At this time Sam apparently was concerned over a seeming lack of energy, a condition not to be wondered at since he was forty one years of age and extending himself in his professional, political and collecting lives. Establishing himself as a patient of G.S. Weir, M.D., Sam obtained a Dietary — prepared for him by a biscuit manufacturing company, Energen of London, England. The purpose and tone of the diet was to increase energy without increasing weight. The suggestions added up to 1820 calories per day, but it would be difficult for anyone to maintain the current body weight on a diet heavy on protein and the company's Energen products, apparently made up of carbohydrates. Extremely busy as he was, his lack of energy probably indicated that he was not getting physical exercise, the horse riding programme being long over, and as well he was suffering from a lack of sufficient sleep.

In August of 1939, Sam met Dr. Sigmund Samuel, described by C.T. Currelly, the first curator of the Royal Ontario Museum, as our 'great patron.' The Sigmund Samuel Canadiana Building on Queen's Park which he underwrote, served the Royal Ontario Museum well until the renovations of 1982 when the Sigmund Samuel Canadiana Gallery, now underground in the Royal Ontario Museum, was opened to showcase some of his magnificient bequests. This is where the J.W.L. Forster portraits, the hoped for basis of the short lived National Portrait Gallery, begun in 1939, now find their home. Naturally their conversation turned to the acquisition of Canadian prints, a passion they shared. A correspondence between the two avid collectors ensued and Sam felt honoured to be invited to visit Samuel and view his collection of prints.

As word got around that Sam and Hamilton were trying to acquire Watsons, Sam received a letter in late September from Herman Silberman offering him a Homer Watson for $2,500.00, no title specified in the letter. Sam replied very quickly that he was not interested, the painting was too large and besides, some of the Watson paintings made for Sir James Ross, very large ones, had gone for $100.00. There is no further correspondence from Mr. Silberman. Even though the acquisition of Watsons was uppermost in his mind, Sam wrote to Ruth on November 13, 1939, a chatty letter about Horatio Walker's relatives and mentions the Walker place at Petronille. "An aunt and niece in Toronto," he wrote, "have taken the paintings to Toronto. They are insane about their value, so I have not bothered about them."

He also noted that he "is taking some sketches of Suzor-Coté for $25.00 each from Mrs. Suzor-Coté. They have been going for $100-$200, so it's a good buy on spec."

Just before Christmas Sam wrote to Arthur Coté, Suzor-Coté's brother, to tell him that after consulting with Mr. Worrall, he wanted to buy the oil of 'the little girl,' but since it was not characteristic of Suzor-Coté's work, he did not feel it was worth the price Coté put on it. After some negotiation *The Little Model* arrived in the collection and is now a much loved work.

The correspondence with the Cotés continued. Mathilde Coté turned to Sam on numerous occasions with tales of woe, being unable to pay her rent and so on. For the most part Sam seemed oblivious to her plight in the copies of his many letters to her, but nevertheless, he was anxious to get more Cotés. There is some evidence that he helped her financially in a small way from time to time without reference to obtaining works of art. The wheeling and dealing between Sam and Mathilde, Arthur and Roman Bronze Works of New York, the casters, went on for years. Sam dallied to the despair of Mathilde and eventually to the anger of Arthur until well into the late forties. Arthur wrote at one point to Sam that "you are a most unsatisfactory customer." Sam went his own sweet way, bringing Frank Worrall into the picture now and again for advice on prices and general condition of the works

on paper. Perhaps he enjoyed the contacts so much he wanted to prolong the negotiations as long as possible, at least until one of the Cotés stamped a foot. What had started out charmingly had evolved into polite acrimony, with Sam frequently disregarding eight or nine entreaties to make up his mind. His excuse was illness, pressure of work and so on.

In December Sam was wrangling a better price on Paul Kane's book *Wandering of an Artist Among the Indians of North America* from a bookseller in Brighton, England. The offering price was £10.10. Sam got it for £6.6. At this point Sam was buying a good many books mainly from the United Kingdom.

Always eager to try new plants in his garden, Sam heard about Chinese chestnut trees and accordingly wrote to Dr. Wallace Crawford who had studied medicine at University of Western Ontario with George Sutton. He was now on the staff of West China University Chengtu, Szechuan and Sam wanted to know what species there were and what the growing suggestions were as he wanted to develop a plot. There is no answer from Dr. Crawford in Sam's voluminous files. In the same year, in various letters to friends, Sam decried the British government policy of buying wheat from Argentina, in preference to Canada.

In July of 1939 Sam put in large orders for lilies and roots from growers in France particularly Vilmorin-Andrieux

et Cie 4, Quai de la Megisserie, Paris. In one order were 100 *vinca minor alba* for 120 francs and 75 Regal lilies, which hopefully arrived before World War II began. He also ordered two ties from Liberty's. They were sent by registered mail for which the total bill was 5/6. The ties were 2/6 each.

In his capacity as director of the Homer Watson Art Gallery at Doon, Ross Hamilton acquired a sketch he called Walker-Watson. He told Sam that he would sell it at the same price as the Watson sketches Sam had purchased earlier from Phoebe, $40.00. Sam asked various people to comment, some declaring it Horatio Walker and others Homer Watson. Sam felt it was a Walker mainly because it had small figures in it which was not Watson's style. After a two year cogitation Sam agreed to acquire it in 1941. The sketch is entitled *Landscape At Doon*.

In another letter to Ross Hamilton, Sam wrote that he had been offered a couple of Krieghoffs, signed A. Gifford 1872 and 1873, said to be a Canadian. The offer to sell came from the Douthitt Gallery, 9 East 57th St., New York with the suggestion that Krieghoff painted under the name of Gifford. Sam wrote:

> *"I do not think they are as good as Krieghoff's. As a matter of fact they look pretty awful but the colour might give them some charm. Do you know anything about this A. Gifford?"*

Sam was beginning to feel a mite targetted by dealers with whom he had not had any contact, but he put it down to a growing reputation as a serious collector of discernment and taste. No other acquisitions were documented for the remainder of 1939. Perhaps Sam's time was taken up with politics. There was considerable speculation that he would be voted upon to run in East Middlesex as a National Conservative candidate. However, the ex-mayor and Sam's friend, T.F. Kingsmill, became the candidate in March. Sam acted as his official agent, a time consuming activity for the Liberal-Conservative Association of East Middlesex, which was really the Conservative Party. As Sam wrote to the Association, he did not feel comfortable running in what was primarily a rural riding. He felt that a rural resident would have a better chance of winning.

Sam's announcement that he himself would not run was carried in the *London Free Press*. "When I declared my intention of standing in East Middlesex, it was my plan to discuss our domestic troubles and some of the obvious remedies which neither political party has had the courage to effect. The war came after that. All our national effort must be given to winning the war. I feel that it is not the time to talk about other things. For that reason I will not be a candidate in the present election."

8 THE EARLY YEARS OF WAR

EARLY IN 1940, SAM WAS ELECTED TRUSTEE OF THE MIDDLESEX LAW Society. After studying the charters of the benevolent societies for both New York State and the United Kingdom, Sam pressed for something similar for the Law Society of Upper Canada. In April of that year, he joined the Arts and Letters Club of Toronto as a non-resident, proposed by D.M. Goudy and seconded by Judge Frank Denton. While not often able to make use of the club, he apparently found it a congenial spot and it doubtless pleased him to make the acquaintance of many leaders of the artistic community on a convivial level. As a new and young member at the time, Raymond Peringer, now the club archivist, remembers Sam after a long and pleasant evening motioning imperiously to him and saying in no uncertain terms, "Boy, get me a cab." Done to the amusement of all present, it must be recorded, at Sam's expense.

As soon as Britain and Canada, had declared war in 1939, Ruth had become active in the Sunnyside Red Cross Volunteers and became Director in June of 1940. Even though Paul had repulsed any overtures from his family at this time, she prevailed upon Wilbur to try to locate him. After much sleuthing he was successful and Ruth duly reported to Sam that Paul was working on a ship called the *S.S. West Irmo*, American West African Line sailing out of unknown African ports to New York. She also asked Sam at the same time to do a

little Christmas shopping for her. "Would you be good enough to buy a little medicinal liquor for Martha. It is so good for colds. I have forgotten the price of that Canadian bottle of Scotch." Apparently Sam had asked Wilbur to attend a sale of small items [not identified], but Ruth wrote that he had been unable to do so. In another letter, in response to one of Sam's to her, Ruth suggested that Sam should consult a Dr. Fitzgerald, a distant cousin practising in New York, for his eye troubles. She commented on his mentions of discouragement, "You are alone too much."

Still toying with the idea of acquiring a summer retreat in Quebec, Sam wrote to the Hydrographic Survey in Ottawa for maps of Ile d'Orleans. The maps arrived with a letter signed by an employee of the department asking him, "not to make it public for the duration of the war." So much for the department's understanding of wartime security.

The following year the tax rolls showed G.S. Weir M.D., owner of two lots of vacant land with Martha, spinster and Sam, barrister, as owners of the house and lot at 139 Oxford Street West. Paul had been officially dropped from the family roster. Sam and Martha apparently wanted to make sure that their roof should not be subjected to seizure for tax delinquency, but they gave George Sutton the satisfaction of owning some land in his own name. Sam's interest in the land took many forms. At the side of his office building on Dundas Street, a parcel of land belonging to the Cathedral of the Anglican Church was left unweeded and forlorn. Sam sent $50.00 to the Dean toward making it into a garden, "Which I hope to enjoy someday." He wrote friendly chatty letters to seedhouses far and wide with his requests, requests which reflected his vast reading and great and informed interest in horticulture.

Matters in the office were sometimes delayed by Sam's health problems. Yet another of the heavy chest colds which plagued him all his life kept him in bed for some days in the fall of 1940. On November 15, he wrote to a legatee, irate at not having a speedy disposition of a will, that he was "just now getting to the office part time." Sam dreaded the winter months in London and made every effort to get to the warmth of the south. A notebook from the 40s lists hotels, restaurants, favourite shops and many names of friends, ladies in New Orleans, Nassau, London, England and so on, souvenirs of his travels.

Just before Christmas, on December 20, 1940, Kenneth Forbes, whose portrait of Sam hangs in the entrance hall of River Brink, wrote thanking him for hospitality while in London and also for a commission received involving a portrait for which Sam had been the mediator. Sam was a fervent and consistent supporter of Forbes work and, through his New York

connections with Ruth and her gallery, continued to obtain many a commission for him in the Eastern United States.

Although Sam campaigned hard and received a good measure of support from out-of-towners, he was not elected as a Bencher in the 1941 election. He wrote a note for a letter he dispatched to the Law Society of Upper Canada: "Most of the benchers occupied as counsel, most members of the profession occupied as solicitors. Problems of the day are mostly concerned with the work of solicitors." He wrote other letters showing his concern with the legality of the professional status of solicitors fully employed by trust companies. "Are they really solicitors in this case?" he asked. Details of law captured his attention. Noticing that the form for wills to be used by military personnel did not include space for an executor, Sam wrote to the Department of the Judge Advocate General pointing out the oversight. It was corrected promptly.

9 THE WAR AND SAM'S DEEPENING CONCERN FOR HIS FATHER

AS THE WAR DEEPENED IN INTENSITY, SAM BUSIED HIMSELF MORE AND more with his pursuits, horticultural and otherwise. He joined the Royal Horticultural Society, bought seeds in abundance, all of which seemed to have arrived safely and in due course despite the U-boat harassment in the Atlantic. As well, he had three oriental carpets dispatched from Liberty's on approval and decided to buy five Persian carpets for a total bill of £24.18.0. To a friend in Montreal he wrote that he would be glad if he would call on Mrs. James Weir and her boy and incidentally "you can get into the residence of Sir William Van Horne by telephoning Vincent Whipple to view his wonderful paintings." It would seem that Sam had already availed himself of the privilege and was offering his name as an introduction for the friend.

From December of 1941, George Sutton indicated his anxiousness to attend the Detroit Conference of the Evangelical Methodist Church being held in Flint, Michigan the following June. Ruth and Sam arranged between them that Sam should accompany his father, which he did. As the oldest delegate present at 83 years of age, George Sutton claimed to be hale and hearty. However, not long afterward Sam attended church one Sunday in London without his father. George had succumbed to another one of those painful ulcerous attacks and was suffering intensely. The preacher,

George Sutton Weir ten years before his death in 1944,
as sketched by Barthé.

upon observing only Sam in the accustomed pew of the Weirs, made an unflattering observation about the absence of Brother Weir who was obviously lacking in his Christian duty. Knowing how ill and in what pain his father really was, Sam got up and left the church vowing never to return.

George Sutton's health continued to deteriorate and was the cause of great concern to both Ruth and Sam. Their letters indicate that they traded accounts of their father's various symptoms and he seems to have been somewhat obstinate about seeking another doctor's advice. After all, wasn't this the whole purpose of his studying medicine himself, to diagnose his pains where others were baffled? If he couldn't heal himself, who could, the old gentleman reasoned. Sam wrote to his father in New York advising strongly against dosing himself with benzedrine sulphate. Consult with doctors first, Sam begged him. In the meantime, George was overdue on his property taxes again and Sam had to come riding to the rescue once more.

Sam joined the Royal Society of Arts, an organization whose aim was to encourage artistic standards of quality in British manufacturing and to promote such products abroad. In his application form to join, he listed himself as a member of the Canadian Bar Association, a King's Counsellor, serving on a committee respecting Administrative Tribunals and Law

Reform and also as an associate member of the Association of the Bar of New York City. He gave as his interests outside the profession, "Largely in the arts: Member of the Council of the Architectural Conservancy of Ontario: physical exercise: gardening."

Sam also tried to enlist in the Royal Canadian Naval Volunteer Reserve, not on active service since he was considered too old for that, but in a legal capacity. However he was identified as over age for that branch of the service also. His lifelong struggle with colds and pneumonia and a heart condition which had concerned Ruth when he was a child undoubtedly contributed to his rejection. He then applied to the Civil Service Commission and the Department of Labour to serve in a wartime capacity. Rejected by the Armed Forces, Sam was anxious to serve his country in some other capacity.

His collection of books and works of art continued. Many letters to Sol Weinroth, the rare book dealer, indicate that Sam alerted Weinroth to be on the lookout for specific works that he wanted and also to apprise him of anything in his area which might be of interest. At the same time he was shopping around for etchings, prints and paintings. There is a receipted bill from T. Eaton Co. for *Landscape* by Kinnear, $75.00 less 25%, dated May 2, 1941. Sam had a habit of accepting works on consignment and then holding them for lengthy periods to the anguish and annoyance of dealers and owners alike. The Kinnear appears not to be in the Collection. Perhaps he traded it up for something he really wanted. Invariably, Sam pleaded ill health and vacations for his neglect in making up his mind about the consignments, but he continued to correspond with and to befriend the artists whose work he admired. He received a Happy New Year card from Phoebe Watson, hand painted, presumably by Phoebe. It is presently in the Weir Collection in the Ontario Archives in Toronto.

Ruth and Sam regularly ordered items not available in their own countries due to wartime trade restrictions and had George Sutton act as their faithful courier when Sam was not going to New York on legal business for his clients. Rather unusually, Ruth bought Sam a 14" x 18" watercolour *Fishing Shack On Green Lake* by George Lockridge, a Canadian, who, according to Ruth, had exhibited at the Toronto Art Gallery, the Metropolitan Museum of Art and the Chicago Art Institute. "Certainly lots for the money," was her comment. She paid $2.98 for it. It also is not listed in the Weir Collection. Perhaps Sam used it for barter as he frequently did to raise the importance of his collection or he may have given it away to a client.

He wrote to Madame Suzor-Coté telling her that he wished to buy drawings by her husband for $50.00 each. He suggested dealers in London who might help the widow

dispose of works. Sam was also in communication with the Cellini Bronze Works in New York to produce bronzes of all of Suzor-Coté's works as he wanted to own an example of every one of the sculptor's works. Madame Suzor-Coté was happy to co-operate provided she received a casting of each one. It was the Cellini Bronze Works that would cast the Barthé sculpture of the head of George Sutton, presented to Western University by Sam and Ruth to celebrate their father as one of the first graduates in medicine.

"There is an old Scotch painting given to me by a client for a small sketch by Homer Watson similar to the large Watson," Sam wrote to Ruth, April 20, 1942. "Martha is much taken with it." In the same year Sam picked up three unnamed Clarence Gagnon etchings and from Mrs. Newton MacTavish, in a private sale, a painting by John Russell, *Shrimping at Dieppe*. He also acquired a colour lithograph over the signatures of E.B. and E.C. Kellogg of *The Niagara Suspension Bridge*. This last he purchased from a sale of the University of Western Ontario library of discarded nineteenth century materials.

Starting in 1942 and continuing for six years off and on, Sam was in touch with Lorne Pierce of Ryerson Press, concerning a book for the *Canadian Artist Series* of Ryerson Press on both Homer Watson and Suzor-Coté. Pierce wrote back to Sam that he would have to defer a book on Homer Watson, but

that he wanted to see what Sam could produce on Suzor-Coté. By 1948, when nothing had materialized, it was agreed that Sam and Ross Hamilton would co-operate, but again nothing came of the idea.

Throughout 1942 George Sutton's health and increasing fragility were a major concern to both Sam and Ruth. He was stricken with pneumonia while staying with Ruth, who then nursed him. At the same time both the Weir and the Howell households were coping with wartime measures and restraints. Martha tried to help Sam find a new housekeeper and Wilbur, needing a new typewriter, turned to Sam as they were alleged to be easier to locate in Canada than in the U.S. Sam regularly ordered household items, even ash trays, from New York department stores, B. Altman was a favourite, to be sent to Ruth's home. As Sam often arranged for articles to be brought across the border by his father, the brother and sister would get into complicated arrangements of figuring out who owed what to whom.

Sam also went on a buying spree over the year, 1943, with thirty-nine separate art works being acquired. Thirty-seven of these were separate etchings, aquatints, prints and lithographs depicting scenes in Canada, Canada West and Quebec. It was a brilliant area for him in which to specialize. During this period there was very little interest in old etchings

and prints and especially in those showing scenes of Canada, a rather remote place with a lot of trees to most English collectors. Some of his purchases were acquired in sets of five or six related subjects and Sam gleefully bought the works. Cartons of books were dispatched from Britain and Sam negotiated with many private owners in the United Kingdom for old sterling silver pieces (he particularly liked Georgian pieces), family things that were being offered for sale during the war. Of the many letters Sam wrote to Maggs Brothers, the renowned book sellers in Cavendish Square and by appointment to various European royals, one written in 1943 talks of "my hobby of collecting Canadian things." It seems remarkable, almost miraculous, that none of the many works ordered from England by Sam during the war years was subjected to loss by enemy activity.

At a time when prints and etchings of old Canadian scenes were not an attraction even to the majority of Canadian collectors, Sam had the field more or less to himself. It was in the forties that he laid the foundation of the great historic significance of the collection at River Brink. Fortunately when art historians of a later date came to value this aspect of the history of our country, a permanent collection of great importance had already been put in place. Naturally when Sam acquired these works the prices were the merest fractions of their current worth. Following the outbreak of respect for Canada's heritage, which would receive much scrutiny in 1967 during the Centennial of Confederation, the prices increased as their rarity and their importance became recognized.

In 1943 Sam also acquired an oil by Horatio Walker *Auto Portrait, 1900* and a drawing, *Child's Head, 1902* from Olive Perry, a niece of Walker's. He also bought a few reproductions of portraits, a mezzotint, published 1772 by Richard Houston, *The Death of General Wolfe* and an engraving of a *Portrait of General Townsend* by Miller for $1.00. He also purchased a *Portrait of Brigadier Robert Monckton*. Townsend was Wolfe's second in command at the Battle of the Plains of Abraham after Brigadier Monckton was wounded. Monckton, who had assumed command upon the death of Wolfe, was to recover from his wound. Sam also acquired an engraving by Simon François Ravenet, as well as a print by Ridley, of *Admiral Boscawen*, together with a one line engraving of *General and Rt. Hon. Jeffery Amherst, Who In A Combined Effort Captured The French Fortress Of Louisburg In 1758*. A mezzotint *Portrait of The Earl Of Durham*, published in 1838 by C.E. Wagstaff after Lawrence was obtained. As well, two other engravings after portraits of *General Benedict Arnold*, the American general who planned to deliver West Point to the British in 1780 and of *Rt. Hon. Isaac Barre* who had taken part under Wolfe in the battle of 1759, both by artists

105

unknown, also were added to Sam's collection.

In a sale Sam attended in Toronto around the same time, he picked up several engravings of cityscapes in Ontario, dating from the nineteenth century. He donated a couple depicting *Toronto Canada West, The Waterfront*, to the University of Toronto and those of interest to Londoners to the University of Western Ontario. There is no record of a letter of thanks from either institution although Sam kept such correspondence with care. Anything of Niagara Falls he kept for the house *cum* gallery at Queenston which was beginning to take shape in his mind.

On December 21, 1943, Sam wrote to Melvin MacDonald of the Ontario Forestry Station in St. Williams to tell him he had bought the small plot of land in Queenston which eventually would become River Brink. He was still hankering for a farm where he could become a dairy farmer raising Jersey cows, but he felt he would have to postpone that until after the war. He relied on MacDonald for advice on his planting of trees which he wanted to do as soon as possible.

Not unexpectedly, George Sutton's health was declining steadily. Ruth wanted to send him to London after the summer, but only by December 10 was the gas furnace working properly again. Before that date Sam felt that the house would be too chilly for the elderly man. Consequently,

Sam and Martha went to spend Christmas holidays in New York and it was arranged that Sam would bring his father back to London afterward. In the meantime Sam had business in New York on behalf of Kenneth Forbes who wanted to start an action against a man named Salomon, in respect of Forbes' portrait of Mrs. Salomon done in 1937, for which Forbes had not been paid.

Sam's art interests were accelerating at the same time and he took much pleasure in browsing in the more celebrated antiquarian book and print shops in the city and getting to chat with and hence know the various owners. He already had purchased a Krieghoff colour lithograph and a colour aquatint of Queenston, *The Landing Between Lake Ontario and Lake Erie* by an unknown, which must have given him a great deal of pleasure as it tied in with what he was planning, a house in the Niagara area containing an historical record of the site. As well Sam had acquired a John Harris print (after Lady Alexander) *Grand Military Steeple Chase in London, Canada West, May 9, 1843* and two Lucius O'Brien watercolours, *Mountain River* and *Sea Shore*.

It would not be until spring that George Sutton was well enough to travel back to London and even then he was in constant pain. After days and nights of personal care from his son, necessitating Sam's absence from the office, George Sutton died on August 16, 1944 and was buried in Mount Pleasant

Cemetery in London.

Once more Paul's rejection of his family created a difficulty for Sam and Ruth. There were inheritances, small it is true, but rightfully Paul's. He along with his siblings was a beneficiary of a life insurance policy that George Sutton had taken out around 1922. Both Sam and Ruth went to several sources, The Seamen's Institute for one, to ascertain where to send a number of cheques that had accumulated since Sarah's death. Paul had refused even to open letters sent by Ruth. On March 25, 1945, Sam wrote to Paul under the cover of the New York Life Insurance Company for Paul's address. It was a friendly conciliatory letter, reminding Paul that Mother had been dead for ten years and that Father had died last August. "Ruth is unwell, Martha is not in the best of health, as they both have high blood pressure. How are you? (signed) Ted." There was no response from Paul.

10 TAXES AND THE LITTLE MAN

HAVING ACQUIRED A NUMBER OF PORTRAITS OF HISTORICAL FIGURES THE preceding year, Sam was keen to build his library. In particular he sought out and purchased a great many books on history and on historical accounts written about travels in British North America, as well as maps. Canada West, Upper Canada and the Niagara area were the foci of his interest. His library collection was definitely taking shape. As avid as he was to collect rare old volumes, he was insistent that they be in excellent condition. He corresponded at great length with all dealers and private owners to make sure that each volume was in a condition as near to mint as possible.

Paying taxes on paintings and books repatriated to Canada irked Sam, as indeed paying any sort of tax irked him. Perhaps it was an unconscious throwback to his father's cavalier attitude to his realty taxes. He wrote on the subject to the Rt. Hon. W.S. Mackenzie King, the prime minister, as well as to cabinet ministers, including the Hon. James Lorimer Ilsley, Minister of Finance with responsibility for directing Canada's support for World War II and now remembered chiefly for *The Ilsely Report* of 1957 on Copyright Law. As a one man lobbyist Sam set up a convincing argument and he did it relentlessly to, alas, no avail in the immediate future.

After his splurge in the art world in 1943, only five works are documented as joining the collection the following

year. A colour lithograph by Day & Haghe (after Beaufroy) was bought through T.W. Jones of the Clark Galleries in Toronto, from Maggs Bros. in London, England. A letter from Maggs wishes the lithograph safe travelling. It had been mailed in the midst of the terrifying buzz bombs. More importantly, Sam acquired the *Self Portrait* by Paul Kane and two versions by the celebrated Canadian sculptor, R. Tait McKenzie, of *The Sprinter*, one in bronze and one in plaster. Sam also ordered a third casting of Barthé's bust of George Sutton Weir to be presented to the University of Western Ontario.

In the last year of the war, Sam acquired eleven prints and sets of prints. One find was a set of seven Bartlett prints, four concerning the Niagara region and two of Toronto for $1.00 each. He also acquired four lithographs after Krieghoff and an etching, *Osgoode Hall*, by Owen Staples.

Throughout the war years and for some few years afterward, Sam's dealings with a number of book sellers was erratic to say the least. He took books in lots of consignment, declined parts of the lots, failed to pay for those he wanted to keep, and was negligent in returning those he did not wish to keep. As well he complained about the condition of books constantly. The booksellers of Ontario and New York State were driven to distraction. There are peremptory requests for the return of all books shipped in a single order, months and

even years after the shipping date. A few were outspoken in promising never to do any business with him in future. Sam usually paid up to these demands, but always insisted that books, no matter how old, be in mint condition, a difficult undertaking for an antiquarian book dealer. On the other hand, his dealings with Maggs Bros. in England always seemed to be cheerful and prompt. It does rather seem that the more prestigious the house, the more promptly did Sam settle the bill.

Perhaps remembering that horseback riding had been of help to him in past years in his constant wish to lose weight and to better his health, Sam wrote for a price list from an outfitter, Alkit, in England, for riding habits and accouterments, but he does not seem to have followed it up. If he were to take up horsemanship again, at least he would be dressed impeccably.

When Sol Weinroth had to appear in court before Magistrate Tupper Bigelow, to answer a charge of keeping a second hand book store in an area on Yonge Street designated as a no second hand stores district, Sam, and others, came to Mr. Weinroth's defense. Professor C.T. Currelly of the Royal Ontario Museum of Archaeology; Professor A.D. DeLury, Dean of University College; Professor E.A. Dale and Professor F.W. Banting, later Sir Frederick Banting, were all ready and present

110

The Sprinter, in bronze, by the exceptional Canadian sculptor, R. Tait McKenzie, originally of Almonte, Ontario.

to testify. Each had acquired scholarly and valuable books from Mr. Weinroth.

The charge hinged on a $2.00 license which City Hall claimed Weinroth required to operate a second hand store which, had he taken it out, would have automatically barred him from that area of Yonge Street because of the city by-laws prohibiting second hand stores on certain sections of the street, a catch 22 situation. Sam came in from London riding high in a just cause, for, as he put it, the pleasure of defending Weinroth.

Sam began by submitting to the court: "The police commission by-law which defined second hand goods to include waste paper, rags, bones, bottles, bicycles, automobile tires, old metal and scrap material and junk...," according to the *Toronto Daily Star* of March 1, 1945. The report continued;

"Mr. Weir handed Constable Tom Bradley an old book, 'What is that?' he asked. 'It's a second hand book,' said Bradley.

Magistrate Bigelow examined the old book, *Tracts 1653-1660* and believed to be by John Milton while he was secretary to Oliver Cromwell.

'It's value,' said Mr. Weir, 'cannot be estimated.' Magistrate Bigelow then

pronounced that he had no hesitation in defining antiquarian books as works of art and antiques within the meaning of the law."

The distinguished academics were not required to testify.

Had Mr. Weinroth had the means to furnish his book shop with expensive carpeting, mahogany glass fronted book cases and appropriate club chairs for browsers, the charge would never have been laid, but many of the contents of the shop as Sam had pointed out were inestimable in value. "Let no one sneer at a second hand book that is worth hundreds of dollars," Sam was quoted as having said in the *Globe and Mail* of January 26, 1945. It was a celebrated case in the last months of the war and a welcome and a comic relief from the dark news from overseas. Mr. Weinroth thanked Sam by sending him a line engraving of *Sir John A. MacDonald* by B. Haste, 1891, now in the collection.

In November of 1945, Sam wrote again to Mackenzie King regarding the taxation that Sam hated so much, on importing works of art. "You used to visit the late Homer Watson," he wrote. "I used to hear about your interest in paintings etc. The best source of supply for engravings and prints of early Canada is London or New York. Why do we have to pay tax to repatriate our own artifacts?"

Very shortly after World War II ended, Sam reasoned

that there would be a demand for new housing and accordingly he initiated the first housing development company in the city of London, the Housing Development Services Limited, and he acted for Precision Built Homes, an American company. In an excellent position to provide mortgages because of his long association with Sun Life, he also embarked on construction legal work. His closest friend at Sun Life, H.B. Smythe, had been moved to the company's offices in Montreal, and Sam and Smythe's successor were not in sympathy. Sam had enjoyed an arrangement of exclusivity when Smythe was in charge and he never got used to sharing legal fees on mortgages with other members of the Middlesex law fraternity. In fact, when other lawyers were brought in to do mortgaging legal work, Sam was incensed. He wrote to Smythe complaining that his successor had brought in a lawyer in particular whose wife was a close crony of the successor's wife. The situation was not resolved amicably. Sharing the workload was not to Sam's taste even though there was a great deal more work to share.

By summer's end Sam was planning to drive to New York with Kenneth Forbes, but as he wrote to Forbes, he was "trying to get a car – no success – and the old one is so moody that it isn't safe to start a trip." Automobiles were hard to come by for some time after the war ended while factories scrambled to re-tool from war to peace. Many correspondences between Sam and Kenneth Forbes indicate that Sam spent long hours he could ill afford continually trying to procure portrait commissions for Forbes.

All faculties at the University of Toronto were anticipating an influx of servicemen students under the grants obtainable from the Department of Veterans Affairs. With his twenty five years of experience as a barrister and solicitor, Sam still longed for an LL.B. Accordingly he wrote to F.E. LaBrie, the Secretary of the Faculty of Law, University of Toronto, indicating his desire to become a part time student and in the shortest possible time be eligible for the degree. The reply, dated October 2, "...the programme of studies has undergone considerable change since your alleged enrollment. The Faculty Council is doubtful as to whether your rights acquired by enrollment are still maintained..." did not deter Sam. Subsequently he did enroll for a few courses with a view to obtaining the coveted and elusive degree. However, dogged by ill health, difficulties in commuting to Toronto and a greatly increased work load in the office, Sam reluctantly had to withdraw. Nevertheless one of his lecturers was Professor LaBrie who subsequently became a close and greatly cherished friend to the end of his life.

The year following the war only three acquisitions are

documented. In March Sam went to a Memorial Exhibition of Eva Bradshaw in the London Public Library and Art Museum and bought *The Green Kerchief*, which he promptly passed over to Frank Worrall who put a linen backing on it. Sam was becoming more and more dependent on Worrall's advice in restoration and preservation. Through an American dealer Sam also acquired two prints, by unknown artists, one published in 1831, entitled *A Distant View Of The Falls Of Niagara and Rapids And Bridge Above The Falls At Niagara*. There was very little interest in works of this sort at the time and Sam made some judicious purchases. It took many long years before other collectors and curators realized the value of these historically important documents.

Around the same time Sam wanted to acquire an armoire from Paul Gouin who had opened a shop on Sherbrooke Street in Montreal to dispose of his collection. H.V. Baron, the Toronto dealer, then told Sam that Gouin had changed his mind and invited Sam to look over others available in Toronto. He apparently found one to his liking and later the same year, in August, Sam despatched a quantity of furniture from Oxford Street: a sideboard, six chairs, a rocker, desk, leather chair, bed and "an old walnut table that used to be in my room" to an auction house. Clearly there was no emotional tie to the familiar pieces of home. Oxford Street was to be refurnished with the sort of antiques and items of value that Sam felt to be appropriate to his position as a householder of wealth and professional prominence. Sam did not have position in London society.

In the year 1945 Sam despatched a great many letters requesting subscriptions to law reports, and other letters to publishers such as Heritage Press, regarding complete sets of Dickens, Anatole France and so on, the sort of prestige items that would enhance a personal library. Immediately after the end of the war, he subscribed to the *Canadian Jersey Breeder*, an indication of a life long wish to establish a dairy farm as his grandfather had done.

In his enthusiasm for what was becoming the new and popular hobby of photography, with the improvement in cameras and with more precision available to the average user, Sam was determined to become proficient. Accordingly he wrote to the Ilford Films Canadian distributor requesting books and information. Many letters ensued. Sam sent money orders requesting brochures and other goods that he had read about. Finally head office sent back his money and told him rather peremptorily to keep an eye on the local outlet!

11 ACHIEVEMENT, PROMINENCE AND SUCCESS

WRITING IN 1946 TO THE PRESIDENT OF THE MIDDLESEX BAR Association concerning the up-coming election of Benchers, Sam pointed out that while he lost out in 1941, due to "hanky panky," he made it abundantly clear that he did not want "such machinations again." Justifiably or not Sam was deeply suspicious of his peers in London but, finally, in 1946 he was elected to the Benchers.

Always interested in Canadian authors, Sam wrote to Philip Grove in June 1946 to ask him if he would autograph a book. Mrs. Grove replied that her husband had suffered a stroke, but that he would initial the book with his left hand if Sam would bring the book to their home and if her husband were able. Sam, of course, had no idea that Philip Grove although a popular author, was very poor and had resorted to rough manual labour to support his wife and himself.

In September of the same year, Sam wrote to R.M. Willes Chitty K.C. at the *Fortnightly Journal* in Toronto, on the subject of Saturday closing of a law office. "It works well," he wrote, "I have been closing for the last month." But Sam wondered if he could be sued for negligence of duty. Mr. Chitty, as editor of the journal, stated that in his opinion, he could not be sued as there were no regulations covering office hours for the profession. Sam's was the first law office in Ontario to be closed to clients on Saturday, although he went

in to his office and found that day a splendid opportunity to catch up on paper work. One after another of his peers adopted his policy and soon afterward a five days a week of the office open to clients became standard procedure throughout the province.

Immediately following the end of the war, clients sought Sam's professional help in searching out birth certificates for Canadians now domiciled in the United States. With so many American relatives himself, Sam was alert to the problems of transborder residency and the idea of an office in New York became attractive and took shape, an idea that eventually became Weir and Associates, 44 Wall Street, New York. There was a great back log of work immediately following the war's end and Sam, with his usual habit of filing documents wherever and whenever, drove at least one client to distraction over his procrastination in enabling her to take up residence in the United States. He forgot where he had put her birth certificate. Month by month her temper rose, but eventually the certificate turned up in his car, and all ended well, if belatedly.

In January of 1947 Sam sent his cheque to the University of Toronto, once more planning to take lectures within the Faculty of Law in the hopes of gaining that elusive degree. At the same time business was expanding in every area

and Sam needed more office space. His two specialties, insurance and mortgages, were exceptionally fast growing markets. He tried to persuade his landlord, the Canadian Imperial Bank of Commerce, to let him take over more space in their building by flooring over a light well. With the Rental Control Board, still in operation, creating difficulties and the CIBC opposed, the suggestion went nowhere.

Meanwhile, Sam and his younger cousin, Arthur Thompson, were not getting along. Arthur served two terms as alderman while Sam was on the London City Council. He figured he had two votes in that Arthur would vote as Sam directed, but Arthur turned out to be an independent thinker. Eventually the cousins had a falling out and Arthur left London for Walkerton where he established a successful practice.

Another lawyer on staff was needed and Charles B. Kirk arrived most fortuitously on April 2, 1947. He would stay with Sam for four years. Back from overseas, Charlie Kirk decided he wanted to practise outside Toronto. One day he came by train to London, to look around, ran into an army pal and went with him for a beer at the Hotel London. There they met another veteran pal who told him Sam Weir was always complaining about his over loaded practice. Kirk called on Sam at once. At the interview, he told Sam he would work for a small salary of $100.00 a month "until you find out my worth."

For two years Sam resisted requests to put Kirk's name on the door, on letterhead or on an additional shingle. Sam was adamant about Weir and Associates listing no names as associates. Kirk naturally wanted a share of the fees gained from his own friends, as well as recognition. Ultimately Charles left the firm, but remained in London. He recalls that Sam gave all sorts of advice *gratis* to wealthy clients, "But a widow would get soaked...he was a master at making up a bill." As a bachelor Kirk was invited out to the house where Martha was frequently present. "She kept him in order," he remembers.

Socially Kirk recalls that Sam was very unsure of himself, but quite the opposite professionally. "He was a very lonely man...had some bad habits...never on time. Sometimes he was a year or so late." Charles remembers that on one occasion he was very nearly fired. He had cleaned up piles of files (which Sam invariably insisted be spelt 'fyles') and organized them into a filing cabinet. "Sam was livid. Everything had to be replaced on the floor."

One day, as Kirk recalls, Sam went downstairs in the Bank of Commerce building to see the manager whose office was directly below Sam's. The manager was talking to a customer. Sam tried to duck away but the customer called out, "When are you going to work on my file?" Sam replied, "It's under my desk where all the important papers are." On

another occasion, Sam sent Kirk to a court to ask for an adjournment for a Weir case. The court clerk groaned and handed the judge the file. It was filled up on both sides with previous adjournments. Sam's clients knew they were in extremely competent hands, but their patience was often sorely tried.

Sam's extensive library impressed Kirk. One day a salesman arrived and gave a pitch for *The Canadian Abridgment*, a thirty volume work. After a lengthy discussion Sam and the salesman, happily thinking he was about to make a sale, went out together to lunch. Being out on the street at four o'clock, Charles ran into the salesman in a most rueful mood. The conversation had centred around sea food restaurants in Montreal, with no book talk and no sale.

Kirk soon got to know of Sam's love of buying books and pictures, (particularly from Marsburg and The Old Authors Farm, now in Upper Canada Village). Sam asked Kirk, "Would you mind if I used your name to order some books?" He agreed. Books arrived, but he did not pick them up for ten days nor did he pay for the shipment. Kirk recalls getting the nastiest letter he ever received after the shipment was returned to sender. One letter began, "To a lawyer and a louse etc, etc."

Recalling Sam's loneliness, Charles Kirk remembers that the younger lawyers couldn't stand him. When Sam was

campaigning for election as a Bencher from Middlesex County, the Middlesex Law Association would not support his candidacy because of his procrastinatory work pattern. However, Sam did persuade twelve lawyers to support his candidacy and a letter went out as though it were supported by the Middlesex Law Association. There was a great furor. The twelve signatees did not realize what Sam would do with their endorsements. Kirk managed to get his name off the letter. "That's how he got in," he recalls. "John Cartwright got the gold medal in graduation that he wanted so desperately. So he was determined to win everything he went in for afterward."

Thinking of his social awkwardness, Kirk recalls the two of them going together to a Bar Convention in Montreal. By Friday evening, Sam wanted to go home and did so. A client and his sister had invited them to a dinner dance, but Sam had never learned to dance. He was too insecure to go to the party and instead pleaded business and having to get back to the office. The client later came to London and Sam went out to dinner with him and his sister who shortly afterward went on a trip to Scotland. Two months later she was married in Scotland. Sam's comment was, "Now why would a nice girl like that want to marry a Scotsman?"

Sam was upset when Kirk married. At the ceremony, Sam sat beside a girl, a friend of the bride's. Apparently he kept muttering to her throughout the ceremony, should he go home and change his pants? With everyone but him in striped trousers, his extreme insecurity was evident. The story came back to Charles through the girls. Again Sam seemed upset when Kirk became a father. Kirk felt really sorry for him, Sam had such a chip on his shoulder. He was approaching fifty and he had begun to think that life had passed him by. Kirk remembers Sam once telling him, "I wish I'd got married earlier." "There was a real persecution complex," he recalls. "If you got on his bad list, he could be very nasty."

Sam was doing all the Sun Life mortgage work until a new manager, Wells, arrived. He had also done much of their legal work. However, Sam and Wells had a falling out which went as far as the head office in Montreal where Sam's old friend, H.B. Smythe, the former manager had been promoted. Their differences were settled after a fashion, but Kirk remembers that he managed to keep out of the firing line and out of firing range.

Sam had few friends in London at this point in his life, "not many and not close," as Kirk recalls. Penny Krull, the daughter of Sam's cousin, Agnes Weir Randolph, recalls Sam arriving somewhat late for a family funeral in Sarnia, bearing a bunch of flowers. What made his offering different from most arranged floral tributes was that Sam obviously had rushed

home and, remembering that flowers are a funeral custom, paused long enough to uproot something out of his garden, roots and all and bung it in the car. The family just shook their heads at that being Sam's way when the flowers, roots, mud and all landed in the front hall of his relatives' home in the midst of the reception.

Kirk recalls a client of Sam's, an elderly prominent citizen in his mid-eighties, a rich widower, driving around with a young girl, a nurse companion. The family tried to have the old gentleman put away in a mental home. Sam was retained to get him out of the place. Sam got a Dr. Shaw, a prominent psychiatrist, to examine the older man and to testify that he was enjoying life and had the money to do it, and that a psychiatric hospital would shorten his life. Soon afterwards, when the man was hospitalized, Sam brought an action of Habeas Corpus. The client in question was examined by two family doctors and Sam tore them to shreds. "A masterful discrediting of the doctors," according to Kirk's recollection and the family got a new lawyer. "Unfortunately Dr. Shaw's prediction came true and the elderly man died before the appeal came to trial. Weir did a great job, he was a good lawyer," is his summary of the case. When Charles Kirk left the firm of Weir and Associates, Sam was merciless. "He could be unpredictable," was Kirk's description of his former associate. Kirk remained on Sam's 'bad list' for some time.

12 THE ART INVESTOR, AVID HORTICULTURALIST AND BUSINESSMAN

ON JUNE 4, 1947, SAM WROTE TO WILBUR THAT HE HAD FOUND A SELF portrait by Mengs, the German eighteenth century painter, and that he could get it for $500.00. "It's about 18 inches square. When you drop into art galleries, ask if there is a market and if I could make a profit."

Niagara and other Canadiana works figure prominently in his 1947 acquisitions: the F.M. Bell-Smith painting *Niagara Falls in Winter* being acquired from Ward Price for $9.00, a print after Bartlett, *Brock Monument*, and a print after Bartlett, *Monument to Wolfe and to Montcalm, Quebec*. Of the eleven arrivals to his collection of that year which are known, the prize, surely must be the Tom Thomson *Sketch for the Jack Pine*, the studio painting of which is in the collection of the National Gallery in Ottawa. He also acquired Tom Thomson's *Northern Woods*, Frank Hennessey's *Snowland, Lake of the Woods*, miscellaneous prints of Hornyansky and two etchings of George Agnew Reid: *Pioneer Ploughing* and *Red Pines, Lowell Lake*. From Parke Bernet he bought *Portrait Sketch of Counsellor John Dunn*, by either Gilbert or Jane Stuart and a print after Bartlett of *Brock's Monument*, the old one, destroyed in 1840.

By November of 1947, Sam wrote to Dr. Caz to tell him that Gavin Henderson had a gallery on Grenville Street in Toronto and had expressed interest in the Rodin drawings owned by Caz, telling Sam he might sell some in Toronto. About the same time, Sam wrote to Ruth that Martha had been advised

119

to have all her teeth out. Sam's comment was, "In my opinion we have a hereditary nervous weakness and all these medical theories are of no importance...Even losing one tooth is a sorry parting in my experience."

Only six purchases of art are known for certain in 1948. A portrait of *Major General Wolfe* by Richard Purcell entered the collection at this time as well as a good selection of etchings, some in sets of the Niagara region and of Upper Canada. However, statements from Maggs Bros. in the book buying area were increasing steadily as the library was being established. Frank, then his son, John Maggs, frequently went to auctions in London to bid on Sam's instructions and on his behalf. But if an offering fetched a price either one thought too high or if the quality was not of the first rank, they declined to bid for him.

In his continuing quest for fairness he had written to F.H. Brown, Deputy Minister of Taxation, on his old letterhead of S.E. Weir K.C. and A.C. Thompson, pointing out that interest was not paid to taxpayers on overpayments of income tax, but that interest was charged on tax arrears and also that the heavy rate of taxation was a burden on low income taxpayers. As indicated earlier, Sam hated income tax mightily, or any other tax for that matter. Eventually the Department of Internal Revenue did alter matters so that overpayments were subject to interest payment by the Department. Perhaps this and subsequent letters of Sam's

did have some influence.

Sam was well known for his impulsive generosity. When the Dublin Gate Players came to London in January of 1948, after enjoying a performance or two and arranging a dinner for them, Sam sent them a bushel of apples, grown by an Irishman, for which they were most appreciative. He had been given the apples by a client.

Later that year at the inaugural meeting of the Architectural Conservancy Association, Sam was invited to be present. It was a black tie affair. Since Arthur Nutter might well be in town, Sam wrote to Harold Walker, in charge of the affair, indicating that he might bring him. "I don't suppose he will have a dinner jacket with him and in that case I will support him by forgetting my own." Perhaps Sam had memories of Kirk's wedding. It was a typical gesture of Sam's to give such thought and care to another and an indication of how important it was to him to be seen as knowing the right way to be attired on all occasions, a throwback to the raggedy days and experiences of 'Little Monkey' once again.

In his still ongoing pursuit of gaining authority to practise law in New York State, Sam wrote to the New York Bar Association that he was, "Honorary Advisory Counsel to Judge Advocate General of Canada." At the end of the year, Sam wrote to his friend Paul Berman in Baltimore, ..."Up and down to

Toronto each week to take lectures on taxation, labour law, administrative law and things of that nature which have developed since I graduated. Mr. Farber once made me a proposal to practise in Baltimore. I think it would have been nice." There was more than a little nostalgia in the letter, Sam at fifty years of age still pursuing that elusive LL.B. and with a wistful look back over his shoulder at a chance to get out of London once and for all not taken. A few months later, Sam wrote again to Berman, "I hope you don't get such a deep feeling of futility as comes to me from time to time. It just seems to me that I have no control over my own life." His health had not been good over the past year. A severe ear infection and the recurring bouts of heavy colds and pneumonia had troubled him and had contributed to his melancholia and his loneliness, and it was thought that he suffered a mild heart attack which frightened him considerably.

Arthur Nutter, the architect who had spent much time with the Weir family before going to Florida to live, wrote to Sam from Houston, Texas, "Paul visited me in Houston on April 12, 1930. I looked it up to be sure. I had an idea it was more recently than that. He was in good health." Sam sent the news, stale as it was, to Ruth. They both were still interested in tracking down Paul's whereabouts. Nutter also wrote that he had hatched up some plan for the Niagara lot, that planting some willows on the bank was needed and that he would work on a route cut down to the water's edge and get a few piles driven for a dock, an idea that was scrapped.

The previous year Sam had started negotiations to acquire the site of the Catholic Records Building on Dufferin Street. Characteristically in Sam's affairs, after a minor controversy, he was successful. For the site, Sam had in mind a building which would be a local trust company operated by and for the citizens of London. He reasoned that such a locally owned organization was both needed and desirable and that it could be financially profitable. Accordingly he approached his old friend Tom Kingsmill and the Baldwin brothers, Bill and Bentley, as well as a few others. It took several months of planning, but eventually District Trust was the result.

According to Bill (W.P.C.) Baldwin's recollection, the small founding group bought slightly over 40 per cent of the outstanding stock and figured that it would give them control. The group and their friends invested the amount without any trouble. Unfortunately things did not go quite as planned. They needed an underwriter to come up with the rest of the required capital. A group outside London bought a 40 per cent block from the underwriters who did not inform the original founders, with the result that they effectively lost control. One such shareholder, according to Bill Baldwin "worked with an employee, made trouble and was subsequently arrested, and jailed. District Trust

started off well, but shares were sold and there were stories in the papers that hurt the company." Sam and the Baldwin brothers kept their shares even though they were not worth much. Sam later sold almost all his shares in the Trust Company, but remained the landlord under the original leasing agreement.

Bill Baldwin remembers Sam as a good lawyer, very astute, and a character. "He worked alone, was never able to delegate. He always had to run the ship alone." There was a problem under Sam's chairmanship of District Trust as Baldwin remembered it. Sam wanted to do all the legal work, to draw up the mortgages and control the legal work in its entirety. When buyers wanted to use their own lawyers, there was conflict. He didn't seem to have close friends in the community, according to Baldwin and could make very cutting statements about people. Although the Baldwins, Tom Kingsmill and Sam were all of the opinion that there was space for a small London owned and financed trust company, Sam was drawn to the concept out of some bitterness in his thinking that Ontario Loan Corporation and Canada Trust had not given him his share of business over the years.

Sam had urged the Baldwin brothers to "brighten up their offices," with paintings, perhaps start a collection of paintings related to textiles, but the Baldwins, in the business of manufacturing work clothes, felt they had no money for such a

project. Sam, however, could be impulsively generous according to Bill Baldwin and once gave him a hand cut crystal vase about 40 centimetres high, along with a story of its creation now forgotten.

By now the two empty lots adjoining the family home on Oxford Street, that had been held in the name of George Sutton as owner, had been sold by Sam who then became the mortgagee of both properties. In a handwritten note he indicated that he was glad and relieved to be rid of lots 34 and 35. There were so many unhappy memories for Sam in the disputes he and his father had had over landscaping as well as childhood memories of his mother's extreme tiredness, yet still having to milk the cow. The properties must have brought back recollections of Paul, tending his chickens, working in the garden in long ago and happier days. Now he was rid of the extra land and could concentrate on the flowers that he loved with no interference from anyone. He wrote to the Royal Horticultural Society to subscribe to the Society's publications and to acquire a complete set of all their transactions from the outset of the series. Sam corresponded with many members and traded seeds and plants. His enthusiasm for exotics was as great as any of the rabidly enthusiastic English gardeners and horticulturists.

Plants and seeds were ordered in profusion all year long from well over two dozen seed suppliers, principally in England and the United States. The rarity of a plant had the same effect on

Sam as a rare painting. He corresponded with like minded enthusiasts through the Royal Horticultural Society, specialists in such areas as orchids native to North America. From the Arnold Arboretum in Cambridge, Massachusetts, to collectors of exotic plants in England, Sam wrote to many a friend in high glee that he had acquired very special seeds of a tree native to China, a survivor of the last glacial age from paleontological time, "a bit like the larch, sheds its leaves." Apparently an expedition had gone from Cambridge to China and, with the help of a Chinese student at the Arboretum, had acquired the seeds which had been distributed to only a chosen few. Sam was mightily pleased with his rarity and in a time when there was no diplomatic exchange between the two countries, it was a coup indeed. Alas, no stock survives.

Still in the midst of post war expansion, Sam was trying to increase his staff. He was looking for a current graduate. "I am old fashioned enough," he wrote to Arthur A. Macdonald K.C. on June 21, "to pay some attention to examination results. There are so many people in this profession without the necessary ability for it that I am anxious to get somebody that has some mental equipment." He was now doing insurance and mortgage legal work intensively for both Sun Life and Confederation Life.

In the summer, Martha and Aunt Eva Thompson, together with Sam, drove to Cape Croker to search for Reverend Henry Bawtenheimer's grave. Ruth was invited to join them but apparently declined. Sam suggested that he motor to the Bar Convention in Montreal and then drive on with Ruth to New York. In his growing interest in his roots, he was also planning a trip to Ireland both to drum up business in the shape of encouraging money to be lent to his Canadian mortgagors as well as doing some genealogical research. Intensely proud of his Irish heritage, Sam regularly ordered bolts of Irish tweeds direct from the weavers in Dublin and had them delivered to his tailor in London.

Sam maintained a close friendship with Ross Hamilton who by now had bought the Homer Watson home and was promoting it as an art centre *cum* memorial to Watson. Hamilton also introduced Sam to an attractive war widow, but his matchmaking did not end in a wedding. Sam and the lady retained a warm but platonic relationship to the end of his life. Ross Hamilton had been negotiating with Lorne Pierce, the editor of Ryerson Press to write a monograph on Homer Watson for *The Canadian Artist Series*. After Pierce had shown an interest in Hamilton's proposal, Sam wrote to Pierce on March 18, 1948, "I have perhaps a great deal more material on Suzor-Coté than anyone else. I have spent a week at Arthabaska, visiting the Coté family and had many long conversations with Arthur Coté who has since died." These conversations had been taped and Sam had also acquired Arthur Coté's scrapbooks. He

had plans and high hopes on writing for the *Series* himself, plans which did not materialize.

As usual when Sam became interested in anything, he wanted to acquire both knowledge of the subject and the best of the best equipment necessary, be it books or, in 1948, fishing gear. His friend, Mr. Justice Robert Irvine Ferguson of the Ontario High Court of Justice persuaded him to go up to his summer place and 'drop a line.' Sam took to the sport with gusto and ordered a complete line of equipment from Gimbel's but never managed to use it.

In July he had a special invitation to the Annual General Meeting of the Canadian Bar Association which pleased him very much. "You became a member in February of 1922 and that you have kept your membership, there are few left who joined in the early years," the invitation read. It is not known whether or not he attended.

On September 26, 1949, Sam wrote to the Department of Fine Arts, Yale University.

"Dear Sirs:

Some years ago when I was visiting Yale University I saw a statue in the hall of the building devoted to architecture or fine arts. This was marked, according to my best recollection, Ange de Leide.

While I was looking at this figure a gentleman told me that it was a copy of an original owned by the late Mr. J.P. Morgan. I inquired about the original in New York on two or three different occasions and also had some correspondence with the library of the late Mr. Morgan as to how I could get a copy. It has turned out now that the gentleman was not correct. The figure which was owned by the late Mr. Morgan is called The Ange du Lude and it is very much different from the figure which you have.

I therefore made bold to address you for some information on the figure which you have at your University. I would also like to know whether this could be copied. If so would one of your students undertake to do it for me in clay so that I could have one cast. In this case would you require that it be a different size from your own figure which I remember was also a copy.

Anything you feel that you can do to help me will be greatly appreciated.

Yours faithfully,"

It took many years and dogged persistence on Sam's part, but the *Ange du Lude*, in a casting by Philip Schiavo of Roman Bronze, eventually found her way to River Brink.

13 THE LIBRARY AND THE GROWING COLLECTIONS

During 1949, Sam in his continuing mood of depression wrote to Eugene LaBrie on April 26, "Dear Gene: — I will be very happy indeed to talk with your friend. But, of course, my experience in practising law has been of a rather difficult nature because I made the mistake of staying in a small place where there was practically no growth and where one had to wait to fill dead men's shoes. I was aware of this all the time but unfortunately could not help it because of family difficulties. Sometimes family difficulties gather around bachelors more than they do around married men."

Turning increasingly to his art collection, his books and to a new found interest in antique clocks for solace, Sam read widely on the subject and began writing to English antique clock specialists where he did find some notable additions for his collection. Previously he had written to Winston Churchill, asking if any of his paintings were for sale. A rather haughty reply came from the Honorary Secretary, P.C. Hyde-Thomson "...I regret, however, that Mr. Churchill has none of his paintings for disposal." The same year Kenneth Forbes was taken on by Portraits Incorporated, New York, largely due to Sam's recommendation on his friend's behalf.

Sam's interests in growing plants stretched into his business life. He had been active in Glassgrowers Limited, a greenhouse supplying nursery stock primarily to the home

buyers of Sam's housing development companies. In 1949, the company lost its letters patent for default in filing annual returns. The following year Sam acted for Glassgrowers in selling their operation. The client had a warrant to take over another property and a writ was required to get the real estate free of the renters. Sam had trouble getting paid.

Tax returns from 1949 on indicate that Sam received rent from nine properties in London and it was said of him that he paid more in income tax than anyone else in that city. Meanwhile Sam and Homer Neely worked together to set higher tariffs for Middlesex lawyers. Some lawyers had been undercutting and hence wooing clients, a custom that Sam found distasteful and disrespectful to the profession.

Throughout the late 1940s and the early 1950s, Sam's health was a constant worry to himself as well as to Ruth. He had long used bifocals, but he was concerned about his sight, blaming the blow on the head in the baseball game when he was a child. He had to have an operation on three teeth with an infected area on the jawbone and then suffered an infection in his right ear, which was diagnosed as arthritis. He claimed he was "under the weather" all year long in 1950 with a chest pain, thought to be evidence of another minor heart attack. To cap it all off by November he wrote to Ruth that he had "stomach trouble" especially alarming to one who had nursed a father

with ulcers and in such grave pain.

However, in between bouts of being bedridden, Sam did made purchases of art. Thirteen are documented: a line engraving *The Water Fall of Niagara, 1794* by Robert Hancock; four pen and ink drawings by J.A. Hope-Wallace; *Houses and Women* by Lawren Harris; as well as *Twilight* by Tom Thomson, which hangs now at River Brink in his bedroom as it did during his lifetime. In addition, more line engravings of Canadian subjects are known to have been purchased in 1949. The following year, Sam took possession of seven art works and a vast number of books. *Horsedrawn Sleigh in Winter* painted in 1854 by Krieghoff was probably the most important acquisition, and as well, he bought a watercolour drawing through the estate of D. Caz-Delbo in New York, *Femme à sa Toilette*, attributed to Rodin, as well as a number of drawings.

In several letters to friends, Sam reiterated his ambition to get a farm and raise Jersey cattle, "but I never seem to get around to it." He was also endeavouring to write articles on law and its interpretations and enforcements, as well as establishing a branch of the Royal Canadian Institute in London. On January 8, 1951, in the *London Free Press* it was announced that Sam had been named a Bencher, the third from London. The first was Sir George Gibson, the second T.G. Meredith, and Sam filled the vacancy left by the appointment of John R.

Cartwright to the Supreme Court of Canada, the same Cartwright who had won the gold medal so coveted by Sam in their graduating year. Sam kept a very thick pile of congratulatory letters from every section of the province along with copies of his replies to each one. It was obviously a popular choice and doubly pleasing to him after his earlier defeat and his opinion that the Middlesex Law Society had in some way undermined his campaign for election.

Sam and his father's cousin, Bert Currie Weir, drove down to Virginia together. Bert Weir frequently went to New York to stay with Ruth for two or three weeks at a time. They travelled on minor roads and whenever Sam caught sight of an architectural feature that appealed to him, a front door surround perhaps, or the slope of a roof, he stopped the car and knocked on strangers' doors. He was gathering ideas for the Niagara home, his dream home. Frank Worrall also went along on more than one occasion. Sam once drove down to Queens especially to pick him up. Enroute, he also was taking careful note of the Virginian gardens. On one such excursion, when driving on the Pennsylvania Parkway, Sam was much taken with some dwarf ornamental trees. He promptly wrote to the University of Pittsburgh, Department of Buildings and Grounds, to find out what they were. The answer came back English Hawthorne or *cratalgus oxycanthis rosea*. He ordered some

at once for River Brink. At the same time he wrote to a number of greenhouses to order *Wichuriana Rose*, enough for a 100 foot high and 300 foot long bank.

According to the *London Free Press* of May, 26, 1951 "Glimpse of Tom Thompson, two sketches of fine art are on display in the London Public Library, Queens Avenue, loaned by S.E. Weir K.C. of this city." It was one of the few times that Sam had lent his paintings to a public gallery, but he felt the importance of the Thomsons merited their public display as well as the approbation he would receive.

In 1951 only five acquisitions are noted, a portrait, a charcoal drawing of *S.E. Weir* by F.H. Varley and two paintings by Arthur Heming, *The Forest Fire*, 1925 and *Wolves Attacking a Wolverine* also 1925, *A Watercolour of Falls of Niagara* and a print after Dufy, *Bateaux*. A number of letters concerning this last acquisition for which Sam paid $125.00 would indicate that it might be a forgery. Sam hated to be 'diddled' and increasingly took enormous pains to avoid another such situation. He did not enjoy his 'good eye' for a work being challenged, a direct blow to an area in which he took great pride.

In late 1950, Sam had approached Fred Varley to make a sketch of him. There was some talk of an oil later. Sam sat for Varley and on February 22, 1951 Varley wrote to Sam that the sketch was completed:

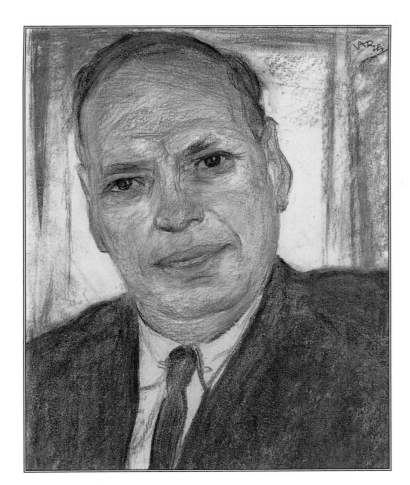

Portrait of Samual Edward Weir, charcoal on paper,
by Frederick (Fred) H. Varley, 1951.

"56 Grenville

Dear Sam,

Thank you for your note — I am glad the about 70 miles an hour — got you safely back in London in time for your appointment — My drawing of you is complete and was awaiting you — & now will await until you come again — unless you tell me to post it to you — I believe the more you see of it — the more like you it will become — I could depict you again — rugged in powerful light and shade if I were painting — Who knows? — one photograph, one drawing is only a part of you — Rembrandt painted himself a score times — they were all different. It depends on mood — light & shade & who looks at you & the artist tries to get a composite of the many changes — Your cousins, your aunts & your dearly beloveds see through their eyes & the artist — the impersonal "son of a gun" — looks at form — plus his reactions to the form & his sympathies towards the sitter — So where are we? Thank you for the cheque — I will await news from you —

Yours cordially

Fred — "

It must be remembered that 70 miles an hour was an outrageously dangerous rate of speed in 1951 and in wintry conditions even more so.

After a visit to Bermuda where Sam had made many friends with whom he corresponded for years, including the late Sam McLaughlin, he took a fancy to acquiring property for the winter and old age, as he put it. He consistently made offers so low that none was either accepted nor even subjected to negotiation. It seemed that nearly all Sam's close friends were at a distance from London. H.B. Smythe in Montreal frequently invited him to spend weekends with him and his wife. Sam also corresponded with Irene Quigley, now of San Francisco, and formerly known as Gert when she lived in London. Many speak of Sam's habit of holding a one man conversation, and a lady whom Sam frequently asked to dinner at this time, always with a chaperone, speaks of his ability when out shopping with him to 'get the sales girls all of a-twitter.' He told wonderful stories and used to keep the entire club car in hearty laughter on his way back to London from Toronto by train. His accounts of his court experiences were apparently hilarious. One friend remembers with great pleasure the occasions of hanging his latest painting after a good dinner. It would take the entire evening just to hang one, the placing, the height that had to be adjusted again and again until it was precisely to his satisfaction

with one of his favourite recordings, Vivaldi's Four Seasons or the Beethoven Fifth, playing in the background. These were relaxed and convivial evenings in an otherwise solitary existence.

An oil painting, *Northern Lights, McGregor Bay* by Gordon R. Payne, is one that Sam chose in 1952, not with any idea of trading it up for a work with a better known signature, but simply because it entranced him. It is an extraordinarily evocative rendering of the aurora borealis on a summer's night in Georgian Bay, a most unusual and successful treatment of a fleeting phenomenon. Sam acquired two other works among others that year, a watercolour *Full Length Portrait of a Young Man* by George Heriot and an oil *Quebec Habitant Farm Scene* by G.H. Hughes. The latter Sam bought from Leslie Lewis of 11 Bury Street, St. James, London, the man who emigrated to Toronto, was involved, accused and convicted in a celebrated art fraud case, and served time in a U.S. prison. Sam defended his friend, Frank Worrall, who also was accused of having a connection with Lewis' frauds. Worrall was acquitted, but when Lewis had to stand trial in New York, Sam could not defend him.

The following year, 1953, Sam, still on his determined mission for a degree in law, wrote to Dr. C.P. Parker at Wolsey Hall, Oxford on October 9, seeking full particulars of tuition for an LL.B. at the University of London. He also drafted a letter to

129

Winthrop Rockfeller with a suggestion for turning Niagara-on-the-Lake into a Canadian type of Williamsburg with the help of Rockefeller money. He pointed out that a Mr. Kendrew, a Canadian on the staff at Williamsburg, could probably handle it "without very much of the preliminary difficulties which you must have had at Williamsburg." It is not known whether the letter was ever sent, probably not, as Sam reopened the question a few years later. One aspect of "preliminary difficulties" that Sam overlooked was the participation, wishes and interests of the council and of the townsfolk of Niagara-on-the-Lake, all of whom were not privy to Sam's concept. Sam also wrote to the curator of the Barnes Collection at Merion, Pennsylvania in June, seeking permission to view the collection and describing himself as a collector on a modest scale. The answer came back: "Regret impossible. Schedule complete until after September."

Earlier in the year he made a visit to Puerto Rico and afterward corresponded with an American girl he had met there, a relationship that remained on paper. Athough Sam wanted to attend the Coronation of Elizabeth II that year, he felt he could not get away from the office. A client in London, England who had retained Sam to search for his Canadian father, wrote to him of his disappointment that they were not able to meet on this occasion.

Several more views of Niagara were purchased in 1953, including sixteen watercolours by L.J. Cranstone painted between 1850 and 1860 that Sam had come across on a visit to Nassau. He also bought an Emily Carr, *Friendly Cove* and an Albert Robinson, *Church in the Evening*. The Carr watercolour was purchased from Eaton's Fine Art Galleries. Sam wrote to Richard Van Valkenburg of the Galleries, "The colour of this painting is exceptional, but it only appeared so after the old glass was taken off." Sam specified that the glass be replaced by Pilkington 1/8 Patent Plate. "The Pilkington plate is a colourless glass that does not affect the colours in the painting beneath, whereas most glass has a greenish tinge and throws off the colour of the painting." He continued, "Unfortunately the Pilkington glass is heavy but I would rather put up with the weight and keep the colours pure through the glass." It was another instance of the knowledge and meticulous care Sam showed in his stewardship of his works of art. He also purchased a portrait, by Sir William Beechey, of *Sir George Yonge*, after whom Yonge Street is named. At this time Sam wrote to A.J. Casson with the intention of paying a call on the artist and perhaps making a selection. The busy artist replied that he preferred casual shoppers to call his agent.

Sam suffered a motor accident in December of 1953, leaving him with a crushed knee and much pain, and added

aggrevations to his general health problems. The doctors he consulted, and there were many, told him there was nothing wrong with it, but the pain continued for the rest of his life. His Meteor was badly damaged and the ensuing litigation carried on for many a year.

In 1954 Sam was now fifty-six years of age. He was making investments in Canada and abroad in a great variety of stocks, with the exception of distilleries, perhaps a harking back to the teetotalling religious beliefs of his forebears. His firm, now known as Weir Greenlees and Dunn, was well established and Sam was appointed by The Law Society of Upper Canada to serve on standing committees on Legal Education, Unauthorized Practice, County Libraries and Public Relations. His name was second on the list of twenty-three petitioners for the formation of a Benevolent Association for lawyers. He was also, along with H.J. McLaughlin Q.C. and Harold C. Walker Q.C., on a three man committee to supervise the care and maintenance of the gardens at Osgoode Hall with an indefinite term.

On June 14, 1954, Sam set out his opinion on capital punishment in a letter to Don F. Brown M.P. Chairman of the Committee on the Criminal Code:

Anyone who commits murder or treason or rape is just as well out of our social organization. But the difficulty is that in order to administer the death penalty some other human being must be the agent. This, in my opinion, is the final answer to all arguments.

We in our society, are opposed to killing members of our society. This should not be done whether by process of law or otherwise. I think we might give a convicted person the option of killing himself, but even that is looked upon askance under the religious principles of a large part of the community.

His letter so succinctly expressed deserves to be more widely known. He is in agreement with the opinion of George Bernard Shaw who stated he was opposed to capital punishment because of its effect on the hangman. The lawyer's opinion comes from the head and the playwright's from the heart, but they coincide.

In the same year, Sam concerned himself with ordering household minutiae from advertisements he culled from *Vogue Magazine*: silver plated sardine can keys, a miniature cuspidor, whiskey labels, ceramic cats, a long handled shoehorn. Perhaps Martha had a hand in at least some of this as Sam valued her opinion on all aspects of the refurbishing of Oxford Street. He also gave her a subscription to *Vogue* each

131

Christmas.

At this period in his career he had great plans to open a law office in Toronto in conjunction with F.E. Erichsen-Brown. The name suggested for the new firm was to be Erichsen-Brown, Weir and Associates. Sam suggested that F.E. Bowlby's portrait of Erichsen-Brown should hang in the new offices. At the same time Sam wrote to F.H. Varley: "Dear Fred: Heard you were back from Russia, so I went around to your old diggings...wondering if you still have any idea of painting my portrait? Do you have paintings for sale?" Perhaps Sam thought of a Varley hanging beside the Bowlby making an impressive background to the new partnership. He had taken a Varley and a Johnston on consignment from Roberts Gallery of Toronto and after several months decided against them both, shipping them back to Roberts.

In November, Sam was in another motor accident between Hamilton and Dundas and his old knee injury flared up again. He consulted a number of doctors, but was told that nothing could be done to alleviate the problem. By the end of the year Sam had another bout of pneumonia. It caught him just as he was about to go on a cruise to Bermuda. Although he did not feel that he had recovered until well into the New Year, Sam did make several more enquiries about purchasing real estate in Bermuda, and also about the possibility of acquiring land in the British Virgin Islands and Tortolla.

From Madame Laliberté, the widow of Alfred Laliberté, Sam bought five bronzes. In a letter to Miss Eugenia Berlin, from whom Sam had bought her *Eskimo Child and Dog* at a show in Stratford, Sam wrote, "The last bronze I bought was by Laliberté. I never liked his work but simply got this item for a collection. Old Coté was very much better. In fact I prefer him to all Canadian sculptors up to his time. I have his group of Indian women." Several bronzes were added to the collection at this time as well as a J.E.H. MacDonald, *Thornhill Garden* and a Morrice, *Harmony in Green and Silver* along with other paintings.

Correspondence indicates that Sam was interested in buying silver pieces from England again although he was also developing a fondness for early Canadian silver from Quebec. He wrote to Louis Melzack, a Montreal dealer, that his little Epstein head did not please his sister and that he was thinking of selling it. He also rejected a print *Sleigh Scene, Toronto Harbour*, from the well known and respected Parker Gallery, 2 Albermarle Street, London, by appointment to Queen Mary. Sam considered the print imperfect so back it went.

In March of 1955, Sam wrote to Ruth that he had acquired a new Buick and that he would drive it down to New York as soon as it was run in. Presumably his accident had resulted in sufficient damage to the old car to make it advisable

to start afresh.

One of Sam's many interests was in the formation of a National Portrait Gallery. He lobbied long and hard for it. World War II intervened and the concept, which Sam felt was an important Canadian cultural endeavour, never really captured public enthusiasm. In a story in the *London Free Press* in 1955, Lenore Crawford, the art critic, wrote that fifteen painted portraits by J.W.L. Forster and ink drawings by C.W. Jeffreys were on view at the McIntosh Gallery at the University of Western Ontario. These had been brought together by Forster prior to 1939. However, in 1955, the plan was that Forster's paintings should be given to various universities in the country. Two Londoners were mentioned as being members of the present corporation, Dr. G.E. Hall, President of the University of Western Ontario, and Samuel Edward Weir. President of the corporation was R.J. Cudney and eleven other prominent Canadians also served on the board. The portraits were scattered and the concept came to nothing, to Sam's disappointment. He doubtless would have made a contribution of his own likeness. As it happened Sam had contacted Archibald Barnes in June of 1955 with a view to commissioning his portrait.

Although Sam's romantic pursuit of Topsy had resolved into a long standing friendship, they kept in touch on

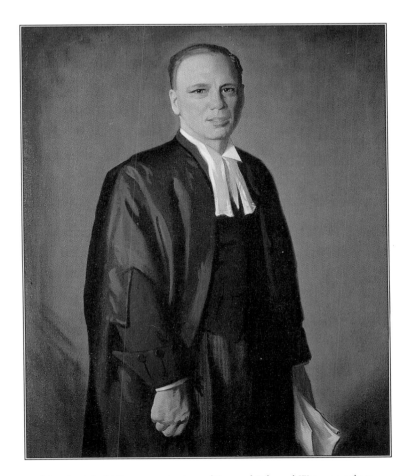

The Archibald Barnes painting of Samuel Edward Weir, now lost, believed to have disappeared from Costa Rica when Sam had a home there.

133

a rather sporadic basis. Then early in 1955, Sam met a French Canadienne, Françoise, who quite charmed him. She had him over to dinner in Toronto on several occasions and apparently a romance developed. It was their religious beliefs that spelled the end of the relationship. Neither would budge. Françoise, a Catholic, bade him goodbye. A close friend remembers him standing in his beloved garden, talking about her and breaking down in tears.

That summer in order to ease the pain of their parting, Sam decided to take a trip and go to England by boat and do some genealogy tracing in Ireland. He booked into the Park Lane Hotel and caught so bad a cold that he was forced to call a doctor and remain in bed for a week. He did however, contact a young cousin, John Weir of Edmonton, who was reading law in the Inner Temple. Once safely back home again, Sam wrote to Elizabeth, John's mother, Mrs. John Alexander Weir, on October 6:

"It was delightful to find your son in England. I think he is a very nice lad. You might tell John that after he left I received a telephone call from the Under-Treasurer of the Middle Temple, stating that the Acting Treasurer had requested that I meet him for lunch. I went down there and was introduced to the Acting Treasurer, Mr. Price Q.C. and he took me to his office where sherry was produced. Then I was taken to the private dining room of the Benchers where I had the best food I had had in England. The conversation was exceedingly good too. Then the Acting Treasurer and Sir Reginald Swan Q.C. took me around to show me all their prizes. Among them was a table given them by Sir Francis Drake, the top being made out of some wood off his ship, The Golden Hind. On my return here Mr. Chitty Q.C. of Toronto informs me that I have had a very high honour done me."

Elizabeth had written to thank Sam for taking John to Ireland with him, indicating that she was fascinated by the family history he had unearthed.

14 A SUMMER TRIP TO REMEMBER

Sam delighted in every opportunity to see artists personally and he made it a habit to develop ongoing acquaintanceships with those he admired. Jacob Epstein and Augustus John, two British artists, were both visited by Sam during his summer trip to England. To keep a happy memory fresh, Sam wrote up an account:

Memorandum of a Visit to Mr. Augustus John O.M.R.A.

"On Saturday, September 10, 1955, I left Waterloo Station for Fordingbridge, alighted at Fordingbridge and walked to Fryeden Court pronounced in the neighbourhood "Frying Court". There I was received by Mrs. John who said her husband was painting. We carried on conversation for well over an hour when a young girl called "Hannah" appeared in the living room and said she was through sitting. Shortly after that Mr. John himself appeared. We four sat down to afternoon tea.

After some conversation about his friendship with the Phillips family in Canada, I showed him photographs of two paintings, one being of a Spanish Gypsy and the other of a young boy. The former was

135

signed and he recollected having done it. The second was not signed but he took the photograph and wrote a certificate of authenticity on the back of the photograph. Mrs. John took the two photographs to a desk in the corner and after a little while returned with a notation on the back of each of what she thought to have been the dates when the pictures were painted.

I made a remark about the boy looking cross and determined. He thereupon said "that's my son, Edwin. He was a stubborn little bastard." It appeared from conversation that Edwin is now an artist living at a town about 20 miles out of Paris and quite successful. Another boy whose portrait was hanging over the fireplace, is an Admiral in the British Navy.

When I asked for comment on the two paintings, Mr. John said that he considered them both among his best work. As regards the Spanish girl, he said her name was "Chiquita." He thought she was somewhat of a Mongoloid. He then said "she certainly looks ready for business." I asked him about the dress and he turned to his wife and said "I think that was a dress you had and that you cut the sleeves off and gave it to the girl." Mrs. John remarked that

she had given her many dresses. I asked him which of the two paintings he preferred and he said that he rather preferred the one of the boy. But he said the other "is not without merit." I brought this around by asking him if he would mind if I asked him a dirty question. He said he would try to answer it, with a laugh. I asked him about the panel on which the boy was painted and he said this painting had been done at Alderney in the Channel Islands. At that time he used quite a few panels which he bought there locally. He was of the opinion that it would withstand climate change to Canada. But he added "what difference if it cracks as long as the paint is there."

As regards the Gypsy, he said with a smile, "naturally I could not tell you all I know about her."

After a while two gentlemen came in, one being named "Raymond," a Frenchman who is writing a series of monographs on plants illustrated by himself. We men went to the other end of the house and had a drink. Mine was Seagrams which had come from Mr. Phillips. The others drank some Chilean Wine. The bottle being opened by Mr. John very ably.

Mr. John was in his pyjamas with a dressing gown over and a cast on his leg as he had recently

broken his leg (the left). His wife remarked that fortunately it was only the fibula. The cast is to come off in a few days.

I showed him the pen and ink drawings of Irish Peasants which I bought at Lester Galleries and he exclaimed, "I did that." I then said, "I like it very much." And he said "I am glad you do, I like it myself." Mr. Raymond drove me down to the Railway Station. I had intended to walk but Mrs. John said I should stay longer and she would drive me down. Then Mr. Raymond volunteered to drive me.

Mrs. John said that they would be happy to have me come back. He said that he would like to spend a longer time with me and that he had intended having me to his place in London but had not been able to get there because of the broken leg. I took some pictures of a modernistic studio which he built. Mrs. John says that he never uses it. He paints in his bedroom, the smallest room in the house.

At present he is doing some drawings of some sitters in London. The painting which he was doing at his country place was apparently for his own amusement.

He showed me some paintings by Sir Matthew

Smith and remarked that he and Smith are very great friends. He also showed me some large busts in different colours of bronze. He said he had been working at sculpture of late and these were some of the results.

He autographed his book for me and said there would be another volume published early next year. He says he has it practically completed.

I had hoped to take some pictures of him, but did not have the nerve to ask him to pose because of the outfit in which he appeared. He was exceedingly gracious. Mr. Raymond remarked on the way to the Railway Station that he had had as a boy a great admiration for Mr. John and was amazed at how their acquaintance had developed after he had met him of late. I remarked that Mr. John was very pleasant and Raymond said "but it is not always so with him."

Dictated London, England

S. E. Weir
September 5, 1955"

When he was in Aberdeen on the British tour of 1955, Sam bought a grandfather clock. He had it packed so that he

could bring it back with him on the *Empress of Australia*. It was a very stormy crossing and the clock suffered damage to its works which came loose, hit the glass face and broke it, doing damage to the cabinet as well. Sam's knee enjoyed the trip even less.

During that summer in England, two occurrences befell Sam. He fell headlong in love with a young lady, Lillemor Johannsen, who passed herself off as a lawyer practising in her native Sweden, and he lost his gold watch. He pursued Lillemor so ardently that, while at first she certainly appears to have led him on, ultimately she seems to have been overwhelmed and fled back to her home in Sodertalje, a town in Sweden. Scotland Yard was called in about the watch and at one point when Sam discovered that she was not a lawyer at all, he wrote to the Canadian Ambassdor in Stockholm about her credentials. He even wondered if she had been a party to the watch incident, but still he wrote bundles of letters, the most part of which he kept rough drafts and sometimes carbon copies, offering her such inducements as a place in his law practice. The correspondence went on for years. Lillemor obviously did not take him seriously and, when pressed repeatedly to send a picture, sent a passport type snap. Sam was so used to getting his own way that rejection by this beautiful Swedish girl was a bitter pill. It was another episode that demonstrated so clearly his uneasiness in his search for a

marital partner.

Writing to Ruth on October 24, Sam recounted:

"Caught flu second day home. Don't be surprised if you get an invoice for two different heads in bronze by Epstein. I ordered them in England and they will shortly be on the way out. As there is a very heavy duty on bronze objects coming into Canada, it seemed best to let you buy them for delivery in New York. I will look after them over here when I am there. I sent the Augustus John panel to Mr. Frank Worrall the restorer in Toronto. ... He thinks it will stand up as it is painted on an oak face although the back laminations are soft wood. He also says the painting is 'terrific' and says he thinks it is a good investment. ...I showed the photograph to the manager of Durand-Ruel in Paris and he was quite enthusiastic about it. I think the Caz story that Durand-Ruel had a large stock of Guillaumins may not be correct. Anyway they pretended when I was there they only had three in their whole stock. One of them was a scene on the Seine and they were asking big money for it because they said it was of historical importance. If I remember correctly the price was somewhere up

around 1,000,000 francs (about $20,000.00 Canadian). They had two others which ran about $1000.00. I came across another in another gallery which is a remarkably good one and they ask $850.00. I have a photograph of this too and will be glad to show it to you."

To Arthur Nutter in Texas, he wrote "... P.S. Dr. Shaw says my knee will never be any better than it is now. It carries me around but it doesn't feel very happy."

Throughout 1955 more colour lithographs of Niagara Falls found their way to London. Paintings, bronzes and a three quarter standing portrait of Sam by Archibald Barnes were delivered along with a head and shoulders sketch. The portrait was destined for the new Court House at London, but the Middlesex Law Society decided not to accept it. As Sam had taken a leading part in the drive for a much needed new court house, he was quite put out at the Law Society decision. The portrait was, however, exhibited in the Royal Canadian Academy of Art Annual Exhibition of 1955. Its present whereabouts is unknown.

Paintings and prints arrived in profusion throughout the year from France and England, as well as from Canadian dealers: more Suzor-Coté, Varley, Paul Peel, Sir Matthew

139

A Suzor-Coté bronze entitled *Maria Chapdelaine*, dated 1925, and acquired by Sam Weir in 1955.

Smith, Augustus John, including his *Chiquita*, as well as various works that Sam acquired in browsing through local auctions. Apparently attending auction sales was one of Sam's favourite uses of what leisure time he had. The collection was taking shape as a privately owned gallery of particular importance to Canada's history and artistic heritage.

In letters to Roberts Gallery in Toronto concerning three Varley oil sketches, Sam indicated he was interested in acquiring them, but dickered because he claimed one was badly cracked and another had slight damage to its surface. Two were unsigned and Sam insisted upon signatures or no sale. Roberts stood firm about the asking price and Sam decided on two, *Ploughed Fields* and *Arctic Ice*, but one frame had to be replaced and the other touched up. "I feel that someone else should buy the cracks in the other sketch. It is pretty bad and will get worse," was his informed comment.

Just before he left for England to get over his grief about Françoise, Sam had heard from a dealer in Montreal who offered him a "magnificent" Krieghoff. Most probably this was *Indian Council*, 1855. As Sam often turned to his art collection for solace, he would be enticed. Later, after his return to Canada, he wrote a letter to Isobel (Cross) Weir with the postscript, "By the way I got reckless and bought a painting by Kreighoff. I would be afraid to tell you the price."

On March 5 of 1956, Sam wrote to Frank Worrall with a proposition:

"I have something on my mind. I think we should organize a travelling show to be called "Three Great English Contemporaries" or something of the sort, and I think your name as well as mine should appear on the catalogue. It could go around to different Art Galleries. The London Art Gallery has already decided it would like it this Fall. This show would feature Sir Jacob Epstein, Sir Matthew Smith and Augustus John. I have another drawing on tap by Augustus John which makes three, as well as the two oils. Then we have the two oils and the drawing by Sir Matthew Smith. And I have a couple of small busts by Epstein, and I will see whether some additions can be made to that.

I feel that a show of this kind would be in demand by the different art galleries, even though a small show.
P.S. Would you like to write the texts with an account of the artists?"

At this point in his collecting career, Sam was happy to

140

lend some of his works around and, incidentally, increase his renown as a collector.

With his eye on a law firm of his own in New York about to come to pass, Sam wrote to Arthur Nutter on July 23, 1956, "cleaning up my library and as much of the rest of the house as I can. Trying to rent office on Wall Street where I propose to spend part of my time offering my services to Americans as a Canadian lawyer. I am hoping that it will give me a better life than the one that has been so unsatisfactory in this town. And I will see more of my sister before she has a stroke which I think may be inevitable."

The wrangles with Wells at Sun Life continued. Wells claimed that Sam charged higher fees than those paid by London Life. Sam countered by indicating that London Life paid a retainer fee, hence lower fees per transaction, but "Sun Life would not be so foolish as to follow this practice," wrote Sam in rebuttal.

In the election for Benchers of 1956, Sam came in the twentieth of seventy five, re-elected with 1137 votes. J. J. Robinette, the front runner, had 2274 votes. At this time Sam ordered an impressive number of brief cases and they seemed to have been distributed to a number of lawyers after the election. It was his way of saying thanks and his usual custom for favours or kindnesses received. He ran a regular account at

Tiffany's for teething rings and coffee spoons, sent to young lawyers of his acquaintance who had sent him cards of happy occurrences, or as Christmas gifts to young daughters of his compatriots at Sun Life. Sam's accounts from the Albany Club have been preserved for 1956, along with a prodigious number of bar chits, all an indication of his generosity.

R. Tait McKenzie, *Ice Bird.*

141

15 A TURNING POINT IN THE WEIR COLLECTION

THE YEAR 1956 WAS IN A WAY A TURNING POINT IN THE WEIR Collection. It came to Sam's attention that the Hoppner portrait of *Sir William Osgoode* would be offered at auction as part of the estate of Mrs. Goadby Loew of New York. On July 28, 1922, the painting had come up for sale at Christie's and A.H. Simcoe of Welford, Dunkeswell, Devon, whose ancestor had been given the painting by Osgoode himself, received 370 guineas for it. The buyer was Thomas Agnew and Sons. Leggett Brothers purchased the painting from Agnew and it was sold again in 1927 to Mr. William Goadby Loew. It was known to the Law Society of Upper Canada that the painting was for sale, but a decision was made to let it pass. On Mr. Goadby Loew's death, the painting passed to Pierre Bader who auctioned the estate en bloc at Parke Bernet in 1956. Sam only found out about it because, happening to be in New York, he noticed by chance that an open house was in progress prior to the auction in the Goadby Loew residence on Park Avenue. He naturally went in to have a look. Osgoode's portrait was a work that Sam immediately believed should come to rest permanently in Canada.

Sam alerted the Law Society of Upper Canada, as the portrait hanging in Osgoode Hall is a copy of the Hoppner. He felt strongly that the original should be in the hall named after Osgoode. After some debate on the matter, The Law Society of Upper Canada decided not to raise funds in order to place a

serious bid. Thereupon an anonymous bidder offered to go as high as $3000 and present the picture to Osgoode Hall. But if the bidding were to rise higher he might increase his bids up to $10,000, keep it for his own enjoyment and ultimately present it to Osgoode Hall. Sam was requested by the Secretary of the Upper Canada Law Society, Earl Smith, to refrain from placing a bid, the third person so Smith claimed, so requested.

Upon thinking the situation over, Sam decided that he was entitled to buy the work if he so wished. He talked it over with Frank Worrall, Wilbur Howell, his brother-in-law in New York, and with Homer Neely, his legal friend practising in London. They all concurred that Sam was correct in thinking that it was his right to bid if he wished to do so. On the Friday prior to the sale, Sam telephoned Smith to tell him that he would bid. Smith refused to divulge the other bidder's name, but read his letter to Sam which Sam considered to indicate some doubt of the Law Society ever receiving the portrait if it were sold for a high price, but more or less confirmed that, if the portrait sold below $3000, the Law Society could expect it immediately. Sam thereupon telephoned Wilbur and authorized him to bid to a maximum of $3550, a price suggested earlier by Frank Worrall. Parke-Bernet estimated the worth of the painting between $2000 and $2500. Worrall agreed with that assessment, but added that while it would be worth $2000 in England, it could go higher in New York because of its historical interest.

Following the sale, Smith telephoned Sam to tell him that the bidder had dropped out at $3500.00 and that it was believed that the purchasers were the Bronfman family in Montreal. He then informed Sam that it was Fraser Elliott of Montreal who had been the unsuccessful bidder. It must have given Wilbur some great moments of tension when it was knocked down to him at fifty dollars below his maximum authorized bid. Sam dictated his account of the proceedings on May 10, 1956 and this account can now be found at River Brink.

Wilbur and Sam kept their secret for some time. Sam repeatedly told old and trusted friends that he thought the painting should eventually land in Osgoode Hall. However when it became known that it was Wilbur who had bid against Fraser on behalf of Sam, members of the Law Society felt that Sam had behaved underhandedly. When word of their insinuations and accusations reached Sam, he decided that *Sir William Osgoode's* rightful place was in his own collection and would always hang there. So it is that the Hoppner original hangs in River Brink and appropriately so as Niagara-on-the-Lake was the seat of government of Upper Canada when Osgoode travelled with the first Lieutenant Governor, John Graves Simcoe. There he became his friend's first Chief Justice of Upper Canada based at Newark, now known as Niagara-on-the-Lake.

At the same time, and perhaps to mollify the hard feelings of the Law Society, when Sam heard that a recasting of a bronze of Dr. Falconbridge, Dean of the Law School, was necessary and that the Benchers did not want to spend the necessary $175.00, Sam agreed to pay it himself. But the Benchers wanted the students, the articled undergraduates, to nickel and dime the required amount. Sam then suggested that the Law Society could reimburse him for his travelling expenses to Convocation to which he was entitled but had not ever claimed, and that he would remit "$175.00 out of that sum to pay for the recasting." He also suggested that Roman Bronze be assigned the job as he had had an account with Roman for some years and had had a number of works by Suzor-Coté cast for him by the firm.

In the summer of 1956, Sam was back in England visiting Augustus John and others and making a number of purchases. In November, he wrote to Ruth that he had put off a visit to Mexico and New York because of flu and an abscess on his lower jaw that had him paying almost daily visits to the dentist.

Later the same year, Sam got in touch with R.H. Hubbard, Chief Curator of the National Gallery of Canada, the Montreal Museum of Fine Art and other such galleries, offering to send them lists of his collection and photographs of the Hoppner and modern English and French paintings. Invoices from Maggs Bros. for that year indicate that Sam's library was also greatly increased. Long and friendly correspondence ensued with curators as well as with other collectors such as Kenneth Thomson. These two collectors compared notes and their acquisitions over many years and established a friendship which would last until Sam's death.

Throughout 1956 and 1957, Sam was in correspondence with Marlborough Fine Art Galleries of Old Bond Street to obtain paintings by Guillaumin, a minor Impressionist virtually unknown to all but specialists at that time. He also contacted Galerie Paul Petrides of Paris about Guillaumin, but he wanted early paintings. Later works he felt were very odd and he disliked them.

As the New York office was becoming closer to reality, Sam enquired of the possibility of being called to the Quebec Bar. It seemed to him that it could work out to the advantage of both the Quebec Bar and himself. Forthwith, he busied himself studying the requirements to pass the examination. Throughout this time Sam pursued a few girls without success, but he was constantly badgered week by week by the daughter of a client, Mary Fraumeni whose inheritance Sam had handled. Her daughter Nancy made her intentions all too plain much to Sam's horror. The lady constantly overlooked his rebuffs and lack of interest in her until her death, a few years later. It seemed that Sam was destined to remain a bachelor.

COLOUR PLATES

Homer WATSON (1855-1936) Canadian
The Lothian Hills 1892
Oil on canvas, 78.7 x 100.3 cm.

Lucius Richard O'BRIEN (1832-1899) Canadian
At Rest 1889
Watercolour on paper, 64.5 x 43.0 cm.

148

Paul PEEL (1860-1892)
Canadian
Good Morning 1891
Oil on canvas
49.4 x 38.4 cm.

James Wilson MORRICE (1865-1924) Canadian
Le Porche de l'église San Marco, Venise ca. 1901
Oil on wood panel, 12.5 x 15.5 cm.

150

James Wilson MORRICE
La Communiante ca. 1898
Oil on wood panel, 12.8 x 15.5 cm.

Lawren Stewart HARRIS (1885-1970) Canadian
House and Women ca. 1920
Oil on cardboard panel
27.0 x 31.2 cm.

152

Thomas John (Tom) THOMSON (1877-1917) Canadian
Northern Woods
Oil on wood panel, 21.1 x 26.5 cm.

Thomas John (Tom) THOMSON
Sketch for *The Jack Pine* ca. 1916
Oil on wood panel, 21.1 x 26.8 cm.

Paul KANE (1810-1871) Canadian
Self Portrait ca. 1845
Oil on canvas
63.7 x 53.3 cm.

Emily CARR (1871-1945) Canadian
Friendly Cove 1929
Watercolour on paper
69.5 x 50.7 cm.

155

James Edward Hervey MACDONALD (1873-1932) Canadian
Thornhill Garden 1915
Oil on cardboard, 20.3 x 25.4 cm.

Archibald George
BARNES (1887-1972)
Canadian
*Portrait of Samuel Edward
Weir, Q.C.* 1955
Oil on canvas
68.5 x 58.4 cm.

Augustus Edwin JOHN (1878-1961) English
Chiquita ca. 1917
Oil on canvas
86.3 x 63.5 cm.

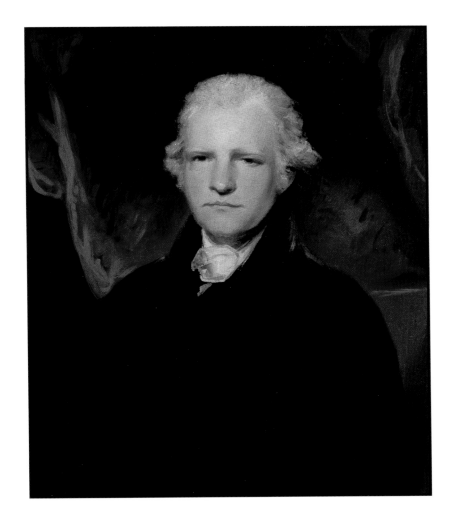

John HOPPNER (attributed) (1758-1810)
English
Portrait of Sir William Osgoode
Oil on canvas
74.9 x 62.2 cm.

159

Maurice Galbraith CULLEN (1866-1934) Canadian
Meadow Stream in Early Winter
Oil on canvas, 46.0 x 61.5 cm.

Albert Henry ROBINSON (1881-1956) Canadian
Farmer Sleighing Home in Winter ca. 1927
Oil on canvas, 57.0 x 67.0 cm.

Cornelius David KRIEGHOFF (1815-1872) Canadian
Settler's Cabin in the Foothills 1859
Oil on canvas, 61.0 x 78.7 cm.

Sir William BEECHEY (1753-1839)
English
Portrait of Sir George Yonge 1790
Oil on canvas
76.2 x 63.5 cm.

Horatio WALKER (1858-1938) Canadian, *The Turkey Girl* 1904, Oil on canvas, 72.7 x 92.1 cm.

Hippolyte Victor SEBRON (attributed) (1801-1879) French
Niagara Falls from the Canadian Side ca. 1850
Oil on canvas
48.9 x 72.4 cm.

Philip Wilson STEER (1860-1942) English
Effect of Rain, Corfe 1908
Oil on canvas, 45.8 x 61.4 cm.

Cornelius David
KRIEGHOFF
Indian Council 1855
Oil on canvas
55.2 x 61.9 cm.

Kenneth FORBES (1892-1980)
Canadian
Portrait of Samuel E. Weir 1966
Oil on canvas
83.5 x 71.1 cm.

James B. DENNIS (attributed) (1778-1855) English
The Battle of Queenston Heights
Oil on canvas, 54.4 x 76.3 cm.

George ROMNEY (1734-1802)
English
Portrait of John Currer 1778
Oil on canvas
76.2 x 63.9 cm.

Johann Joseph ZOFFANY
(attributed) (1733-1810)
German
Portrait of John Graves Simcoe as a Young Man ca. 1770
Oil on canvas
96.7 x 69.2 cm.

16 LONDON, WALL STREET AND POSSIBLY PARIS

On January 30, 1957, it was official. Cards had been mailed to members of the New York Bar to announce that Weir, Greenlees & Dunn had established an office to 'render Canadian legal advice to New York attorneys and that Samuel E. Weir Q.C. will be in personal attendance at the New York office, 44 Wall Street.' Sam joined the Canadian Club of New York.

After the New York office had been running for about a year, Sam wrote to a friend that it "had produced some business. The plan was to do one week in London and one week in New York," but he was not able to carry out this rather bruising routine. He had too many Court appointments and that old bugaboo, bronchitis, had laid him low. Still he did have at least one interesting client in New York, a well known actress who claimed she had been cheated by a Montreal broker. Sam found her a real bother because she persisted in telling him, "All the time what her astrologer tells her is going to happen."

Sam wrote to Arthur Nutter that he had bought another Albert Robinson from his widow. In a letter to her of March 8, 1957, he wrote "As you know I already had the painting of the little *Church in the Evening*. I am trying to get three good examples of each top Canadian artist, therefore I would be interested in getting another work by your husband. Do you still wish to retain the other large canvas which I saw at your residence?"

The letter continues:

"I bought Canadian paintings for years as I could get around to paying for them. I just bought them hit or miss. Then I discovered that if I would do some filling in, I would have a collection beginning with the earliest times and running down to date. By "to date" I mean quite a few years ago because I have not taken at all to this bizarre painting which is being done now. As I am not married there is a good chance that my collection will end up in some public gallery. So for this reason I always feel that I should be looked on as a preferred buyer."

The letter could be said to be a summation of what Sam hoped to accomplish and his philosophy of what he considered worth acquiring. The "some public gallery" had already become River Brink, at Queenston in his mind. His interest in historic paintings and depictions of the Niagara region continued unabated.

A spirited correspondence was carried on with R.L. Pye of the Park Lane Gallery in Toronto over the year 1957. Most of it concerned the watercolour of Niagara Falls by Dartnell that Sam took on consignment and which he claimed had been offered to him for $60.00. Mr. Pye claimed the asking price was $90.00. Finally after eight months Sam sent $65.00 which was returned with a hand written note requesting either the painting or a cheque for $90.00. Pye claimed he had paid $125.00 for it and $90.00 was a special favour to Sam. At the end of November Sam increased the cheque to $90.00, writing, "It was my recollection that you had given me a special price of $65.00. However I will get even with you on another occasion and let us continue friends so I may have an opportunity of doing so." One can well imagine that Mr. Pye was well fortified for battle when he saw Sam approaching his shop in the future and was still more precise in any subsequent dealings with S.E. Weir Q.C.

In a note to a friend in Niagara-on-the-Lake, Sam wrote, "…returning your Crysler book. My great grandmother, Katy Crysler, was terribly religious. Her husband was fond of a good time. When he was drunk she knelt down and prayed so loudly that it could be heard for a long distance over the countryside." At long last the descendants of the fiercely religious could laugh at their ancestors and still remember them fondly. At some time in 1957, George Sutton's cousin, Mrs. E.V. Tillson of Tillsonburg died and left Sam a bar room chair, which had been made in Ireland and had belonged to Archibald Weir, "…my grandfather's. Early Canadian bar room type, but unusual. I imagine the old boy made it

himself." He wanted Thorton Smith of Toronto to make copies of it.

Always interested in historical enterprises, Sam once more explored the possibility of getting Rockefeller's help in making a Canadian Williamsburg out of Sam's new neighbourhood. Ruth Home of the Architectural Conservancy of Ontario was an interested spectator, but no action on the proposal ever came to pass.

During this year Sam wrote to congratulate John Diefenbaker, who was a friend of his Uncle James Weir, the newspaper columnist in British Columbia, on taking over the leadership of the Progressive Conservative Party. A couple of months later in another letter of May 24, 1957, Sam wrote, "I suppose that my friend Roland Michener has mentioned to you that our Party Policy should include abolition of personal income tax . . . but no one seems to worry as long as revenue pays the interest on past debt. Perhaps I am wrong in looking at the capital debt rather than at the interest charge. I refer to capital debt for dead horses and not on a revenue producing account." Sam brought up his idea of abolishing personal income tax again and again. It was a major part of his hatred of taxes of all types.

As well as lobbying for the abolition of personal income tax, Sam was busily trying to gather support for a Bachelor of Laws degree being given to every graduate of

Osgoode Hall. Although he did gather support from across the province with only one opposed, nothing came of it. Sam wrote directly to The Rt. Hon. Roland Michener outlining his scheme. He also sent out cards to all his clients announcing that "We are closing our office on Saturdays the year round. Office hours are 9.30 - 5.30 Monday to Friday. Please make appointments from 10 am - 4 pm so we can get your work done." The office had been following these hours for some time past, but now it was official. Other law offices soon followed his lead. At this period there were several contacts in Detroit who wished to retain him to search out suitable properties for sale for hotels and so on to make a quick profit. Hotels licensed to sell beer were popular as investments for a quick return of capital at this time.

When Sam wrote to Mrs. Robinson about contemporary painting, a style which he found bizarre, he was ready to do something about it. Accordingly on January 4, 1958, Sam along with Kenneth Forbes, Archibald Barnes, Manly MacDonald, Allan Barr and Gordon Conn, the art critic, met to form a new body to be known as the Ontario Institute of Painters (OIP). Forbes chaired the meeting and stated that "Rank modernism had taken over the OSA and the RCA. Something should be done to maintain sound painting."

At subsequent meetings more painters joined up, Evan

MacDonald, Frank Panabaker et al. Clare Bice of the London Gallery invited OIP members to send ten representational paintings for a show in London. Sam and Gordon Conn, both charter members, were now Honorary Members and F.S. Challener was elected Honorary Membership Chairman. Sam was asked to set up the organization charter, drafting by-laws and advising re the seal. The Ontario Institute of Painters was duly constituted on May 15, 1959 with twenty five active members. The following year the OIP held a general meeting on January 10 with Archibald Barnes, Kenneth Forbes and Manly MacDonald as directors, Gordon Conn as secretary and Roy Greenaway as honorary secretary. Sam continued as honorary member and adviser on legal matters.

For years it had been an avowed interest of Sam's to acquire more Maurice Cullens. As usual, he delighted in finding a way to make an end run around the galleries by going to the 'source.' Accordingly he wrote to R.W. Pilot in February of 1958: -

"My dear Mr. Pilot:
I feel at liberty to write you as I am also a member of
The Art Club at Montreal.

I have wondered if you could be persuaded to sell
any of the paintings held by you from your late
distinguished stepfather Maurice Cullen.

The Travelling Show which was held in 1955 contained a painting called Morning, Brittany Washerwomen *which attracted me very much.*

I am primarily building up a collection of Canadiana and the painting which was in this Exhibition entitled Waiting *(Number 38) and the drawing (Number 88) entitled* Cab Stand, Sherbrooke Street *interested me very much.*

Some years ago, I saw at The Arts Club a couple of oils by your good self which depicted French Canadians fishing on the ice. The costumes were of various colours. The effect was attractive. I asked the Secretary to inquire from you as to whether you had any more because he told me that the paintings (I think there were two of them) in the show had been sold. I never heard anything further.

Have you heard of the new "The Ontario Institute of Painters"? I organized the sound painters in Ontario i.e. did the local work just a few weeks ago into an Association of this name. The President is Mr. Kenneth Forbes, R.C.A. The Vice-President is Mr. Archibald Barnes, R.C.A. The complaint of the

sensible painters in Ontario is that the R.C.A. now only has a Show in Toronto every three years and therefore they have no chance to exhibit unless they get along with the Ontario Society of Artists which has gone extremely modern. It is the object of The Ontario Institute of Painters to provide exhibitions at frequent intervals for the Ontario painters. The membership is restricted to Ontario painters but it is proposed to invite painters from outside Ontario to exhibit. The reason, of course, for the restriction to Ontario is the necessity of pleasing the Ontario Government by establishing a Provincial enterprise.

Yours sincerely,

It had been Worrall's custom to travel every two years to England and occasionally on to France or Italy every second year for some time past. Sam gave him letters of introduction to the most prestigious galleries with whom he had been dealing and with instructions to see this or that work and comment on its value and condition. There are many letters over the years from Worrall thanking Sam for unexpected amounts of money - "I don't know what I have done for this,"..."You have been gone for some time, this is in case your funds are low." Sam was a generous and patient patron of the art restorer. At one point he asked Worrall to "Please get out that snow picture. I want it for my dining room. It will go nicely with the serving of ice cream."

The vision that had so struck Sam of the mill of Archibald Weir's in Ireland, stayed with him and on June 10, 1958, three years after he had been there, Sam wrote to Rowland Hill in Belfast with a request "...to paint an old mill near Ahoghill, known as Straid. Appears to be the place where Archie Weir started out. He came to Canada in 1815. What is your fee?... P.S. There is an interesting tombstone with a number of designs including a skull and crossbones, a coffin, an hourglass and a 'rive' by which one of the family told me is meant a part of a mill wheel."

Mr. Hill replied some months later saying that he thought it should be an oil and a good big size. The price would be £150 delivered. Sam had thought of a fairly small watercolour and that rather ended the project. As there is no such sketch in the Weir Collection apparently there was no further discussion.

Pleased with his new Augustus John, *Chiquita*, Sam lent her and other works, including other Johns to the London Public Art Museum in February of 1958. A story by-lined Lenore Crawford in the *London Free Press* appeared and Sam

squirrelled away several copies of the article. The following month Sam by-lined a full page article for the same paper on the need for a new Court House. He wrote in part, "It will interest Londoners to know that in the case of London, while the Court House belongs to the County of Middlesex and is managed by the Middlesex County Council, the citizens of London pay 65% of the cost of the repairs of this building to the county, a matter of friction. The writer became an articled clerk in 1915 and the Court House was in every way adequate for its use at that time." Sam went on to write of A.E. Nutter, an English architect, "who stopped in London by personal misadventure and became the city building inspector. He applied his knowledge of castles with success to the renovation of our Court House. When it was done London had 50,000 people and 50 or so lawyers. In 1958 there are over 100,000 people and 166 lawyers. Many years ago Mr. Nutter told this writer that he had been sat on for wanting to provide a much larger addition. He was only too right."

Because he was also on the County Libraries Committee of the Law Society, Sam made a survey of all the law libraries in every county in the province. As Middlesex County was embarking on a new court house in London, Sam wanted both court house and library to be second to none in the province. Finding money for the maintenance of the law library he envisaged would be a problem.

Sam was under the weather again. The first three months of each year seemed to be the most trying for him; flu, chest colds, pneumonia and bronchitis were an annual source of worry and time lost from the office. In March he wrote to the Home Educators Council in Ghent, New York. "Kindly send me pamphlets of How To Fight Fatigue (25 cents enclosed)." His state of health would be tried again in April when Sam's partner, Greenlees, who had been on a half day basis for some time, retired and Sam looked around for a replacement. He was an exacting employer who could be most generous and yet was not noted for paying unduly large wages, as the procession of secretaries knew only too well. However, a note of cheer arrived when W. Earl Smith wrote to Sam from Osgoode Hall, assuring him that he should have no difficulties gaining admission to the Bar of Quebec since he had been in practice well over ten years. "The exam is more of a formality," he wrote.

Later in the summer Sam wrote to his cousin, Fred Fitzgerald, the eye specialist in New York, "I was asked sometime ago by the Parliamentary Assistant to the Minister of Justice whether I would accept a post on the Trial Division of the Supreme Court of Ontario, and I told him that I wasn't much interested. I would have to sit and listen to lawyers and

witnesses regardless of how sick I might feel." With his incisive ability to sum up situations and his deeply felt regard for the justice system along with his well known wit, the bench was the loser. But his health was becoming of ever more concern. Even though he had made it clear years earlier that he thought judges were underpaid, by now he had accumulated sufficient capital to allow him to take the position offered and with it the tacit approbation of his peers, a rather welcome recognition from the profession at large, yet it was state of health that made him turn it down.

Martha in her quiet way was a great comfort to Sam. She habitually spent the summer months taking care of the home on Oxford Street, doing spring cleaning and overseeing general domestic improvements. Her influence was strong on Sam's acquisitions as his letter of May 9, 1958 to Louis Melzack, a Montreal dealer indicates:

"Dear Mr. Melzack:

I hope you will not sell that Niagara Falls painting without giving me the first opportunity because I am the right one to have it in view of my desire to set up a Niagara Museum Collection.

I am glad you enjoyed my descent on your Library.

I will say that I have not had so much enjoyment in a single evening for a long time. You are worth a special trip anytime.

I am going to look up a photograph of the little head by Epstein in case you are interested in it. But I don't know that I want to sell it. I have the same outlook as your good self. This one is not liked by my sister and that is why I thought of moving it on.

If you want something else, I will be glad to put you in touch with the sculptor's agents.

Yours very truly,"

In one of Martha's infrequent letters she mentions a chest belonging to Sam. In an issue of *Vogue* she had noticed an article on a Mrs. Lydig whose first husband was A.E. Stokes. Martha understood a friend of hers and Sam's to say that the chest came from Mrs. Lydig's family — Spaniards and related to the nobility. Is this perhaps a clue to the unusual chest in the livingroom of River Brink, a bit of a mystery piece and a fascinating one?

At least forty works of art as well as many shipments of books and etchings acquired through Maggs Bros. entered the collection in 1958. By now Sam was showing a far greater degree of self confidence in his own taste and an immense

Martha, Sam's older sister, the gold medallist
shortly before her death in 1959.

depth of knowledge in everything from the subtleties of print making to the diversities of painterly styles. He was also interested in old silver, English and French in particular. Sam had become a true connoisseur.

An invitation which pleased him came from Osgoode Hall when he was invited to the unveiling of the portrait bust of Dean Falconbridge, one of his teachers, for which Sam had undertaken the commissioning. In a letter to George Stoughton, a Canadian legal friend, Sam wrote, "I had a letter from Dean Falconbridge a few days ago thanking me for having got the portrait done. Back in the spring I was told that our Benchers, of whom I am one, had unofficially refused to pay for the job, so I took it on myself." From his friend came the reply, "I chanced to see the Falconbridge edition of the Canadian Bar Journal which had the frontispiece which you commissioned. Bill Dunn will tell you that he and I always enjoyed the running battle between Falconbridge and Hancock."

In his own gallery, Sam was very keen to add a portrait of Lt. Col. Simcoe. He wrote to the Dean of Exeter Cathedral thanking him for permission to copy the Simcoe bust in the church. He also added, "I have been trying to trace portraits of Governor Simcoe. There appears to be a portrait known that has not been located and I have strangely located a hitherto unknown portrait of Governor Simcoe in the Church of

England Divinity College (Huron College) in this city, which is said to have been the gift to the Bishop Hellmuth by daughters of Governor Simcoe." In another letter Sam expressed the opinion that it was not in good shape.

At the close of 1958, Sam wrote to M. Jules Beauroy, Consul General of France in Toronto, "My friend Dr. Pierre Picarda has suggested that I join him at his office in Paris for special experience in the practice of International Law." Sam wanted to know what he had to do for admission to France and for residence for four to six weeks at a time over a period of six months. He had already started the wheels revolving for admission to the Quebec Bar with the presentation of a $15.00 fee.

In June, Martha came home from Sarnia. She was sixty four and looking forward to retirement soon. She had planned to travel during the summer and was about to embark on a cruise when she suddenly complained of pain. She was hospitalised, but died very suddenly on July 12, 1959. Sam was shocked and devastated. The self contained apartment to be built over the garage at River Brink was designed to be Martha's retirement home. Shortly before her death Martha had sent a paisley shawl to Upper Canada Village. The colour was not identified except that it had a brown border and a woolen fringe. It was apparently a Sutton legacy and connected with her Chrysler antecedents, of the Chrysler farm featured in the historic village.

After Martha's funeral, Sam received cousins and friends at the family home on Oxford Street. His Aunt Eva Thompson's daughter, Grace Thompson, and her nephew Fred, the son of her brother Bert Thompson came by train from Toronto to London for the funeral. Fred remembers that there was a large crowd present and that he and his Aunt Grace stayed about an hour. Sam insisted that he drive them to the train station. They arrived with considerable time to spare although there was already a large lineup. Sam barged ahead of the line and shouldered his way past the guard and they followed him to the track. Sam was in a hurry to get back to Oxford Street. When finally the guard opened the gate and the lineup surged through, they got very dirty looks. Grace was very embarrassed. Fred's comment was, "That was Sam. He wanted to get back to the funeral of course!"

Scarcely a month after Martha's death, Sam established a gold medal in her memory, the inscription to read: "Frances M. Weir, Gold Medal in English and History, the gift of Samuel E. Weir Q.C. through the Weir Foundation in memory of his sister who died in the year 1959 and who was at the time of her graduation in 1916 the winner of the Governor General's gold medal which was then awarded to the best student in the

Honours English and History Course." As always he turned to his art collection for solace in his loneliness and this time for his grief over Martha's death.

Throughout 1959, Sam wrote with frequency to Lillemor, sending her piles of magazines and information about Canada. Wherever he was, New York, Nassau, London, he wrote, pleading for answering letters, telling her of his plans to establish the Paris, London, New York connected offices. Some of her replies are coquettish, but usually she tries to make it clear that she thinks of their correspondence as an amusement, perhaps a reunion somewhere, perhaps not. Sam's handwritten drafts and duplicates indicate he was driven frantic in his efforts to see her again, his usual caution in committing himself to showing his feelings in print quite blown away.

Concerning Martha's death "I feel terrible about it," Sam wrote to Lillemor in August. "I have no close relatives here now. Only in New York. And as I am wealthy there is no reason to keep on here. Am interested in international work and have made the arrangements for London and Paris..." Again he invited her to come to London to visit and to study law. His elderly partner, Greenlees, having undergone an operation in January and not having made a good recovery, retired in April. Another employee, Proudfoot, left the firm unexpectedly. Sam was overwhelmed both by grief and by the increased work load. In some of his letters to both Lillemor and to friends there is a bitterness and a certain truculence creeps in. Yet he wrote to his young cousin John Weir in Edmonton offering him a position in the firm, but the western Weir declined.

In October of 1959, Sam, always on the lookout for portraits to enhance the historical importance of the collection, wrote to Henry A. Sutch, the London dealer:

"In the Christie Sale for Friday, November 6th, 1959, there is listed a Portrait of General Gabriel Christie, Lot 109. The Artist is stated to be David Martin about whom I have no knowledge and I expect he is not of any particular gift as an artist. Also, the painting is pretty large being 49 inches by 39 inches. But if you do take a look at it and see that it is worth while, I would not mind buying it at a low price. It is of Canadian historical interest. But, of course, Christie is scarcely known to the Canadian public.

Ken Thomson suggested to me a while ago that if I could get him a Lawrence of as good artistic merit as the Portrait of Dundas which he holds, he would be willing to trade me the Dundas for my historical collection. So you might keep this in mind."

Sam kept his eye peeled for such a Lawrence at a price he considered within reason for a good many years. From 1958 onward Sam had done some 'trading up.' By this time he wanted only 'the best' and 'quality,' the true mark of the connoisseur. As well as the inevitable prints and drawings of Niagara, many splendid items were added throughout 1959.

Closer to home Sam wrote many drafts of an agreement with home owners back of his property on Oxford Street. The subdivision had been approved, but sewers, storm sewers and sanitary piping were to go through Sam's land, now reduced to 276 feet on Oxford Street and 660 feet on Summit Avenue. Sam wanted all precautions taken to make sure they were adequate for the subdivision, but also in case he might want to build a high rise on his lot. The business of drafting and re-drafting specifications went on for a year. Finally Sam was satisfied and they were passed by the city council.

Sam had his own unique way of dealing with requests for money. Once he was approached for the United Way by a senior partner of one of London's top legal firms. The sum of $300.00 was suggested as a suitable donation from him. With old snubs in mind Sam took a lofty tone. "You might be interested to know that I have been helping out some lawyers in this city and have always refused to participate in general fund raising where I have no personal contact with the application of my money," he wrote back.

The daughter of his cousin, Agnes Weir Randolph, Penny Krull, remembers asking her 'Uncle Sam' to pay for her to go to Hawaii as a reward for doing well in her last year in high school. Sam said no, and that was that, so Penny thought. The next time she saw him he presented her with a large can of pineapple. "Here's your trip to Hawaii," he said. "That was Uncle Sam," remembers Penny. "He could be generous but when he didn't want to do something, nothing would budge him. I got to Hawaii later myself. Perhaps that's what he had in mind all along."

Writing personal reminiscences is not an easy task, but Sam had wanted to compile enough to make a book. He did make a start in some short paragraphs, but obviously became bored with the project and let it go. His friends and foes alike remember him in so much more colourful stories and terms than the rather objective accounts of persons long dead and stories of trivial events of long ago that he was trying to recall. It is easy to understand that he lost interest in the project — a project that would wait for a later date.

17 ADVICE, PERSONAL GRIEF AND CANADIAN ART

In the press of family affairs Sam did not submit his application in sufficient time to be called to the Quebec Bar in June of 1959, but he took pains to see that all would be in proper order for a December calling. Membership required a knowledge of Quebec's civil law based on the old Napoleonic Code. The last Ontario lawyer so called before Sam was Hon. Lionel Chevrier, Chairman of the St. Lawrence Seaway Commission.

To his friend, Mr. Justice Robert Irvine Ferguson, Sam wrote in August thanking him for a clipping of Fryern Court. Sam noted that the sculptures are of heroic size, hard not to stumble over. "It wasn't greatly different from my own place except that my obstructions are not sculptural ...No juniors...can't get along with them. If I can't get mature fellows, not 9 to 5ers, I think I will have to sell out and get a much needed rest."

In September he did manage to take a break and attend a Commonwealth Law Conference at which he struck up friendships and subsequent correspondence with an Australian lady, a widow, Mrs. Simpson. But Lillemor from the Conference of 1955 was still very much in his thoughts.

Right after the 1960 New Year Sam wrote to Jim Humphries, the son of his friend, William Humphries, with advice to a young man wishing to become a lawyer:

"If you wish to practice law in the United States, then Harvard is the place to go, to whose graduates go most of the plums. If you stay in Canada then you should become the master of both systems of law prevailing in Canada. McGill or better still the University of Montreal for your Arts course."

Sam advised living with a good quality French family:

"...following in the footsteps of the greatest lawyer of all time in Canada, the late M. Eugene LaFleur."

He recommended going into public life:

"I am sorry to confess to you that I am not a Church goer or a member of any organized religious faith. But I find great satisfaction in my profession. The ethical standard of a fine lawyer is somewhat above most things in this world. You will remember that Cicero was a lawyer. He wrote a series of letters to his son whom he had sent over to Ancient Greece for study and if you will read these letters you will see that although Cicero was what is now called a heathen, he expressed standards of conduct of the very highest

order and above the requirements of the present day law."

Sam had certainly not shrugged off all the teachings of his forebears in that he seems to imply that one is either Christian or heathen and Christian is the approved path to follow. In so many letters to his friends he indicated that he had found the practice of law tedious and frustrating, but to the young man he makes the points of an elder statesman.

By the end of January 1960 Sam was very ill again although he was able to act for a lady who protested the building of a firehall on her property by expropriation. Sam claimed that the house, one of the earliest in London and well over a hundred years old, should be maintained as an historic property. He won. Bentley Baldwin was a City Councillor at the time. Sam did not record whether Bentley was for or against the firehall.

Lillemor did write to him in February, a most impersonal letter thanking him for Christmas gifts and enquiring politely about his health. Sam vented some of his frustration out on Frank Worrall who had a number of his paintings on hand for restoration, reframing and so on, and who was taking his time about finishing the jobs. Sam underlined three that he particularly wanted finished and

delivered so that he could have a least one room where he could entertain guests. He wrote to Worrall to hang "…the Augustus John – then take it to the British Artists Show at Western. Then get it back – with the hangers in place."

Chest troubles had plagued him again the first part of the year. He seemed unable to recover from flu caught in January and resulting in congestion of the lungs. He kept on working as best he could, but his comment to his friend H.B. Smythe in Montreal was "…No fun at all." To another friend he wrote, "…seems pretty definite that I have got to be out of this climate for most of the winter. That knocks a good deal of the working year." But if he were contemplating living and working in London and Paris, he would have found the dampness and the chill in the buildings a real trial.

In a letter of March 14 to former Supreme Court of Canada Justice, and then Dean of the University of Western Ontario, I.C. Rand, Sam invited him to act as Counsel and have his name on the letterhead of his international firm, the first Canadian such effort of its kind, according to Sam. Rand would receive an honorarium each month and no professional work would be expected. Sam outlined the credentials of his associates, R.R. McNutt in New York and Pierre Picarda of London and Paris. That Rand had not been called to the Bar in Ontario or New York did not disturb Sam. He figured it would be easy to arrange as the dean of a university.

In the meantime Sam helped to draw up a manifesto of the Ontario Institute of Painters, headed OUR POINT OF VIEW in five short paragraphs.

1) We believe the painters' concern should be with the warm breathing world of the flesh and blood and growing things.

2) To cease to represent the visible world and attempt to paint the incomprehensible is to abandon his proper sphere.

3) To learn from tradition is to benefit from the experience of the human race of all ages, to reject tradition entirely is to return to the vague gropings of the primitive man.

4) To express his ideas and feelings and by means of conception, composition and style, form the objects of his picture into a unified and harmonious whole.

5) The traditional artist, each with his own individual discernment of beauty, is not concerned with passing fashions. We are therefore confident that traditional art, with its infinite variety, will be vindicated by artistically intelligent people.

Sam's sentiments exactly.

The Queenston property by now was taking up much of his time and interest. Sam told a friend that he was needed on site to give instructions. Extra windows were to be added on the south end and a fallout shelter in the basement. However he was still very much a part of the OIP activities and at one point got into a "very hot" argument with Kenneth Forbes who claimed, according to Sam, that the artist is the expert and that his opinion is invulnerable, whereas Sam claimed that the artist is very rarely a good critic. Sam apparently enjoyed the fracas. The onlookers, the other members of the OIP executive, enjoyed it as well, two informed and opinionated persons hurling insults at close but respectable quarters. By the end of the year Sam sent the OIP a bill for $558.55, of which $500.00 represented a fee for drawing up rules, regulations, application for letters patent and so on "as agreed." He may well have felt that since he had paid them well for their artistic expertise, it was the artists' turn to pay him well for his field of expertise.

In July he wrote to Ruth of his concerns and about an acute pain shooting down his arm which alarmed him a great deal as he thought it was related to a heart problem. Sam explained to Ruth that the pain disappeared after he would take coffee with evaporated milk. More doctors were consulted and with an x-ray of his 'inward economy' Sam was put on a diet and 'restricted conditions.' He did notice some improvement, but one trouble was a hernia of the diaphragm.

Ill as he was, Sam fired off a two page letter on July 14 to T.D. MacDonald, Director of Combines Investigation, Department of Justice at Ottawa on the subject of what he felt were combines among publishing houses and their agents. Sam had had to order books from Canadian distributors for a much higher price than he would have paid had he ordered the books directly from the offshore publishers. He felt with some heat that he should be entitled to order books, especially law books, directly from the foreign publishers. He regarded the elevated price to Canadians as a form of unjust taxation.

In a letter of August 16, 1960 Sam wrote to his cousin, Irene Rempfer, that he was expecting Ruth and Wilbur to visit him in the fall and that Irene would be so welcome at the same time, probably late September. He wrote more letters to Lillemor, addressing her sometimes as Princess and sounding ecstatic when she sent him a card. He reminded her that they had met when he attended a Commonwealth Lawyers Conference exactly five years ago. He was planning to be in Ottawa for the next Conference within the next few weeks. Lillemor was invited to join the family party. Sam claimed that his sister was always chiding him about his bachelor state. He definitely had a proposal of marriage to Lillemor in mind, but she was non-committal. As it turned out Lillemor, Irene, Ruth

and Wilbur all failed to make the trip. Ruth's high blood pressure and other health problems prevented her and Irene, because of her age, did not feel up to it.

In November 1960 Ruth suffered an attack and died very suddenly. Sam was utterly devastated. The sister he loved almost like another mother, and upon whom he depended in so many areas of his life, to be taken so suddenly and so soon after Martha's death was a blow from which he never fully recovered. Only two months before her death there had been a series of short animated letters between the brother and sister on the subject of the relative merits of electric ranges destined for River Brink's kitchen. Ruth's death made a deep hole in his life and his loneliness was intensified. The one bright ray was that Sam and his brother-in-law were close friends and became an important support for each other.

In the latter part of the year Dr. R. H. Hubbard, Curator of the National Gallery, and Sam had been in frequent communication. Sam offered to have photographs taken of his most important works and he undertook to send copies of the photographs along with sizes and provenances to him. Hubbard frequently sent his grateful thanks to Sam. Again in a special period of loneliness and mourning, his collection of beautiful works of art was the greatest source of comfort to Sam. He had acquired a *Winter Scene with Horse Drawn Sleigh*, a

watercolour signed P.G.C. and obviously a view of Montreal. It was Hubbard who suggested that P.G.C. might well stand for George P. Conklin, an engraver and lithographer of the period who was active at the appropriate time in Montreal.

Throughout the late fifties and early sixties Sam's real sphere of interest seemed to be in the acquisition of art and artifacts of historic importance to Upper and Lower Canada, mainly Upper of course. He made it clear that he wanted to possess a copy of all Suzor-Coté's sculptures, even works done by Suzor-Coté of Matilde. When it is remembered that Matilde was first his nurse after his stroke for five years and then his wife and nurse for the ensuing five years, it is difficult to accept that these late works would have true artistic merit. Sam had written to Matilde in May of 1958 with the news that "one of the partners of Roman Bronze works was bumped off by his father-in-law after they had had a fight at their summer home about how much paint would be required to cover the house. This was Battalgia, one of the two working partners. Mr. Schiavo does the office business," yet it was Philip Schiavo who took over the Roman Bronze Works and became a good friend to both the Suzor-Coté family and to Sam as well as many a Canadian sculptor.

In April of 1961, Sam was elected a Bencher for the third time. Again the notes and letters of congratulation

Acquired in 1956, this bronze work, *L'Essoucheur*, was one more Suzor-Coté acquisition. Sam Weir wanted to own a copy of all Suzor-Coté's sculptures.

poured in from across the province. It was obviously a popular win in the minds of lawyers practising in small cities and in rural communities. Sam was obviously delighted to have won with or without the support of the prominent legal fraternity in London. His ingrained habit and characteristic standing up for what he perceived as the right, the best interests of the citizenry at large, the just and the moral, had given him something of a maverick reputation. Lawyers practising in the small and sometimes remote, it seemed to them, areas of the province responded with approbation. At this time also Sam was admitted to the Harvard Club and his Wall Street office was doing well.

Kaye Lamb, the Dominion archivist wrote to Sam enquiring if he would be attending an auction at Parke Bernet in New York. He wanted a certain ship's log book and asked Sam to keep an eye on the bidding. Sam was interested in the item as well. Lamb was willing to bid up to $150, but Parke Bernet made an error and wrote down Lamb's top bid as $50.00. Sam got it for $60.00, but when the two of them settled the mistake, he wrote to Lamb that he could have it for the $60.00 Sam had paid for it. In addition to all these other interests Sam was in frequent touch with Ruth Home, a fellow member of the Ontario Heritage Conservancy. Sam had discovered the Butler House in Niagara-on-the-Lake and was most anxious to persuade her to try with him to have it preserved.

To keep his house in order, Sam employed a Chinese houseboy, Mark Gar, the son of a landed immigrant. Sam then had to see about citizenship papers so that Gar could be taken with him to New York. To a friend Sam wrote that he was doing a thorough cleanup at 139 Oxford Street West, the home he had lived in for almost sixty years. Since all the Weirs were inveterate keepers and squirrelers, it was a mammoth exercise. Sam reminisced that the house had been built originally by an English 'remittance man' and without any form of central heating. There were 'fimbles,' holes cut through walls for passage of smoke through pipes which led to the chimney. The pipes were fed from stoves on the main floor of the house. Three fireplaces were kept going all winter. Coal oil lamps supplied all the lighting until gas was installed shortly after the Weir family moved in. Ruth, in training at Roosevelt Hospital at the time, had written a letter to her mother in a rather worried frame of mind, lest they get too deep into debt over the gas installation.

Although Sam was still passionately searching out works of art, documentation for arrivals of works in 1961 is comparatively slim. The death of his two sisters so closely following one another left him without the two confidants he valued most in his art quests. Perhaps it was a potent reminder

189

Samuel Edward Weir's residence, London Ontario, black ball point pen and black crayon by Silvia Clarke (signed LR).

to him of his own mortality that made him all the more keen to fill the holes in his intention of providing a collection featuring the development of art in Canada.

To add to his troubles in 1961, the Ontario Municipal Board approved the sale of the Canadian Imperial Bank of Commerce building for $750,000. Sam had to find new quarters and move his office within an eighteen month period. Reorganization at home and facing a move of his office spaces simultaneously took its toll, physically and emotionally. Over the past ten years or so the clutter of 'fyles' in the office had worsened considerably with Sam's real interests being centred far more on artistic matters than the humdrum routine of his practice. Eventually a handsome Georgian style building was erected for him, which he had sketched by Nicholas Hornyansky, an artist he greatly admired. This building later became the Head Office of District Trust and a London landmark. The sketch was reproduced and used by Sam for promotional purposes.

18 FAMILY AND FRIENDS

WILBUR HOWELL, FINALLY, HAD BEEN ABLE TO TRACE PAUL TO Guttenberg, New Jersey. One evening in May, 1961, Sam went to the address unannounced and knocked on the only door on the third floor of an apartment that showed a spot of light under it. When the door opened, the occupant, a man, dived after a cat that sprang out first. With a sense of shock it occurred to Sam that this man was his brother. Wanting in turn to shock Paul into some sort of recognition, Sam at once said, "I have come to see if you will look after my funeral."

"Whose funeral?" asked Paul, for it was he. "My funeral," replied Sam. Paul slammed the door in Sam's face. Sam was not even sure that Paul had known him.

Sam wrote to a lawyer in Guttenberg recounting his experience, pointing out that the brothers were the only surviving members of that generation and that he wanted to make his will without giving his trustees a lot of trouble, and also he wondered whether Paul would accept a considerable legacy. Sam pointed out to the lawyer that his brother had been dangerously ill in the early twenties, stricken with sleeping sickness and typhoid fever, apparently together, and had been unconscious for some weeks. Afterward he had acted rather strangely for a long period and that, in living with his sister in Queens, he was the cause of strained relationships all round in her household. Eventually a serious disagreement had ensued

after which Paul, or Carl, as he wished henceforth to be known, had left the house and had refused to communicate further with his relatives.

The lawyer responded that he had been retained by Paul in a case in which he was being sued for slander. Paul, registered as the owner of the building at 18-69th Street, Guttenberg, ran into trouble when he felt he was over assessed for tax purposes on the property. He wrote letters to the local governing authorities vigorously setting out his opinions and inferring that properties belonging to the local authorities were greatly undertaxed. "He may have been right," wrote the lawyer. It was alleged that Paul had threatened the town attorney, but later claimed it was a hoax. Resistance to property tax certainly ran in the Weir family. The lawyer promised to contact Paul on Sam's behalf.

By August, the lawyer wrote to Sam informing him that letters he had forwarded to Paul were returned to him after being opened and reglued. After such a rebuff the brothers were estranged completely until Paul's death, when of course, the lawyer brother had to wind up his brother's affairs.

In October 1961, Sam was still addressing letters to Lillemor Johannson. These had become ever more outspoken and romantic in a curiously detached way. Lillemor found his letters off putting. One letter asked bluntly: "Can you have babies? Do you want babies?" However, during this period Sam often visited Isobelle Erskine's bookshop, the first paperback bookshop in London. She also had classical records and, what first attracted Sam, the walls were hung with paintings and drawings. Sam was invited to her openings and Isobelle was invited to his office for tea. She remembers it strewn with books, silver and paintings. "You never saw such a mess." But there were wonderful occasions when, the tea being poured, the ceremony of unpacking a new batch of treasures followed. "His taste was not infallible," Isobelle remembers. "He would test others to convince himself that he was not being diddled." When Agnes Randolph was in town on legal business involving herself and Sam, Isobelle was invited to the house for dinner with Agnes as chaperone.

The living room Isobelle remembers as charming, gracious and attractive. The host she remembers as "an untidy, huge, ugly man. He could be hostile and contemptuous, even aggressively so." It was her opinion that the local lawyers did not know what he did. "The dining room was a shock, a pleasant one, with its subtle elegance, the outstandingly beautiful silver, used every day and not put on show for visitors. The Chinese houseboy was a touch of the exotic for London." Accompanying him upstairs to see more books, "...incongruously there was a collection of cookbooks, about

193

five hundred volumes," Isobelle recollects.

"What do you think of this? Do you know who painted this?" were questions reiterated over and over. Everyone always used the side door and, with so many worries for Sam to contend with, Isobelle remembers that it was not surprising to her that the grounds inside the stone fence were not looked after. But inside everything was gracious. Floor to ceiling shelves were built in around the semi-circular extension on the library. Boxes were piled everywhere on the floor, treasures to be opened, examined and enjoyed, all the marks of the collector with a true passion. Isobelle remembers a dinner table conversation in which Sam claimed he had read somewhere that only male hormones were influential in transmitting intelligence or lack of same to the offspring. Therefore, Sam claimed, a man of high intelligence could marry an unlettered peasant and produce exceptionally intelligent children. The mother's genes, he claimed, did not matter and had no bearing on the child. Since there was no point in arguing with Sam when he was convinced of his position, Isobelle kept her silence, but laughed heartily afterward and decided not to let the relationship take a more intimate turn.

In October a car turned suddenly in front of Sam and his knee, still in a fragile condition from previous accidents, was further jolted. This only added to his aggravations. He also was concerned about the Queenston house. It was still without a heating system and already he had stored some good furniture in it. His new office was not ready for occupancy as yet and he thought longingly of spending the entire winter in New York away from ice and snow and any more damage to his knee. Wilbur was planning to spend the entire winter in Spain so that the house in Queens would be untenanted. The following month, Sam fired off cables to Lillemor begging her to come to Canada, promising to send her the air travel ticket. In December of 1961 Sam sent another cable to Lillemor: "Please be a good girl and reply to my letter, Love, Sam," the first time in all the letters that have been saved that he used the word, 'love' in writing to her.

In the early part of 1961, while in Montreal, Sam had met a young lawyer, Joan Clark, and something of a low keyed courtship began with the discussing of cases of mutual interest, then developing into more personal subjects. That the lady in question, as a practising lawyer, would seem to have more intellect than an unlettered peasant did not deter Sam in the least. Perhaps he gradually forgot the article which had so amused Isobelle. By the beginning of 1962, letters to and from Sweden dwindled and then ceased. Letters to Montreal took their place.

Sam was, of course, well known as a discerning

collector in New York and London, but on January 10, 1962, he wrote to a gallery in Boston outlining his interests and purpose: "I am interested in picking up paintings of Canadian worthies or persons connected with the history of Canada by important painters. This is what I am concentrating on at the present time. I recently bought a portrait of Sir George Yonge by Beechey...I also recently bought a portrait of Wolfe which is causing me to do some research. ...I have a nice little landscape by Grant Wood. I would like to get a particularly good Childe Hassam. Bellows and Speicher also interest me."

Impressed by the remarks made by J.C. McRuer, Sam wrote to him on January 29, 1962, pointing out that he advocated the operation of a fund for payment of all damages occurring in the use of automobiles. Sam noted what he saw as: "The tremendous and growing amount of sharp practices in private adjusting and preparation of untrue material for presentation to the Courts to determine the liabilities of the respective parties." Sam decried deciding liability on a percentage basis. He also spoke out against the accelerated trend toward throwing the rights of citizens into Commissions and Boards, a matter of much concern to him. He also brought up a question which had troubled him for some time, that of an injured party seeking damages who seemed to recover with remarkable speed once a sum of money was awarded.

The restorer, Frank Worrall, upon whom Sam depended heavily for advice on all paintings he bought, found himself in difficulties in being paid for a painting given to a client on consignment in 1962. Worrall was eighty years of age. He had purchased a Jan Van Goyen from a Toronto doctor, a newcomer from Holland, and had sold it for $2500. Worrall asked Sam to retrieve either the painting or the money after five years of stalling on the part of the buyer. Sam took on the case and traced the client to New York. The case dragged on for five years more at which time, when Worrall was eighty-five years of age, the client surfaced and offered to buy the painting at the 1962 price. Art prices had escalated in the intervening years and Sam went to court for his old friend and won a respectable settlement.

Sam's interest in pictures of and books about Wolfe was increased greatly when he thought that he might be a collateral through his grandmother Sutton, who claimed they were descended from the Wolfe family. The General had never married and was reputed to be a misogynist. Sam was also on the trail of acquiring a Thomas Hart Benton sketch. To this end he corresponded with the artist who had just completed a second mural for the Power Authority of the State of New York on the theme of "Father Hennepin's Discovery of Niagara Falls." The colour sketches, he was informed, would be available after

the completion of the building. Whether due to ill health or forgetfulness, Sam apparently did not follow up on this possible acquisition from so notable an American painter, an acquisition that would have furthered his goal of a museum on Niagara.

19 A FRAUD CASE, A FOUNDATION, AND A FLOUNDERED RELATIONSHIP

IN THE COURSE OF STUDYING ITEMS OFFERED FOR SALE FROM VARIOUS dealers in Britain, Sam came across an offering of a 'Grant of Letters of Administration by the Archbishop of Canterbury' developed while the Ecclesiastical Courts were still functioning over the personal property of deceased persons in England. Sam obtained it and presented it to the Law Society of Upper Canada, pointing out that, "…you will note that although it is stated that the administration, accounting etc. are 'well known to appertain only and wholly to us,' King George managed to get a tax stamp on it. It is most interesting to see that a good deal of the language of this document is used without alteration in our Surrogate Court grants today."

In March Sam and Frank Worrall set off for New York. A dealer wanted to trade a French Impressionist of Sam's for a Cullen and a Coburn. Sam wrote to him on March 23, 1962: "I rarely ever part with anything I buy. I make pretty sure of wanting it before I buy it. So I don't have any Impressionist paintings to trade or even to sell. As a matter of fact I only own 4 or 5 of them anyway. If I were to sell them, I would make a large sum but they are better to look at than the money." Sam subsequently bought the Coburn for $900.00 US.

Sam found himself involved in the notorious Art Fraud Case in which Leslie W. Lewis and Neil Sharkey were charged in a far reaching and well publicized scam.

Inadvertently Frank Worrall was involved and Sam defended him. As well as working on restoration projects for Sam, Worrall had a great many well known and influential clients, including the Province of Ontario for whom he was responsible for the cleaning and care of the paintings in the Legislative Assembly. He had known Lewis in England before Lewis, the art dealer, had arrived in Toronto. So it was natural that Lewis would turn to Worrall now that both were active in Toronto, and when Lewis had repairing and cleaning jobs for Worrall.

Without warning, Worrall's premises were entered by members of the RCMP and by Nathan Stolow, Director and Scientific Consultant of the National Conservation Research Laboratory of the National Gallery. Paints, equipment and paintings were seized and were found to be similar to paints used by Rita Mount, a Montreal painter whose works were used by Sharkey without her knowledge with forged signatures of members of the Group of Seven and others.

Sam was incensed at the intrusion and defended Worrall. He argued, successfully, that the pigments seized were used by Worrall solely in his restoration work and were used by everyone, which was no proof at all that Worrall had been part of the Lewis and Sharkey ring. Several of Sam's acquisitions were, in fact, in Worrall's basement at the time of the search and awaiting the elderly restorer's attentions.

Sam and Judy LaMarsh, Niagara Falls lawyer and federal cabinet minister, were good friends and frequent correspondents. Many meals were shared together when she was at home in her riding of Niagara. At one point a young man spread the rumour around London that she was promoting Sam for Liberal candidate in Middlesex. "How do you do it?" asked Sam in annoyance. At the same time, he expressed his disgust once more regarding the pettiness of the work in the Law that kept him so dispirited. Sam asked her to see if Lester Pearson could assist him to get a job either full or part time with the United Nations. With his office in New York, a part time posting in New York seemed to him at this point a most attractive idea. Whether the suggestion ever got farther than Judy LaMarsh herself is not known.

Every so often Sam and Judy LaMarsh would exchange short and pally notes. One from Judy started off, "Sam dear" and ended: ..."take good care of yourself and much love, Judy." It was a good natured bantering relationship, hardly deeply romantic but obviously enjoyed by each. When Sam learned that Charles Comfort, Director of the National Gallery had retired, he immediately wrote to Judy about his availability for and expertise in such a position. Time and again Sam made it evident to Judy and to others that he wanted desperately to leave London and go on to a position of prestige elsewhere,

almost anywhere. In October Sam received a letter from Paul Martin, Secretary of State for External Affairs indicating that he had taken note of Sam's interest in an appointment as Consul General in New York and that he would be glad to keep Sam in mind. But nothing came of it.

On July 8, Sam wrote to Nutter in jubilation. The apartment in Queenston was occupiable. He was able to bunk, as he put it, in Queenston at last. But there were still things to be done in London. In October, Sam wrote to the Postmaster in London with a request to move the delivery box closer to the street or across the street at Richmond and Dufferin. "The box is a disfigurement as well as blotting out to some extent the view of the garden." It was typical of Sam that an annoying detail should bring forth a letter calling for action just as much as more important situations that affected the entire country.

After much cogitation and investigation into how various foundations were organized and to what purpose, mainly in the United States, Sam was ready to sign into law, the Weir Foundation to protect his art collection and to save it for posterity. Accordingly on November 5, 1962 the document bringing the Weir Foundation into being was duly signed and sealed. The signatories were Sam, of course, Wilbur Franklin Howell and Olive Loretta Woolcock, identified as accountant and who was Sam's office manager. If the Weir Collection and Library of Art could be said to have a birthday, November 5, 1962 would be its Founders Day. By mid-February of 1963, the Weir Foundation was a *fait accompli* and Sam hoped to improve his personal tax situation thereby. In his searches for filling in missing parts of his collections, he also wrote for assistance to the Selden Society, a rare book locating service based in Amsterdam.

In December of 1962, Sam had a dizzy spell. It concerned him that Worrall was not getting his work done. After all Worrall was now over 80 years of age. "You seem to be almost entirely monopolized by Ken Thomson and Eric Phillips, and others who are there on the ground pushing you," he wrote. "Cut the phone a couple of days and do the Montreal sleigh, so it's half finished and the two Lake Erie Naval Battles. I want to hang them in the Queenston apartment."

The year 1962 was one of great activity in Sam's collection. Some of his most important non-Canadian works arrived, frequently from sales at Parke Bernet. Mary Cassatt, Degas, Epstein, Augustus John *et al* joined the collection. An oil by P. Wilson Steer, *Effect of Rain, Corfe*, purchased for Sam by Maggs Bros. from a Sotheby's sale in London, was formerly owned by Somerset Maugham. Sam wrote to Somerset Maugham about it and received a pleasant reply. Two Franz Johnston oils, *Belle Rapids* and *The Belle River, Rouyn Quebec*, also

199

arrived in London.

The following year was an above average period of acquisition. Views of Niagara, many lithographs from unknown artists but of historical importance, a black and white mezzotint *Portrait of James Wolfe*, a subject of great interest to Sam, along with a Verner watercolour, *Indian Encampment*, Horatio Walker's *The Turkey Girl* and a landscape by his old friend Homer Watson all found their way to the Samuel E. Weir Collection at this time.

To see in the New Year, 1963, it was arranged that Frank Worrall would come to London. It was to be both business and pleasure. Fortunately Worrall was staying in the house, since right after New Year's Day Sam suffered a severe case of lumbago and Frank stayed on to help him. As soon as he was able to travel to New York in late February, Sam consulted with the best physician he could find. Osteoarthritis in the lumbar region was the diagnosis, with sciatica the immediate result. It was a situation which would give him increasing pain for a number of years.

Sam's interest in the genealogy of his family was growing. In a letter to his cousin Irene, daughter of his Uncle Samuel, he wrote in late February that he was beginning to be able to get around after the lumbago attack and reminisced about the family. Sarah Bawtenheimer Weir had thought of

Irene's stepmother as 'hoity toity' toward poor relations, while Sam's father anticipated each letter that came from his brother Samuel. "It is a very strange world," Sam mused, "We had many relatives not too far away who more or less looked down on us because of our poverty. But by the strange turns that life takes, I expect that I could today buy the whole bunch of them out and have quite a margin besides. This particular type of relative now finds occasion to get in touch with me quite frequently." He might also have added that his sister's New York home was also a reason for the new found popularity of the George Weirs and their relatives. Sam went on, "I remember how impatiently my father used to wait for letters from his brother Sam and how he used to answer them forthwith. There was a great affection there."

At the end of February Sam offered a dealer in Montreal one half the asking price for some early Canadian silver. The dealer angrily refused and gave Sam a dressing down. Sam immediately fired off a testy reply. His aches and pains were not helping to sweeten his temper. However friendly letters from Miss Joan Clark in Montreal probably helped. They all begin, "Dear Teddy" from which it can be inferred that Sam intended to bring the lady into the family.

A dealer in London, Ontario, Harry M. Ellice offered Sam three silver tumblers, early Canadian and all hall marked.

Mr. Ellice insisted on selling the three as a group for $2000.00. Maillou, Ranvoyze and Chambellan were the silversmiths. Of fine workmanship, the three made a splendid addition to the collection. Perhaps with a memory of the Montreal dealer's displeasure, there was no counter offer made to Mr. Ellice. Sam spent some months examining these fine examples of Canadiana, but finally succumbed and sent Mr. Ellice his cheque for the asked price.

After rushing Lillemor, it must have seemed a flattering change to be rushed himself. Each and every day brought letters and telephone calls with glowing compliments and protestations of undying love from the young lawyer in Montreal, Joan Clark. Sam responded and the telephone bills mounted. In March he sent her a bouquet of roses and she thanked him fulsomely. Sam had an impressive list of clients. In his record book there were pages of listings of litigations pending, more pages of conveyancing, collections, companies and estates for which he was acting. His was a profitable practice. Miss Clark showed some interest in it and, in passing through from the United States back to Montreal by train, she stepped off in London to look him up. From at least one letter to Sam, she enjoyed her visit, hinting very delicately of their time spent together with him alone. She spoke of the 'sweet cradle,' an antique which Sam lately had brought in from the United States. Sam at that time had been dreaming of a marriage with Lillemor and characteristically had bought the cradle with an heir in mind before he obtained a bride.

Sam seems to have been somewhat overcome by the advances made by Joan Clark. She was anxious that he meet her father. He did so and her father was most favourably impressed. Sam was invited to, as he put it, a state dinner to meet her mother on his birthday. Miss Clark baked a birthday cake which he later described as "terrible." He made her an offer, both of marriage, which was accepted, and of partnership. The arrangement was to be that she would put up $20,000 to buy into the practice, the value of which was well over a million dollars, and they would share profits equally. A day in April 1963 was set for the wedding and all arrangements were made by the bride's family for the ceremony, with a reception to be held in a Montreal hotel. The bride, however, seemed to want to defer the wedding but keep the business arrangements. There were many scenes and one, which Sam described in detail, with the bride calling the whole thing off, in floods of tears in a restaurant in Ottawa. Sam lost patience with the demonstrations of tenderness followed by hysterics. He found out more or less inadvertently that he was one of a number of men who had received the same treatment. It seemed as though she was ready to share equally in anybody's

lucrative practice without contributing anything like a fair share of capital.

In a letter to a lawyer friend in Port Arthur, a fellow art collector, Sam wrote on May 24, "The picture market is boiling. Prices are rising so rapidly as to make one's head ache. I think if you were to buy a good Guillaumin or a Loiseau or a Moret, you would have cause to congratulate yourself four or five years from now. ...When I was in England in 1955, I made a very few purchases, but I am kicking myself now that I did not step in and buy a truck load even on borrowed money."

Still on the topic of art, Sam wrote to David Garfield, a gallery owner in Toronto, that at a Homer Watson Retrospective, he had noticed a small work, credited to the Garfield Gallery and from the Sir Henry Pellatt estate. How much was it, he wanted to know. Sam also stated that he was a bit disappointed in the show, "...too much weak work...best period around 1900 had very few examples..."

An advertisement appeared in the *London Free Press* of August 16, 1963, for the District Trust Company: – "Under date of this 12th day of August, 1963, the authorized permanent capital of two million dollars, divided into two hundred thousand shares, par value of ten dollars each. Weir & Associates, Solicitors for the Applicants." About the same time Sam learned from Kingsley Graham, Canadian Ambassador to Sweden, that Lillemor was not licensed to practise law. He also received an Easter egg from her, badly packed and broken and full of ants. It had arrived rather late for Easter but as he wrote to her in a short thank you note, "Nice ribbon though."

In November of 1963 Sam discharged Mark Gar, the Chinese houseman. Gar had made the mistake of washing a porcelain elephant, which was never to be subjected to water, on Sam's orders. During the last few years, from 1959, Sam had been advertising, apparently with some regularity for a housekeeper. Previously, a French Canadian lady, Madame Testart, whose talents in the kitchen were most appealing to Sam had appeared. She had remained with him for some years, only giving up the position because of family matters demanding her presence in Quebec. After her departure subsequent housekeepers did not stay long, personality clashes and poor cookery skills seemed to be the chief problems. Sam and his housekeeper corresponded each Christmas until her death and whenever Sam wanted to get the recipe for one of his favourite dishes.

All in all, 1963 had been a year of aches and pains as well as disappointment and general frustration in his hopes and machinations of quitting London and relocating with a certain amount of glory attached to an official position in the arts field in Ottawa or in New York. However offsetting the

Original etching by Nicholas Hornyansky *Weir's Law Office*, dated 1963.

disappointments, he could now rest his bones in what was to become his beloved River Brink and dream of the day when it would be the setting for all his treasures.

On January 7, 1964 Sam received a letter signed 'Judy' on government letterhead claiming that she knew nothing about the impending retirement of Comfort, but that there would be an opening for a representative from London on the Canada Council. However nothing came of that observation either.

Whenever Sam caught sight of an opinion to end personal income tax, he was quick to affirm his approval. In January of 1964 he wrote to the editor of the *Financial Post* regarding such an article and pointing out that he felt that personal income tax is a tax on thrift and that he had written to John Diefenbaker on the subject. He also objected to what he felt was a distasteful form of espionage in the enforcement of income tax. Exposing one's personal affairs seemed to him to be unjustified in a free society. Another interesting point he raised is that because of the revenue from personal income tax as acquired by government, the need for thrift and good management on the part of government personnel was being undermined and eroded.

At a meeting of Convocation of the Law Society, it was announced that Sam had presented two Massachusetts deeds, dated June 3rd, 1820 and June 4th, 1835. Earl Smith, Secretary of the Law Society, wrote to Sam to express the appreciation of Convocation and the grateful acceptance by the Law Society together with the assurance that they eventually would find a place in the Law Society Museum in the West Wing of Osgoode Hall.

In June, District Trust opened its doors to the public in a series of gala ribbon cuttings and so on. Sam filled a fishbowl with coins and guests were asked to estimate the total amount in the bowl. The winner was invited to take as much as possible in one fistful. Sam was the largest individual shareholder and the Baldwin brothers were also heavy investors. Now Sam could deal in mortgages and the financing thereof from his own company.

Even with the opening of District Trust on his mind, Sam did not overlook a possible addition to the art collection. He wrote to Garfield in Toronto expressing some interest in a Franz Johnston, an addition to enhance the growing importance of his Group of Seven paintings. In July, Sam wrote to Lenore Crawford, art critic of the *London Free Press*, giving her a little history of the London Art Gallery from the perspective of one who was serving on the Public Library Board and vitally interested in the formation of an art gallery for the city, one which would be quite independent of the Public Library:

"It was understood," he wrote, "at that time that the upper floor (of the Library) would be turned over to the Western Art League to operate as an Art Gallery. The part taken by the Library Board, if any, was to be technical only. But the late Mr. Crouch, who was very anxious to build up his domain as Librarian, so engineered things that the Art Gallery became part of the Public Library, and the Western Art League only held meetings at the Art Gallery from time to time."

"There is no question in my mind," he went on, "that an Art Gallery suffers if it is not an independent operation. ...I think you will find that in most metropolitan communities the Art Gallery is a separate organization. And, indeed, it is usually an organization separately created under its own private legislation. In that case, it does, of course, have to seek its own funds."

There was considerable discussion at the time in London as to whether a separate Art Gallery was desirable or feasible. Sam was all for the creation of a separate gallery of course.

In September, Sam was appointed Vice-Chairman of the Unauthorized Practice Committee. After one meeting, the Chairman was heard to declare somewhat ruefully that the committee really had two chairmen. Sam apparently had dominated the entire meeting.

By October 1964, Joan Clark was her loving self once more, at least on paper. Another date was set and arrangements were underway again for the wedding. Abruptly she called it off, finally and with finality. The party arrangements went forward, but without a wedding ceremony or even a groom present.

So angry, upset and humiliated was Sam that he sent Miss Clark a non-wedding gift, a thunder mug. "To Joan Clark" was printed on one side, "From her dearest Edward" on the other. There may have been some significance in the nature of the gift as Sam heard via various jungle tom-toms that the bride had boasted of getting a millionaire, an old character, out of town, to agree to what was going to be a real windfall for her, lots of money in a money making office, not much for her to do and the profits to be divvied up between them. The venue for this reported bragging apparently was in a women's washroom.

In other ways they continued to harangue each other for some months. Eventually Sam would be served with a cease and desist order from the Law Society of Quebec. Thus the

205

affair with Joan Clark ended acrimoniously on both sides and Sam was the sadder man upon realizing he had been duped by a fortune hunter. That he was not the only victim of her series of scams perhaps eased the mortification somewhat. It was a mercy that Ruth was never to hear of the goings-on.

Again Sam came down with influenza, shortly after what would have been his wedding day, and it later turned into pneumonia. He complained of time lost at the office and general ill health right into the next year. Despite his activities and general ill health Sam was as busy as ever, checking over catalogues from antiquarian book dealers and from auction houses, listing paintings, prints, etchings and lithographs.

Sam's stories were famous and his delivery apparently made the anecdotes even funnier. A letter he wrote to the president of the Prest-O-Lite Company in Toledo, Ohio on November 9, 1964, is an illustration.

"Dear Sir:

I am an old lawyer in a reminiscent mood.

I saw your advertisement in Business Week of October 31, 1964. I had not heard of the Prest-O-Lite Company for many a long year.

When I was a law student, the Province of Ontario from which you are receiving this letter, enacted a prohibition measure. Shortly after it came into force, there was a trial at London Court House in which the Prest-O-Lite Company was plaintiff against a man named Mitchell. As I remember it, Mitchell had been the agent for re-charging Prest-O-Lite lighting cylinders for motor cars which at that time used acetylene for their lighting systems. He had had some difficulty with Prest-O-Lite or saw some light in the heavens and proceeded to make his own acetylene cylinders. Prest-O-Lite brought action against him for an injunction. Prest-O-Lite was represented by the famous S.F. Washington, Queen's Council of Hamilton, Ontario and Mitchell was represented by Sir George Gibson, Queen's Council of London, Ontario.

The argument by Washington was that in filling a Prest-O-Lite cylinder, Mitchell was representing that the contents were from the Prest-O-Lite Company or of Prest-O-Lite manufacture. The thing I want to tell you is that Washington made the statement in a humorous vein that as far as Prest-O-Lite Company might know, Mitchell might be filling these cylinders with liquor, and the Judge who was presiding, Chief

Justice Sir Glenholme Falconbridge, rejoined that that was a very good idea, Mr. Washington! My recollection is that Prest-O-Lite lost the case. This was in 1916.

If this brings you a smile in a day's heavy work load, I will feel justified in writing it.

Yours very truly,"

From Parke Bernet, one of Sam's acquisitions was a collection of seven paintings attributed to Thomas Birch, 1779-1881, *The Battle of Lake Erie, 1813*. The Americans won this battle prompting Perry, their leader, to declare, "We have met the enemy and they are ours." He also bought two oils by Loiseau at Galerie Durand-Ruel in Paris and a Joaquin Sorolla y Bastida, *Girl on a Beach* from Parke Bernet. Sam had been on the prowl for a Sorolla for some time, on the advice of Ruth, so this must have given him great satisfaction. A Horatio Walker watercolour, *Man Digging* also entered the collection along with, inevitably, some views of Niagara and other works of historical and general interest.

In January of 1965 it came to Sam's attention that two employees of the Ontario Provincial Police had been created Justices of the Peace within the precincts of the Ontario Provincial Police Building near the waterfront in downtown Toronto. He called the affair scandalous. The court in which he had attacked one of their search warrants took the position that the Justices of the Peace had been appointed and the Court could do nothing about it and had to give full credence to their action. This was all in connection with the action brought by Sam on behalf of Frank Worrall when Stolow from the National Gallery and two officers of the Ontario Provincial Police, along with the RCMP, had searched and seized paintings and some paints in Worrall's, workshop. There never was a charge against Worrall. It angered Sam that a man he had known as a friend for years and had considered honourable should have his privacy violated on what Sam believed to have been a trumped up charge. Worrall had known Lewis and Sharkey, had done business with them, but never, Sam believed, had been a party to the frauds of which the two were to be convicted in a New York court.

During this period Sam was invited to join the Committee on International Law established at the Canadian Bar Annual General Meeting with Maxwell Cohen, Dean of the Faculty of Law at McGill and four others. In January of 1965, Sam became a Life Bencher of the Law Society, an honour automatically bestowed after three elections.

20 THE PLAGUE OF ILL HEALTH

POOR HEALTH CONTINUED TO DOG SAM INTO 1965. HIS SECRETARY, Mrs. Woolcock, sent off letters to all and sundry who were pressing for action on their various affairs, that Mr. Weir had been sick on and off all winter and at present (this was in March) was home with the flu.

Never slow to make his opinions known, Sam had written to John Diefenbaker upon several occasions on other matters and was following up on his suggestion that individual income tax be rescinded. In this March of 1965, despite his illness, he sent off a telegram, "Why don't you make it possible for me to run against Pearson in Algoma?" Nothing came of it, but the good souls of Algoma would have had a lively campaign for their pleasure and interest, not to mention that the subsequent history of Canada might have been quite different had Sam run and won.

Shortly before his income tax return was due, Sam informed the Justice Department that he was to be questioned. He was keen for this to happen because he had made an affidavit in which he had stated that the Income Tax office in London had carried on a vendetta against him for years. He saw this cross examination as an opportunity to get the ear of the Minister of National Revenue about his complaints concerning the way in which the local tax office was run.

By May Sam and his old architect friend Arthur Nutter

were having a *contre-temps* over work at River Brink. "Honestly, Arthur, I get very indignant at you of late years . . . I remember how my mother slaved to do your washing and tried to make you comfortable here, no matter how long you stayed, which was usually much too long." Sam went on in the same letter to accuse Nutter of costing him far more than a local architect would have done with hotel bills and so forth and "Other advantages while you were here ducking the hot weather in Texas." The rising costs and the unexpected expenses associated with building a house in a location other than one's home base were of increasing concern to Sam. Already there was a gardener on site, described by Sam as a German Canadian, a very severe Mennonite, who apparently worked very hard on the grounds.

Ill health notwithstanding, his international law office was much on his mind. Sam made overtures to Adjutor Dussault, Q.C. in Quebec City with a request to be made a Q.C. in Quebec. He pointed out that he was a pioneer in Canadian practice in New York and that the Canadian Consulate in New York was encouraging him in his endeavours in that city. Sam presented an historical document to the Law Society, which was received with thanks and referred to the Committee on Monuments and Memorabilia. The item was a solemn will dated 1705, made in the reign of Queen Anne with the Church Court Probate attached.

In the *London Free Press* of October 5, there appeared an account of an interview with Sam. He was quoted as having said, "I take great pleasure in collecting objects of art connected with history – My greatest delight in recent purchase was of seven paintings of the Battle of Lake Erie because of its importance in the War of 1812. When I started law the Courthouse had been done over. It was beautiful. Today it is hopelessly inadequate. We apprentices of 1915 were like hockey players. We were sold back and forth – The trouble with law today is that they are trying to make it a business, it's an old fashioned profession."

Toward the end of 1965 Sam was invited to take an honorary position as Chairman of the Board at the Doon School of Fine Art, in the continuing co-operation of the University of Waterloo and the Doon School of Fine Art. He wrote to Dr. Elmore Reaman at the University that he thought that if they were serious about its art activities they should look to the example of Yale or Temple, establish an art department and, "not fool around with the Doon School of Fine Art."

Sam also pointed out that he had set his sights on retiring now that he was 67 years of age, to be able to enjoy his collections. He revealed that there were only two honours he would like to have. One was to be made a Q.C. in Quebec and

the other was to be given an LL.D. He hinted rather archly that Brock University "is not after me very hotly" for favours. Alas, his attempt to play off one university against another did not have the desired effect.

In December, Sam received a letter from Madame Suzor-Coté. They had lost touch over the years. Sam felt that there were casts still owing to him because of advances paid to her and that a plaster bust of Suzor-Coté as a young man had been taken to Queenston because he had had it for years and did not know what to do about it. As expected, books, paintings, watercolours and etchings continued to arrive in profusion and to augment Sam's collection until the end of the year.

Over many years in London, Sam had received so many snubs from the local citizens and particularly from many of his peers in the legal profession that he began to perceive a snub where perhaps none was intended. In writing to a fellow member of the Canadian Bar Association in January of 1966, he pointed out that he was among the four or five longest standing members and that for many years he had wanted to be elected to the Council, but failed every time he was nominated. He claimed it was a personal thing, the enmity of the lawyer and bencher Park Jamieson. Sam felt it was because he had 'lit into' Jamieson for refusing an adjournment when Sam had been brought in only a short time before a proposed trial. Sam

had arranged an appointment with an engineer at Queenston concerning the house, prior to the court appearance, Jamieson insisted he was fabricating. There had been bad feeling between the two ever since.

The copy of the last letter Sam retained that he had written to Lillemor was despatched on January 31. It was rather formal and chilly in tone. He had not heard from her since September, and he wrote that he was putting her cards in his archives. The affair, such as it was, was long over.

Rushing out of his bath one morning in July to answer the telephone, Sam's soapy feet slipped out from under him. He sprained his back and was in great pain for a number of months. He had had a couple of bad falls three years ago, he wrote, but this latest was the most excruciating. But such accidents did not halt his activities.

In August Sam was still trying to repossess the agreement that he and Joan Clark had made. Clark was reportedly saying to all who asked about her marriage, "I changed my mind." However she had told co-workers that she had hooked a millionaire lawyer up in Ontario which was reported through a series of informers to Sam. Both the lawyers were ready to press charges of various types against one another. Sam had found the report of the wedding reception going ahead anyway without his presence bizarre to say the

least. Each was ready to blacken the other's reputation. Clark suffered far more, of course, than Sam.

In the fall of 1966, the *London Free Press* reported a break-in at Sam's office. A window was smashed, a cheque of low value and $1.91 in coins were taken. But at the same time hoodlums were smashing windows in Queenston and painting the bricks. Sam felt that the local police were not of much help and so a security system was soon installed, the first of a number, for Sam was beginning to feel that he was the victim of persecution.

Sam reopened his recriminations against Sun Life Assurance Company in a letter to H.O. McKay of Montreal, dispatched in November, 1966. Sam wrote that he had run the mortgage development office of the company in London long before the official office was opened. He went on to relate how a young lawyer named Mitches dropped in on him on a Saturday afternoon to tell Sam that he had been at a party the preceding evening and that John Robarts had said that he was going to take all the Sun Life legal business away from Sam Weir. Sam ignored the intelligence at the time. "However it turned out to be true, didn't it?" There was more to tell of local shenanigans. Sam obviously wanted his experiences to go on record.

In an action brought by the executors of the estate of Henry Button against Sonia Garfield, the executrix of David Garfield, the proprietor of Garfield Galleries in Toronto, Sam acted for Mrs. Garfield. It was charged that twenty five sketches, paintings, etc. were brought to Garfield's Gallery by Henry Button to be sold on consignment. Many were unsigned. Sam was able to argue successfully that Button had been paid for the three most valuable. The case was settled by offering the Button estate fifteen of the remaining works by relative unknowns or unsigned. The plaintiff had asked for $20,000, but Worrall put a valuation of a fraction of the sum asked. Some of the signed works do seem to have unusually low values as estimated by Worrall however, a mere two figure pittance.

The fortunes of the National Portrait Gallery, originally formed in 1939, were not rising. Only two of the original directors remained alive, some portraits had been distributed to universities and the Information and Particulars forms as required by the federal government had not been filed for 1964 and 1965. It would seem that the demise of the whole scheme was imminent. Sam asked what had happened to the funds from the will of J.W.L. Forster, the portrait painter who had been the prime mover. No answer from R.J. Cudney Q.C., who was acting as chairman of the Board of Directors, has been preserved. Mr. Cudney accepted a position in the Manitoba government subsequently and the National Portrait Gallery

was dormant temporarily. One hundred and eighteen paintings and thirteen drawings were put in storage in the basement of the Sigmund Samuel Building of the Royal Ontario Museum and some are now on view in the Sigmund Samuel Canadiana Gallery.

In 1966 and over the two following years, Sam acquired a large part of his entire collection. A William Brymner oil, *Landscape*, purchased in 1966 in Montreal, was inadvertently overlooked when Sam checked out of the Mount Royal Hotel, "Forgotten in anxiety over your inadequate service." The Kenneth Forbes *Portrait of Samuel E. Weir*, along with the pencil sketch, also were acquired in 1966. Augustus John, Maufra, Moret, more views of Niagara and some important early Canadian watercolours were among the treasures which arrived in batches from dealers across the United States and Britain.

With the general emphasis on the celebration in 1967 of Canada's Centenary, Sam was drawn into celebrations of his own for his collection. A record number of views of Niagara were purchased, in particular the watercolours of Captain John Caddy, and an oil, *Battle Of Queenston Heights*, painted by Major General Sir James B. Dennis who was a young officer in the battle and who in 1797, was in a regiment commanded by General (then Lieutenant Colonel) Brock. In addition two drawings of William Hind and William von Moll Berczy's *Portrait Of Robert Prescott* circa 1799 were acquired. Governor Prescott later became Earl of Amherst. Sam lent his portrait in 1968, briefly, to the Royal Ontario Museum for a special exhibit, plus many other outstanding works including early Canadian painters largely overlooked at the time. Sam's collection was being recognized by the Canadian public.

21 FROM THE CENTENNIAL YEAR TO THE SHAPING OF RIVER BRINK

PERHAPS THE MOST IMPORTANT AND GRATIFYING EVENT OF THE Centennial year for Sam was the honour paid him by Chief Joseph Akiwenzie of the Cape Croker Band of the Ojibway, where Sam's grandfather had been the first Methodist minister. In a most impressive ceremony at Cape Croker on July 1, Dominion Day, Sam was inducted as Honorary Chief Wah-Ka-Skah-Ahnung, Chief Shining Star, wearing the traditional feathered head dress. The head dress now has a place of honour in Sam's bedroom closet display at River Brink. He was presented with a scroll of which he was very proud, on which was written in part, "Chief Wah-Ka-Skah-Ahnung we believe will carry this honor with pride and dignity at all times and remember he is forever welcome to this home of his new brothers." Stories and photographs appeared in all papers of the area and Sam kept many copies. He was particularly pleased with a photograph of the towering new chief surrounded by the Chief and his daughter, also in the traditional and graceful Ojibway dress.

All heard the outburst in Quebec of General Charles de Gaulle, who, while a guest of the Canadian Government, proclaimed from the balacony of the City Hall on July 1, to a large crowd gathered to celebrate Expo 67 in Montreal, "Vive le Québec libre." Following this direct call for Quebec to sever from Confederation, Sam received a letter dated 27th July, 1967,

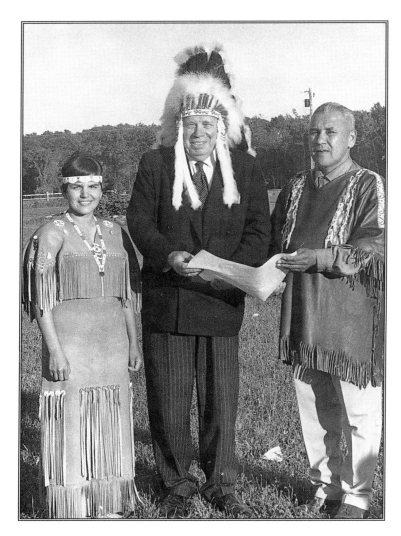

Honorary Chief Wah-ka-skah-Ahnung, Chief Shining Star (S.E. Weir)
with Chief Joseph Akiwenzie of the Cape Croker Band of the Ojibway,
and his daughter –, July 1, 1967.

214

from one of the most prestigious galleries in Paris, Durand-Ruel, a letter signed Charles Durand-Ruel from whom Sam had bought many a painting.

> *"Dear Mr. Weir:*
>
> *I should like you to know that General de Gaulle's outrageous behaviour had caused great surprise, and a storm of indignation here in Paris.*
>
> *We are revolted by his conduct, and deplore the severe damage of relations which must ensue. We can only hope that, although his unspeakable breach of hospitality can never be forgiven, the present state of affairs is not irreparable.*
>
> *May we extend our heartfelt apologies to you?*
>
> *Yours very sincerely,*
>
> *Charles Durand-Ruel"*

A rather more enjoyable event occurred in early March at the University of Western Ontario, Faculty of Law, when the Ontario Law Students Association Moot Court Competitions being held in London were a great success. "I think I can truthfully say that not only were the Moots of this competition of a high calibre, but the Bench was the most refreshing one we've had. But then again, we had the best." The

letter of thanks for Sam's participation was from the Chairman, Moot Committee, University of Western Ontario Legal Society. Earlier in his career Sam had turned down an appointment to the Bench.

River Brink's architect, Arthur Nutter, died at the age of 92 in Houston. Sam kept the obituary but without comment. By now the house was up and enclosed and he was on his own for architectural detailing. His cousin, John Robert, was a comforting source of help at the time. John and Vera travelled back and forth from London to Queenston, their car filled with small articles and Vera's piles of correspondence ready for Sam's signature.

Earlier in the year, also in March, Sam took an advertisement in the *London Free Press* to announce that he had resigned from the Board of Directors of District Trust, "and therefore considers himself no longer responsible for the management of the Company." The original Board of the Trust with Sam as Chairman, had secured control of slightly less than fifty percent of the stock. When Gairdner, the brokerage firm in Toronto, entered the picture, it became obvious to Sam and the Baldwins that they had lost control. There was also another problem. As it was, in a sense, Sam's baby, he had insisted that he be responsible for doing all the mortgage and insurance work. However, there were potential mortgagors who already had a lawyer and did not want to engage an additional one. Sam's continuing ill health and his habit of spending a good part of the worst of the winter in a warm climate meant that deals were sometimes not closed promptly because of his absences. Naturally both lenders and borrowers found all these situations unsatisfactory. The Baldwins and Sam parted company.

One of the controversial items of Mrs. Garfield's custodianship of her husband's gallery was a painting by Degas that David Garfield had sold a few years prior to a wealthy businessman. The buyer and Garfield had exchanged a fair bit of testy correspondence, the buyer claiming that the painting was a forgery. Garfield had been enraged. He claimed that a clear provenance had been established. Acting for Mrs. Garfield, Sam persuaded the buyer to keep the Degas and free the widow from indemnity, pointing out that she had no resources with which to indemnify him anyway.

Although Sam was not badly injured, his car was rear ended in May of 1967, not a pleasant occurrence for anyone, but particularly unpleasant for the injured back, with its sciatica and arthritic spine, and his troubled knee. Still he pressed on.

On behalf of Worrall, Sam wrote to the President of the University of Western Ontario regarding a number of works of John Linnell, described by Sam as a "famous English artist," a

215

gift from Worrall to the University. Annoyed that these had never been exhibited and worse, that they had been stored in a basement without temperature control, Sam demanded that the gift be returned to the donor. There seems to have been no follow-up and no reply although it is possible that the subsequent negotiations were by telephone and the paintings returned to Worrall's studio.

Toward the end of the year, Sam enquired of the Women's Editor of the *Free Press Weekly* in Winnipeg about acquiring some of the New Maple Tartan, She wrote back that it was popular in the West, "...and I must say it looks best on red-blooded Canadian men and women." Sam was convinced and sent off an order for some of the material right away. By the year's end, Sam was writing to a friend in Ottawa, ".... But I am still alive to say that the practice of law affords no food for the soul. I am working towards retirement as fast as I can."

In the winter of 1967-68 Wilbur Howell went off to Mexico and, early in the new year, died in Cuernavaca. Sam bought the house from Wilbur's estate as a New York headquarters for himself and for use by the Howell grandchildren. Peter, Sarah's son, made himself so thoroughly at home and so destructively that the lad and Sam had a bitter falling out. Once again the house in Queens was the site of a family squabble that was never resolved.

In spring the proceedings against Mrs. Garfield were still in progress from Henry Button's estate. Worrall was now back from an English trip and could be reached for the purposes of the preparation of the Garfield inventory. Worrall claimed that the Tom Thomson and the J.E.H. MacDonald had been sold prior to Garfield's death and that Button had received his money owing for their sale. Worrall also claimed that most of the other paintings were 'rubbish.' In May, before the Supreme Court of Ontario, Sam claimed that Mrs. Garfield had sold the assets of the gallery as per instructions, that it was permissible for her to do so by the lower court. As for the paintings which had been sold prior to Garfield's death and Henry Button paid, Sam pointed out that neither lady knew much about her husband's business dealings. He also brought up the question of whether Button's deposits with Garfield on consignment belonged to Button or were they the property of J.M. Dent, the publishing house, whom Button had represented in Canada.

After Madame Testart's departure in the late fifties, Sam had been unable to find a reliable housekeeper, indeed one who would stay. Since he had planned to go to Ireland to attend the Dublin Bar Meeting and to hunt up ancestors as well as visit friends and distant cousins, he also put an advertisement for a housekeeper in the *Irish Independent*. He had to cancel his

attendance at the Bar Meeting due to ill health and so postponed the visit, but he still hoped to find an Irish housekeeper, perhaps feeling that with a common background they would understand one another.

Although Sam was by now a Life Bencher, he was approached by Brendan O'Brien, Treasurer of the Law Society of Upper Canada, to be Chairman of the Unauthorized Practice Committee, not usual practice for a Life Bencher apparently. As well he was asked to serve on the Finance, Legal Education, County Libraries and Public Relations Committees. With his interest in horticulture he was also asked to take part in an advisory capacity on the Grounds Committee, all in all an acknowledgement of the respect for his abilities and his wisdom held by his peers in the Law Society.

On July 10, 1968, Sam wrote a letter of complaint to the Hon. Mitchell Sharp, Minister of External Affairs about the unpleasant level of noise made by U.S. jets over Queenston. A reply came to the effect that a treaty exists permitting U.S. military aircraft to fly over Canada. 'The boys', he was told, like the air currents on the Canadian side better. Sam's comment in reply was that while this was fine for defense, it was not acceptable for unnecessary daily practice. What is in the treaty? he wanted to know. The complaints were to continue for some years with Sam eventually sending off a barrage of letters to

three Presidents in the White House in Washington.

In August Sam wrote to an antique dealer, Edward Denby in Pennsylvania, about a Brown Bess, a rifle used in the Revolutionary War. The rifle was manufactured by a Bawtenheimer in Pennsylvania and Sam wanted one. He also enquired around to various dealers and to Ben Ward Price, for a cannon, preferably one that had seen service in the War of 1812, to be mounted at River Brink, hopefully not to be trained across the river on the United States Air Force base that had so annoyed him.

Professor D.O. Spettigue of the Department of English at Queen's University had been told that Sam had had contact with the writer, Frederick Philip Grove. He wrote to Sam seeking information on the author. On August 20, Sam replied that he had visited Grove two or three years before his death in 1948. "He was living at Simcoe, Ontario with his wife in a modest dwelling. He was working in a local cannery and his wife was teaching school. Grove said his father was at one time a wealthy man and that he had studied archaeology. His father lost his money. Archaeology was not a remunerative specialty. Grove was a bitter man." Sam's purpose in going to visit Grove had been to ask him to autograph copies of his books that Sam had added to his library.

A Homer Watson, *The Pioneer Mill*, was scheduled to

come on the market. The work is a preliminary study for another painting now in the collection of Her Majesty Queen Elizabeth. Sam thought it might be a forgery. He wrote to Tom MacDonald, Curator of the Art Gallery of Hamilton about it. MacDonald replied that it certainly was a genuine Watson, that the first owner was Sir Henry Pellatt and that the provenance was clear. In October at a Sotheby's auction, Sam bid on and got the Watson for $4200. At the same auction he also bought eight medals including a George III silver medal struck to commemorate a convention of Indians at Niagara in 1793, described as "fine and very rare." In a report of the auction in the *Globe and Mail*, Sam was identified as Judge Weir of London, Ontario, much to his amusement.

In seeking out Indian medals and gorgets, Sam was in touch with Professor Kenneth Kidd of Trent University. He wrote, "I am also fascinated by the idea of leaving something behind me for the public benefit rather than letting my money disappear in a fraction of a second in the consolidated revenue funds of both Canada and Ontario. You see, I am a bachelor and my estate will be heavily taxed."

During the same period his clock collection was growing. Sam was in touch with a gallery in Salem, New York about another pillar and scroll clock he wished to obtain. His acquisitions were many and varied. From London he also ordered 25 - 30 yards of the Weir tartan, the ancient colours, and ten or twelve tartan scarves. He liked to have his overcoats lined with the family tartan.

Norman W. Long sent Sam a copy of his booklet on John Graves Simcoe from the John Graves Simcoe Foundation. In his reply Sam indicated that he was interested in having copies made of a rondel of Simcoe at Exeter, one for himself and others for the Parliament Buildings in Toronto and perhaps the Foundation. Sam also mentioned his interest in the project in the past ,but that ill health and fatigue had interfered although he still was hopeful of getting the rondels cast. Nothing came of this however. Keen to acquire works of Paul Kane, Sam wrote to Peter Swann at the Royal Ontario Museum pointing out that the Museum had a great number of Kanes and that he would be glad to take one or two off their hands. In wanting three works by each Canadian artist of note, Sam wanted an early period, a middle period and a late work. In this way he felt the artist's development could be shown and appreciated. In his reply Swann appears not to have been amused.

Although Sam had a pencil sketch of himself by Varley, he wrote to the artist's son, Peter, telling him he would like to acquire "a good Varley portrait," not a commissioned work. "I mean a portrait that was painted by the artist to please himself." There seems to have been no follow-up on his letter.

While still hankering for an LL.B. if not an LL.D., Sam was importuned by the Faculty of Law at the University of Toronto for donations. He wrote back that he was not classed as an alumnus, but why, he asked, if they had him on their list of alumni and thus open to solicitation for donations, not make it legal and give him the LL.B. His question remained unanswered and Sam did not give support to the Faculty of Law's campaign for funds.

At least forty major acquisitions were recorded as having entered the collection in 1968. There were views of Niagara as usual and a Robert Harris, *Sandy Point Sturgeon Lake*; W.G.R. Hind, *Dominique: Chief of the Montagnais*; two Krieghoffs, *Indian Wigwam in Lower Canada* and *French Canadian Habitants Playing at Cards*; George Romney, *Portrait of John Currer*; Suzor-Coté's *Le Halage du Bois*; and four etchings of Homer Watson.

Sam and Kenneth Thomson corresponded with frequency on the passion they had in common, the collecting of art. In 1968 Thomson wrote to Sam that as he was going to move to London, England he would offer to do Sam an occasional favour, pursuing a painting, sending Sam catalogues, or making discreet enquiries on his behalf, "...whenever I can be of help to you, please let me know." Their interests, parallel perhaps but not coincidental, except in the case of Krieghoff whom they both admired, kept them friends who encouraged one another, but whose goals did not collide.

In December Sam wrote to G.E. Beament Q.C. in Ottawa, a fellow devotee of matters historical and of John Graves Simcoe in particular. Sam sent Beament a copy of Simcoe's writings on escheats, *Remarks On The Law Of Descent, 1779* and *Remarks On Consistency Of The Table Of Descent, 1797*, the latter written after Osgoode was Chief Justice of Upper Canada and subsequently Chief Justice of Lower Canada. In the letter Sam repeated the rumour that Osgoode was an illegitimate son of the King of England and that Hoppner was also rumoured to be illegitimate, also a son of the King of England. In remarking on the Hoppner portrait of Osgoode, Sam wrote "...so it was an extremely wonderful association of two royal bastards."

In the late 60's and in to the 70's a portrait, *Miss Bruce* by Berthon, was offered to Sam through Leslie Lewis. Sam researched the provenance and ultimately Blair Laing, the Toronto dealer, and T.R. MacDonald of the Art Gallery of Hamilton got into a *contre temps*, MacDonald declaring it genuine and Laing otherwise. Lewis said he picked it up "on the road." Canny Sam did not bite.

With his frequent travels to the United States, Sam was most keen to visit the Barnes Collection in Merion, Pennsylvania. He tried to get an appointment on three separate occasions, in 1961, 1967 and 1976. Twice he was refused and the

219

third time, an appointment was given to him, but he had made a prior arrangement to be in England.

In planning his country home, River Brink, eventually to be a sanctuary for artifacts relating to the area, as well as for other art objects of great beauty, the idea of being buried on the grounds appealed more and more to Sam. He wrote to the Department of Finance and Commercial Affairs. Cremation was suggested. Sam wanted burial. He wrote to everyone in the Legislature whom he thought would be influential, from the Premier to his sitting member. It took years of negotiating, but Sam knew what he wanted and refused to give up.

22 KNOWLEDGE AND
EXPERIENCE

As well as responding to letters from his fellow Chief on the Cape Croker Reserve, requesting help of various kinds, Sam was approached by a number of Indians seeking legal advice from Chief Shining Star. He responded to all with pertinent remarks, sometimes suggesting lawyers in other provinces if that were in the best interests of the appellants.

A lawyer in Port Arthur wrote to Sam for advice in starting an art collection. Sam replied with his customary care and courtesy:

"It takes a long time for a fellow to find out that the best stocks are the ones that sell for the highest price. This is true of oil paintings to a certain extent. By qualifying in this way, I mean that there are vogues in painting. However, the French Impressionists have been in vogue for forty or fifty years now and no other type of painting seems to push French Impressionism aside.

I think you can buy Moret and Maufra around $1,500 to $2000 still. I find some of Maufra's paintings are pretty weak, but Moret did some very strong paintings. I almost bought one last year from Victor Hammer in New York, and as I am going to be there soon again I will see if he has got it. I like it

very much and the price was around $2,000. But don't let me urge you to do something you don't want to do. My confidence in these high prices is due to a long collecting period. Through the years I have learned a good deal about it. And the thought of paying $4,000 or $5,000 for a painting (which I have only done on two or three occasions) does not disturb me. My Bank Manager told me one time when I asked him for some money to pay for a painting, that he guessed it was all right because I had appeared to do better in Art than in Stocks and Bonds. I know a fellow in New York who put a couple of hundred thousand into an Art Collection between the Wars and it is now stated to be worth over a million. But it takes time to build up this confidence in oneself so as to become involved for a large amount in any one painting. The late Gordon Hyde, who was a terrific lawyer in Montreal, told me as a young man that he could see lots of fun in paintings up to $350 or $400 or even $450, but beyond that he would not dream of gambling."

Ruth's daughter, Sarah Howell Michaelson, had been through a divorce and was now to be married again. After the death of Wilbur, Sam took over as *pater familias* and it was he who ordered the wedding announcements on formal Tiffany stationery. Tiffany's had always been a favourite shop of Sam's for teething rings and small silver spoons, his usual gifts to the children of friends and colleagues. Sarah wanted him to come and spend Christmas with her and her new husband in their apartment on East 72nd Street.

In January of 1969 the case of Worrall versus Stolow of the National Gallery of Canada which began because of the raid on Worrall's premise in late 1962, finally came to court. Worrall surrendered all claims and the case was closed. Worrall was too tired and too elderly to have the energy to pursue the matter further. More to close another case than anything else, Sam wrote to the Police Chief of Sodertalje, Sweden, Lillemor Johannson's father, hoping to get news of her, noting that it was twelve or thirteen years ago since their affair had been in progress. An answer, if there ever was one, has not been kept.

As noted, Sam had a somewhat cavalier attitude to many local dealers in books and papers. To Maggs Bros., of London's West End, he submitted payment promptly, to others he was at times negligent to the frustration of the dealers. When John Maggs came to Toronto on a business trip, Sam stocked his room at the Royal York Hotel with suitable refreshment, with a note to the effect that he would be arriving on the eve of a

holiday and the liquor stores would be closed. However in March of 1969, J.G. Sherlock, who had taken over the management of the venerable old firm of Joseph Patrick Books, invoiced Sam for $150.00 for a letter of Simcoe's six months after Sam had received the letter and agreed to purchase. It was by no means the first invoice. Sherlock frequently had similar problems with Sam's account and felt that in Sam's anxiety not to be overcharged by dealers, he frequently left himself open to have advantage taken of him. The book sellers in Toronto generally felt that he was penny wise in dealing with them, but pound foolish when his collecting passion got the better of him in the charged atmosphere of the auction room. Sam trusted Maggs Bros. implicitly, but was convinced that local dealers were 'out to get him.'

On April 25, Sam wrote to the Post Master in London that his office at 486 Richmond Street was closed and that mail for Weir & Associates was to be directed to 1 Summit Avenue, a new street formed from the subdivision of his land, after April 30, even though he was spending more and more time in Queenston as well as in New York. However his mail continued to take an erratic course in attempts to catch up to Sam.

The following month, Sam wrote a long and chatty letter to Dudley Tooth, a dealer in paintings in London's West End, from whom he had made a number of purchases over the years. Tooth had previously sold Sam the Matthew Smiths that he prized highly. Sam mentioned in the letter that he cannot get any of his friends to appreciate them as he does and pointed out that, "can't get along the road so far as Vuillard." Tooth had sent him a catalogue of Vuillard works, but Sam wrote, "he is too vague for the clarity sought by a lawyer in ordinary circumstances. I know his colour is good." Sam mentioned that three "have some appeal for me but not enough to make me venture." He also mentioned that he had bought two drawings by Augustus John depicting Canadian soldiers in the first Great War at an auction in Toronto.

At the same time Sam wanted to resign as Vice-President of the National Portrait Gallery, feeling that the entire undertaking was now moribund. He wrote to Cudney as president that he, Cudney, had not responded to Sam's calls and that he felt he could not make arrangements to secure portraits on his own. Forster had left money in his will for just such a purpose, but there had been no fiscal statements, audited or not, for at least two years. The following month the Provincial Auditors sent Sam a statement indicating that there had been no meeting of members since 1950; no meeting of directors since February 26, 1960; certain items of business and conduct of the Corporation had not been presented to nor confirmed by the members due to failure to hold meetings of

directors and members. The balance as of May 31, 1969 of $14,945.76 was noted as being invested and in a bank account. Of nineteen portraits, fifteen were donated by J.W.L. Forster. Finally on June 16, 1969, a meeting was held. Five directors were appointed, but to all intents and purposes a separate National Portrait Gallery was not to be. Sam was neither present nor elected and an audited statement quoted the balance at $15,036.76. Sam's interest in the National Portrait Gallery as it was constituted was at an end although he still felt that the idea itself had merit.

It seemed that Sam was subject to a great many misadventures when he ordered almost anything by telephone or by mail. From shirts made to his measurements by an Ontario factory, to cheese, June cheese for preference, to furniture delivered on the wrong day to an empty house, all bungles were the order of the day. Files of letters to various shops and manufacturers attest to his frustrations and annoyances. In December he ordered new beds and mattresses from Eaton's in Toronto. Mattresses were delivered but no beds for a good many weeks. The store wanted payment for the mattresses. Then the wrong beds were sent. Sam snarled: "Do you want me to quit dealing with the T. Eaton Co. Limited? Or are you going to improve your service? I hear complaints about it from all over. Even your clerks. Yours truly." Whenever he

could Sam would buy shares in any company with which he had accounts or dealings. Letters of complaint for poor service were dispatched to the president or chief executive officer and always mentioned: "as a shareholder in your company..."

Throughout 1969 although more works of art and boxes of books and papers continued to arrive, the passionate searching seems to have withered a little. However, a self portrait circa 1860 by Zacharie Vincent, 1815 - 1886, appeared and also a print of Robert Havell's *Storming Fort Oswego, Lake Ontario* as well as several etched plates of Jacques Callot, 1592 - 1635, *Les Caprices* and *Les Gueux*, circa 1621.

From time to time Chief Sam heard from Chief Joe and Irene Akiwenzie. Gradually the letters began to be more and more on the subject of what a gift of money would do to enhance life at Cape Croker and less on the state of Chief Sam's health and matters of general interest to them both. In January of 1970 Chief Joe thanked Chief Sam for his Christmas cheque of $25.00 for the "ballroom fund." Chief Joe mentioned also that his daughter Julianna and her husband Joe were expecting a baby and if a brave, he would be christened Sammy Joe.

The following month Sam was off on the subject of abolishing personal income tax again. This time his letter was addressed to the Right Hon. Robert Stanfield, but no reply is on record. Perhaps it was because Sam was without heirs, which he

had indicated that he wanted so badly, that he intended to leave formal memories of himself. He had already started along these lines with the establishment of the medal in memory of Martha at the University of Western Ontario, with himself as donor. He began to think about another medal given solely in his own memory. He considered something for the University of Western Ontario, but after a couple of months of thinking it through he decided on something of national significance. To this end he wrote to C.H.C. Edwards, Secretary Treasurer of the Association of Canadian Law Teachers, who was on the staff of the Law Faculty of the University of Manitoba. Sam's plan was to offer a medal annually for the most deserving law teacher in the entire country. Edwards replied on May 12, 1970 thanking Sam for the suggestion, but pointing out that the administration of such a tribute was too complicated to handle, there were just too many teachers in the field.

Sam next fired off a letter to David Freeman, Counsel on Foundations in New York enquiring as to whether the Weir Foundation could be listed in the Counsel's list of charitable foundations. The answer came back in the negative. Giving university scholarships and the publication of historical materials owned by the Foundation did not qualify. There would be no listing because the Weir Foundation was a family one. Only grant giving foundations are listed, endowed through pooling from many donors in the community, he was told.

Knowing that his friend, Tupper Bigelow, was an ardent whodunit fan, Sam sent him the *New York Times Book Review* of May 7, with special articles he knew that Bigelow would enjoy. As a member of the Baker Street Irregulars, Bigelow wrote back a most appreciative and warm letter of thanks. It was typical of Sam. He loved to pass on items of interest to friends, a habit that had begun early and lasted all his life. Equally it was a pleasure sometimes to wind up drawn out cases. Finally in May of 1970 Sam agreed to an out of court settlement of $1000 for the motor accident of November 20, 1954 in which he had injured his knee quite severely, an injury that would plague him for the rest of his life.

As he was no longer associated with District Trust, except in the capacity of landlord, Sam took issue with the handling of an estate with a trust established for a lady who had been asked to sign papers she had not understood. Sam acted for the legatee who claimed she had not received money she felt was due to her under the terms of a will, involving some securities which had not been found. Sam's letter to District Trust was a graceful example of a velvet glove on an iron hand, pointing out that the legatee had not had counsel in anything she had been asked to sign and that the income of the deceased could be ascertained from the income tax paid and perhaps it

was time for the matter to be out before the court. The matter was speedily put to rights to the satisfaction of the legatee. The matter never came to the attention of the press, as Sam would have kept copies of any such publicity as was his custom whenever his name was mentioned in the press.

On September 14, Sam wrote to Geoffrey Joyner of Sotheby's & Company, Toronto, stating that he "would get some stuff into your hands." Sam was considering divesting some of the Johns, the Matthew Smiths, and an Epstein or two. For some reason, Sam found Joyner unsatisfactory to deal with and later wrote to him "send all back to me." Although he had thought of consolidating his collection in September, by early November an auction of Sotheby's in Toronto had Sam back in action. An invoice dated November 10, from Professional Installation Service was for picking up ten lots at Sotheby's and delivering them to Worrall, so presumably all ten were paintings, prints and etchings.

For some time Sam's focus on his collecting had been centred more and more on Canadiana, and in particular, the Queenston area. He had made himself thoroughly familiar with every phase and activity of the Battle of Queenston Heights. Mary Di Matteo, the wife of Don, Sam's handyman gardener and occasional companion, remembers driving with Sam at the wheel and Sam pointing out to her and to Laurie, her small daughter, the historical significance of the area. "He knew what had happened at every square foot all over, the battlefields, everything. He was a wonderful teacher," she said.

23 RIVER BRINK AND DOMESTIC TRANQUILITY AT LAST

ON NOVEMBER 11, 1970, SAM'S TROUBLES WITH HOUSEKEEPERS CAME to an end. A housekeeper came into his life who turned out to be the ideal for whom he had searched from the beginning. It so happened that Margaret Ferguson, the daughter of Sam's old and cherished friend, Judge Robert Irvine Ferguson, knew that in the death of her neighbour the housekeeper would be seeking a new position. She effected an interview for Sam with Judy Mahoney, born in Cork. Sam and Judy took each other's measure, an Irish descended protestant and an Irish born catholic. Sam wanted her to start right away, now, but she insisted on returning to Toronto to pick up her belongings.

"I suppose you want to go to church?" Sam asked her. "Yes, sir. I do," Judy replied promptly. "Very well. I will see that you get there." Sunday after Sunday Sam and Judy set off from Queenston together for Niagara Falls so that Judy could attend mass. One Sunday Sam drove Judy to St. Vincent de Paul Church in Niagara-on-the-Lake. Sam drove on to call on his friend Norman Long. They had a pleasant time together and Sam, forgetting all about Judy, drove home to River Brink. Judy walked home all the way. Sam had been well entertained by Long and was having a nap when Judy arrived, in a fine Irish temper. Her comment later was, "I could have slew him, dearie." Sam apologized and made sure he never forgot Judy again.

Judy settled in quickly and gave Sam the caring and

devotion he had never received before for the rest of his life. Occasionally they had their differences. Upon one spirited Donnybrook, Sam yelled at her, "You're fired." Judy came back with, "No, I'm not. I quit." Tempers cooled suddenly. Each realized the loss it would be and the previous conversation was thereby cancelled. They each had learned the limit of the other's tolerance. Although from time to time they had their squabbles, threats made by either one were not taken seriously and the two settled down amicably once more. Invitations to dine at River Brink became all the more sought after now that Judy's cooking was added to Sam's lively and entertaining conversation.

In October of 1970, Sam was pleased to be informed by his old friend, Ken Jarvis, that he was now a life member of the Law Society of Upper Canada. The Middlesex Law Society decided to hold a party for members with fifty or more years of legal practice. Nine were eligible. Sam sent back his regrets that he was unable to attend. He could plead ill health, or the travel from Queenston on a December night, but when he considered the slights he had received and the material help he had given those in need plus the advice to fellow lawyers when asked, he decided to stay put in River Brink that evening.

At the end of November, Sam wrote to Tommy Lee at Royal Trust in St. Catharines:

"I have built a foolish house on the Niagara River with the idea of leaving it for a museum, art gallery, library etc., mainly Canadiana. I expect there will be no inheritance taxes. This is my idea of doing good in my life or at the end of my life without helping out the consolidated revenue fund for a split second."

Sam still hated taxes. In other letters and notes, Sam sometimes wrote of his 'folly' house which was costing far more than he dreamed. He had many a run-in with workmen and about hardware delivered but considered inferior or coming later than promised. At length Alexander Kiss came on board as finishing carpenter and Sam was well pleased. Kiss began on November 7, 1968 and finished August 17, 1971. "Mr. Weir was one of the best and most trusting men, and one of my best customers I have ever worked for. It was a pleasure," he wrote. "Every room at River Brink was panelled with a different wood. Every detail was thoroughly thought out and researched." Alex Kiss said of Sam, "He was not a fussy man. He knew what he wanted." Cherry, mahogany, oak, knotty pine, walnut, clear pine ceilings and a birch ceiling in the dining room have continued to give River Brink a warmth, a welcome and a magnificent background for the paintings, sculpture and the lovely old pieces of antique furniture.

At the end of 1970, on December 23, Sam fired off a somewhat acerbic letter to the Hon. John White in the Legislative Assembly at Toronto, reminding White that Sam had been lawyer to both his mother and his grandmother. Automobile insurance and the claims thereto were the subject of Sam's concern. He described claims adjusters as one of the worst cankers in our society, with release forms pressed onto the injured. Aware of the insurance companies argument that money is lost on automobile insurance, Sam wrote that he had suggested to insurance companies in which he was a shareholder that they get out of an unprofitable business. He also suggested that their losses may be exaggerated since their overhead is carried by the rest of the business as well as by the automobile. Sam advocated no-fault insurance, but that finality in awarding payment should not always be the case. A provision for review should be in force, he felt. A suggestion that he made was that the province take over the insurance and form a money pool by charging motorists for insurance when licenses were obtained or renewed. He may well have been thinking of his own injury to his knee and his constant discomfort for sixteen years.

In the late fifties Sam had acquired a series of twenty two letters known as *The Amherst Papers* for around $10,000 from Sotheby's in England. These letters were written by Jeffrey Amherst, 1717 - 1797, the First Baron, to his wife, Jane Dalison, whom he addressed as 'Jin' while he was serving in British North America. Amherst was charged first to command the force which took Louisburg. While Wolfe took Quebec, Amherst captured Fort Ticonderoga and Fort Niagara and took the surrender of Montreal in 1760, which was, of course, the chief reason for Sam's interest in the collection.

In 1967, Amherst College in Massachusetts produced a catalogue of its paintings of the Amherst family, of which it owns ten. Sam obtained a copy of the catalogue and continued a correspondence with J. Richard Phillips of the college. At first Sam thought of selling *The Amherst Papers* to Amherst and in 1969 he sent them a typewritten copy of each of the letters. He then pointed out that he wished to keep some, notably those dealing with the surrender of Montreal. He had thoughts of offering one of them for auction to Parke Bernet to test the waters on their value. The following year 1970, Sam wrote to a small press in Port Washington telling them that Parke Bernet told him the package should be sold together for a much higher return than would be realized by offers of individual letters. He further stated that Amherst College had shown interest in at least some of them. Sam then approached the small press publisher with the idea of issuing the letters under the imprint of The Weir Foundation, but that Parke Bernet had

informed him that after publication the originals would lose their value. Sam's real interest, he claimed, was not in the value of the letters themselves, but whether such a publication would be saleable. The reply from Kennikat Press was that they would be delighted to discuss the matter. Sam also attempted to interest Amherst College into co-sponsoring the cost of such a publication. The matter dragged on until 1977 when Sam, writing to Frank Milligan at the Canada Council, spoke of journeying to Amherst to discuss a joint publishing effort and that he was thinking of making a presentation of some of the letters to Amherst and retaining the rest for River Brink. Sam also wrote that Sotheby's thinking was that the letters should be issued in a limited edition of not more than 1500 copies in a deluxe presentation. Sam's hope was that such a publication would include reproductions of the Amherst portrait by Reynolds, presently in the college collection, together with other interesting properties and engravings of both Amherst and River Brink. Nothing seems to have come of the ambitious project although Sam broached the subject now and again until almost the end of his life.

Even though Sam indicated that he wanted to focus the collection on works pertaining to the history of the Niagara region, when auction catalogues came across his desk, the old urgings of the passionate pursuit of the true collector took

over. Over twenty three new works of art arrived in 1970, including two Eugene Speicher drawings, *Kneeling Nude* and *Nude*, as well as a *Portrait of Mother and Child*, an early nineteenth century primitive purchased through Parke Bernet. He also purchased seven watercolours by Elizabeth Simcoe, all of them views of nearby landmarks and a P. Wilson Steer, *Framlingham*, 1932 from the Rutland Gallery in London.

By 1971 Sam had retired, more or less, from his practice in London and had taken up residence in River Brink. He now found himself with time on his hands as his practice became less and less demanding. Clearly a man of his intellect and intellectual energy needed an outlet. He began a collection of paragraphs, which would, he hoped, eventually become a volume of reminiscences. Although Sam could keep a passenger train full of Londoners returning home from a day in Toronto entranced and laughing hysterically, heartily appreciative of his anecdotes, when he wrote them down in a straight forward manner, they became somewhat cold recollections of the activities of persons long dead and largely forgotten. The project came to a halt.

However, the writing of letters carried on at a ferociously increased pace. Sam wrote to everyone and anyone. Opinions expressed by various leaders and politicians in the daily press brought forth, not letters to the various editors, but

letters addressed directly to the persons involved or quoted, especially those in public office.

Although River Brink was nearing completion, Sam toyed with the idea of establishing his art holdings far from what he considered to be the covetousness of the Canadian tax authorities. In a letter to a friend, Sam referred to River Brink as the Gold Coast, it was costing so much more than he had envisaged. Bermuda and the Cayman Islands were both considered as potential sites. He had long shown an interest in acquiring property in Bermuda, but could never bring himself to meet the prices asked. Mr. and Mrs. James D. MacDonald (Jim and Aileen), friends of long standing, had established themselves in Grand Cayman and Jim MacDonald had been admitted to the Bar to practise law in the Cayman Islands. The tax situation was far more favourable in the Caymans as regards income and realty taxes, as well as death duties, than in Canada. Sam's good friend, Eugene LaBrie, had already been admitted to the Cayman Islands' Bar. Sam filled out the forms and dispatched them.

At approximately the same time, Sam became acquainted with favourable opportunities for investment in Costa Rica. Investing in a banana plantation appealed to him. He tried to interest Clement Markert, the husband of his cousin, Margaret, Irene (Weir) Rempfer's daughter, to go in with him on the venture. Sam and the Markerts had been on close friendly terms for a number of years. At first Sam was wildly enthusiastic. The climate seemed to him to offer just what he wanted, heat and sunshine. But, alas, the Garden of Eden had its drawbacks and one of them was a *bête noire* of Sam's, snakes. In a number of letters Sam had shown himself to be positively phobic about any kind of snake.

However, another attraction for Sam was the possibility of investing in that country's railway system. Sam went down to San Jose to check it out. One evening he met a pair of Costa Rican girls in the bar of the hotel where he was staying. In the course of conversation, the girls revealed that they wanted to improve their grasp of the English language. Somehow Sam invited them both to London to work in what was to be the winding up of his London office. He journeyed several times throughout the year from London to New York and on to Costa Rica, usually passing through the Caymans on the way. With his usual heartfelt enthusiasm for any new undertaking, the prospect of establishing a practice in Grand Cayman and making frequent trips to Costa Rica to check on possible investment opportunities put the enticement of purchasing property in Bermuda farther from his mind.

Another of Sam's ongoing enthusiasms was tracing his genealogical roots. Throughout his adult life he had

maintained a steady correspondence with both Weirs and Bawtenheimers. At the beginning of the seventies, this interest intensified. He found a cousin, Stanley Bawtenheimer and his wife Lou, both ardent genealogists, to be kindred spirits. Together they travelled to the Bawtenheimer family reunion picnics. Sam enjoyed the spectacle of his cousin David Bawtenheimer, who owned the dredging business on the Niagara River at Queenston, and himself arriving in Sam's large car, sometimes driven in earlier times by Sam's Chinese houseman. To say that the other Bawtenheimers were impressed is an understatement. The children especially remember that it was not acceptable to approach one's own parents nor attempt to interrupt the conversation of this awesome cousin, even if the interruption were to be on a matter of urgency.

On his way to Costa Rica in January of 1971, Sam drove Judy to the New York house. Perhaps because of a series of break-ins at Queenston, and the necessity of street parking on Forty Seventh Street in the Sunnyside area of Queens, Sam had a large sign made: 'DYNAMITE AND EXPLOSIVES - Please do not touch - POLICE NOTIFIED.' Indeed the police had been notified and apparently Sam, Judy and New York's finest all thought the sign an enormous joke. Of course the car was not carrying anything that would blow up. Whether the sign was responsible or not, it was never touched.

On January 11, 1971, Sam sent off a letter to John Robarts, Premier of Ontario, headed "Re Getting Buried in River Brink." Sam began the letter, 'Dear John.' In passing Sam mentioned that Fred McAllister had approached him about standing for the Middlesex Provincial seat as no suitable candidate for the Conservative party had been located. "He put it up to me to run," wrote Sam. He then continued that he had agreed if he did not have any work to do in the convention. After some preliminaries, Sam claimed that McAllister had told Sam that the nomination would be on a certain date. Hours prior to the convention, according to Sam, McAllister telephoned Sam to say that the delegates thought that Robarts would be a better candidate. McAllister, according to Sam, was paid off with the job of police magistrate in London. "I had at that time assisted him financially with loans on some real estate when he was right up against it. Dana Porter let the cat out of the bag to me," wrote Sam to Robarts. Sam went on to write that Dana Porter had promised Sam that he would put him on the Niagara Parks Commission. "But he never had it done. . . . I notice that there are a couple of vacancies there now," Sam hinted delicately.

Burial on the River Brink property became a fixation with Sam. On March 1, 1971, he wrote to J.R. McAlister, officer-

in-charge, Cemeteries Branch of the Ministry of Consumer and Commercial Relations of the Provincial Government, "…relates to my previous correspondence re burial on the Queenston property." Sam, in the letter, mentioned again his intention of making the property into a gallery of art with the *Osgoode* portrait by John Hoppner and also Sir William Beechey's *Portrait of Sir George Yonge*. He also mentioned a portrait of the Right Honourable Henry Dundas, Secretary of State for the Colonies, by Sir Thomas Lawrence. "The price seems high and I am hoping to get a better deal." Unfortunately that was not to be, but it indicates that Sam was interested in acquiring portraits by noted British painters of persons who had played a significant role in the history of Canada and particularly of Canada West or Upper Canada.

The grounds of River Brink were uppermost in his mind now that his "Gold Coast folly" was so nearing completion. From Beaverlodge Nursery in Alberta Sam ordered forty-four trees. It is a little difficult to imagine where he would have planted such a large number. Presumably there would not be fruit trees in such an order, nor the coffee tree that was put in the ground in the front lawn of his cottage across the road. Despite the Canadian winter, it has survived for well over twenty years.

One of Sam's many letters to politicians was addressed to Hon. Edgar Benson, Minister of Finance in May of 1971. "What is this valuation day stuff?" was the gist of the short note, clear and to the point. If Benson ever answered, it has not shown up in the many boxes of Sam's correspondence. Another letter was despatched to John A. Weir in Edmonton, reminding him that they were together in Ireland some fifteen years earlier in the summer of 1955. He went on to write of the Lombardo family in London. Guy Lombardo's father, a tailor from the island of Lipari, had made clothes for Sam and for whom Sam had acted as solicitor.

Two other matters claimed Sam's attention again in May of 1971, his health and his investments. To R.W. Cross, his bank manager, he wrote that he was, "putting all English shares into the Weir Investment Company with my holding shares here (in New York) or in Grand Cayman by the following year." He claimed he had been advised to get rid of Weir Investment Company as soon as possible.

To Betty, the wife of James Craig Weir, of Montreal, Sam wrote of the deterioration of his spine, caused by a bad fall he had sustained some years ago, he thought. Vertebrae pressing on nerves until, as he put it, "I wanted to scream." He found it necessary to take pain killers, sleep on a heating pad and to try not to move his spine during the night.

However, a sale scheduled for June 3 in Montreal had

Sam, the always eager collector, writing to Bernard Amtmann, the Montreal Fine Art dealer on May 7, "If number 287, 'Speech by Cheate,' refers to Alexander McLeod tried for murder over the Steamship Caroline, I would like to buy it as I have a full report of that trial. I will leave it to you as to what it is worth." Apparently Amtmann was a dealer whom Sam trusted to bid only up to a fair price for the item.

In June of 1971, Sam was vitally interested in the celebrated fraud case involving Worrall and Leslie Lewis. His friend was subsequently acquitted, but Lewis spent time in a federal prison of the United States. Sam got Sidney Allen to act for Worrall as he was not licensed to do so himself in a New York district court.

After fifty years of general law practice, Sam wrote to Frank Carter, QC, President of the Middlesex Law Association to thank him for the "magnificent cuff links" from the association. "Mr. McCracken, one of my juniors, is now general counsel for Sun Life in Montreal. I believe," Sam wrote, "that they are all thankful to me for having given them a good training in practice which I learned in my time from the very wonderful old timers of the Middlesex Bar."

J. Russell Harper, the 'ultimate authority' of the time on Canadian painting, wrote to Sam on July 6, 1971, mentioning his regret at being tied up in Toronto and not getting to Queenston. He was planning a book, he wrote, and in a most cordial letter obviously written to a friend, asked Sam what his opinion would be about reproducing some of Sam's possessions for inclusion in the new work.

Sam replied that Harper would be welcome to photograph any of the paintings in question, "...if they are reproduced in pleasant surroundings and credit is given to the Weir Foundation or to myself, Samuel E. Weir QC." Sam went on that he was inclined to complain about not having been presented with a copy of Harper's book *Paul Kane's Frontier*, on the strength of having made a contribution to it. "This is the first time I have been overlooked in this way. I always expect a copy or any copies of any book which figures any of my art collection." Sam went on to discuss the primitive portrait of the little girl with a background of Niagara Falls. Harper was interested in reproducing it, but Frank Worrall had it in his possession for restoration. Frank Worrall, according to Sam, had suffered a heart attack and was hospitalized.

Harper and Sam corresponded regularly and at length about their passion in common. Upon one occasion Sam wrote, "I am still trying to get up on my walls the pictures that I own. I can see I have a considerable surplus. And now I am looking into the future of building an additional gallery on the front corner of my lot in the same style as the house." Later in

the same year Sam confided in Harper, "Just at present I am tired of paintings and tired of everything else. The Canadian government now have an act on the boards to prohibit export of any painting from Canada of the value of $5.00 or more without a permit. I think it is time to move out of Canada." Nevertheless at the slightest hint of a sale or an auction yielding materials in which he had an interest, he was off and running again.

His absence being noted at the July 1 Bawtenheimer reunion picnic, Sam wrote to Wilfred Bawtenheimer, a contractor and builder, of accidents galore at Queenston, of a plastic roof shipping water for one, and of his apprehension about traffic on the holiday weekend, all keeping him away.

Although Sam had sold off most of the Oxford Street fronting property and the back portion had been developed into a housing estate to his profit, he insisted that his postal address should still be listed as 139 Oxford Street and not be changed to Number 1 Summit Avenue, the new street created by the subdivision of his property. In a mood of truculence Sam insisted it was his right to decide what address he wished to use and it was none of the postmaster's business. This led to ongoing problems of magazine and other delivery. Acrimonious letters were exchanged and Sam complained to Ottawa that the former Postmaster Davie "…insisted on

carrying on a vendetta." Sam's sensitivity to criticism had now spread to other areas. His temper seems to have become more fractious and he was quicker to take offense, at least judging by his letters. Yet to close friends he trusted he was still the wildly witty raconteur, the jolly companion that had won him so many well wishers over the long course of his career.

On August 1, 1971, Sam locked up the house in London, put it on the market and took off for Queenston, now his principal residence. But real estate troubles loomed. Real estate taxes owing on the Queens property got mixed up with three different addresses. Cheques were dispatched, returned to sender and interest charged until Sam wrote a blistering letter to Mayor Lindsay of New York City, the gist of which was, "clean up your act," and an equally angry letter to the Borough Hall, Kew Gardens, New York. The chief difficulty seemed to be that Sam had overlooked change of address cards until August of 1970 and understandably the United States Postal Service had trouble differentiating between Queenston and Queens.

As the landlord of several properties, Sam had the usual problems, a tenant started renovating the loft in a barn, other tenants wanted new locks installed. As well there was a move on foot to change the name of Queen Street in Queenston to which Sam took exception. Such concerns take their toll. He had put on more weight and needed new shirts,

but wrote to the shirt factory in Kitchener that he was planning to go to Texas to a clinic to lose weight, so new shirts could wait until he could send them measurements more to his liking.

Suddenly the urge to own a cannon returned. An 1812 or Revolutionary War model was what he wanted for River Brink and he set about writing to antique arms dealers throughout the eastern seaboard. That importing such an animal would bring up a variety of interesting problems; the weight and size of bringing it into Canada, a weapon of war, taking an historic artifact out of the United States, all did not seem to matter to Sam a bit. He wanted a cannon and that was that.

Sam fired off another letter of complaint to Colonel John G. Blewett, Commanding Officer in Niagara Falls, New York for sending military planes over River Brink despite the injunctions received from the Pentagon on the matter. A copy of the letter along with a formal complaint was sent to the White House.

The Selden Society, founded in 1887, "...to encourage the study and knowledge of the History of English Law," claimed Sam as a member although it is doubtful that he ever intended to become active in the organization or to attend meetings, although he did use their services from time to time. Always on the lookout for interesting historic projects, Sam wrote to Larry Ryan of the Ontario Heritage Foundation to the effect that if he should run across interesting old houses needing to be bought by someone ready to invest in their preservation, Sam would like to know. "You bet," was the happy rejoinder from Ryan. Around this time J.G. Sherlock of Joseph Patrick Books gave Sam a 'Lawyer's Sign' which Sam then presented to the Law Society of Upper Canada. Letters to both Sherlock and Sam went out from John H. Lytle, assistant secretary of the Law Society expressing genuine pleasure in the acquisition.

Harper and Sam continued to exchange letters to one another. In Sam's letter of November 2, he alludes to a remark made by Harper in a letter, now lost, writing "...in spite of your idea, Frank Worrall is, I think, the most honest man I have ever known." Apparently opinions differed on Frank Worrall and his connection with the convicted forger, Leslie Lewis. Sam never felt that Stolow from the National Gallery had ever made a proper apology to Frank Worrall after his seizure of Worrall's property.

John Clement, Communist candidate in St. Catharines, was unwary enough to send Sam election material. Sam's reply in early November 1971 was pithy and to the point:

"Dear Sir: I live in the riding in which you are

running for the Legislature. The circular has been left at my house which you have issued on behalf of your candidature. Although you say you are running as a Communist you note that you own a house in St. Catharines. If you are a Communist, actually, I would like to know what right you have to a house. If Communism came in here your house would be taken away from you immediately. Are you sure you understand what you are about? Yours truly, (signed) Samuel E. Weir Q.C."

A letter to Sam, postmarked Winnipeg of February 10, 1972 from N.E. (Mrs. Paul) Kane indicates that Sam had written to her enquiring about Kane paintings that might be available. She wrote that she had only one, outside of some European studies, and it was on loan to the National Gallery and in a travelling exhibition. She wrote that she wished to sell *Niagara Falls Panoramic View from the Canadian Side*. There seems to be no further correspondence with Mrs. Kane.

In February of 1972, he wrote to his cousin, Margaret Markert, that he expected to be in New York later in the month, down to Texas for a visit to a spa and clinic and then to Grand Cayman on business. The anticipated visit to the Texas spa had to be cancelled abruptly. On March 8, 1972, Paul died.

Sarah Michaelson telephoned Judy Mahoney in Queenston and Judy rushed down to Queens and went with Sam to Guttenburg, New Jersey, to identify the body. Sam had not seen his brother for over forty years except for the nasty door slamming incident. Judy recognized Paul at once without question. Sam was amazed. "How did you know? You never met him!" he questioned her. "I knew him at once," Judy told him. "He's the image of that bust of your father."

Paul died intestate and it was Sam who had to take care of all the details, but in a later letter to Margaret Markert, he admitted he had done so grudgingly. "My brother always seemed to interfere with my plans," he wrote. "Even his death made me change my plans and give up the spa." There was no longer any love or even tolerance between the two brothers. Sam reflected sadly in a letter to a friend that he was the last living child of George and Sarah Weir.

To a cousin, Gilbert Grant, in Souris, Manitoba, Sam wrote, "The body was found on March 9 in Guttenburg, New Jersey. This brother of mine had sleeping sickness and must have developed a tumour or something of that kind in his brain. He was always very bad tempered and perverse. He hastened the death of my mother undoubtedly because he was her favourite. But here it is now that his brother whom he hated, had to go and look after his dead body."

At the end of March, 1972, Sam was in his letter writing mode. He wrote to Hiram Walker of Gooderham and Worts distillers. He wanted to get hold of small casks of Canadian whiskey so that he could age them himself. A petty annoyance which finally angered him into writing to the *Globe and Mail* was about the papers' box being taken down from the edge of the War Memorial across the road from River Brink. He thought the Niagara Parks Commission was responsible and he suggested that the box could be put in his driveway, or at least the driver could toss a paper over his fence on his way to the Queenston Post Office. His requests were not acted upon.

The following month Sam was in touch, after many years, with a French Canadian nurse, Denyse Jacquemoi, with whom he had been so much in love as a very young man. He traced her to a hospital in San Diego where she was Head of the Radiology Department. She sent him an affectionate invitation to come down and visit her as well as some pictures of herself. Sam did not respond to the invitation to visit her, but sent off a friendly response anyway.

A note dated May 27 and signed Jim, began "Dear Uncle Sam: Sorry you missed my wedding but Mother says you had a heart attack." In this same period, Sam had written to L.D. Griffiths, president of Laura Secord Incorp., thanking him for the invitation to the opening of the Laura Secord House in Queenston which Sam had been promoting. He had to be in New York for "urgent reasons," he wrote. Sam also invited Griffiths to come on over. "Judy usually turns people away when I'm not there," he wrote. "I'll tell her to let you in." The urgent medical problem may well have been the reason for the reference to the heart attack.

Still searching for a cannon or even a Brown Bess for River Brink, Sam was offered a pair of fine American made Revolutionary swords from an antique dealer. He was not tempted. The following month, in June of 1972, Sam took on the case of Queenston versus David Bawtenheimer, his cousin, the operator of a dredging and sand business on the riverfront at Queenston. Apparently David Bawtenheimer's dredging ship gave off more smoke than was acceptable to somebody and he was fined. Sam tried unsuccessfully to have the fine revoked. On the other hand, Sam commenced an action against Shalamar Camp, a public campsite across the Parkway close to River Brink. He enlisted the support of another neighbour, Richard Hearn, to force the campsite to close down, but the campground remained in business. It seemed to be the summer of discontent all round.

An early supporter of the Shaw Festival in Niagara-on-the-Lake, Sam, in going over a Sotheby's Parke Bernet catalogue of a forthcoming auction of Shaviana, was happy to

tip off Brian Doherty and John Brook of the Shaw Festival. Sam already owned a bust of Shaw by Jacob Epstein. However, about twelve pieces were purchased by Sam at the auction. A considerable sum was raised by Doherty and Brook in four days to pay for part of his successful biddings.

There was also correspondence between Sam and Dr. Peter Swann, Director of the Royal Ontario Museum, on the subject of the National Portrait Gallery. In a letter of May 28, 1972, Sam wrote that he was indignant at Cudney for getting him into the National Portrait Gallery in the first place, as he was led to believe that he, Sam, would follow Cudney as president and run it as a hobby of his own. He wrote, in part:

"But I wish to inform you that I am afraid that you are breaking faith with a dead man by what you propose: some to be dispersed to universities; some to be interred in the basement of the Sigmund Samuel Canadiana Building with regard to the National Portrait Gallery. The late J.W.R. Forster left a substantial sum of money and several portraits of noted Canadians for the purpose of founding a National Portrait Gallery. Cudney incorporated this in his own office at the Parliamentary Buildings in Toronto when he was Deputy Provincial Secretary...I

George Bernard Shaw, in bronze, by Sir Jacob Epstein dated 1934.

239

do not think you people at the Royal Ontario Museum are in a position to make a separate success of the National Portrait Gallery."

The peace and the quiet of Queenston were shattered intermittently again and frequently, to Sam's fury, by the American Air Force Base at Fort Niagara. Sam fired off letters to the Commanding Officer, Colonel Blewett once again as US Army planes buzzed his rooftop. On July 1, he wrote, "It tempts me to buy an anti-aircraft gun. I do not understand why you and your men do not obey orders from the Pentagon which actually came from President Nixon. The President is your Commander-in-Chief and I suppose his orders should be obeyed." Sam copied all his letters to both Colonel Blewett and the various presidents of the United States. One letter from Fort Niagara jauntily noted that "…our boys like your air currents." Letters were fired off to the Canadian Department of National Defence as well as to the Pentagon and the White House on the "frequent and illegal invasions of a friendly foreign state." After a period of time the annoyance stopped without loss of face for the "invaders" and an international incident was avoided.

Earlier in the summer Sam had been in Boston, and his prized possession, his tam, was stolen. It was a gift from his friend, Joyce De Vecchi, a prized possession, indeed a souvenir of her travels in Scotland. Sam was devoted to his tam. There are many pictures of him wearing it at a jaunty angle. Sam wrote to Herbert Johnson, hatters, in Aberdeen about making him another one with specific instructions so that it would be an exact copy of his original, a bobble on top and in the Weir tartan. He wanted it to be duplicated in every respect. In September Sam received another note from Denyse Jacquemoi signed, "Love and xxx, Denyse." Here the correspondence seems to have been dropped as there is no further record.

Several important and significant works came into the collection in 1972. A Homer Watson, *Cottage Beside a Rocky Stream*, painted in 1894; the Impressionist Albert Lebourg, *La Seine Effet de Neige*; James Henderson, *The Valley at Fort Qu'Appelle*; two works by Guy Gene du Bois, *Holiday Lady* and *Holiday Gentleman*, both purchased from Parke Bernet, and many others all joined the collection.

Sam established himself as a Canadian non-resident in 1972. His idea at that time was to go to his house in Queens and use it as a *pied a terre* while he had legal work to do in New York and then spend time in the winter months in Costa Rica, going to Grand Cayman as his principal residence. The no income tax policy of the Caymans appealed to him particularly and Costa Rica beckoned. Accordingly, Sam spent the Christmas period

of 1972-73 first in Grand Cayman and then in Costa Rica. He had been ill in November of 1972 for three weeks with pneumonia and as soon as he was well enough he hustled off to the warmth. However by the end of January he was back at River Brink and writing to Margaret Markert about Costa Rica, a place he had come to love despite its snakes:

"There was an English architect at my place in London a couple of years ago when I was trying to sell it to Taylor Woodrow, world wide house builders. He had been serving in the army in Burma during the war, and so I commiserated with him on the number of vicious snakes he must have encountered. His reply was that there is not much trouble in Burma but Ceylon is the place for snakes. An old woman who took the cash at the restaurant where I ate as a law student told me she was raised in Ceylon and it was so bad there that when you walked up the road the enormous snakes slithered off the top of the hedges. I am glad to know from your account of Ceylon that it is very beautiful, but why didn't you say something about the snakes? In Costa Rica there are notorious snakes, but as I was living in the capital city, I saw none. They tell me it is cold in the mountains and that

the snakes stay down on the coastal area where it is hot but I expect Ceylon is hot all over.

You should not have missed Costa Rica. I have fallen in love with the place after being there five days. The principal reason is that I don't have any bronchial trouble there. I was in the Cayman Islands for business reasons. There are no taxes there of any kind except import duties. Even your house has no impost on it. But I have had pneumonia in New York and spent three weeks in bed there. I expected that the heat in Cayman would have cured me but it didn't. I think the Trade Winds were picking up sands off their beautiful beaches because I had irritation in the throat and neck constantly. So I was driven over to the Costa Rica. A plane flies there twice a day from Cayman and when I got up the first morning I was there my chest was perfectly clear. But this is a beautiful, fantastic country and deserves a visit from you.

In addition to other family nonsense my father had a cousin named Houston who was so adept a railway worker with the old Grand Trunk Railway in Canada that he was hired down to Costa Rica and Nicaragua as superintendent of railways. When I was a young lad he used to tell me that Costa Rica was the place

to go, 'keep out of Nicaragua, and if you have plenty of money, go to Mexico City.' "

Perhaps Costa Rica had always seemed to Sam to be a mythical Garden of Eden according to his father. With his characteristic energy and enthusiasm he did investigate the possibility of buying a banana plantation. He wanted to go halves on the project with Margaret's husband, Clement Markert. Costa Rica was perfection according to Sam, despite a few snakes. To protect himself Sam had ordered high boots from an English bootmaker. The boots that arrived were so high that Sam found he could not bend his knees. The bootmaker advised slitting the cuffs at the back to give possibility of movement. Sam was incensed.

Fortunately for all concerned, before the purchase of a banana property took place, Clement indicated that he wanted no part of it. Sam considered it a potentially profitable enterprise, but Clement thought otherwise. Later Sam was made fully aware that negotiating any sort of business involving vicious snakes, whether animal or human, was unwise. The snakes won out and the Garden of Eden he had hoped to find had its own kind of expulsion.

When a Canadian lawyer who had taken out United States citizenship in order to practise in the United States wrote to Sam and asked him how he had managed a law practice in Manhattan as a Canadian, he replied, "I had an agreement with the Senior Bar Association, New York City that so long as I took in business from other attorneys, whether New York or otherwise, they would not interfere with my New York work." He might have added that he had received encouragement from Canadian sources: government, legal and banking. Apparently nobody had ever started such a service in New York State, if not in the entire country, before Sam opened his office on Wall Street.

In writing to his cousin, Margaret Markert on February 3, 1973, Sam finished off a cousinly chatty letter with:

"Two or three years ago I thought I was retiring but have been bothered more with things since than I ever was before. And the tragedy about it is there is no money in any of it. If prices keep going up so astronomically, I may decide to go back to work. I expect to be at Queenston on the Niagara River all summer, then I would suggest you come up then and get some quiet. When I pass on, I hope there will be some quiet under ground. But not according to the religionists who, I think, have me slated for limbo and hellfire."

Margaret and Clement did come to visit the following September.

Although in increasing pain, Sam carried on the wind-up of his law practice, oversaw prodigious plantings in River Brink, carried on a vast correspondence and above all, maintained his vigilance over the auction catalogues that arrived in great quantities. He had obviously confided in Arthur Pattillo of Blake, Cassells and Graydon about his arthritic condition in his fingers and toes. Pattillo wrote to Sam on May 28, 1973, suggesting a trip to China for treatment. We are not told whether Mr. Pattillo was recommending acupuncture or something arcane in herbal treatments. At any rate Sam did not follow his advice.

With a passion for ordering things from out of the country, shoes and furniture from England, cloth for his tailor from Scotland and Ireland and so on, it is not too surprizing that Sam wrote to a fish merchant in Aberdeen for smoked salmon, "not soaked in oil as I have found it in Canada, which is not suitable for cocktail parties." One wonders what the fishmonger in Aberdeen thought to himself as he read the letter with its order. In fairly frequent letters to Kenneth Jarvis, who was Secretary of the Law Society of Upper Canada, that he was considering writing a book of reminiscences about various lawyers who had died, Jarvis wrote that he liked the idea, but

that he had no staff to help. He suggested taping interviews in order to build an archival collection, but after a few somewhat abortive attempts on Jarvis' part to interview Sam to record his reminiscences, this undertaking was dropped.

The stepfather of Ruth's and Wilbur's granddaughter applied to Sam for money for the educating of the girl. Sam replied that an ample share of her grandfather's estate was left for her benefit and, as an executor of Sarah, Ruth and Wilbur's daughter and Sam's niece, Sam demanded an accounting. An answer, if one there was, has not been preserved. Sam, in another letter to the man, a lawyer in New York, threatened to take him to court as he had been observed entering the Sunnyside house and removing items for which Sam had previously paid Sarah, as executor of her father's estate when he purchased and took over the Sunnyside home upon Wilbur's death.

That Sam had never written two or three examinations at the conclusion of his studies at Osgoode, because of illness which had forced him to go home to London for a period of many weeks, was a continual sore point. That a Bencher of so many years standing and a Queen's Counsel should not be given an LL.B. continued to rankle Sam, as indicated in the many letters he wrote to friends, and would be with him for the remainder of his days.

244

24 SAM'S LAST ROMANTIC FLING

IN JUNE SAM WAS OFF TO COSTA RICA AGAIN FOR SIX WEEKS. Although he had suffered very much with his arthritis, he wanted to spend some time in the Caymans to establish his practice. By the end of October, after Sam had spent considerable time and effort to bring the two young Costa Ricans to work for him, the vivacious girls arrived to help with office work. Becoming proficient in English was their stated intention and they did their best to learn. Sam had made their acquaintance in the bar of the hotel where he had stayed in San Jose during his first visit to Costa Rica. One seems to have gone back home shortly afterward or have left for other employment, but Sam had been very taken with Margarita Montero Quiros. Before arriving in Canada, she had sent many letters to Sam, flattering him and indicating that she was fond of him, signing her letters, 'Love.' Sam commented in a letter to Margaret Markert that Margarita brightened up the office and was becoming effective in language and office procedure.

In early November Sam added a codicil to his will, "I hereby declare my domicile and residence in the Province of Ontario have been abandoned and are now in the Cayman Islands." In December Sam wrote to his friend, Joyce DeVecchi in London, from Grand Cayman, "Christmas must be meant to be enjoyed by you with your folks all alive. I have none now..." Despite all his activities and illnesses, including a bout of

pneumonia in the fall, he wrote a letter from the Cayman Islands to Chief Akiwenzie of Cape Croker.

Sam, the inveterate and passionate collector, still managed time to acquire a number of important works of art for River Brink throughout 1973. Curiously, George Luks' *Bassoon Player* entered the collection. Sam may well have thought of it strictly as an investment to be divested later when, hopefully, its value had increased and it could be used as trade to acquire something more in keeping with the majority of his holdings. The painting is oddly misnamed as the player is holding what quite clearly is a saxophone not a bassoon. A mezzotint of General Wolfe by an unknown was purchased as well as Jacobine Jones' *Portrait Bust of Brian Doherty*, and a Suzor-Coté, *The Stable Boy*.

Early in 1974, Sam flew from his home in Sunnyside to the Cayman Islands to get warm, as he put it. He had not made prior hotel reservations and to his fury was unable to get a place to stay. He flew right back to New York, caught a bad cold and was back in Queenston by mid-February. A fragment of a letter written to Sam on April 8, 1974 mentions that his friend Eugene LaBrie had been called to the Bar of the Cayman Islands. Sam was keen to follow suit.

Asked by the Shaw Festival personnel to lend his bust of George Bernard Shaw by Jacob Epstein once again, Sam replied that as it had been away for about six months the year previous, he must refuse. "I like looking at it myself," he ended his letter.

At the end of May, 1974, Alexandra Haldane, assistant curator of the McIntosh Gallery at the University of Western Ontario, wrote to Sam after his enquiry as to the fate of his gift of two paintings:

"For Your Information: The two oil paintings attributed to James Hamilton which you so generously donated to the University Untitled Landscape *oil on canvas 30 1/16 x 39 15/16 inches and* Untitled Landscape *oil on canvas 21 5/8 x 31 inches - are now on display in the McIntosh Gallery as part of the exhibition 'Recent gifts to the University'. The exhibition will continue to August 18/74. Yours sincerely, (signed) Alexandra Haldane."*

They apparently were and continue to be on display in the University.

On July 31, 1974, Sam delivered the deed of land for the last piece of real estate at 139 Oxford Street West, London, to the Ontario Housing Corporation and was paid $185,000. He was relieved to be free of it, but still it was a wrench to leave the

home of his boyhood and all the intervening years and where his mother, father and Martha had spent their last days. The old place was razed and townhouses took its place.

In September, Sam's New York neighbour, Ed Sutphin, drove him from River Brink to Queens. They stopped at Sir William Johnson's house on the Mohawk River, a battleground of the American Revolution, and in the 1760s, what came to be known as the French and Indian Wars. It was while the comely young guide was taking them through the place that Sam surprized everyone by demanding of the girl, "Are you a virgin?" "Yes," the startled girl replied. "Are you?" Sam was not noted for subtlety and it was not the first time he had been rather blunt in his encounters with young women, but it was typical of his utter absorption in what was passing through his mind at the moment that he should launch a frontal attack. He was thinking a great deal about producing an heir at this time. He wanted to have someone related to him to whom he could pass on his collection. With the death of Paul, it had been brought home to him forcibly that there were no male descendants of George and Sarah, his parents. Ruth's son William Howell, known always as Billy, had died of illness while still a young man, leaving only a small daughter. But Sam longed for a Weir descendant. Marriage was an important component, but courtship not so.

In correspondence with the branch of the Canadian Imperial Bank of Commerce near his London office, with whom he had dealt for many years, Sam indicated that he had a will to be completed. Various dates had to be filled in. He also wrote that he was contemplating a trip to Russia and invited a girl in the office identified only as Mary Anne to go with him. She declined the invitation. It never seemed to occur to Sam that a story like that would travel speedily through London town and add a little something to the opinion of many that he was an eccentric.

By October Sam was riding high again with a complaint against the Bell Telephone Company which he took to the Board of Transport. His London telephone number was changed without his knowledge, in all probability because he was out of the country, or certainly not in London. Bills for the unrecognized number were not paid and Bell Canada's London office ordered the Niagara-on-the-Lake office to cut off his service. After heated exchanges, the London office agreed to cut off the amount owing after his number was changed without his knowledge. Sam wrote of his displeasure to the Board of Transport, furious that 'Ma Bell' should be so "omnipotent" and asking the Board to "do something."

There was also an ongoing feud with Sheridan Nurseries. Sam claimed that he should get his stock at

wholesale and Sheridan claimed that since he was not about to resell it, he was a private customer. Eventually Sam claimed $100.00 for loss of a year's time in his landscaping plans, as he claimed part of the order did not arrive. Sheridan Nurseries brought suit against Sam, but eventually all was settled out of court.

During this period Sam seemed to be involved in a number of disputes, and from his letters, it would appear that his temper was becoming more volatile. A cantankerous element was increasing with the absence of an amused or ironic expression that had made his letters heretofore both apt and entertaining. It must be remembered that it is difficult to be witty when in great pain. Mary Fraumeni's daughter, Nancy, came through with her regular proposals of marriage, writing again and again of her attachment to Sam, feelings which were not reciprocated and which indeed had been repudiated at regular intervals for many years. Sam found her protestations of love and hints of her availability for marriage really trying.

In a letter of October 18, 1974, to Margaret Markert, Sam wrote "I don't know whether I told you that I am the owner of a bunch of letters written by the Earl of Amherst to his wife during the years 1758 to 1761 when he was commander in chief of the forces in North America. I hope to make an arrangement with Amherst College to bring these letters out in a limited edition under the imprint of Amherst College in the U.S.A. and the Weir Foundation in Canada. I have told Amherst College that I am giving some of the letters to them for their archives. They say they have quite a bit of material but nothing so intimate and interesting as this. I know they have a plate for reproducing a coloured portrait of Amherst by, I think Gainsborough, and I don't see why they shouldn't lend that to the joint effort."

On November 15, 1974, Sam wrote to Joyce DeVecchi, his trusted friend, of his troubling arthritis and that he was looking for an acupuncturist, or a place in Texas. He was thinking he might try Battle Creek in Michigan except that, "They once put me on a diet for a week and I weighed more at the end of the week." At the end of the year, Judge V. Lorne Stewart wrote to Sam inviting him to join the Stewarts in Cayman at Cayman Sands over Christmas.

Kenneth Thomson and Sam had kept up a correspondence over the years and had become friends through their shared passion for collecting paintings. Thomson wrote to Sam that he would like to buy one of Sam's Krieghoffs for $25,000.00. Sam said, "No deal." He prepared a listing of all his works stored with Frank Worrall for framing, cleaning, stretching and so on. Twenty four are listed, but there were more than the number would indicate. Five of the

247

numbers referred to envelopes in which at least two and sometimes thirteen or fourteen separate items were enclosed.

To Mrs. John T. Elfin of Buffalo, Sam wrote in response to a letter of hers after she had been to River Brink to see the collection on October 18, 1974, "You mentioned in your letter the painting *Red Jacket*. I went to New York purposely to try to buy this painting for my house at Queenston. I took an art expert from Toronto with me and he was afraid that I was going to go over the deep end. So I told him that $10,000.00 was my limit. When the picture was put up the bidding was very slow at first and I began to think I might have a chance of getting it but as you know it ultimately rose to something over 30,000. I am glad you have it in your museum because it is of great local interest. Red Jacket was of course a friend of the British who lived in Buffalo or near there and used his influence for all the warring people of the time."

Sam spent the holidays, at least in part, in his home in Queens. A painting in a special travelling exhibit in the Metropolitan Museum of Art by Albert Eckhout caught his eye and Sam wrote to the artist's dealer in The Hague asking for details of price and so on. The dealer, S. Nystad, replied on January 13, 1975 that a client was interested and that the painting was to return to Holland after the New York showing. He also mentioned that the painting was insured for $200,000 and that he was sending a leaflet to Sam with more information on it. The lack of a copy of a reply to Nystad would suggest that Sam did not pursue the matter, the price being from his standpoint, prohibitive.

Judy was, of course, in New York taking care of Sam. Together they went into the city to see the Antique Show at The Armouries. They parted inside agreeing to meet at a certain spot before lunchtime. When Sam showed up he had a couple from Vancouver in tow and it had been arranged that the foursome should have lunch together. Accordingly they went to a restaurant and were seated. Introductions were made. The couple from Vancouver expressed surprise that Sam and Judy were not married. "This lady is my housekeeper," said Sam. The Vancouver pair made it obvious that they were not accustomed to eating with the help. Sam immediately stood up and bade Judy do the same and out they went. Sam was angry at what he considered ill bred snobbishness on the part of his erstwhile acquaintances.

Another day, Sam saw that there were two auctions in New York on the same day. He was interested in items being offered in each sale. Accordingly he went to one and Judy was dispatched to Parke Bernet with instructions to bid on a couple of offerings . When Judy started bidding, a young employee came up to her and wanted to know more about her. "I'm

bidding for Mr. Weir," said Judy in her carrying voice with its Irish lilt."Oh! That's all right then," said the young man. Judy was very proud that she got one item a shade below Sam's maximum and the other went beyond and she stopped bidding on it. Both were pleased with the day's accomplishments.

A letter written by Sam to The Hon. Ken Thomson, from Queens to Toronto in early January of 1975, spelled out Sam's state of health, his troubling arthritis, the pain killers being inadequate and being told not to increase the dosage. He was hoping to go to a clinic in Arizona to take off some of his 244 pounds. His sketch by Tom Thomson for the famous *The Jack Pine* was being sought after by a number of collectors. "So as to avoid trouble I expect I better keep on holding it. Then there won't be any jealousies among the collectors," he wrote. He continued:

> *"I don't feel that I will sell any of my paintings. It would probably be wise of me to do it so as to get out of my bank loan, which has been costing me 13 1/2% interest, more than flesh and blood can stand... Picture collecting, and for that matter, even books, are a bad disease. Since I came down here this last month I have gotten interested in a portrait by Benjamin West whom I never thought of as a considerable portrait painter. He was rather more a painter of groups and spectacles. These eighteenth century British portrait painters were good at tossing in red color. Epstein, whose book I have, and I expect you have it too, refers to them as the Eighteenth Century British School of Port Wine Painting."*

Although Sam was still purchasing particular art works that he felt would enhance the major thrust of the collection, his accumulating zeal had worn off a little, tempered by the general increase in prices, although he retained all his old interest as a collector. However among other acquisitions, he did obtain a watercolour, *Study of a Tree*, painted in 1875 by Daniel Fowler, exactly a century old when he bought it.

The following month Sam had returned to River Brink and, in responding to an enquiry about the Weir family from James Donald Weir of Calgary, he wrote that he "feel too old and too weary to give much answer." Sam went on to enquire, "Where is your sister Mrs. McMally? I wish I had been lucky enough when I was young to persuade her to put her boots under my bed. I like her. I am still unmarried..."

Time continued to be made for writing a great number of letters to all and sundry. As noted earlier, it had long been his

custom to buy shares in any company with which he had business dealings. Then, if anything displeased him, if employees were slipshod or disrespectful or if the products shoddy, Sam would fire off a blast to the president or chief executive officer, outlining his annoyance and reminding him that he was a shareholder. He enjoyed feeling that he had some clout with the powers that be. Increases in club and organization dues bothered him. Like many of his age group he dismissed the general inflation of the day as unnecessary and a nuisance, especially since his legal practice with its income was at an end. That his investments were yielding a greater return was not commented upon.

Later that year, in October, Sam and Eugene LaBrie were making plans to go to Bermuda. They intended to put up at the Royal Bermuda Yacht Club, but even as late as mid-December the trip seemed to be still in the planning stage.

That Sam was on the prowl for paintings to "fill in" his long ago aim to have three examples of the leading Canadian painters up until the Group of Seven era is shown by his letter to the Arts and Letters Club of Toronto, dated January 15, 1976. Although not a frequent user of the club, he apparently had been there and noticed an A.J. Casson on the wall. Sam wanted it and, of course, at the lowest possible price. After all it would be in a museum situation, he reasoned. The matter does not

seem to have been pursued and Sam had not acquired a Casson for the collection by the time he died, even though he continued to admire Casson more than some of the other members of the Group.

By the end of January, Sam had done his usual winter journey, down to Queens and then on to Grand Cayman. On the thirteenth of the month, he wrote to Joyce DeVecchi that "we" in the Caymans had to endure damp living conditions. Dogs, cats, frogs, lizards and centipedes were underfoot. The nights were a cacophony, cats howling on the roof to begin with and then the roosters and dogs taking over. Sam was beginning to lose his enthusiasm for Grand Cayman as a place to live although the tax situation was still a strong allure.

On March 3, 1976, F.J. Dunbar, Secretary of the Board of Trustees of the Royal Ontario Museum responded to Sam's letter of the preceding August regarding the fate of the paintings intended for the National Portrait Gallery:

> *"...You mentioned that you had collected quite a number of self portraits by eminent Canadian artists which you thought might end up in the Gallery but that you were considering turning your own house in Queenston into a little museum. You may not be aware that one of the main problems facing the National*

Portrait Gallery is space to display the portraits that it owns. Had you thought that your own house may become the National Portrait Gallery, certainly for the time being? This, by the way, is a personal opinion which I have not discussed with anyone else. If you were interested, perhaps you might have your own solicitor get in touch with me to see what might be involved."

This was a 'ball in your court reply' if ever there was one. Considering the extensive collection and the wall space of River Brink there was not enough room for the Forster collection there either, nor did it conform to Sam's original intentions. The Forster Collection remained out of sight in the Royal Ontario Museum.

Nancy Fraumeni's monthly proposals of marriage written on note and greeting cards came to an end with her death in 1976, but Sam received many letters from "the little girl," Margarita Montero Quiros in Costa Rica. She had travelled again to Canada, by herself this time. Her friend Zayda had dropped out of sight much earlier, presumably to give Margarita a clear field for carrying on a relationship leading to a marriage. In her many letters to Sam she almost invariably thanked Sam for at least one cheque. While she expressed interest in his health, she also had sad tales to tell of her mother's illness, costs involved, as well as her own health problems, plus her need for employment and the bewildering series of jobs she held temporarily. She apparently found steady employment tiring. When his sympathies were aroused, Sam, like many another, was very generous.

On May 6, 1976, to the surprise, consternation and perturbation of his friends and cousins, Sam and Margarita married, "at the Governor's House, Costa Rica" according to the announcement Sam sent out. Judy's account of the wedding, in a letter she wrote to Sam's cousin Margaret Markert on the 10th of May, 1976, has a different version:

"...a short note to say we arrived in Mexico on Friday the 7th. Mr. Weir very much improved since we left Cayman Islands. Well, the wedding took place on Thursday the 6th at 12 noon at the Civil Office — her brother did not attend. There was only the two attendants and there were 2 from the hotel where we were staying. Mr. Weir bought a house in San José so we hope to see ye next winter."

With his typical generosity, Sam bought Margarita a cream coloured cotton gown for the wedding. Judy was on

hand when it was purchased and she thought it "a lovely dress for a bride." On the eve of the wedding Margarita decided to wash it and according to Judy, "it looked like a rag, all spoiled and no iron to set it right." Just before the ceremony Margarita produced a document, which was not notarized, stating explicitly that there would be no connubial intimacy. Perhaps the bridegroom did not believe her, perhaps he considered such a document had no validity, but Margarita meant it. On the wedding night the bridegroom slept in lonely splendour. Judy and Margarita roomed together. Prior to the wedding Judy and Margarita had got along fairly well. Judy had given her money on at least one occasion when she was leaving Queenston to return to Costa Rica, claiming she had none. After the wedding, however, the situation was uncomfortable to put it mildly.

Sam had an automobile built in Canada and modified for use in the tropical climate. Getting it into Costa Rica presented insurmountable problems. Sam engaged two young men to drive it all the way from Queenston with Judy as a passenger. It was an adventure she did not forget and did not recall with pleasure, but it was finally delivered. Judy felt that the delays were because there had been no provision for presents of money to be handed out at various Central American checkpoints to persons at the port of entry offices. Sam was finding that his Costa Rican paradise was indeed riddled with

serpents. Not least was the treatment he received from Margarita's brothers, who, before the wedding, had been obsequious, but were now a grave problem. One even threatened Sam with a knife and the police were called. Sam had bought a house for Margarita, himself and Judy as housekeeper. When Sam returned to River Brink without Margarita, he found out that her entire family had moved in to his house in Escazu and stripped the place, right down to the light bulbs.

Sam tried to keep peace in his household against all odds, but Margarita did not fare well in the northern winter. When all three went together on a pleasure trip to Europe in October, Judy sent postcards off to family and friends, including a number to Margaret Markert. In the summer Sam had provided the means for Judy to travel to Ireland for a chance to visit with her relatives. He thought of it as a settling down period for the strained emotions. While many Canadians whom Margarita met in the summertime at River Brink were charmed by her, she was not the nurse and care giver, nor the cook, that Judy was. By the time of Judy's return both Sam and Judy realized a mutual dependency. Margarita returned to Costa Rica and only ventured north briefly in the summer months to assume the position of chatelaine at River Brink. Relations between Judy and Margarita continued to be strained, Margarita claiming she was afraid of Judy and Judy

having no patience with someone she saw as taking advantage of her 'dearie's' generosity.

Archibald Barnes had painted Sam twice. One was full length. Sam thought the full length portrait should grace the new London Court House for which he had campaigned. However the Middlesex Law Society did not agree. On May 27, 1976 Sam complained to Roy McMurtry, Attorney General for Ontario, of the Middlesex Law Society decision. It was suggested that the London and Region Art Gallery might like it. Eventually it was shipped to Escazu, Costa Rica, and was subsequently lost in the disappearances, break up and sale of Sam's house.

Flights over River Brink by the U.S. Air Force quartered near the border recommenced in the summer of 1976 and again Sam fired off letters of complaint, this time to President Ford. The flights continued. It seemed to Sam that the Air Force was flouting international law in total disregard of the border and, in particular, was taunting him.

In August Sam wrote to John A. Weir, now a practicing barrister and solicitor in Edmonton, reminding him of their meeting in London when Sam attended the Commonwealth Law Conference and John A. was a student. He wrote of the Swedish girl, Lillemor, whom he later thought had been responsible for his loss of his gold watch. Apparently, John, as a very young man, had rather thought Sam's obvious pursuit of

the girl an embarrassment. In his letter Sam sought to justify himself by asserting that his interest was a serious courtship. John had not answered a number of Sam's letters when both were back in Canada. As John had accepted Sam's invitation to be taken to Ireland on an ancestral hunt, Sam initially had been hurt at his subsequent coldness.

By the end of the year Sam and Judy were in Queens. Sam underwent surgery on his left leg and foot and Judy nursed him. Although his interest in acquiring more works for his art collection had dwindled a little, he also had a number of works delivered on approval, but he sent several back. It would seem that the year 1976, a disappointing and exhausting one on many counts, had left his energies waning. He toyed with the idea of having Barthé do a head of him, but was finding the man another problem as he had left New York and was thought to be somewhere in the Caribbean. To add to his aggravations, Sam's problems with receiving his mail were compounded with his additional address in Costa Rica. Constantly he had to chase down cheques, wandering from country to country. Notwithstanding weariness, he still was ordering plants. In a letter to a bulb dealer for well over 1400 *scillae, narcissi* and lilies, he wrote:

"I am still determined to develop it [River Brink] *as a small paradise. I have a will leaving it to a*

charitable foundation as a family memorial and I want it to look pretty wonderful when I pass out."

However, in 1976 one of the most interesting and important paintings of the collection would arrive in River Brink. Obtained from an auction at Christie's in London, it was attributed to Johann Zoffany, *Portrait of John Graves Simcoe as a Young Man*, painted about 1770. Sam immediately got in touch with John C.G. Vowler at Parnacott, Holsworthy, Devon, a direct descendant of John Graves Simcoe. An interchange of several letters followed, growing increasingly friendly. In one letter Sam commented that he wanted to come to Devon and to get bronzes cast from a rondel of Simcoe presently in Exeter Cathedral. He wanted one for the Ontario Legislature Building in Toronto, another for a public place in London, Ontario, one for Kingston, Ontario, and, of course, one for River Brink "...so that is one errand I have before I die that I feel must get done." This, alas, was not fulfilled. "I wish to visit around the Simcoe area in Devon," Sam continued, "and perhaps in a wider field because my father had an uncle who came from Devon [His great aunt Jane's husband, David Chambers…, perhaps] and we have always felt a fondness for that beautiful county which I have not yet seen." Sam added that the painting had been despatched to New York for cleaning. "Christie's said it was

pristine, but it was filthy."

Another strong and deeply felt wish that was not realized, as outlined in the many letters to fellow collectors, was Sam's ambition to acquire Sir Thomas Lawrence's portrait of Henry Dundas, later Viscount Melville. Neither Dundas as Home Secretary nor Yonge as Secretary of War had ever travelled to the Canadas, but Simcoe had enshrined their names in his road building projects. Sam wanted to have a painterly record of what have become familiar names of historical significance.

Sam seemed to have had more than his fair share of troubles caused by incompetence. He wrote to the National Railway Passenger Company at L'Enfant Plaza North in Washington detailing the fate of baggage checked at Grand Central Station in New York in February 2, 1977, to be picked up at Buffalo. The baggage turned up five days later at Fort Erie. He wanted to be reimbursed for having had to hire a driver for the unnecessary trip. He also detailed various other experiences, buying a berth in a compartment allegedly for three and finding it containing only two berths making it necessary for Sam to sit up all night long. Shortly afterward he bought a ticket for Orlando to Miami and found his seat occupied by a passenger with a ticket from New York to Miami. The train was full and Sam was unable to find any seat at all. On another trip

SAM'S LAST ROMANTIC FLING

from Boston to New York, in the heat of summer, the air conditioning was broken before the train pulled out and then the lights failed. He pointed out that he had brought these situations to the attention of the company before and had received no satisfaction.

On February 22, Sam wrote an accusatory letter to James D. MacDonald in Grand Cayman, indicating that, on the premises rented by Sam from MacDonald, Sam had been sent utility and gas bills which Judy had paid before vacating the house. MacDonald had also charged Sam for preparing minutes for his company. In the letter Sam claimed to have told MacDonald at least twice that he would draw up his own minutes and further that he had been charged a higher rent than was charged by MacDonald on his other similar properties. This disparity angered Sam and he wrote that technically MacDonald was not entitled to any rent as it was rented as a furnished house and lizards, frogs and centipedes were running around in the rooms. If good old English Common Law were to prevail in the Caymans, Sam wrote, the house with its unwelcome inhabitants could be declared unfit for habitation and hence no rent need be collected. In spite of these problems, Sam still wanted to be part of MacDonald's law firm and to be admitted to the Grand Cayman Islands Bar.

A portrait alleged to be of Joseph Brant, possibly painted by Gilbert Stuart, was sent to Sam in New York on approval from Leo Heaps, a dealer in London. Sam took it to the Metropolitan Museum of Art in New York. Their American experts decided it was certainly not by Stuart, but probably by a British painter. That the portrait did not show an Indian Chief medal made Sam doubt that the subject was Brant. He planned to go to the New York Public Library at the advice of the Metropolitan experts and have them retrieve all the likenesses they had of Brant for comparison. Sam sent the picture back to Britain with the comment that Heaps was expecting too much profit on an unsigned and unscribed painting. He ended the letter: "If you still have it after a while get in touch with me again." He regarded it as an intriguing puzzle for possible further investigation.

Although Sam was no longer a director of District Trust, he still owned the premises of the company's head office. Due to constant misdirection of his mail, Sam had omitted paying city taxes on the property rented from him by District Trust. The City of London tax office then informed Sam that District Trust's rent was to be paid directly to the city until the taxes in arrears were paid up. Sam was incensed and blamed it entirely on his mail constantly going astray among three residences.

Still vigorously interested in purchasing art objects, Sam welcomed the latest arrival, a set of Coalport sweet dishes along with sterling wine labels. He also purchased materials in

commemoration of the Queen's Silver Jubilee. In a letter to a dealer in Bristol of March 15, 1977, he wrote "...I am desperately wanting to be in England along in May or June. I am just now a shade under 80 years of age and it will probably be the last trip of my life. But there are things I want to do in England very much."

"One of these things is to get a sculptor to make a copy of our first Governor Simcoe which is displayed in a bas-relief at Exeter Cathedral for which I have permission from the Dean. I wish to make a number and distribute them around Ontario so that this old boy, who did his best considering his English pomposity, may be more remembered here in Ontario. Very few people seem to have heard of him."

In a postscript to the same letter, he wrote of his interest in clocks, in particular a table clock with paw feet which did not please him. He wondered if there was a table clock available with wall feet, and if there was a possibility of obtaining a Ben Franklin, apparently a scarce item.

Sam's interest in genealogy continued. He had purchased two annual diaries of a Jimmy Bawtenheimer an ancestor, from Hugh MacMillan, the well known archivist of Guelph. Other diaries in the Series of 37 are in the Ontario Archives collection in Toronto, and a few extracts were made for Sam who showed them to E.C.H. Phelps, Archivist of the University of Western Ontario, who, in turn, found them to be of great interest. Sam and David Bawtenheimer went together to Ancaster to visit the old homestead of Sam's great grandfather, built around 1850, and at that time the home of Professor and Mrs. Gordon Webster. Sam made an immediate offer to purchase the house. The Websters were taken aback and declined to sell. Sam, having been shown through the house, wanted to buy it at once so badly that his tears flowed at the owners' refusal. It was a favourite spot of his mother's, he told them. However, records of Sarah ever having had the time, leisure or money to travel to Ancaster from Toronto, Brigden, Owen Sound or London are not noted.

David Bawtenheimer died in April 1977. Sam mentioned frequently in letters to friends that he missed his cousin and neighbour, their rolling up together in an impressive car to overawe the Bawtenheimers gathered at the annual family reunions, and the various other excursions to visit family tombstones around the area.

Early in April of 1977, Sam wrote a short article, "The High Cost Of Being A Canadian In Ontario:"

"I am seated with three bottles of Scotch whiskey on the table before me. I purchased them for the purpose of this article. The first bottle was legally bought in New York City. It is 26 ounces, but it is 80% proof put out by Bulloch Lade, one of the very best brands. While marked "imported" I believe it was bottled in New York from casks despatched from Scotland. It costs $4.98 in a private retail liquor store. There is no government monopoly in the State of New York!

The other two bottles are from the Ontario Government Liquor Control Board store (government monopoly) at Niagara-on-the-Lake. Note well that their labels state the whiskey is 40% proof, which I suspect is half the strength of the New York sample. These are also bottled from casks brought in from Scotland. One is "Extra Special" and the other is marked "Light Blend." I am amazed to see that they are stated as 25 ounces, which is a departure from the old 26 ounce reputed quart. Is this part of the cheating - one ounce at a time, in our Liquor Administration? The price of each bottle is $7.90.

Now of course there is a monetary exchange

difference. The New York bottle was purchased when exchange rates were level. At $7.90 a bottle, is the real cost of this Scotch $15.80 to equal the strength of the $4.95 New York bottle?"

In an earlier account, March 19, 1977 *Globe and Mail* article entitled, "Govt. Sale of Liquor," Donald Creighton listed various makes of liquor, their proof and their prices in New York City "in more than 80 retail stores." The article continued:

"People in Ontario should compare these prices, under retail competition, with those of the Ontario Liquor Control Board. In Costa Rica where I spend much of my time, the distillation of alcohol is a government monopoly; but the private companies build their own brands on it and there is no control of prices on imported brands. The price for other whiskies at 26 ounces and 80% proof, is around $4.50.

Now is there any question that the Ontario Government is running a big rip-off on its citizens?

An intimate friend of mine (the late Robert Cudney, Q.C.), when Deputy Minister of

Liquor Control Board, and I were once passing the LCBO warehouse on Fleet Street, I remarked that the very building was probably financed on their profits for three months or so. He replied that it was one and one half weeks."

Sam apparently had it in mind to write a series of articles on what he considered government ripoffs, but this April, 1977 one appears to be the only one he completed.

From River Brink, Sam fired off a four page letter to the President of Costa Rica, Daniel Oduber, acknowledging the President's reply to an earlier letter of Sam's, all with complaints about a Fred Werner of the Chorotega Hotel, whom Sam felt was guilty of extortion. He also sounded off about the fate of the Ford car he had brought to Costa Rica. The status of *pensionades* was mandatory for a foreigner owning a car in Costa Rica, otherwise it would not be possible to obtain insurance. Sam was angry that, although he had applied for *pensionades* status, the paper work was not forthcoming. He had other complaints, the poor state of public transportation, both bus and train, the exorbitant, to Sam, cost of insurance, the variety of poisonous snakes, which last he pointed out, could easily be overcome by importing mongoose, as had been done in the islands of the Caribbean and, lastly the state of the mail

service, much more deplorable than the mixups in London, Queenston and Queens. If the President replied to this letter or deputized someone else to do so, it has not been preserved.

Despite tense drawbacks, Sam was back in Costa Rica and the Cayman Islands in June of 1977, from where he wrote to Frank Worrall. Worrall had apparently told Sam that he did not owe him a cent. Sam concurred that he had paid Worrall for all the work which had been done for him. However Sam felt that Worrall owed him a great deal of money. On June 9, Sam wrote to Worrall:

> "...I kept you out of jail. A lawyer's time is expensive. My own time for you was a great deal. I also paid the late Arthur MacDonald Q.C. for appearing in court for you $800. There were other court expenses, telephone calls, etc.
>
> You purloined from me a painting by Robinson which you gave to Leslie Lewis who sold it. You never paid me, of course. The price then does not matter as in case of the misappropriation, it is the price I now demand. Robinson's paintings are at $8,000 - $10,000 dollars. I will set it at $8,000. I liked this painting and I never could understand why you behaved like that.

Also there is a painting of Robert Holmes which you gave to me. And where are the two paintings by Forbes which you gave to me? As these were gifts, I don't want to be mean about it. But they do belong to me and your son, Bob, never gave me a satisfactory answer. He was bullying towards me. And apparently from your letter I am to be kept out of touch with you. But I know where you are. I regret that I am unable to drive a car to see youIf the paintings are not returned to me immediately, I am going to sue him [Robert, Worrall's son]. ...But never forget you owe me a great deal for legal services. ...And I got on to the fact that you pushed me into the Barnes portrait to get money which Barnes owed you. I didn't want it. I had to get a better one by Forbes. ...Why didn't you finish everything? You had some for more than ten years."

It was inevitable that there should come a day of reckoning after their rather loose and unbusinesslike dealings with one another over more than thirty years.

By the end of June, on the 29th, Sam wrote to a lawyer he retained in San Jose with regard to the house he had purchased in Escazu. The previous owner had stayed on in the house after having been paid for the sale, and Sam had had difficulty in getting him and his wife to vacate. Sam had given the lawyer explicit instructions which were not carried out. In addition, his problems with Margarita had escalated to the point where he was considering filing suit for divorce.

The troubles with Frank Worrall and his son, Robert, continued to grow. In a letter of October 11, 1977, addressed to Robert Worrall, Sam wrote about two large pictures "...which you are holding back are worth about $20,000 and as I wanted them back in New York to sell them to credit my bank debt over there, you have become responsible for the interest on that sum by holding these pictures out from me. ...Do you have the correspondence between myself and A.Y. Jackson regarding the painting that I got from your father? A.Y. Jackson acknowledges painting this picture in the correspondence. I have not got the correspondence back and it must be with you people."

Sam went on, "I am sorry to say that I think your mother was the cause of this trouble without having any realization of what legal services are worth. You are practising extortion on me. On the other hand I would be glad to help your father if he gets up against it because I am really fond of him."

Earlier in the summertime, Sam had been in touch with a real estate dealer in Georgetown, Grand Cayman. He was considering buying a house there and there was some

259

intimation that he would place some of his art treasures in such a dwelling. Also he was pursuing the prospect of getting his reminiscences written and published. To this end he approached at least two columnists to 'ghost' the memoirs for him. In one such letter he wrote, "Over at Osgoode Hall they refer to me as the Raconteur of the Law Society," but apparently he was unsuccessful in interesting anyone in his project.

In October Sam found out that he had inadvertently acquired a clock from a dealer in Bristol. He had made out the cheque, left it on his desk and then changed his mind. Someone, being helpful, mailed the cheque and Sam wrote that he would pay for it anyway. He also wrote that he was planning to go to Britain the following month to attend a sale at Christie's, as well as consulting physicians. Apparently Sam was well enough to travel to England in November, 1977 with Margarita and Judy. They spent some time in Spain and returned to North America in early February of 1978.

Only three artworks acquisitions have been recorded for 1977. *Fence in Winter*, painted in 1973 by Donna Marie Jackson who visited him at River Brink at which time Sam bought the painting from her. An untitled Indian portrait by Edmund Montague Morris (1871-1913), a pastel on paper work, also was acquired as well as a hollow cut portrait silhouette, executed in 1825 by Henry

Williams. The subject was Senator William H. Harrison, 1773-1841, the ninth president of the United States, elected in 1840 but who survived his inauguration by only one month.

After some negotiation, Sam was able to get the necessary clearance to have *Ange de Lude*, cast in bronze by Philip Schiavo of Roman Bronze Works in Queens. Martha had seen a copy of the Jean Barbet work (active 1475-1514) many years before and had loved it. Ruth was fond of it also in the copy in the Frick Museum in New York. Sam wanted his copy to be of bronze so that the angel could look out over the garden and be seen from his living room window. There are indications that Sam regarded it as a memorial to Martha for whom he had originally conceived of the living quarters over the garage as her retirement home.

Sam and Judy arrived back home from overseas in early February of 1978 to find that the pipes had burst on the water intake to the house. Sam received a bill from the town for turning off the water and replied that since he had paid $2,200 in taxes to the town, he considered he was entitled to a consideration because he claimed the system had been laid out incorrectly in the first place. Life was uncomfortable at River Brink until the pipes were replaced and reconnected — a temporary discomfort.

25 A TIME OF FRUSTRATION

ON ST. VALENTINE'S DAY, 1978, SAM WROTE TO BRUCE HENRY, Curator of Manuscripts in the Huntington Library and Gallery of Art in San Marino, California. He began by thanking Henry for the photostatic copy of the *Simcoe Journal*. He thought he would get it bound and set alongside the two copies of Simcoe's *Journal* already in the River Brink collection. His real interest was in obtaining the Commission issued to Simcoe upon his appointment as Lieutenant Colonel of the Queen's Rangers. This regiment of which Simcoe became full Colonel was formed from the celebrated Roger's Rangers. Sam was under the impression from Magg's Canadian Catalogue that the Commission was in San Marino. Sam's knowledge, in enormous detail and great depth, of the historical events surrounding the Niagara area frequently is shown through his correspondence.

Sam wrote to Henry that:

"I do not know of anything of the circumstances or documents, if any, relating to Simcoe's appointment to Upper Canada. Lord Dorchester, who was a Guy Carlton, and who also fought in the Revolutionary War did not want Simcoe appointed. He was rooting for Sir John Johnson, the son of Sir William Johnson of colonial fame before the Revolution. Sir John

Johnson having succeeded to the baronetcy of his father remained loyal to Britain and after the revolution the Johnson estates were confiscated by the State of New York. I remember that Sir William Johnson had been given thirty thousand acres of land by the British government at the cessation of what you Americans call the French and Indian Wars. Here it is known as the Seven Years War, which was, as you know, almost world wide.

...Many years ago I researched on portraits of Simcoe and came to the conclusion there is one missing which I think was a watercolour. The University of Toronto holds a portrait of Simcoe in their offices known as Simcoe Hall. But this is a portrait of a youngster in a group. Then there is a known portrait that I bought. There is also a portrait at Huron College, London, Ontario, a department of the University of Western Ontario. This portrait was given by the Hellmuth daughters of Bishop Hellmuth of that diocese. But unfortunately it was turned over to an ambitious young man in London, Ontario, to restore and he made such a mess of it that when I took an expert restorer to look at it he told me to have nothing to do with it. He was afraid it could not be brought back to anything like Simcoe. The water colour which is missing has never been located by me. As a matter of fact I have not followed it up but if I ever get time I will do so. You must realize that a man of eighty years of age has a lot of friends who have survived the same accidents and diseases of this mortal coil. So I am kept very busy...anything to do with the Hispanic Museum in New York which is very little known but which I regard as one of the very best things in the U.S.A. The paintings by Sorolla in that museum are terrific. When in Spain I visited the Sorolla Museum because the present Director, Pons Sorolla, is somewhat of a family friend. I found Madrid to be a very cold city and I was amazed to be met by Pons Sorolla in an overcoat in his own museum."

Girl on a Beach, the Sorolla work which Wilbur Howell had helped him acquire in 1964, pleased him so much that he visited the rather out of the way Sorolla Museum when he took Margarita and Judy there in the last days of 1976. He was delighted to find the museum cared for by a descendant of the artist. The paintings that Sam referred to in New York at the Hispanic Society were no doubt the series of fourteen mural panels Sorolla painted between 1910 and 1920 representing

scenes typical of the provinces of Spain.

Shortly after he returned home from overseas in February, Sam was once more involved in various pursuits. He decided that he wanted a Kerry Blue terrier. He wrote to the Kerry Blue Terrier Club of Canada and put an advertisement in Irish papers. Several replies arrived. In his desire to have ironwork and other fixtures compatible with the Georgian style of architecture in River Brink, Sam wrote to the Society for the Protection of Ancient Buildings to enquire about grates. The Society sent him several sketches. Whether he had sketches faithfully copied is not known. Soon he was off to Costa Rica, only to return to River Brink in early May, quite ill.

However, despite his health, later that same month, Sam wrote again to Colonel Blewett of the United States Air Force at Lewiston, threatening to write to President Carter if the annoyance of military planes buzzing him did not cease. They did not and later in July, Sam did write to the President about the planes' habit of trespassing over foreign air space. "Dear Mr. President: Could you arrange with the Pentagon to lend me an anti-aircraft gun? I need it here on my lawn in Queenston on the Niagara River in Canada..." There is no reply to this letter recorded. It was seven years after he had written to President Nixon who had directed a non-committal reply be sent which was signed by a Colonel Getty, USAF.

In June Sam got around to sending Alan McAfee & Company, bootmakers of 5 Cork Street, London W.1, a cheque for his boots which apparently had arrived just in time to accompany him to Costa Rica in 1972. The boots were intended to protect him from his *bête noire*, snakes. He had written to McAfee that, "It is extremely difficult to walk. It's nice to have extra protection but it is not possible to be mobile." The boots extended beyond his knee joints and he could not bend his legs. "So I expect I would have to stand and let the snakes bite me instead of running away quickly." McAfee wrote back, "If boots are constricting at the knee, you may safely cut a slit at the back as far as the lining. This will increase mobility at least to the extent that the snakes will have to keep changing position as they strike at you." Sam emphatically was not amused by the lighthearted attitude. Snakes were not a laughing matter with him and he considered the levity misplaced.

At the end of the year Sam planned a big Christmas party in Queens to coincide with a visit by Margaret and Clement Markert. He wanted the lapels on his dinner jacket corrected to the way he had ordered it, a duplicate of a suit he had ordered some years ago from the same tailor in Savile Row. The particular satin that Sam wanted reproduced was no longer in stock. In vain the tailor tried to convince Sam. The jacket did not arrive in time for the party nor were the lapels

263

what he wanted. Sam was considerably annoyed.

Throughout the year 1978, Sam continued to have constant troubles with Robert Worrall who still had retained the two paintings estimated by some to be worth about $20,000, one by Rockwell Kent and the other by Albert Lebourg, a lesser known French Impressionist. Worrall, father and son, each claimed that the other had possession. By December, Sam felt he had no option other than to commence an action in the Supreme Court of Ontario against the pair.

The art collection became more definitely focussed in these last years of Sam's life. From various notes of his and in letters to friends he made reference again and again to his intention to have three examples of the most important and representational Canadian painters as well as a complete collection of the sculptural works of Suzor-Coté in his collection. This early intention was accompanied by his wish to have the most intensive history, both visual and literary, of the Niagara region as well as an extensive history of the early days of Canada West and of Upper Canada.

To further this end, Sam made tentative attempts to sell some of his acquisitions which did not complement his aims, such as some of his Epsteins, the *Winston Churchill* for example, his Augustus Johns, such as *Chiquita* (Sam had written earlier that he feared he had overdone it with Johns) and his

Matthew Smiths which he had hoped would be a wise investment. He found prices depressed in New York City. He contacted possible outlets in Vancouver for the British works, those not appertaining particularly to Canada. He had also incurred a loan from his New York banker to help finance the house in Costa Rica and at 13 1/2 percent, Sam found the interest hard to stomach. Thus he really had two motives in putting a part of the collection on the block. He also contacted Joyner of Sotheby's in Toronto about auctioning off a few works, but then decided that he did not want to sell anything through them.

Not surprisingly, additions to the collection in 1978 centred on modest works pertaining to Canadian historical events. Portraits arrived, two of James Wolfe Esq., mezzotints by Richard Houston, and one of Louis Joseph, Marquis de Montcalm, the latter published in 1790. Among other works interestingly was a mezzotint by S. Arlent Edwards of *George Washington*, whose influence on the course of Canadian history was certainly substantial.

It was evident that the Frank Worrall case was troubling him at the beginning of the year. On January 3, he wrote to Anna Russell who lived then on Church Street in Toronto, indicating that Worrall had presented him with a painting of Holmes, the painter of flowers, (Robert Holmes

264

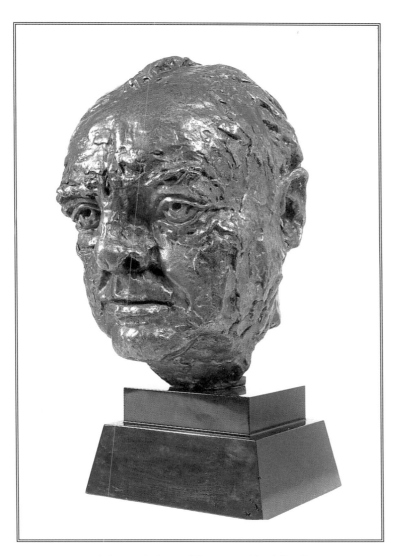

Sir Jacob Epstein's bust of *Sir Winston Churchill* in bronze,
acquired in 1956.

1861-1930), "but I had not collected it before Frank became senile and his son took control of him. ...I wonder if you know where this painting is...this should be in the National Portrait Gallery." The portrait in question was painted by John Wentworth Russell (1879-1959).

Poor health, a continuing problem, led to Sam's staying longer in Queenston in early 1979 than intended. He had suffered a bad fall in River Brink and had been in great pain for some weeks. He commented to a friend that Judy was very strong and did things he didn't think she should nor did he want her to do such things as lifting luggage and so on. That his 182 days per annum of legal residence in Canada were being eroded by his illness and by the consequent delay in travelling to Costa Rica for the warmth essential to combatting his predisposition to bronchitis and pneumonia, caused him some anxiety. Seemingly the new year 1979 was opening with frustrating problems still plaguing his days.

26 LETTERS AND MORE LETTERS

IN A LETTER DATED MARCH 5, 1979 TO GEORGE FINLAYSON "ESQ., Q.C. etc., Treasurer of the Law Society of Upper Canada," Sam wrote:

> "My dear George: ...I am hived up at present in my house in Queenston, Ont., which I regard as a rather beautiful house. It has in it a collection of paintings, world wide, books, prints, etc., going into an amount in millions as crucially valued by Blair Laing in Toronto.
>
> Now I had a sister, long dead, who was in my company when I was at Yale University many years ago. There was a terra cotta figure in the School of Architecture said to be given to the University by the "Friends of France in America." My sister was so taken by this that she never gave up talking about it. So one day I found it in the library of J.P. Morgan in New York where I used to go a great deal. They used to tell me that the only Canadians that came in were Mr. Scott, the lawyer at Ottawa, and myself. This figure was called the Ange de Lude and was taken off a steeple of a medieval church in France. Morgan had bought it and had kept it for a long time in the entrance to his library and private rooms at the corner

of Madison Avenue and 34th Street in New York City. When J.P. Morgan died I happened to notice that the estate was embarrassed for money. So various methods were used to raise money and this particular bronze casting was sold to the Metropolitan Museum in New York City for $100,000. They set it up in the Frick Museum at the corner of Fifth Avenue and 70th Street (approximately). So in respect to my dead sister who won the Governor General's Medal at the University I decided that it was quite appropriate to put in my garden here at Queenston on the Niagara River. So I visited the Louvre in Paris where they offered to make me a cast some years ago when I was very short of money. They did not seem to be able to talk to me intelligibly when I was there a few years ago. So I found a caster in Connecticut who was illustrating this angel without selling any. He made it in lead. So I bought from him a lead figure for $2,000.00. I then had it shipped to the Roman Bronze Works in New York City who are very famous for casting ornamental figures. Probably there is no one else in the United States that can vie with them. Our friend, Kenneth Jarvis, has had work done by them and he knows the management as I do. It was

thought eventually that I was running into risk by setting this lead figure up in my garden because of the amount of vandalism in this region. So I then decided to have a bronze casting made from the lead. The bronze casting is finished and ready to deliver to me here at Queenston when the weather improves. But the lead casting is still with Roman Bronze Works in New York.

Now I have decided that I would like to give the lead casting to the Law Society if they would accept it. It would be perfectly safe in a quadrangle or some sort of situation outside Osgoode Hall itself. Or it could be set up in Osgoode Hall.

I am enclosing a card printed at Princeton University depicting this object but not too well.

I am willing to give this to the Law Society with the necessary stonework to support it so that it might be there forever. But the question of course is whether the lawyers would take kindly to it.

This figure is so important that the Canadian Customs Department has sent a direction to the Customs Office in Niagara Falls to pass it on to me free of charge. The duty would be somewhere around $1500. But I think I could get the same permission

with regard to the lead. There are many places that I can give this lead figure but I have thought a lot about my own alma mater (if such I can call it). Therefore I would like you to consider this. I don't know whether Mr. Jarvis has seen this object or not in his goings and comings from the Roman Bronze Works at New York but I know I am sending him a copy of this letter as I know he knows something about it and if I can find it I will enclose another postcard depicting it so he will know what it is like...

It was done in the 15th or 16th century. For a long time it was not known who did it. But when Morgan bought it, it was definitely known as by the man to whom it is ascribed on the postcard."

Sam refered to the angel in a letter to his old friend W.R. Meredith Q.C. of Ottawa. In the early spring of 1979, he wrote:

"The aeronautical chart interests me very much. But I should think that any amateur would be very confused. I will keep it by me in case I take wings soon. While I am putting a bronze angel at a high cost in my backyard here for decoration, I don't believe in heavenly angels or any after life. I think most of us have become agnostics."

The memory of the minister who had belittled his father publicly for his absence in church when George Sutton was suffering great pain had never really healed.

By now the lease on Sam's property to District Trust had expired and his property manager wrote to Sam that he had principals wishing to rent and begging Sam to turn his attention to the matter. Sam was relieved that District Trust had not wished to renew the lease, and had, in fact, moved out.

With the generosity so typical of him, Sam wrote on April 19 to the Secretary of the Metropolitan Club in New York to request a temporary membership for Professor Eric Arthur, of the School of Architecture at the University of Toronto. The professor had expressed a desire to see the interior of the club because of its association with Stanford White, the architect of many of the imposing buildings of New York and, in particular, of the Metropolitan Club. Sam wrote that he would be glad to take care of Arthur's chits.

As a life long member of the Conservative, then the Progressive Conservative Party, Sam was uneasy about the coming election. He addressed a letter to Hon. Joe Clark in Ottawa. "With an election coming up, I very much fear the

return of Trudeau...I am not too sure you can win an election. You have not the support of the people to any extent. They seem to almost uniformly think you are not up to it. Many of the voters refer to you as 'a boy.' Perhaps Trudeau will be hurt by his wife...I will enclose an address with this letter that I have mislaid for the time being, of a firm in New York which runs elections. They may be very expensive but they might even be worth while at that. I suggest you get in touch with them. They have a great reputation for success."

In July Sam went off to New York, "as my tax permitted time in Canada is running out." He wrote to Stanley Bawtenheimer that he still missed their cousin, David. He also wrote to Margarita in Costa Rica asking her to join him in New York, adding that Judy would be in Queenston. A month later he wrote to her again with various questions of a purely domestic nature; getting the release of the car, paying the storage on it, repairing the dishwasher, a major undertaking in Costa Rica apparently, and also that he had left a suit and some clothing in Escazu and were they still there. He told her that Margaret and Clement wanted him to hold his Christmas Party in Niagara-on-the-Lake. He hoped that she would come too.

By September Sam was 'holed up' in Lewiston to transact business and look after affairs in River Brink. He wanted to save his remaining tax free days for the Christmas festivities. In late September, Sam wrote to George Finlayson asking for a reply to his letter of March 5 concerning the *Ange de Lude*. The lead casting was in New York and Sam wanted to know if Osgoode Hall wished to accept it. He was off to New York and then Costa Rica and wanted to be able to give Philip Schiavo of Roman Bronze the appropriate directive if they were prepared to accept his gift.

Before he left for New York he wrote again to Margarita to tell her he was intending to sell the house in Escazu and rent an apartment in San Jose, more convenient for everyone, especially with the car still not cleared for entry and use. He also wrote that if the car could not be sold in Costa Rica, it could be driven back to River Brink with the Barnes portrait of Sam, some Hudson Bay blankets and "other things."

In typical 'ride 'em cowboy' style, Sam fired off a three page letter to the Combines Investigation Branch in Ottawa. Among the objects of his ire were: the Ontario Nurseries Association, a combines price setting he felt; a casket manufacturer whom Sam felt had unfairly forced out competition and was selling the product at an overheated price to those in mourning and therefore vulnerable; the manufacture of eye glasses where again Sam felt the retail price was out of line with costs and a reasonable markup; the unjustified markup on imported alcoholic beverages and the

269

excise tax on new automobiles built in Canada. He also still objected to the agreements between English publishers of law books and the Canadian distributors, preventing a Canadian from ordering directly from the publisher at a much reduced price. While he was at it he took a crack at the egg and dairy marketing boards. "Billions of pounds of butter are sold or thrown away by Ottawa every now and then because they keep piling butter up to make it scarce and enhance the price." He felt he was surrounded by cartels and combines which made it, in his opinion, very expensive to be a Canadian.

He also wrote to Hon. James Snow, Minister of Transport and Highways over a difficulty in getting an appointment for a driving test. "I am forced to complain bitterly against your examination office in Niagara Falls." A copy was sent to Hon. John Robarts, the Premier of the province. That Sam, at the age of 81, was the sort of driver with whom some passengers were terrified to drive, did not enter into his consideration of the matter.

The year 1979 was fast moving forward, but still it was not known if Osgoode would welcome the angel.

27 THE ANGEL ARRIVES AND THE MARRIAGE ENDS

ANOTHER LETTER WAS SENT TO MARGARITA AT THE END OF AUGUST to inform her again that the house in Escazu was to be sold and that she had her choice of living in New York or in Queenston. He hinted that if she did not show up there was a girl in Montreal who would come and live in River Brink and look after things. He offered to let her bring her maid and reminded her to see about a passport for the girl, a Costa Rican.

Margarita wrote back that she was afraid to come to Canada:

> *"It's about your bad temper and I'm more afraid about you, thinking when you have put out side, and were asking me to leave for leave the place if it happens to me far away..."*

Later she wrote that she was having trouble with snakes. Sam's advice was to bring a pair of mongoose from Jamaica and carry a flashlight after dark. Sam and Judy went to New York in December and apparently the Christmas party was off or transferred to the house in Queens. He wrote that he was thinking of taking Judy to Costa Rica and on to the Cayman Islands and that he had been advised that he should not go anywhere without someone with him. He continued to have trouble with his feet and legs as well as some high blood

pressure but he wrote, "...I don't have any shortage of breath or serious problems that prevent me from drinking the good stuff."

An acquisition of 1979 of great interest was *The Old Horse*, a casting from an original by Thomas Gainsborough, which Gainsborough had made as a gift to John Constable. Fortunately the plaster mold had been kept, so it was possible to cast another from the original. Sam acquired it from the Heritage Fine Art of Bristol, England. There were several letters back and forth with considerable discussion on what kind of horse was represented. A Shire horse, Sam was told. He wrote back that in Canada, Clydesdales and Belgians were the draft horses more commonly used. The heavy horse usually was imported from the United States, he continued. With so many farming forebears, Sam continued to feel a strong liaison with the land although he had abandoned his ambition about breeding Jersey cattle. As part of this correspondence, Sam wanted to have Heritage Fine Art ship him at least two clocks.

Another bronze that arrived in 1979 was a bust of George Washington by Jean Antoine Houdon, along with two paintings that Sam acquired at auction from Parke Bernet, *Portrait of a Lady* by Alphonse Jongers and *Getting Water from his Neighbour's Place*, by Allen Sapp, painted in 1972. The highlight of arrivals in 1979, however, occurred when *Ange de Lude* finally

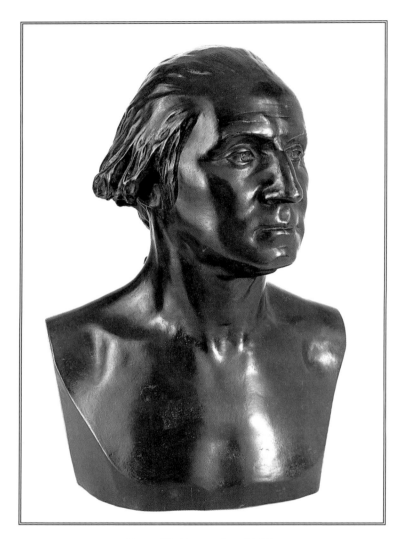

George Washington, dated 1785.
An inscription on the left side shoulder reads: "This bust was taken from life at Mount Vernon Oct - 1785 by Jean Antoine Houdon."

arrived and took her place in the garden. It must have been shortly after the middle of May, as the documentation with the closest date of the *Angel's* appearance is the Shipper's Export Declaration, dated May 15, 1979 from Philip Schiavo, President of Roman Bronze Works Incorporated at 96-18 43rd Avenue, Corona, New York.

On July 12, 1979, Sam wrote to Schiavo:

"Dear Philip: I have owed you a letter for some time.

First of all the angel came here on a truck on the day when I was supposed to enter the hospital in Toronto... So I felt I had to look after the Angel even if it is inanimate. So I got in the dog-house for not reporting to the hospital...

We got the angel up on a stone base, used the fast drying cement which you directed, and levelled the base and did everything that seemed to be necessary. So the angel is standing upright on a stone base and it looks very well indeed. Just after we got it mounted the laburnum trees which are either side of it came out in full glory and we had a terrific sight. Sometimes when I look down the treed avenue I wonder if I have created a Roman Catholic Park?

I shut my eyes to this as I am a confirmed Agnostic...

I also found that I have been using a wrong title for this angel. The correct title is Ange de Lude. *According to a letter which I hold from the Frick Collection dated August 1, 1949, this angel was formerly the property of a Marquis de Talhouet and was used by him to ornament one of the towers of the Chateau de Lude in the Sarthe region of France. I always understood it had been a steeple on a chapel but in this I seemed to have been wrong. The angel was taken off the tower and used for a newel post on the grand staircase in this chateau. It is not known how it got into commerce but some views are that it was a weather vane and I suppose this is how I got the notion that it was on a steeple. It was in the Universal Exhibition of Paris in 1867 where it became famous. After Morgan died his estate sold it to the city of New York for $150,000.*

We still have to decide what to do with the lead figure. I have offered it to our Law Society but although I wrote them several weeks ago there has been no answer yet. I suppose they think they should have time to think it over."

273

Ange de Lude, mounted on a stone base in the garden
at River Brink in 1979.

Sam took every precaution with the precious angel. Her base is strongly embedded four feet deep, so as to be sure that no frost upheaval will ever harm her. One can easily picture the ailing and weakening Sam standing in the large gallery of River Brink facing south and admiring *Ange de Lude* in her beautiful setting. It may well have been a chance remark from the ever faithful Judy, the staunch Catholic, that got Sam pondering about his 'Roman Catholic Park.' Nevertheless, they were the first of many who have looked out down the south garden and have been refreshed by the timelessness of her serenity.

For Sam's 81st birthday on August 12, Judy gave him a birthday card inscribed: "Special Birthday wishes for a special young man. Wishing you a Happy 81 Birthday, Judy."

Sam spent the close of 1979 and the first few weeks of 1980 in New York at his home in Queens. Judy was with him and applying her nursing skills. They spent a short time in February in Grand Cayman. Sam still had not been called to the Cayman bar, but as he had transferred some capital to a holding company he had set up for that purpose in Grand Cayman, he had business which called for his attention there.

Back in Queens in April of 1980, Sam wrote with unconcealed disdain of the treatment he had been accorded in his attempt to re-enter Costa Rica from Panama the previous

year. He addressed the letter to the Department of Tourism, San Jose and in it he spelled out the problems that had been building since 1977 when the Ford car was driven to Costa Rica. The car had been in bond until Sam's application for *pensionato* status was settled. He had sent a cheque for $500 US drawn on his account in the Caymans which was apparently satisfactory. The cheque had been cashed and no receipt was forthcoming. Subsequently Sam sent $2000 US to Margarita to be used to clear up any charges outstanding for storage and with instructions to her to have a man identified as Desoto get the car and bring it to the house in Escazu.

Margarita claimed that Costa Rican Customs had already taken possession of it and that it was no longer in storage. Sam assumed that the *pensionato* plates were to be affixed at the Customs Office. Margarita claimed that it was too late to pay storage because it had been released. The question was, released to whom?

Sam saw his car, easily recognizable, being driven about San Jose by the Chief of Customs, who, when confronted by Sam, professed to know nothing about it. Later, a Customs employee told Sam that the keys were on the Chief's desk. Not unnaturally it appeared to Sam that there had been some sort of collusion between Margarita and Costa Rican Customs, just as there had been between Margarita and Immigration in

March of 1980 when Sam and Judy were both detained at the border after Margarita successfully engineered a shopping trip for all three to Panama. Apparently Sam had not been keen to make the trip and had found himself buying a substantial amount of clothing for Margarita on her Panama spree. Margarita gave false evidence that she had been abused by Sam, an accusation totally without foundation, but which both angered and troubled him. One consequence was that Sam and Judy were both detained over night, Sam in jail and then in a hotel, and Judy in a convent.

Judy's account of the episode written on March 14, 1980 on Hoteles Royal Dutch letterhead, San Jose, to Margaret Markert indicated that neither she nor Sam were staying in Sam's own home and tells of the deteriorating relationship:

"We just got back from Panama, the 3 of us But she did some dirty work while we were there. She wrote to the immigration to stop us from entering Costa Rica. She also sent them a cable saying we were ARRIVING yesterday they have taken our passports again so that is the reason we are here in this hotel. We are going to see a Lower [sic] today at 3 pm. The POLICE drove us to the House last eve. they would not let Mr. Weir into the House. I went in &

got some of his papers so now he want [sic] her out of the House. They told us at the airport yesterday that it was a Costa Rican woman did it. So he asked them if she sent a CABLE and they said yes. he [sic] is mad and very upset...The House is not sold and it is she that is stopping it."

Later that year Margarita wrote to Sam demanding a pension which he refused. Sam's will was redrafted to make sure that Margarita would receive no benefits. He considered a suit for annulment, but later brought suit for divorce in the State of New York. Margarita countersued for a divorce, but Sam died before either suit came to court.

Although Sam's health was failing, he wrote to the President of Costa Rica outlining his plight concerning both car and house. He engaged a legal firm in San Jose, but it seemed to Sam that roadblocks were being put in his way at every turn. Margarita demanded half of the sale price of the house at Escazu. Sam countered that the pre-nuptial agreement had made it clear that the house was entirely in his name. The marriage, such as it had been, was definitely over.

28 THE FINAL DAYS

By the autumn of 1980 Sam was virtually bedridden. Judy was in constant attendance upon him and his good and loved friends, Joyce DeVecchi, Margaret Ferguson, Eugene LaBrie and others rallied round. Ed Phelps brought his young friend, Peter Adams, from London to help with the task of lifting Sam. Eventually a night nurse was brought in, but Sam refused to accept pills or medications from anyone except faithful Judy.

It was a sad Christmas at River Brink in 1980. Sam's bed was brought downstairs and placed in front of the fireplace from where he could see the painting that seems to have given him the most pleasure of all in his collection, Homer Watson's *The Lothian Hills*. Christmas dinner in the dining room was a subdued and doleful affair. Sam was able only to sip a little lemonade in his bed and everyone knew the end of his days was imminent.

On January 18, 1981, Margaret was alone at his bedside when he died around 10:30 in the evening. At the end he had been surrounded by his closest and dearest friends whom he trusted and by the greatest and most beloved treasures of his life, his paintings, his art works and his books, solace in the myriad of annoyances both petty and profound that had come his way in the last decade of his life.

Samuel Weir worked at a ferocious pace all his life. There were many achievements and many disappointments.

Would he have done anything differently if he had been free to make more decisions on his own in his young days? Perhaps there is a clue in the bequest to the Law Society of Upper Canada of $13,500, of which $10,000 was to be earmarked for special lectures, and the much publicized $3500, to be awarded to the graduating student with the lowest marks to be spent on a party or an expensive date or some such frivolity.

In paragraph 11, sub-paragraph (h) of his will, he stipulated:

> *To pay to the Law Society of Upper Canada, of which I am a Bencher, the sum of Three Thousand Five Hundred Dollars ($3500) in Canadian money to be invested and the annual revenue therefrom to be given to the student in the Bar Admission Course who stands the lowest among all the successful Candidates at the final examinations or other final tests with my recommendation that he or she takes his wife, or husband or fiance or serious female friend out for a gay evening on the money with my encouraging comment that many with very low standards at the Law Society examinations have become illustrious members of the Bar by keeping dark their want of legal knowledge. In case the Bar Admission Course*

> *shall pass out of existence as I expect it may for various pressures some of which are now evident the said sum of Three Thousand Five Hundred Dollars ($3500) shall be added to the sum bequeathed to the Law Society under the Provisions of the following sub-paragraph,*

> *(i) To pay to the Law Society of Upper Canada, of which I am a Bencher, the sum of Ten Thousand Dollars ($10,000.00) Canadian money to accumulate the income therefrom which shall be used from time to time to defray the cost of special lectures to be given at Osgoode Hall whenever sufficient money is available for other headquarters of the Law Society of Upper Canada for the time being by an eminent scholar in The English Speaking World (including Quebec) it being my intention that such lectures shall be of sufficient merit to be published as "The Weir Foundation Lectures." This legacy shall be cancelled if the legacy in sub-paragraph (h) is not accepted by The Law Society.*

The package was turned down by the Law Society of Upper Canada, "who could not go on record as condoning bad grades." Sam had taken no time out for play in his student days

and this unusual bequest may have been a formal regrettal of his almost monastic existence coupled with his constant need for recognition, as in a special lecture probably bearing his name. In this, as in so many of his activities, he was misunderstood.

Before he died his request to be buried on his own property was granted. His aspiration to be called to the Cayman Bar was finally realized when the documentation arrived, albeit too late for him to enjoy. "He never knew it came," Judy reminisced sadly. "He was too ill to look at his mail by the time it arrived. But it's on his tombstone. It's all there."

Sam's lifelong passion for beautiful objects, whether they be works of art or plants, magnificent old clocks or finely worked coins, has yielded a treasure house filled with beauty and a tangible regard for our history. More than two hundred paintings; almost one hundred works of sculpture; almost seven hundred prints, engravings, etchings and lithographs; in excess of five thousand books, many of great rarity, of which about forty percent are on art and art history, and sixty percent on history or of historical significance; between forty and fifty works of late eighteenth and early nineteenth century silver and well over two hundred and fifty examples of rare coins, stamps and old china comprise this superb legacy.

There is at least one mystery and that is the fate of 100 gold sovereigns and some gold South African Rands. Two, we know, were given as presents but the others can only be recorded as "whereabouts unknown."

As the visitor passes the grave on the way to the entrance of his trove of almost seventy years of documentation of beauty, so generously left 'for public enjoyment' to all who love Canada and its history, it is well to pause and to read Boswell's quotation on Samuel Johnson engraved upon Sam's tombstone.

"He touched nothing he did not adorn."

Samuel E. Weir Q.C. did just that.

River Brink. Once his home, the building is now a gallery housing Samuel Edward Weir's treasured collection of paintings, prints, sculptures; etchings, lithographs and books, assembled over his lifetime and left as a legacy for viewing by the visiting public.

Weir Family
Highland Scottish ancestry, family relocated to Ulster

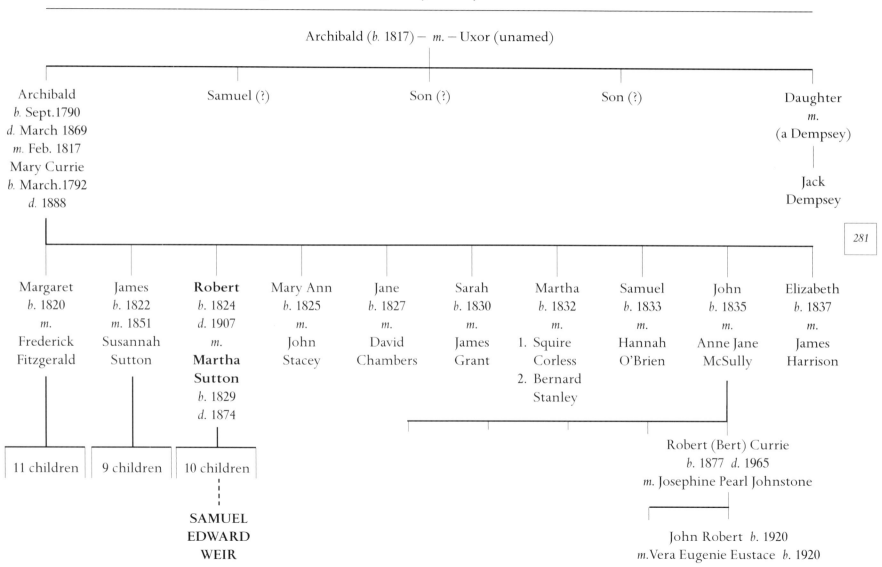

Archibald (*b.* 1817) − *m.* − Uxor (unamed)

Archibald
b. Sept.1790
d. March 1869
m. Feb. 1817
Mary Currie
b. March.1792
d. 1888

Samuel (?)

Son (?)

Son (?)

Daughter
m.
(a Dempsey)

Jack
Dempsey

Margaret
b. 1820
m.
Frederick
Fitzgerald

11 children

James
b. 1822
m. 1851
Susannah
Sutton

9 children

Robert
b. 1824
d. 1907
m.
**Martha
Sutton**
b. 1829
d. 1874

10 children

**SAMUEL
EDWARD
WEIR**

Mary Ann
b. 1825
m.
John
Stacey

Jane
b. 1827
m.
David
Chambers

Sarah
b. 1830
m.
James
Grant

Martha
b. 1832
m.
1. Squire
 Corless
2. Bernard
 Stanley

Samuel
b. 1833
m.
Hannah
O'Brien

John
b. 1835
m.
Anne Jane
McSully

Elizabeth
b. 1837
m.
James
Harrison

Robert (Bert) Currie
b. 1877 *d.* 1965
m. Josephine Pearl Johnstone

John Robert *b.* 1920
m. Vera Eugenie Eustace *b.* 1920

Weir Family

Second child of Archibald Weir (1790-1869) and Mary Currie Weir (1792-1888)

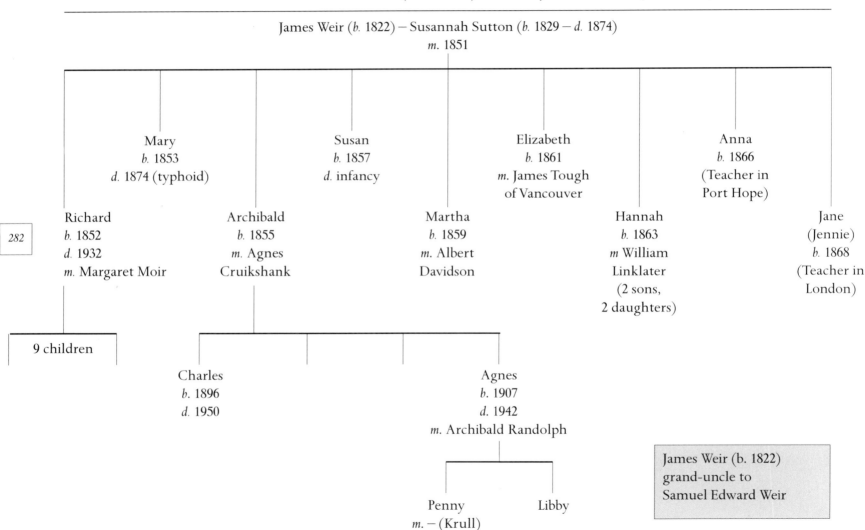

James Weir (*b.* 1822) – Susannah Sutton (*b.* 1829 – *d.* 1874)

m. 1851

282

Mary
b. 1853
d. 1874 (typhoid)

Susan
b. 1857
d. infancy

Elizabeth
b. 1861
m. James Tough
of Vancouver

Anna
b. 1866
(Teacher in
Port Hope)

Richard
b. 1852
d. 1932
m. Margaret Moir

Archibald
b. 1855
m. Agnes
Cruikshank

Martha
b. 1859
m. Albert
Davidson

Hannah
b. 1863
m William
Linklater
(2 sons,
2 daughters)

Jane
(Jennie)
b. 1868
(Teacher in
London)

9 children

Charles
b. 1896
d. 1950

Agnes
b. 1907
d. 1942
m. Archibald Randolph

Penny
m. – (Krull)

Libby

James Weir (*b.* 1822)
grand-uncle to
Samuel Edward Weir

Weir Family
Third son of Archibald (1790-1869) and Mary Currie Weir (1792-1888)

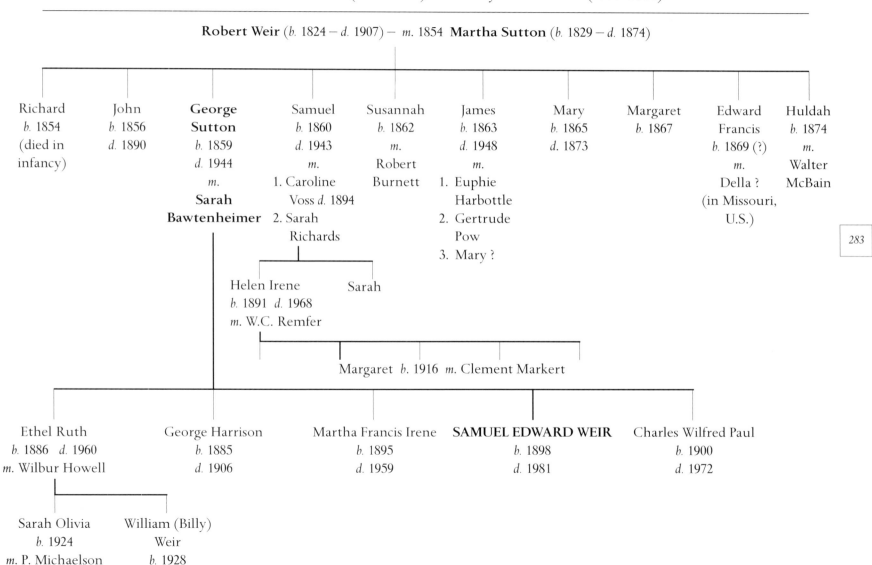

Robert Weir (*b.* 1824 − *d.* 1907) − *m.* 1854 **Martha Sutton** (*b.* 1829 − *d.* 1874)

Richard
b. 1854
(died in
infancy)

John
b. 1856
d. 1890

**George
Sutton**
b. 1859
d. 1944
m.
**Sarah
Bawtenheimer**

Samuel
b. 1860
d. 1943
m.
1. Caroline
 Voss *d.* 1894
2. Sarah
 Richards

Susannah
b. 1862
m.
Robert
Burnett

James
b. 1863
d. 1948
m.
1. Euphie
 Harbottle
2. Gertrude
 Pow
3. Mary ?

Mary
b. 1865
d. 1873

Margaret
b. 1867

Edward
Francis
b. 1869 (?)
m.
Della ?
(in Missouri,
U.S.)

Huldah
b. 1874
m.
Walter
McBain

Helen Irene
b. 1891 *d.* 1968
m. W.C. Remfer

Sarah

Margaret *b.* 1916 *m.* Clement Markert

Ethel Ruth
b. 1886 *d.* 1960
m. Wilbur Howell

George Harrison
b. 1885
d. 1906

Martha Francis Irene
b. 1895
d. 1959

SAMUEL EDWARD WEIR
b. 1898
d. 1981

Charles Wilfred Paul
b. 1900
d. 1972

Sarah Olivia
b. 1924
m. P. Michaelson

William (Billy)
Weir
b. 1928

Weir Family

Grandson of Archibald (1790-1869) and Mary Currie Weir (1792-1888), and first son of James and Susannah Sutton Weir

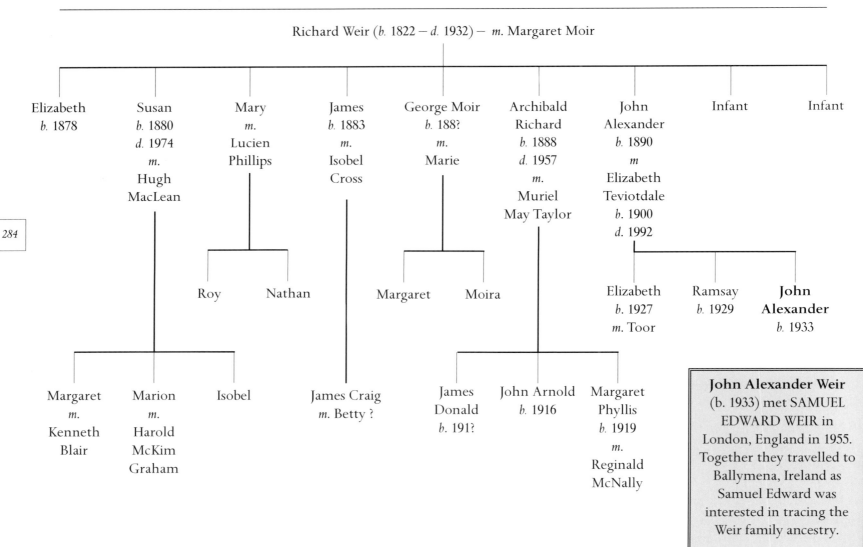

John Alexander Weir (b. 1933) met SAMUEL EDWARD WEIR in London, England in 1955. Together they travelled to Ballymena, Ireland as Samuel Edward was interested in tracing the Weir family ancestry.

Bawtenheimer (Badenheimer) Family

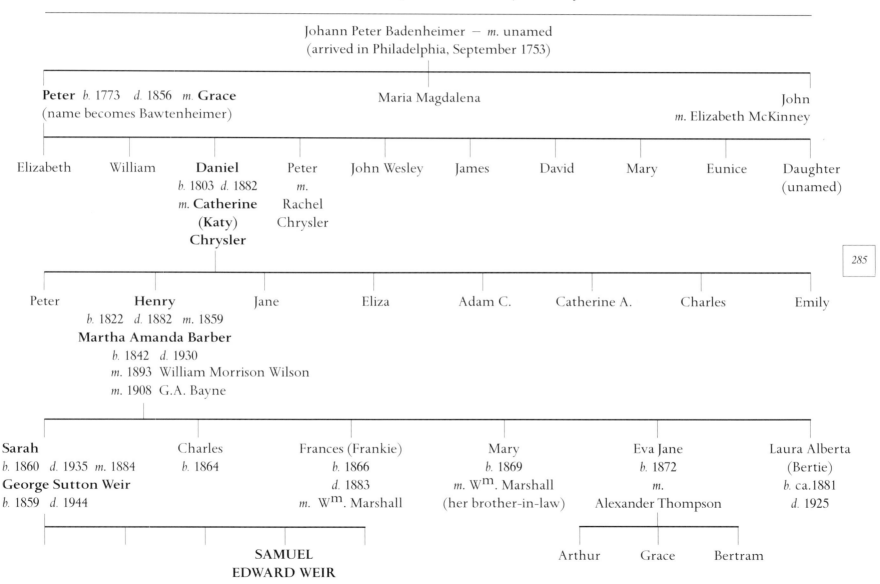

Johann Peter Badenheimer — *m.* unamed
(arrived in Philadelphia, September 1753)

Peter *b.* 1773 *d.* 1856 *m.* **Grace**
(name becomes Bawtenheimer)

Maria Magdalena

John
m. Elizabeth McKinney

Elizabeth William **Daniel** Peter John Wesley James David Mary Eunice Daughter
(unamed)

Daniel
b. 1803 *d.* 1882
m. **Catherine**
(Katy)
Chrysler

Peter
m.
Rachel
Chrysler

Peter **Henry** Jane Eliza Adam C. Catherine A. Charles Emily

Henry
b. 1822 *d.* 1882 *m.* 1859
Martha Amanda Barber
b. 1842 *d.* 1930
m. 1893 William Morrison Wilson
m. 1908 G.A. Bayne

Sarah Charles Frances (Frankie) Mary Eva Jane Laura Alberta
b. 1860 *d.* 1935 *m.* 1884 *b.* 1864 *b.* 1866 *b.* 1869 *b.* 1872 (Bertie)
George Sutton Weir *d.* 1883 *m.* W^m. Marshall *m.* *b.* ca.1881
b. 1859 *d.* 1944 *m.* W^m. Marshall (her brother-in-law) Alexander Thompson *d.* 1925

SAMUEL
EDWARD WEIR

Arthur Grace Bertram

SOURCES

SAMUEL EDWARD WEIR COLLECTED AND KEPT VOLUMINOUS FILES AS part of his personal records: letters, newspaper accounts, excerpts from journals and catalogues, invitations etc. All the source documents quoted in the text come from these files which are located either in the Archives at River Brink, Queenston, Ontario or in the 60 boxes of materials known as The Weir Collection and housed at the Ontario Archives, Toronto and yet to be catalogued. The one exception to this is the quotation from the March 19, 1977 *Globe and Mail* article by Donald Creighton, entitled "Gov't Sale of Liquor."

The other key source of information on the life of Samuel Edward Weir came through numerous personal interviews, phone calls or correspondence as indicated below:

Arnold, Mrs. Kim, Archivist, The Presbyterian Church in Canada, Knox College: Toronto, Sept. 21/93.

Baldwin, William P.C. February 7/94 in London.

Bawtenheimer, Mr. and Mrs. Charles, Bay City, Michigan. Replied to letter May 30/93.

Bawtenheimer, Paula Elliott. At her home in Mississauga, Ontario, April 17/93, subsequent telephone calls August 29/93; October 6/93; February 20/94; February 20/95.

Bawtenheimer, JoAnne Fulcher (Mrs. E.L.). By telephone April 20/93; follow up September 4/93.

Binnie, Susan, Archivist Law Society of Upper Canada. By telephone February 14/96; April 18/96.

Blair, Hugh, Calgary. By telephone November 21/94.

Blair, Mrs. Margaret McLean, Vancouver. Interviewed January 23/95.

Brook, John. In Niagara-on-the-Lake, Ontario, August 12/95.

Brunner, Mr. and Mrs. Charles. In London, Ontario, April 25/94.

Burtniak, Prof. John, Archivist Brock University. Interviewed October 1/96.

Campbell, James, Curator Samuel E. Weir Collection 1993-1998, Innumerable conversations of inestimable help.

Faithe, Ann Scobbo, Canadian Club of NYC. Interviewed May 25/94.

Cashel, Margaret J., American Red Cross. Interviewed August 23/94.

Choles, Jack, General Reference Archivist, Ontario Archives. Interviewed September 13/93.

Cochrane, Peter, retired employee Dudley Tooth Gallery. Interviewed, April 15/94.

Eisenberg, Merna, College of Physicians and Surgeons. Telephone interview, September 9/93; September 16/93 letter to confirm GSW in 1st class of graduates in Med. UWO.

Cooper, Dr. William and Mrs. Moira. In Niagara-on-the-Lake, May 9/96.

DeVecchi, Joyce, member of the Board, Weir Foundation. In London, April 25/94, passim River Brink.

Dimatteo, Mary, Don and Laurie. Interviewed May 11/94.

Earp, Jeanette (Mrs. Alan). Niagara-on-the-Lake, August 11/94.

Elliott, Paula, see Bawtenheimer.

Erskine, Isabelle. In London, April 26/94.

Fair, Barry. At London Region Gallery of Art, February 7/94.

Falls, Dave, Registrar McIntosh Gallery UWO. Interviewed September 8/96.

Ferguson, Margaret, member of Board now Chairman Weir Foundation. Innumerable interviews from beginning of working on biography, April 3/93 until completion.

Fiedelleck, Mrs. Dorothy. By letters of February 7/95 and May 7/95.

United Methodist Church Secretary. Letter of November 26/94 (no signature).

Hudson County Probate N.J., Letter, June 6/94 (no signature).

Humber, Charles J. Interviewed November 3/95.

Irwin, John. Interviewed November 30/95.

Ivey, Barbara (Mrs. Peter). Interviewed February 17/94.

Johnston, Basil. Interviewed March 21/94.

Jones, Fred. In Niagara-on-the-Lake on May 9/94.

Kiss, Alex. In Niagara-on-the-Lake on May 11/94.

Kirk, Charles B. By telephone in London, February 7/94.

Kormos, Jonathan, member of the Board, Weir Foundation, and Elizabeth. In Niagara-on-the-Lake on May 11/94.

Krull, Mrs. Penny. In Sarnia, Ontario, October 3/93.

Lynn, Mrs. Eva. In Hamilton, February 4/95.

LaBrie, Dr. Eugene. Interviewed August 13/94; March 29/96; April 4/97 at Toronto; passim Niagara-on-the-Lake.

Lindsay, Isobel. In Toronto, May 30/95.

Macdonald, James. Interviewed Toronto, May 16/94.

MacMillan, Hugh. Interviewed Guelph, November 3/95.

Mahoney, Judy. Interviewed upon innumerable occasions from April/93 until her death October 12/95.

Markert, Margaret. In Colorado Springs, October 18,19,20/93.

May, Margaret. Interviewed October 2/93.

Murray, Andrew, of Mayor Galleries. In London, Ontario, February 28/94.

Moore, J.H. Interviewed London, July 12/94.

McCulloch, Gretchen. In Waterloo, Ontario August 26/94.

McCullough, Hon. J. Douglas. Interviewed February 17/94.

McMillan, Dr. Patrick (Paddy). Interviewed May 12/94.

Neely, George. In London, Ontario, July 13/94.

O'Brien, Paddy. Interviewed London, Ontario, April 25/94.

O'Donal, Rory. By telephone, February 17/94.

Peringer, Raymond. Interviewed October 29/94.

Phelps, E.C.H. In London, Ontario, September 8/93; October 2/93 and many subsequent meetings and telephone calls of tremendous help.

Poole, Nancy. In London, Ontario, April 26/94.

Reid, Dennis. In Toronto, Ontario, May 17/94.

Schiavo, Philip. In Queens, New York City, June 24/94.

Sherlock, Gerry. In Toronto, Ontario, May 3/94.

Schmidt, Jan. Interviewed January 5/94.

Shorter, Dr. Edward. Interviewed September 24/94.

Silcox, David. In Toronto, Ontario, September 26/93, February 15/94.

Smart, Tom. Interviewed April 28/94.

Smibert, Miss Marie. Interviewed April 5/93.

Solevich, Dr. Joseph. Interviewed September 13/93.

Soren, Albert. Interviewed April 5/94.

Staff, Knox College Archives. Toronto, September 21/93

Staff, United Church Archives. Emmanuel College, Toronto, September 21/93, November 8/93.

Stewart, Judge Lorne and Mrs. In Toronto, February 15/95.

Strauss, Nathan. Interviewed February 21/95.

Simpson, Margaret. Interviewed September 21/93.

Taylor, David. Interviewed March 10/94.

Thompson, Fred and Fran. In Toronto, February 9/95.

Thornton, Jim. In Niagara-on-the-Lake, May 11/94.

Torrance R.J. In Niagara-on-the-Lake, May 11/94.

Turnbull, Miss Mary. Interviewed November/93.

Turner, J. Allyn. In Niagara-on-the-Lake, May 11/94.

Van der Meulen, Mrs. Agnes. Interviewed. January 3/95.

Walker, Wentworth. In Toronto, October 29/94.

Webster, Mrs. Betty. In Toronto, March 8/95.

Weir, John Alexander. Interviewed October 31/94.

Weir, John Robert. In London, October 3/93 and passim in Niagara-on-the-Lake.

288

CREDITS FOR ILLUSTRATIONS

ALL VISUALS, BLACK AND WHITE PHOTOGRAPHS AND COLOUR reproductions, are the property of The Weir Foundation, Queenston, Ontario. Permission to use these visuals has been granted courtesy of The Weir Foundation, Queenston, Ontario; unless otherwise indicated below:

COLOUR PLATES

WATSON, Homer (1855-1936) Canadian
The Lothian Hills 1892
Oil on canvas
78.7 x 100.3 cm.

O'BRIEN, Lucius Richard (1832-1899) Canadian
At Rest 1889
Watercolour on paper
64.5 x 43.0 cm.

PEEL, Paul (1860-1892) Canadian
Good Morning 1891
Oil on canvas
49.4 x 38.4 cm.

MORRICE, James Wilson (1865-1924) Canadian
Le Porche de l'église San Marco, Venise ca. 1901
Oil on wood panel
12.5 x 15.5 cm.

MORRICE, James Wilson
La Communiante ca. 1898
Oil on wood panel
12.8 x 15.5 cm.

HARRIS, Lawren Stewart (1885-1970) Canadian
House and Women ca. 1920
Oil on cardboard panel
27.0 x 31.2 cm. By permission, family of Lawren S. Harris.

THOMSON, Thomas John (Tom)
(1877-1917) Canadian
Northern Woods
Oil on wood panel
21.1 x 26.5 cm.

THOMSON, Thomas John (Tom)
Sketch for *The Jack Pine* ca. 1916
Oil on wood panel
21.1 x 26.8 cm.

KANE, Paul (1810-1871) Canadian
Self Portrait ca. 1845
Oil on canvas
63.7 x 53.3 cm.

CARR, Emily (1871-1945)
Canadian
Friendly Cove 1929
Watercolour on paper
69.5 x 50.7 cm.

MACDONALD, James Edward
Hervey (1873-1932) Canadian
Thornhill Garden 1915
Oil on cardboard
20.3 x 25.4 cm.

BARNES, Archibald George
(1887-1972) Canadian
Portrait of Samuel Edward Weir, Q.C.
1955
Oil on canvas
68.5 x 58.4 cm.

JOHN, Augustus Edwin
(1878-1961) English
Chiquita ca. 1917
Oil on canvas
86.3 x 63.5 cm.
© Augustus Edwin John
1998 Vis*Art Copyright Inc.

HOPPNER, John (attributed)
(1758-1810) English
Portrait of Sir William Osgoode
Oil on canvas
74.9 x 62.2 cm.

CULLEN, Maurice Galbraith
(1866-1934) Canadian
Meadow Stream in Early Winter
Oil on canvas
46.0 x 61.5 cm.

ROBINSON, Albert Henry (1881-
1956) Canadian
Farmer Sleighing Home in Winter
ca. 1927
Oil on canvas
57.0 x 67.0 cm.

KRIEGHOFF, Cornelius David
(1815-1872) Canadian
Settler's Cabin in the Foothills 1859
Oil on canvas
61.0 x 78.7 cm.

BEECHEY, Sir William (1753-1839)
English
Portrait of Sir George Yonge 1790
Oil on canvas
76.2 x 63.5 cm.

WALKER, Horatio (1858-1938)
Canadian
The Turkey Girl 1904
Oil on canvas
72.7 x 92.1 cm.

SEBRON, Hippolyte Victor
(attributed) (1801-1879) French
Niagara Falls from the Canadian Side
ca. 1850
Oil on canvas
48.9 x 72.4 cm.

STEER, Philip Wilson (1860-1942)
English
Effect of Rain, Corfe 1908
Oil on canvas
45.8 x 61.4 cm.

KRIEGHOFF, Cornelius David
Indian Council 1855
Oil on canvas
55.2 x 61.9 cm.

FORBES, Kenneth (1892-1980)
Canadian
Portrait of Samuel E. Weir 1966
Oil on canvas
83.5 x 71.1 cm.

DENNIS, James B. (attributed)
(1778-1855) English
The Battle of Queenston Heights
Oil on canvas
54.4 x 76.3 cm.

ROMNEY, George (1734-1802)
English
Portrait of John Currer 1778
Oil on canvas
76.2 x 63.9 cm.

ZOFFANY, Johann Joseph
(attributed) (1733-1810) German
*Portrait of John Graves Simcoe as a
Young Man* ca. 1770
Oil on canvas
96.7 x 69.2 cm.

BLACK AND WHITE
ARTWORKS:

SUZOR-COTÉ, Marc-Aurèle de
Foy (1869-1937) Canadian
Femmes de Caughnawaga 1924
Bronze
Height: 43.1 cm.

BARTHÉ, Richmond (b.1901)
American
Sketch of George Sutton Weir, 1934
Charcoal and coloured pencil
on paper
57.3 x 45.7 cm.

McKENZIE, Robert Tait
(1867-1938) Canadian
The Sprinter 1902
Bronze
Height: 22.5 cm.

BARBET, Jean
Ange de Lude (Angel)
Bronze casting after Jean Barbet
(active 1475-1514) French
Height: 98cm.

VARLEY, Fred (1881-1969)
Canadian
Portrait of S.E. Weir 1951
Charcoal on paper
38.0 x 30.5 cm.

SUZOR-COTÉ, Marc-Aurèle de
Foy
Maria Chapdelaine 1925
Bronze
Height: 39.1 cm.

McKENZIE, Robert Tait
Ice Bird 1925
Bronze
Height: 49.8 cm.

SUZOR-COTÉ, Marc-Aurèle de
Foy
L'Essoucheur 1925
Bronze
Height: 40.0 cm.

CLARKE, Silvia
(1911-1994) Canadian
*Samuel Edward Weir's Residence,
London, Ontario*
Grey wash on paper
30.4 x 36.2 cm.

HORNYANSKY, Nicholas
(1896-1905) Canadian
Weir's Law Office 1963
Etching on paper
23.8 x 29.0 cm.

EPSTEIN, Sir Jacob (1880-1959)
English
Portrait of George Bernard Shaw 1934
Bronze
Height: 42.5 cm.

EPSTEIN, Sir Jacob
Portrait of Sir Winston S. Churchill 1946
Bronze
Height: 29.5 cm.

HOUDON, Jean-Antoine
(1741-1828) French
Portrait Bust of George Washington 1785
Bronze
Height: 45.7 cm.

291

BLACK AND WHITE PHOTOGRAPHS
Family Photographs, Courtesy of The Weir Foundation

Colour transparencies and Black and White photographs of art works: Thomas Moore Photography, Toronto.

Photograph of River Brink, Courtesy of James Campbell, Curator, Weir Collection.

Care has been taken to notify appropriate sources of the reproduction of art from The Weir Foundation collection within this publication.
Creditation to sources not cited will be provided in subsequent volumes. In this regard The Weir Foundation and/or the Publisher should be notified.

INDEX

Photo by David Leyres

MARY WILLAN MASON WAS BORN IN TORONTO INTO A PROMINENT musical family and graduated from University College at the University of Toronto. A lifelong and dedicated student of fine art, she has written extensively on the subject. "The Consummate Canadian" is her first biography of a collector.

312

ABOUT THE AUTHOR